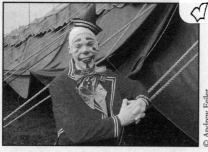

© Andrew Feiler

PRAISE FOR BRUCE FEILER and *Under the Big Top*

"What a splendid book—funny, insightful, quirky, entertaining, and beautifully written. Bruce Feiler may have been a circus clown, but he's also a magician with prose."

—Tim O'Brien, author of *In the Lake of the Woods*

"Feiler's unglossed account of the season is complete with animal rights protesters, sin, sex, sawdust, camaraderie, and personal revelation. 'So now you know,' the ringmaster tells him after his last performance. And now we know, too."

—*Miami Herald*

"Incredible. . . . Exciting. . . . Unbelievable. . . . Your view of the big top will never be the same."

—*Chattanooga Free Press*

"What makes *Under the Big Top* a page-turner is Feiler's eye for detail and his ability to be part of the action but also outside of it."

—*Detroit Free Press*

"As irresistible as cotton candy, as attention grabbing as the death-defying trapeze act."

—*Indianapolis Star*

"In the age-old tradition of truth coming from the mouth of a fool, this clown's rendition of circus life bounds with humanity."

—*Kirkus Reviews*

"Feiler, a superb narrator and storyteller with a gentle, ironic sense of humor, also possesses a potent intellect that at moments blazes forth, illuminating everything in its path."

—*Washington Post Book World*

"A mud- and sweat-filled, but ultimately loving, portrait of the circus."

—*New York Post*

Under the Big Top

A Season with the Circus

Bruce Feiler

Perennial
An Imprint of HarperCollinsPublishers

A hardcover edition of this book was published in 1995 by Scribner. It is here reprinted by arrangement with Scribner.

HarperCollins books may be purchased for educational, business, or sales promotional use. For information please write: Special Markets Department, HarperCollins Publishers Inc., 10 East 53rd Street, New York, NY 10022.

First Perennial edition published 2003.

Library of Congress Cataloging-in-Publication Data

Feiler, Bruce S.
 Under the big top : a season with the circus / Bruce Feiler. —1st Perennial ed.
 p. cm.
 ISBN 0-06-052702-1 (paperback)
 1. Clyde Beatty-Cole Bros. Circus. 2. Circus performers. I Title.

GV1821.C6 F45 2003
791.3—dc21 2002038749

03 04 05 06 07 RRD 10 9 8 7 6 5 4 3 2 1

For my brother,
my other eye

Author's Note

This book, like a circus, contains two parallel stories. One centers on the daily life of the show as it proceeds through the season; the other, woven throughout, focuses on the performance as it proceeds through each act. In circus tradition this running order is called the "Program of Arenic Displays."

Program
of Arenic Displays

Intermission

Second Half

Home

The circus is a jealous wench. Indeed, that is an understatement. She is a ravening hag who sucks your vitality as a vampire drinks blood—who kills the brightest stars in her crown and who will allow no private life to those who serve her; wrecking their homes, ruining their bodies, and destroying the happiness of their loved ones by her insatiable demands. She is all of these things, and yet, I love her as I love nothing else on earth.

HENRY RINGLING NORTH

Winter Quarters

1

A Toe in the Ring

"Before we start I want you all to know there's always a chance we might end up with a dead elephant . . ."

Dr. Darryl Heard's voice was stern and deep, softened only by a faint Australian brogue that gave his already blunt warning an eerie, otherworldly air.

"Whenever you take an animal this large, this old," he continued, "and put her under general anesthesia, there's a forty percent chance that she won't wake up again. We may have to roll her out of here."

"You can't use local anesthesia?" E. Douglas Holwadel stepped forward into the doctor's face, removed a rapidly disappearing cigarette from his lips, and ran his empty hand across his receding gray hairline. As co-owner of Sue, a forty-two-year-old, 5,500-pound, "petite" Asian elephant valued at around $75,000, he alone was allowed to smoke in the operating barn. Though it was not yet 8:30 in the morning, he was already nearing the end of his first pack.

"Not with an operation of this magnitude," Dr. Heard replied. "She might go berserk and crush us all. We have to put her to sleep entirely."

"And you've done this before?"

"A dozen times. Just last weekend I went up to Albany, Georgia, to remove a tusk from an African male. We had him up twenty minutes

after the operation was done. I just want you to be aware of the dangers. We can always stop the operation if you're not comfortable—"

"No," said Doug. "We're here. Let's do it."

"In that case," said the doctor, "I need your signature."

Doug dropped his cigarette onto the floor and retrieved a fountain pen from the well-starched pocket of one of his two dozen Brooks Brothers shirts. A little over four hours earlier, Doug and I had left circus winter quarters in a dark, driving rainstorm not uncommon for late January in central Florida. The previous day, after our introductory meeting, Doug had invited me to accompany him during this emergency operation to remove an ingrown toenail from Sue's right front leg. Never having seen an elephant under anesthesia, I agreed.

It was well before dawn when we set out. The outside thermometer in his maroon Cadillac with EDH plates said 39 degrees. We followed behind newly painted "Truck No. 60, Elephant Department," kitchen white with stylized red letters that read: "Clyde Beatty–Cole Bros. Circus—World's Largest Under the Big Top." Leaving DeLand, home of the circus and undisputed fern capital of the world, we passed through DeLeon Springs ("They don't have a decent bar," Doug mentioned, "so everyone drives to Barberville"), across the St. Johns River, which runs from Orlando to Jacksonville ("Do you know why the St. Johns is the only river in Florida to run upstream?" he asked. "Because Georgia sucks." He laughed especially hard, knowing Georgia was my home state), until we arrived at the crack of dawn at the William N. Inman and Clara Strickland Inman Food Animal Hospital at the University of Florida in Gainesville.

"Could you stop that drilling and sawing," Doug called out to some nearby construction workers after he had signed the papers. "It'll spook the hell out of Sue."

Finally, at a little past 8:30, with the arrangements for the operation complete, Captain Fred Logan waddled alongside the high-tech operating barn and began escorting Sue up the walkway with a bull hook, a short cane with a stubby hook on the end. He paused slightly to let a Vietnamese potbellied pig wobble across the path. A seventy-year-old Canadian who had literally run away to join the circus when he was a

boy, Fred had been the chief elephant trainer with the Clyde Beatty–Cole Bros. Circus for over two decades, but in all that time he had never had to put an elephant under total anesthesia.

Once inside, Fred led Sue to the center of a hay bed about the size of an average mall parking space.

"Be sure she lies down on her left side," called Dr. Heard. "It's the only way we'll be able to get to her right front leg and have total access to her toenail."

"Don't worry," Fred said gruffly. "That's the only way she'll go." Circus elephants, he explained later, are trained to lie only on their left side. It's one of only eight or so commands the average elephant can comprehend.

Once Sue was standing in her place; Fred tied a thick yellow rope to each of her left feet and tossed them under her body. As soon as she felt the ropes Sue started to squirm.

"Back, Sue. Back!" Fred barked.

Sue stepped backward and began to grumble.

"Front, Sue. Front."

She stepped forward and started to shake.

"Steady, steady. . . . Thata girl."

With the patient temporarily calm, Dr. Heard snapped into action. He tossed the ends of the two ropes over Sue's back and ordered four of his white-coated assistants to stand behind the protective railing and prepare to pull her over if necessary. When everyone arrived in position, he gave the signal to advance.

"Down, Sue. Down!" commanded Fred, but Sue did not obey.

"Sue, down!" he shouted.

Sue slowly leaned down on her back legs, disobeying his command to lie down on her side. Fred ordered her to stand up again, which she did with an unfriendly growl.

"Back, Sue. Back!" he continued. "Front, Sue. Front! Down."

The process was repeated several times, but each time Sue kneeled down instead of lying on her side. "Let's try a little psychology," Fred said. He asked one of the assistants to retrieve a kitchen broom, which he used to brush Sue's back in an effort to bribe her down. It didn't work.

Dr. Heard then changed the plan, announcing that he would inject the patient with a dosage of morphine 80,000 times the potency normally given to humans. He rested one hand on Sue's forehead, pulled back her rubbery flipperlike ear, and gave her an injection with a syringe.

The elephant shook angrily even before the injection was completed. She began to swing her head in disgust.

"Down, Sue. Down!" Fred pleaded, but she ignored him and grumbled loudly.

"Hold on to the ropes!" Dr. Heard shouted. "Don't let her fall to her right or we'll have to abandon the operation."

Four men pulled the ropes taut. Doug turned his eyes away. Fred shouted more frequently.

"Down, Sue. Down. Steady!" His voice took on an imploring tone, but at that point it no longer mattered. Sue could no longer hear him. She knelt down on her back feet as she had done twice before, but instead of leaning down on her front knees, this time her entire body went suddenly limp like a deflating hot-air balloon.

"Now, now!" called Dr. Heard. "Pull her toward the left." The four assistants slowly tugged the 5,500-pound Sue until she collapsed droopily on her left side. The ropes had worked perfectly. Sue's inflamed foot was exposed. The operation could proceed.

●

With the patient now in place a swarm of thirty veterinarians dressed in blue jeans and white jackets emerged from behind the protective railing and gathered around the body. One team focused on Sue's right foot—sliding it out from its bent position, resting it atop a hay bale, and brushing off the mud and debris that had collected around her potato-sized nails. Another group rolled out a $10,000 assortment of gadgets, monitors, and computerized gizmos that would monitor Sue's vital functions. A third group climbed atop her back to attach some nodes to the frayed edges of her ears.

Resting on the ground, Sue's head seemed remarkably inert. Her ears, while smaller than those of an African elephant, were still large and fragile, beginning thick and rubbery close to her head but deteriorating like

a giant aging leaf into a tattered, lacy fringe. Her one exposed eye, the size of a billiard ball with a rich amber hue, was closed, but a steady stream of tears seeped out from beneath the lid into the grooves of her skin, dry and corrugated like a baked riverbed. Her mouth was puckered, the inside a startling baby pink in contrast to the somber millstone gray of her skin.

Sue's mouth quickly became the center of attention as Dr. Heard led a group of doctors in trying to insert a respirator into her lungs. At this point the team encountered its first problem of the day, as Sue had instinctively clenched her jaws together when she collapsed under the influence of the morphine. In an attempt to open a passageway for the respirator, one group of doctors tied a rope around her lower jaw and another held her trunk. On the count of three, the two groups pulled and Dr. Heard slid his fingers between Sue's teeth and tried to pry open a narrow space.

He failed, and with the teams still clinging to the ropes, Dr. Heard peeled off his medical coat, rolled up his sleeves, and stuck his arm deep into Sue's throat in another attempt to find a passageway large enough to slide the tusk-sized respirator tube into her lungs. "We should have brought a baseball bat," he cursed, his face straining under the pressure of her throat muscles. After several minutes he withdrew his arm. It was dripping with saliva and nicked from Sue's teeth. "It's going to be difficult. Hand me the tube."

As he poked into her throat again, though this time with the tube in tow, Dr. Heard found it even harder to penetrate past Sue's mouth. Finally he withdrew the tube and dropped his head onto the back of his hand in frustration. Several tense seconds passed, until Dr. Heard snapped to attention with renewed vigor and shouted something to one of his students in mangled veterinary code. The student dropped her notebook, darted around the corner past a series of signs that said: REPRODUCTION BOVINE OBSTETRICS, MEMBER FLORIDA CATTLEMAN'S ASSOCIATION, and WE WISH YOU A SUCCESSFUL DAIRY YEAR, and returned momentarily with that tried-and-true solution to pachyderm penetration: a tube of K-Y jelly. Dr. Heard smeared the jelly over the stiff plastic tube and, moving slowly, pushing hard, and constantly peering at his

watch, eventually pushed the tube past Sue's mouth and inserted it into her lungs. With the tube in place he withdrew his arm and rapidly attached the tube to the respirator. At 9:10 the compressor was turned on, the doctors stood back, and Sue's stomach heaved greatly at first and then settled into a steady breathing rate, her belly expanding noticeably with each gasp from the machine.

As soon as the respirator was functioning properly, Dr. Heard turned to another problem. When Sue was pulled to the ground with the ropes, her head had accidentally landed against a concrete barrier. The doctors were worried that the weight of her head might burst her eyeball. They decided they needed to lift her head to relieve the pressure. If the patient had been a dog, or even a horse, the veterinary team could have accomplished this task with relative ease. But Sue was an elephant and her head alone weighed around 800 pounds. The solution to this unique gravitational problem: a forklift. One of the doctors went scurrying out of the barn and soon returned driving a bright yellow Caterpillar forklift directly into the operating room. Several ropes were tied around the tines of the forklift and then wrapped around Sue's head. As several people steadied the head, and several more held the ropes, the mechanical fork was slowly lifted into the air and several gymnasium mats were slid underneath Sue's head. With her head now swaddled in a bed of tumbling mats, the students in the gallery started to applaud, the prep team resumed its scrubbing, and Dr. Heard finally turned his attention to Sue's ingrown toenail.

•

With Sue now completely out of their hands, the circus team could not bear to watch. Fred, feeling helpless, had retreated to the corner. Doug, overcome, had handed me his camera and driven off to Hardee's to buy a cup of coffee. I, meanwhile, was mesmerized: transfixed by the allure of this elephant and, in truth, still slightly dumbfounded by the unlikely series of events that had brought me to her side.

I first caught the dream when I was twelve. I was attending summer camp in the mountains of Maine when my counselor took me outside with a handful of oranges and taught me how to juggle. For hours that

morning I chased decomposing oranges down a hill; for years afterward I stoked fantasies of tightropes and teeterboards; and a decade and a half later I could still feel those oranges as I set out in pursuit of one whimsical fragment of the American dream by running away and joining a circus.

The dream had developed slowly. After years of practicing juggling as a teenager, I dipped gradually into the world of street performing and harlequinism. First I learned pantomime and whiteface makeup from a teacher in my hometown. Next I developed a short routine combining pantomime, juggling, and corn-pone humor, which I enthusiastically performed at birthday parties, street festivals, and any gathering in my parents' living room—despite the irrevocable damage done to more than one prized family heirloom. In short, I was a teenage pantomime prodigy, all the more easy since I was the only teenage pantomime most people in South Georgia had ever seen.

Eventually, perhaps inevitably, this infatuation with performing led me to the brink of clowning. Like many teenagers fascinated by the circus, I even considered applying to "Clown College," Ringling Brothers' ten-week training course that was founded in 1968 in an attempt to stanch the decline in clowning but was brilliantly marketed as an academic exercise rivaling that of the Greeks. When the time came, however, I chose a more conventional academic stage. At Yale, I taught drama in local schools, directed the children's theater, and even helped start a campus mime troupe, but the dream of joining a circus seemed to be fading away. When I graduated and moved to Japan to teach English, the dream was completely out of my mind.

Yet somehow the clown in me never died. In Japan, where I lived for three years, I would often mime, clown, or occasionally even juggle my way out of a cross-cultural impasse. In England, where I attended graduate school, my sense of humor, my voice, indeed my whole way of communicating were louder and more theatrical than that of my European friends. Was this my personality speaking, my nationality, or both? Spurred by these questions, I decided to come home after five years abroad and spend some time exploring my own culture. It was then that I returned to my adolescent roots: what better way to discover America,

I thought, than from the back lot of a circus. I could join a show, possibly even perform as a clown or a juggler, and write a book about life inside this most American of institutions. Circuses, after all, have been around since the founding of America. They crisscross the country year after year, visiting towns both large and small and always managing to reinvent themselves on the verge of their own extinction. They are, I believed, the embodiment of our dreams: a metaphor for ourselves. And, I hoped, a way home. So it came to pass, fifteen years after learning to juggle, five years after leaving the country, that my childhood aspiration coincided with my adult wanderlust to lead me back into clowning.

Having decided to join a circus, it didn't take me long to realize that I didn't know anything about circuses, much less how to join one. My first step was to visit every show I could find—glitzy and seedy; air-conditioned and muggy. Like many adults without children, I hadn't actually seen a circus in almost twenty years. My immediate reactions were twofold. First, I was thrilled to discover that the circus was almost exactly as I had remembered it, with colorful costumes, daring acts, and exotic animals. Second, I was surprised to find that the circus, though quite traditional, was shrouded in a cloud of controversy of a distinctly modern variety. Many of the shows I visited, for example, were surrounded by picketers protesting the infringement of animal rights. Inside, the circuses themselves adopted a surprisingly defensive air, not only about their treatment of animals but also about their desperate efforts to prevent the circus from withering away. The circus was certainly alive and well, but its future seemed in doubt.

Once reacquainted with the circus, I set out to find the perfect show to join. From a friend, I learned of an organization called Circus Fans of America (its motto: "The Greatest Hobby on Earth"); from its treasurer, Irvin Mohler, I learned of the Circus World Museum in Baraboo, Wisconsin (the original home of the Ringlings); and from its librarian, Fred Dahlinger, I received a list of every circus in America, which was a surprising four pages long and contained 117 entries. At the outset I narrowed myself to tented circuses, ones with greater mobility, deeper access into the country, and more grit. This cut the number to thirty-seven. Next I aimed for large, high-quality shows, with a wide variety of

acts and a full cast of animals. This reduced the list to six. I wrote letters to each of these shows and told them of my plan: I would like to travel with their circus for a season. I'd be prepared to do my part—pull ropes, shovel manure, whatever they needed—but most of all I would like to perform.

I sent off the letters in late November and sat back to wait. To my surprise, all six shows called back almost immediately and said they were interested in hearing more about my idea. In order to decide which show was best, I ventured out a month later on a circus parade of sorts—from Washington, D.C., to New York City; from Sarasota, Florida, to Hugo, Oklahoma. It was during this trip in January 1993, on the two hundredth anniversary of the American circus, that I arrived in the sleepy town of DeLand, home of what had always secretly been my first choice, the Clyde Beatty–Cole Bros. Circus, largest tented circus in the world.

•

"Sit down. Welcome to Florida. Let me buy you a drink."

I met Doug Holwadel at the Lobby Bar, across the hall from Sonora Sam's Restaurant in the Holiday Inn & Convention Center on Route 92 in DeLand. Feeling somewhat like an actor on audition, all day I had wondered what to wear. Would the owner of a multimillion-dollar circus be a slick Hollywood promoter, a bumpkin country lawyer, or an uptight Wall Street investor? To play it safe I wore my most middle-of-the-road preppy casual attire. Fortunately I guessed right. Doug, a salesman at heart, was wearing his button-down best. He was also drinking Chivas on the rocks, and for the first three rounds of our twelve-round night I struggled to keep up (and keep sober) as this former concrete dealer and longtime circus fan told me how he was invited in 1981 to join former acrobat turned administrator John W. Pugh in purchasing the show. In a little over ten years, Doug boasted, the two partners had completely redesigned the show's twenty-seven trucks and 3,000-person tent, solidified a eight-month route that ran the length of I-95 from Florida to New Hampshire and back again, and increased their lagging attendance to close to one million people a year. During this time, he noted, they had accepted invitations to film commercials, documentaries, and hundreds

of local weathercasts. However, they had never accepted an invitation from a writer to travel with the show. He wondered why they should change now.

After Happy Hour, Doug took me to dinner at Pondo's Restaurant & Lounge, just up the road from the thirty-five acres of land where the show resides during the off-season. At the table, he ordered another round of drinks as I examined the menu. Later I learned that this was a test of sorts to see if I was an animal rights provocateur and that my whole plan might have been jeopardized if I had ordered "just a salad." Fortunately I ordered duck (he had lamb), and the two of us began to talk. No, I was not a plant from PETA, People for the Ethical Treatment of Animals; yes, I remembered the first circus I saw. No, I was not an IRS spy; yes, I could live in six inches of mud. As soon as I laid to rest his initial concerns, Doug began to open up. My letter had intrigued him, he said. He was an amateur historian. He liked to read. He relished the opportunity of seeing his circus captured in print. Also, he said, he couldn't help noticing that I wore a Brooks Brothers shirt.

As we sat for a fourth after-dinner drink in our next stop, the Neon Armadillo, I finally got around to asking if he was amenable to having me travel with his circus. Without hesitation, he said yes. After another round, I asked if he would let me perform. To this he bluntly said no. "If this is just a ploy to get a joyride in the ring," he insisted, downing what would become his last drink of the night, "then we're going to have to say no. We get hundreds of requests a year from people wanting to be guest clowns in our show. Some even offer to pay us. We are professionals. We don't cotton to amateurs."

The next morning Doug drove me to winter quarters to meet John W. Pugh, his partner and the president of the circus. By the end of the previous evening I had persuaded Doug to change his "no" to a "maybe," but still he had made it abundantly clear that Johnny, who was responsible for the day-to-day operation of the show, would make the final decision. A short, stocky man with a boater's tan and boxer's handshake, Johnny Pugh was a former trampoline artist and stuntman who had served as Richard Burton's stunt double in the film *Cleopatra*. He patted me chummily on the back, invited me into his roving office, then sat

back and watched as a group of senior officers filed in to meet me—the vice president, the treasurer, even the boss canvas man, a former addict turned crew chief who was responsible for putting up and taking down the tent in every town. All of them were pleasant, considerably more informal than Doug, but still extremely skeptical. What if I saw the mess inside the cookhouse? they wondered. What if I heard that the workers did drugs? Johnny listened carefully to these concerns but didn't say a word. He didn't care what I had written in the past, he didn't care what I might see in the circus. In over fifty years in show business he had dined with kings and wrestled with murderers, and he would read me for himself. At the moment he was mum.

It was not until later in the morning, with the arrival of the marketing department, that the mood began to change. "What a great idea!" said the national marketing director in a voice I soon recognized was taken as the word of God. "Just think of all the publicity we can get out of him." Almost instantly I could see the idea gaining strength as it nodded around Johnny's paneled office in the mobile ticket wagon, Truck No. 33. "I don't see why not," one said. "He does have a lot of performing experience." Finally Johnny spoke up: "We consider this circus to be one big family," he said with a faint English lilt in his voice and a defiant twinkle in his eye. "Everybody works hard, and nobody gets rich. And I warn you: once it gets in your blood, it never gets out." He stood up and stuck out his hand. "Welcome aboard," he said with a smile. "We start in two months."

That evening I was invited to have dinner with Elmo, the show's producing clown, and several of his friends. We were looking through books of famous clowns for inspiration in designing my face. I had a lot to do before opening day on March 25: find a camper; learn to fall; tell my mother. As I sat on a couch making notes to myself, Elmo was watching *Jeopardy!* and calling out the questions. Just before dinner the Final Jeopardy answer was flashed on the screen. The category was "Odd Jobs," and the answer:

It was the profession of Lou Jacobs, model for a 1966 postage stamp, who died in Sarasota in 1992.

The question, which all of the contestants and all of the people in the room got right:

What is a clown?

•

"Damn, her toenail sure is big."

Once the scrubbing on Sue's foot was done, one of the assistants rolled out a surgical tray with several sizes of scalpels and no fewer than twenty pairs of scissors. A team of doctors began gathering around Sue's injured leg, commenting on the dimensions of her foot—approximately the size of a toilet seat—and the thickness of the black hair on her leg—about the consistency of a steel dog brush. Later, if she survived, the wiry hair all over her body would be burned off by a blowtorch just before the start of the season. Fred, unlike other trainers, chose not to primp his elephants further by painting their toenails white. His elephants, though well-trained females, were still dangerous, he seemed to be saying, a lesson one family—indeed one entire community—would learn all too well later in the season.

Dr. Heard interrupted the gawking session to begin the operation. He took a long spike about the size of an oven cake tester and poked it into the heart of the abscess just above Sue's toe. A red, pussy substance oozed from the wound. Using a scalpel, he peeled away the flaky black skin and shaved off several layers of the toenail. As he slowly cleaned the wound and finished trimming her nail, the mood in the barn began to lighten. Several doctors began sizing up Sue's teeth. A handsome male teacher posed for pictures next to her head.

Within half an hour, Dr. Heard had finished emptying the abscess and the doctors began rolling the equipment away. One woman remained, filling the banana-sized abscess with sterilized gauze and wrapping the entire bottom half of Sue's foot with seven Ace bandages. At 10:30, after removing the respirator tube, Dr. Heard administered a shot of the reversal agent into the identical spot in Sue's right ear where he had applied the sleeping drug. Almost immediately Sue's eyes flashed open, she exhaled, and her entire body convulsed.

"Everybody clear!" Dr. Heard shouted, as the last several members of the team scampered behind the gates.

"She's moving!" cried Doug, who had just returned. "She's moving her hurt foot."

"Sue, Sue!" called Fred in his steady cadence. "Steady, Sue!"

Sue nodded her head slightly and stretched her injured foot. Blood seeped from her wound and left a small stain on the bandages. Fred began to pace. Everyone else stood still. Sue issued a muted growl and slowly unfurled her trunk. In a moment she began to rock back and forth in an attempt to gain leverage. Then she collapsed, splashing hay on her face.

"This is where they can most damage themselves," Dr. Heard said aloud. "It should take about fifteen to twenty minutes for her to get enough energy to rise up again."

Fifteen minutes passed, then twenty, but still Sue was unable to right herself. After thirty minutes she stopped swaying, and at forty-five she closed her eyes. The room became tense again. Hoping to coax her onto her feet, Fred walked into the surgical area and unhinged the steel chains around her feet. Doug turned away in fear. Dr. Heard felt Sue's ear for a pulse and wiped away the tears that were streaming down her face.

At 11:30, a full hour after the reversal shot had been issued, Dr. Heard administered a second dosage. Twenty minutes later, when Sue had still not roused herself, the doctors resorted to a set of home remedies. First they got out the broom again and began sweeping her sides. Next they threw several blankets on her back and three team members began giving her a massage. When that too failed, they stuffed a deflated truck tire inner tube underneath Sue's neck and futilely tried to prop her up by inflating it. They even discussed tying ropes to the ceiling and leveraging Sue to her feet.

"It's not going to work," Doug moaned. "She's given up. This is what I was worried about. She's lost the will to live." He asked me to take one last photograph of Sue so he could bring it back to his wife.

By now close to desperation, one of the doctors suggested Sue might be tired of all the humans in the barn and prefer other company. The room was cleared and a student trotted across the lawn to the recuperat-

ing barn and returned with a dashing Thoroughbred stallion who was under treatment. The horse was led slowly into the barn. He looked at Sue. She looked at him. Then she fell back asleep. The experiment had failed. The horse was led away.

When all of these old wives' gimmicks had failed, Dr. Heard decided that he would give Sue one more shot of the reversal drug. Perhaps the dosage he had used on the African male in Albany was not enough for Sue, he speculated. If the third dosage did not work, however, Sue would soon be in serious trouble. After lying on her side for much of the morning, she was in jeopardy of filling a lung with fluid.

For the fourth time that morning Dr. Heard climbed on top of Sue and shot an injection into her right ear. Quickly he climbed over the railing and waited. He did not have to wait long.

Within seconds of the third shot reaching her bloodstream, Sue sat upright with a bold and startled jolt. Moving deliberately, but determinedly, she rocked her body back onto her hind legs and paused. The thirty people huddled against the railing around her paused as well. Then, at 12:37 in the afternoon of a chilly, rainy, late-January day, after three and a half hours of morphine-induced sleep, the forty-two-year-old Sue heaved her two-and-three-quarter-ton body onto her three still healthy feet, arched her trunk high into the air, and heralded the start of the circus year by filling the air with a ceremonial elephantine trumpet blast and flooding the ground with an equally unceremonious outpouring of elephant urine.

Let the season begin.

First Half

The Circus on Parade

Without warning a voice descends from the blue-and-white-striped heavens.

"Ladies and gentlemen, boys and girls, the world's largest traveling three-ring tented circus will start in five minutes . . ."

Behind the back door of the packed big top, Jimmy James turns off his portable microphone, clips on his black pre-tied bow tie, and pulls the ruffled cuffs from underneath the sleeves of his royal red tailcoat. Without thinking, he pats down his hair, unavoidably white after three decades and three hundred thousand miles on the road, and pulls down his waistcoat, surprisingly trim as it settles around nearly three hundred pounds of all-American truck-stop cuisine. He smiles wanly, peers through the flaps at the three thousand people hurriedly assuming their seats, and reopens his microphone to a voice as deep and rich as the three primary colors of the tent itself.

"State law prohibits smoking in a public tented area. For your safety, and the health of our children, thank you for not smoking. Throughout the presentation of all animal acts, and through frequent blackouts, please remain seated. Thank you for your cooperation, and have a healthy, fun day at the circus . . ."

With a quick wave to the veterans and an encouraging nod to me, Jimmy slides through the back-door flaps and steps into the darkened

tent. As he does, the three dozen or so performers slip off their bathrobes, snap on their remaining spandex accessories, and ease their way toward the mouth of the tent. Finally, at precisely 4:30 P.M., Jimmy blows his silver-plated ringmaster's whistle and a bass drumroll hushes the crowd.

"Circus producers John W. Pugh and E. Douglas Holwadel welcome you to the Clyde Beatty–Cole Bros. Circus, entertaining generations of American families since 1884. Your overture, under the direction of James Haverstrom . . ."

As I move into place my heart beats faster. I try to conceal my trembling hands. For several weeks I had been preparing for this moment, lurching between a feeling of suave bravado and a sense of utter fear. When I first told my friends I was joining a circus they had greeted my news with hollow stares, then disbelief. "You're kidding." "You're doing what?" "No, really?" "And where did you go to school?" I got smiles. Rolled eyes. Squinched noses. Nervous laughter. And more than a few snide asides: "Grow up." After a while their attitude would often take a turn. "The circus, huh?" "How fascinating." "I had an aunt who joined a carnival." "My uncle used to swallow swords." But in the end they usually delivered the kicker. "So what are you going to do, be a clown?"

The circus, I soon realized, has an image problem. Many people have fond images of seeing one as a child, but they still think of circuses—and circus people in particular—as dirty, degenerate, and downright depraved. "Watch out for the lion trainer," people told me. "Beware the bearded lady." Even my mother recalled taking me to a one-ring show when I was a boy that was so filthy and stinking that she took me home at intermission and vowed never to let me return.

At first I scoffed at these concerns. How dirty could it be? I said. I'd done a lot of traveling. I'd slept on a lot of floors. I'd met a lot of greasy con artists on overcrowded Third World trains. In fact I secretly prided myself on my ability to get along with people who were not only vastly different from me but often out to rip me off. Still, as the time came closer for me to leave my apartment, my telephone, my cozy group of urbane, Ivy League, vegetarian friends, I began to have doubts. Maybe this world really would be dangerous. Maybe I was getting in over my head. Talking my way onto a show had been a challenge. Now, after I had done it, the circus seemed less and less like a game and more like a world full of pro-

fessionals and artists into which I was plunging headfirst with a swagger matched only by my gall. Dear Diary: What the hell am I doing?

More than the mud, it was these petty concerns about the people (Will I make friends? Will I be accepted? Will I get invited to play on any teams?) that cluttered my mind that Thursday afternoon as I looked around at the host of performers preparing to enter the tent. On one side of me an aerialist was bending over to stretch her back. On the other a trapeze artist was reaching down to untwist his tights. One of the clowns was playing a game with the king and queen of the opening parade.

"One, two, three," cry the boy and girl picked at random from the audience, "start the parade . . ."

As if by magic the ringmaster responds.

"Ladies and gentlemen, boys and girls, come with us to the days of yesteryear when children of all ages eagerly awaited the summertime fun of an old-fashioned circus street parade. With a little sawdust, greasepaint, and imagination you can consider yourself part of the Cole Bros. Circus family . . ."

With this cue the band strikes up a peppy version of "Consider Yourself at Home," the man they call Slow Motion slowly tugs open the back flap of the tent, and the opening spectacle, or "spec," begins. The first person into the spotlight is Jerry, a four-foot-seven-inch dwarf in clown makeup, who just before the back door opens kisses one of the Royal Arabian horses and blesses himself with the sign of the cross before skipping out onto the hippodrome track that encircles the three rings. Jerry is wearing yellow-checked pants, a blue-striped shirt, and an impish red, white, and black face. The adults applaud. The children jump to their feet. As he parades around the track the overhead lights are kindled at each step until finally the entire floating ship of a tent is awash in a glow of light, color, and secret desire.

Indeed, from the moment the performers start streaming into the tent, some wearing headdresses, others waving capes, the circus begins to emerge as the living embodiment of illusion: dangerous, daring, tempting, taboo. A woman glides through in an impossibly tight bikini. A man marches past with impossibly plump biceps. Two clowns amble by, and most impossibly of all, they always seem to be smiling. Even the horses, tigers, and bears seem to be part of this world without constraint.

Approaching the moment of my first entrance, I, too, was caught up in this illusion, by the gloss of romance and the undercurrent of titillation. This feeling would never go away. Indeed, before I could walk out of the tent after our last finale—thirty-four weeks, ninety-nine cities, and five hundred and one shows later—I would be forced to confront two seemingly contradictory truths about the circus: one, the sins were more exotic than I would have expected, and two, the people were more wholesome than I could have anticipated. On the one hand, in the course of one nine-month season in the circus I encountered an array of sins so extensive I had to rethink whether I had ever truly known my own country. These sins, which I nicknamed the Seven Circus Sins, included: murder, rape, arson, bigamy, bestiality, group sex, and organized crime. If you find it in America, I found it in the circus.

On the other hand, even as I encountered this range of illicit activity, I was continually overwhelmed by an even stronger pattern of compassion as performers from thirteen different countries, speaking half a dozen languages and practicing almost twice as many religions, struggled to live together in one community with no means of privacy or escape. This was the family Johnny had told me about. In fact, when I stepped through the back door for the first time, dragging behind me the portable throne containing the king and queen, I became forever a part of this family. I wasn't prepared for it to happen so quickly. Inside my costume I still felt like an outsider—looking up at the lights, looking down at the grass. But from the outside I already looked like an insider. On my feet I wore eighteen-inch floppy red-and-white clown shoes. On my body, to accent my tall, thin frame, I wore bright red pants that reached to my chest, a short white tailcoat that stopped at my waist, and an oversized shimmering gold lamé bow tie. And on my face, underneath a white skullcap and pointy hat, I wore a milky coat of white greasepaint, highlighted by arching black eyebrows on my forehead and bass clefs on my cheeks, a red bubble-gum smile around my lips, and in the middle of this cartoon face, a crisp red nose.

Once inside the tent, a childish thrill rose in my stomach. Cameras flashed in my eyes. Hundreds of nameless fingers waved enthusiastically from their seats. "Hey, Mr. Clown," a girl called from the front row, and

it took a moment to realize she was talking to me. "Keep waving," I called out to the king and queen behind me. "Smile!" The energy seemed to grow as we rounded the track. Kids hurried down to the railing and reached out to touch us. My arms started getting tired from waving. The music was wailing and Jimmy was singing, *"Be a clown, be a clown. All the world loves a clown . . . ,"* when suddenly I looked back and noticed that the little girl in the cart with the brightly striped cape—the queen of the opening circus parade—was crying. Was it the excitement? I wondered. Was it the din? Was it the natural reaction, the inevitable sadness, of having a dream come true?

As we reached the end of the parade, pausing slightly to let the train of ten elephants pass, I pulled the cart to a stop behind the tent and unloaded the king and queen to the ground. The girl was sniffing back her tears; her brother was peering into the tent. "Do we get to see the rest of the show?" he asked. "You sure do," I said. "Let's go." I lifted their hands in my slightly stained white gloves and led them back to their waiting mother. "Goodbye," I called as they scampered to their seats. "Enjoy the show!" The boy, anxious not to miss the tigers, ran directly back to his seat. The girl, still overcome by her circus debut, walked more slowly, and just before returning to the comforting hug of her mother, she stopped, turned around to face me again, and waved her fingers goodbye.

I smiled.

Turning, I hurried back to Clown Alley to change my costume for our first gag, now just minutes away. The stilt walkers sat down on ladders to remove their false legs. The acrobats rushed off to stretch their muscles. Jimmy James strode toward the circular cage that surrounded the center ring, blew his whistle with authority, and waited for the end of the "Born Free" fanfare before making his first call.

"In the tradition of America's Clyde Beatty, we proudly present the Marcan Royal Bengal Tigers, in a rare, exotic breed of four colors. Exhibited under the command of Khris Aaaalllen . . ."

The lights came up in the iron cage, the cats let out a menacing growl, as Khris Allen stepped forward for his first time in the ring and raised his hand in the air.

2

Under a Canvas Sky

Before they erect the heavens, the men prepare the earth.

At 5:52 in the morning the headlights on the pole truck, No. 2, crease the black and empty field. A lone man dressed in blue jeans, a white sweatshirt, and a red knit cap walks to the end of the twin lines of light, picks up a sledgehammer, and begins pounding a wooden stake into the grass. A forklift appears from out of the dark, lowers its outstretched arms to the ground, and scoops up a sack of assorted ropes and cables, which it deposits next to the first of four red flags that mark where the center poles will rise. The sky is dark, but lightening. The town still sleeps. On Route 92 in DeLand, just up the road from Bud's Highway Tavern and across the pond from the YMCA, the circus is coming to town.

Swooning, a second worker sings as he emerges from his bunk in No. 63 and begins to remove a stack of poles from the flatbed truck. A third man, much larger, lights up a cigarette as he shuffles toward the poles. Nobody looks at one another. Nobody speaks. By half past six there is a flurry of silent activity on the fairgrounds and nearly thirty men at work. Soon, the outer poles, seventy-six in all, are laid in a giant semicircle facing the center of the imaginary tent. The pattern of work mirrors the big top itself, with the most important work occurring down the spine, where huddles of men prepare the ground for the advent of the center poles. At a quarter to seven the four center poles themselves arrive, each

one nearly a foot in diameter and over sixty feet long. Made of reinforced aluminum, the poles are escorted one by one into the arena by teams of straining men, like pallbearers.

"You see these babies?" cries the head of the crew, a man they call New York. "We call these the bone crushers. These are the ones that'll make you find religion."

Outside the tent, the shape of the circus is already beginning to emerge. The performers, most of whom pulled into DeLand the previous night, four days before opening, are still sleeping in their trailers along one side of the tent. At the front of the line of thirty or so trailers, a wagon holding ten portable toilets is already in place, along with the ticket wagon, the concession wagon, and the sleeper truck for the clowns. Later skirtlike banners will be laced around the wheels of these trucks, flags will be affixed to their tops, and fluorescent lights will be strung around their roof lines as these otherwise conventional tractor-trailers are transformed into the circus midway, one of the oldest enduring images of a traveling circus, a sort of open-armed "V" inviting you inside. At this early hour the only truck on the midway that doesn't belong is No. 24, a regular cab with a short, stubbed rear end—inside of which are two giant spools, around which is furled the world's largest big top.

"Come along, don't be afraid. You won't hurt it. After this you can say that along with the owner you were the first person to set foot on the new tent."

Johnny Pugh put his arm around me just after 8 A.M. and led me onto the striped sea of blue-and-white canvas. In truth it wasn't canvas at all, but vinyl—a dense twenty-two ounces per square yard, dielectrically heat-sealed by radio frequencies to avoid unnecessary sewing. Manufactured at a cost of $158,000 by Anchor Industries of Evansville, Indiana, the new tent was flame- water-, and wind-retardant up to sixty-five miles per hour. It was also, quite plainly, a sight to behold. Lying on the ground in two separate sections parallel to the center line, the tent looked like two enormous blueberry-and-whipped-cream-rolled pancakes, with splotches of strawberry red and an occasional triangle of butter yellow from fifty five-point stars.

"The spool is always the most dangerous part," Johnny said of the hy-

draulic truck specially designed by a shrimp-boat manufacturer in New Bedford, Massachusetts. "When the tent is folded and wound onto the truck, the abrasion from the spools often damages it. Any pinholes, that's where they'll develop."

Once the tent was stretched onto the ground, the workers gathered to unfurl it. Standing at a distance of one person every six feet, the fifty or so men all grabbed the tent and on command—"Ready, pull!"—unfolded the top layer of vinyl and dragged it away from the center poles. After easing their grip, they walked across the spread and hauled the next fold toward the center. The third pull was to the outside, the fourth toward the middle. Some of the workers used two hands, others one. Some faced forward, others backward. It was a curious rhythm in which each individual note was separate and discordant but together they made a striking chord. With the fifth pull the men reached the end of the vinyl, and with that Johnny ushered me onto the tent. It was 283 feet 4 inches long and, coupled with the other half, 146 feet 8 1/2 inches wide. It looked like an overgrown sail.

"When you designate the size of a big top," he said, "it's the width that matters. Other tents may be longer, but none is wider. That's why we're the largest tented circus in the world."

Rubbing his hands together in childish delight, Johnny, who has been married to a former showgirl for over twenty years but never had children, led me to the line of center poles and proceeded to explain with paternal pride the modern-day physics of this age-old institution. The new tent, which he had personally designed over a period of four years, had a nylon webbing system imported from Germany to hold it together horizontally, an advanced steel cable infrastructure invented in Sweden to support it vertically, and—Johnny's personal pride and joy—a system of state-of-the-art lightweight shackles made from a secret NASA alloy to hook the tent onto the four bail rings that carried it to the top of the center poles. Before the poles themselves were raised, however, one final touch was needed. At 8:21 in the morning Johnny personally slid a five-by-eight-foot flag onto the top of each pole: Old Glory on pole one, closest to the front door; CLYDE BEATTY on pole two; COLE BROS. on pole three; and CIRCUS on pole four.

"We are the only show that uses what we call House Flags," he said as he stepped his way down the line. "A company called Betsy Ross in New

Jersey makes them. It's a nostalgia thing for us. They used to cost twenty-five dollars apiece, now they're a hundred twenty-five dollars. At the end of the year we will pick out someone special and give them this season's flags. Ironically, I'm the only one who doesn't have a set. I want a new set, and I want to be buried with them."

With the flags in place and the poles lifted into the air, the tent was ready to be raised. The outer poles were forced into place, creating a giant fishbowl, the outer lip high in the air and the middle hanging limply to the ground. Next the bail rings were slowly winched up the poles, carrying the center of the tent. With this penultimate stage under way, Johnny gave the word for the elephants to be brought in to push up the inner poles. No sooner had he given the order, however, than the first minor crisis of the year arose. Royce, the rookie manager, came rushing to Johnny's side and informed him that all the outer ropes of the tent were two feet too short. Instantly, the childish thrill went out of Johnny's eyes. His business demeanor returned in haste. He hiked up his trousers, ducked under the tent, and went to rescue his only child.

•

Feeling like a child myself, I savored the blush of this inaugural scene, delighted by the openness of the strangers around me and thrilled by the richness of this exotic world. This sense of excitement would often return. Indeed, one of the unexpected joys of joining the circus was the process—both formal, through books, and informal, through conversation— of learning about the central, almost unspoken role that the circus has played in the American imagination. In many ways, America and the circus were made for each other: both have European roots, eclectic ingredients, and the fulfillment of dreams at their central core. Most American writers— from Hawthorne to Hemingway to Emily Dickinson—have written about circuses, and probably the majority of Americans who ever lived have seen at least one in their lives. For sure, all Americans have felt their impact: words such as "jumbo" and "star," expressions such as "hold your horses" and "get this show on the road," and icons such as the white elephant and pink lemonade all began in the circus. Perhaps even more importantly, many of the great images in the collective memory of American children were

painted in the circus—elephants, clowns, cotton candy, parades, and even if a child never saw one himself, tents.

Big tops have not always been part of the circus. The first American circus, organized by Scottish equestrian John Bill Ricketts, opened on April 3, 1793, at an outdoor amphitheater at Twelfth and Market Streets in Philadelphia. Within three weeks, the show, which presented acrobatics on horseback, clowning, and rope walking in a forty-two-foot circus ring, was seen by President Washington; four years later Washington actually sold the white charger he had ridden in the Revolutionary War to Ricketts. The circus had its first-ever sideshow attraction, not to mention a presidential seal of allure.

Building on Ricketts's success, other promoters quickly realized the potential of taking their shows on the road. This need for mobility, along with the equally pressing need to cope with fluctuations in the weather, led Joshua Brown to erect the first American circus big top in Wilmington, Delaware, on November 22, 1825. The addition of canvas tents gave American circuses a flexibility their European indoor counterparts did not have, allowed them room to add traveling menageries and freak shows, and prompted them to invent the enduring line "rain or shine." In no time, traveling circuses became the principal form of popular entertainment in America, with performers becoming more well known than presidents. In 1848, Dan Rice, the era's most famed clown, persuaded his friend and Whig presidential nominee Zachary Taylor to ride with him in a ceremonial circus parade. When the townspeople saw the two together someone shouted, "Look, Dan Rice is on Zachary Taylor's bandwagon," and politics would be likened to a circus ever after.

The second great phase in American circuses began after the Civil War with P. T. Barnum, the Walt Disney of his time. Barnum, the prince of humbug—the art of careful exaggeration—had already wowed the country with a museum full of midgets, mammoths, and alleged African coneheads before opening his first circus in 1871 at age sixty. Ten years later he joined with his rival James Bailey to create the "Greatest Show on Earth." Together Barnum and Bailey made two momentous changes: first, they stretched their circus to three rings to accommodate more seats; and second, they took their show off the wagon trail and put it on the railroad. The Gilded Age of the American Circus had begun. By the

time the five Ringling Brothers bought out Barnum & Bailey in 1907, the new mega-show would span ninety railroad cars, employ 1,500 people, and seat 10,000 patrons. President Wilson visited the show near the end of his first term in 1916, took off his top hat, and tossed it into the center ring. Those in attendance took it as a sign that the as yet unannounced candidate would seek reelection: politicians now mimicked the circus in the business of show.

In 1956, John Ringling North, heir to the family business, heralded what he thought would be the third great phase in the American circus when he took his show out from under canvas and put it into buildings. The tented circus is a "thing of the past," he declared publicly. BIG TOP BOWS OUT FOREVER, bemoaned *Life* magazine. THE BIG TOP FOLDS ITS TENTS FOR THE LAST TIME, echoed *The New York Times*. Mark Twain, who once wrote that he would rather have been a circus clown than a writer, would have loved the irony of this greatly exaggerated death. The circus big top not only wouldn't die, but it would also live on thanks in large part to the work of people North himself had fired.

The year before closing down his big top because of constant delays in erecting the tent, John Ringling North fired his manager, Frank Mc-Closky, for graft. Undaunted, McClosky and aide Walter Kernan took the money they had skimmed from Ringling and, along with racetrack owner Jerry Collins and attorney Jerome Calhoun, promptly purchased a tented circus from Clyde Beatty. Beatty, the most famous wild-animal trainer in history, had run away from Bainbridge, Ohio, in 1921 to become a cage boy on Howe's Great London and Van Amburgh's Trained Wild Animal Show. By the mid-1950s, he had headlined every major circus in America, performed with a record forty lions and tigers at one time, been on the cover of *Time* magazine, and achieved the status of a matinee film idol. McClosky and company merged Beatty's show with the dormant title of Cole Bros., derived from the nineteenth century's first circus millionaire, W. W. Cole, and took the show on the road in 1957 with thirty-five trucks and the reigning "world's largest big top."

In 1981 the show was still on the road, though much deteriorated, and surviving owner Jerry Collins decided to "donate" the circus to Florida State University for a $2.5 million tax write-off. No sooner had he signed the transfer than the title to the circus was shuffled around a

large conference table in Tallahassee and purchased by Pugh and Hol-wadel. Burdened by debts, the new owners raised $200,000 to take out the show in 1982, but managed only to break even their first year. That winter the show sold all nonessential equipment—scrap metal, spare parts, even palm trees—to raise enough money to "leave the barn" again. The following year the show made money and the rebirth had begun.

Ironically, the Clyde Beatty–Cole Bros. Circus thrived in the 1980s and early 1990s by going against prevailing circus custom. For two hundred years circuses had made their reputations by being "modern": they exhib-ited the "first evidence" of Darwin's theory of evolution; they demonstrated the lightbulb before Edison had made it popular; they even presented mo-tion pictures before theaters were widespread. Now, at the end of the twen-tieth century, when computers and video games held the monopoly on modern, the circus survived by presenting itself as the embodiment of old-fashioned. Come and see the real circus, where the performers are real, where the mud is thick, and where if you come at the crack of dawn you can still see the elephants raise the big top in the part of the circus that promoters proudly call the Greatest *Free* Show on Earth.

•

By half past nine the sound of laughter was everywhere. The smell of sweat and morning coffee permeated the air. A gentle breeze was blow-ing. A crowd of nearly four hundred people had gathered on the lot—a mother and her daughter, a man with his dog, a boy in a wheelchair with a video camera. Out back a family stopped to take pictures with the tigers. Out front a minor trauma was brewing.

After receiving the warning about the ropes, Johnny hurried to the front of the tent, where the big top would be secured to the stakes by a series of bright yellow ropes. Johnny's plan called for the ropes to be twenty-two feet four inches long. The new ropes, however, measured twenty. Angry, but calm, Johnny ordered the manager to move the stakes inward until he could confer with the manufacturers and replace the stunted lines.

"You see, the weakest part of the tent is the stake line," Johnny ex-plained as we watched the big top slowly rise into the air. "If you don't have a good stake line the tent is going to fall down. We have ridden sixty-

five-mile-per-hour winds before, but I like winds under thirty. Even at that point I am not comfortable with people in the tent. If you've got people in there and the tent starts moving and rippling, they will panic. But the funny thing is, you can't get people out from under the tent unless it actually starts to shake. If you say to them, 'Will you please leave the tent in an orderly fashion, the National Weather Service has issued a warning,' everyone says, 'I'm not going out there . . . it's raining.'"

Within minutes the center of the tent had been winched halfway up the poles and the first hint of daylight appeared underneath the span. Johnny took my arm and led me under the concave blue-and-white spread.

"Only once in thirty years have I seen the tent come down with people in it. That was in Auburn, New York, on July 9, 1968. We had had thunderstorms all evening right off the Finger Lakes. I said, 'God, this is going to be a miserable tear-down,' when all of a sudden this wind came up and the tent was gone in two or three seconds. I stood there and could see the whole thing lift into the air. The tent was brand-new, like this one. It fell on the people. Fortunately, we had very few injuries—I think maybe five people with a broken hand or foot. Unfortunately, the local fire department had little experience with tents, and they caused more damage to the tent itself by climbing all over it while the people were still trapped underneath."

Just as the tent reached the top of the poles, the head of Anchor Industries arrived on the lot and Johnny went to discuss the problems with the ropes. After a brief consultation the company agreed to provide replacements, and Johnny began coping with a new problem: one of the fifty quarter poles that support the middle of the tent snapped as it was being pushed into place. Johnny marched over to the crew with the fury of an irate football coach. "I can do a better job than you guys with my privates!" he shouted in a show of force that brought to mind his reputation for swinging a stake or two in his day. "Now concentrate or you're out of a job." Once back in the huddle of businessmen, he brushed off the incident as perfectly normal for opening day with a new tent.

Finally at 10:15 the elephants arrived and the crowd began to cheer. There were three elephants in all—Helen, Conti, and Petunia, alias Pete—each wearing a giant harness around her shoulders and dragging a chain behind her on the ground. They were followed closely by a man

pushing a red plastic wheelbarrow and carrying a shovel. "Look!" someone cried from the edge of the tent. "It's the pooper scooper." As each elephant reached her spot one of the workers would hook her chain to the bottom of a quarter pole. "Move up, move up!" Fred finally called, and the elephants moved forward with barely a strain and pulled the tent magically into place. As each pole dragged across the ground, it left a rut in the grass like a giant golf divot. The process was repeated with quiet efficiency, and in a breathtaking span of under fifteen minutes the tent emerged from its previous fishbowl shape into a glorious blue-and-white whale.

"If you ask me, a circus isn't a circus unless it's in a tent," Johnny said. "In a building you have a very austere effect. The seats are so far away that the performers look like ants. Here, the worst seat isn't the problem, the best seat is. The audience has to make sure it doesn't end up part of the act." For the first time all morning Johnny's eyes misted up. When the circus left DeLand in five days' time Johnny would have to stay behind for an operation for a back ailment brought on from his days as a trampoline performer. "When you buy a ticket for a circus in a tent," he continued, "you buy a ticket for a fantasy. At some point everybody has wanted to be somebody in the circus—a ringmaster, the girl on the trapeze, a clown. Remember that, Bruce, when you become a performer: the only stars here are the ones who sit in the seats. If they don't star in our show, then none of us gets paid."

Johnny patted me on the back and walked away with his eyes toward the sky. I looked around at the massive space—solemn, sacred, almost cathedral. Give or take a yard or two, it could hold a football field, a commercial aircraft, even the White House in its entirety. But every night for the coming eight months it would hold a circus. At the moment, however, it held only promise. By eleven o'clock—four and a half hours after the first stake was struck, three hours after the vinyl was first unfurled—the heavens were now fully erect but the earth still needed work. First the bandstand, then the ring curbs, then the seats were wheeled in. Next, rows of lights were lifted into place. And finally, just before noon when a local priest arrived to bless the new big top and joked about sprinkling holy water on a waterproof tent, the performers began to appear.

A Rare Breed of Tiger

"As soon as I step into the ring I look around to make sure nothing's on the ground." Khris Allen is confident when he speaks. He is dominant and sure. But underneath his blond mustache and behind his clear blue eyes he is always a little afraid. "Sometimes I find pieces of metal or glass. Once I found the head of a baby doll: Fatima would have loved to eat that. Then, just as the last elephant passes the cage, we slide open the door and let the cats into the ring . . ."

The first act of the show is the "cats," the deceivingly casual term that circus people apply to all wild felines. The act is first in the show because it is first in stature, and also because the twelve-foot-high iron cage that surrounds the center ring is heavy and difficult to maneuver easily during the show. Clyde Beatty's original cage was so heavy, in fact, that his act closed the first show every afternoon and opened the second show that evening so the cage would not have to be handled more than once a day.

Despite this historical link to Beatty, the man who occupies the center ring with the cats is hardly impressive on first sight. He is short, around five feet six. His shoulder-length, beach-volleyball blond hair is thinning. But despite his boyish demeanor, twenty-five-year-old Khris Allen, from Atlanta, Georgia, had one of the firmest bodies and strongest wills of any member of the show. Though all year he would be considered a novice, in circus parlance a "First of May" (after the date that cir-

cuses used to start), once he stood in the ring with nine tigers on open-
ing day dressed in riding boots, tight black pants, and a blue lamé shirt
that he likened to Captain Kirk's, Khris Allen was a victor, having tri-
umphed in one of the quietest, but most intense love triangles and power
struggles that the Clyde Beatty–Cole Bros. Circus had ever seen.

"Once I'm out there, I try to sense the mood of the tent," Khris said
one afternoon when we discussed his act. "I want to know if there's any
electricity out there. Are people excited, or are they sitting on their
thumbs?"

Not long after the season began, I realized that the circus and its per-
formers have two parallel lives and that to grasp the full dynamics of the
show I would have to understand both of these worlds and how they re-
late to each other. The first—the legendary traveling part—is the life
that occurs outside the tent as the show moves across the land, from city
streets to country roads, from mud to sleet, from one child's deadly ear
infection to one mother's inexpressible pain when her son runs away
from home. But to me that experience seems all the more extraordinary
when contrasted with the other world, the life that occurs inside the tent
as performers do the same show twice a day, seven days a week, every day
from March to December without a single day off. To try to make sense
of this side of the show, I decided to sit down with each performer in the
course of the year and discuss his or her act. Their stories left me breath-
less with admiration. Khris Allen, like his act, was the first.

"The thing that surprises me most about the cats is that they, too, can
sense the audience," he said. "If there's energy out there, I know they'll
perform well. They're like the elephants. They love the applause. But if
the crowd is small and there's not much energy, then I'll let them play a
little in the ring before I start the act."

The first cat into the ring is Zeus, an immense, lumbering "liger"—
the controversial offspring of a male lion and a female tiger bred by
owner Josip Marcan. At two years old, Zeus is the youngest, at five hun-
dred pounds the heaviest, and at most times the laziest of the cats. He is
followed by Tito and Simba, the two slowest; then Barisal and Orissa,
the liveliest; and finally Toshiba, Fatima, Taras, and Tobruk. As members
of the Royal Bengal family, all of the cats have Indian names; yet each

has a distinctive coloring. In addition to two ligers, which have faint tiger stripes and stark lion features, there are three standards—orange with black stripes; three tabbies—cinnamon with blond stripes; and one rare snow white striped in black.

"The snow white is the feistiest of them all," Khris said, "and it's because of her I stand to the side when they come into the ring. In the beginning of the year I stood in the middle, but one day she waited by the back of the ring to jump on another cat and almost knocked me down in the process. If she had wanted me, I'd be dead."

The opening few seconds of the act, seemingly tame, are not. The previous year, in Reading, Pennsylvania, when Kathleen (the previous trainer) was doing the act, two of the tigers escaped at this stage during the 4:30 show. The two cats—Fatima, a one-and-a-half-year-old female tabby, and Tobruk, a two-year-old male standard—walked nonchalantly through the supposedly locked steel door of the cage and into the open tent. At first there was disbelief, then panic. A few people started screaming. Jimmy James sprang into action: *"Ladies and gentlemen, please remain seated. Stay calm and keep your voices down . . ."* With a prearranged wave of his arm, he gestured for the band to play in hushed tones in an effort to calm both the crowd and the animals. Ahmed, the prop boss, was standing in ring one when the cats first emerged. He froze. Two assistants were standing next to him. They ran: the worst thing to do in front of a tiger, as it frightens the animal and gives it a target. Fatima, however, didn't jump. She walked very calmly up to Ahmed, who equally calmly kicked her in the shoulders. This startled the tiger long enough to let Kathleen grab her around the neck and lead her back to the cage. One cat captured. One still loose.

Tobruk, meanwhile, had made it out onto the track and was heading directly toward the seats, threatening hundreds of people. Several nearby performers leapt into action. Julián Estrada, a veteran Mexican tumbler, threw a bank of three chairs at the tiger. Tobruk jumped back, but continued. Julián's brother Antonio grabbed the curtain used to keep people out of spec and blocked off the seats. One woman and her daughter, however, were left in front of the curtain, and Tobruk began to stalk them. Khris, then Kathleen's assistant (and her boyfriend), came sprinting

from the line of cages. But at this point the confrontation was already set and Tobruk could not be stopped.

At the crucial moment, one of those unexpected defining moments when a circus seems most like a dream, the woman, instead of panicking, slowly crouched over and sheltered her child with her body. Tobruk approached the woman, sniffed her from behind, and, for reasons no one ever quite figured out, suddenly jerked his face back in disgust—the same face the tigers are known to make when they smell another cat's urine. That moment of pause gave Khris enough time to pounce. He grabbed the tiger around the neck and waited for Kathleen to slide on a leash. Tobruk was led back to the cage and the act resumed.

•

Once all the cats are in the ring, Khris sends them to their seats with the pidgin command "Platz, platz! Come on, everybody, platz," a mix of German bossiness and English courtesy. For his first trick he has all nine cats sit up on their hind legs atop their pedestals. This trick, which the tigers performed every day for Khris, was the same trick that they had performed every day for Kathleen, that their parents had performed every day for Josip, and that their forebears had performed regularly in wild-feline acts for over one hundred and fifty years. The tricks that followed, however, were strikingly different.

Cat acts in America began in 1833, when Isaac Van Amburgh first stepped into a cage with a lion, a tiger, a leopard, and a panther. Dressed like a Roman gladiator in toga and sandals, Van Amburgh emphasized his domination of the animals: he beat them into compliance with a crowbar and thrust his arm into their mouths, daring them to attack. When he came under attack for spreading cruelty and moral ruin, Van Amburgh quoted the Bible: Didn't God say in Genesis 1:26 that men should have dominion over every animal on the earth? To enhance his case, Van Amburgh actually acted out scenes in the Bible, forcing a lion to lie down with a lamb and even bringing a child from the audience to join them in the ring.

Van Amburgh's vicious theatrics gave rise to the so-called American style of feline acts, a style that reached its apex a century later in the

dashing glamour of Clyde Beatty. Beatty, who performed at one time or another with lions, tigers, leopards, pumas, hyenas, and polar bears, cultivated a safari image. Dressed in khaki jodhpurs, brandishing a dining-room chair, and firing a pistol into the air, Beatty would raise the ire of the animals to a fearsome roar until his survival seemed in doubt. In one famous routine, a full-grown male lion would knock Beatty's chair from his hands and force the legend to flee from the cage in fright. Pausing to wipe his brow, Beatty would reenter the steel arena to thunderous applause and force the jungle beast to slink back in retreat using only a manly stare.

Beatty's theatrics were perfect for his age, but by the 1960s the American attitude toward animals had shifted and the public was ready for a new style of training. The new style came from Europe, and it was embodied by two men who arrived in the United States in 1968: Gunther Gebel-Williams and Josip Marcan. Gebel-Williams, a German, quickly became a superstar with Ringling Bros., demonstrating the so-called European style, which stressed the skill of the trainer in bringing out the natural, yet still obedient nature of the animals in a nonconfrontational way. Marcan, a Croatian, meanwhile, performed in various parks and circuses across North America. In 1986, he brought his European training style, his continental lifestyle, and his unique breeding style to the Beatty–Cole Circus. The show would never be the same.

"He put an ad in the Daytona *News-Journal* and I answered it," remembered Kathleen, who was then a naïve, twenty-year-old part-time horticultural student from Morgantown, West Virginia. "The ad said: WANTED FEMALE TO TRAVEL AND WORK WITH ANIMALS. The next day I drove to winter quarters for an interview. We had lunch and he explained the logistics of the job: cooking, cleaning, raising tiger babies. Being, as he put it, 'like my wife.'" Kathleen giggled as she recalled the encounter. The job description was certainly blunt, but was she ready to sleep with a man who had all but advertised for a temporary spouse in the want ads of a local newspaper?

"Originally I was a little bit intimidated," she confessed. "He was pudgy and bald, and I didn't understand a word he said. But the minute I looked through the fence and saw those tiger cubs, well, he could have

not paid me and I would have stayed. It felt comfortable. It felt right. It was my destiny."

Kathleen did stay that day, and after her first year she stayed for another. "When I first arrived on the show no one took me seriously. That was his third year, and I was his third girl. So when I stayed for a second year they were in shock. They probably thought I was a bimbo."

During Kathleen's third year Josip decided to return to Europe but agreed with the show to leave his act behind. For the first time since he began breeding cats, Josip needed someone to present his act. He selected Kathleen.

"I never dreamed of being a circus star," Kathleen said, and her demeanor suggested why. Her brown hair hung uncombed around her shoulders; her pale face was devoid of makeup. She looked more like a tomboy than a showgirl. "I just wanted to spend more time with the cats."

But suddenly she was a circus star. Her picture was in the newspaper, her story was on television. People came for miles to see her opening performance. Then, on Kathleen's first day in the ring, the unthinkable happened. With documentary film cameras rolling and reporters filling the seats, she was knocked down by one of the cats, Simba. The next show it happened again, and the following day it also happened, Kathleen barely escaping injury with each time. The experiment seemed a failure. Everyone on the show expected her to quit.

"At that point it was a challenge," Kathleen said. "None of the people on the show thought I could do it. None of them. Not one. Everybody is extremely cruel here. They all thought I would fail in a week and go crying home and Josip would have to replace me. Screw you guys, I said. I'm going to show you I can do this."

Kathleen did show them she could do the act, though she never truly mastered the routine and never really liked it very much anyway. Incidents like the cat escaping in Reading only heightened her frustration. Other performers on the show blamed her for not locking the gate. She countered by blaming the crew. In any case, her isolation only deepened. To make matters worse, at times her five-minute act stretched to twenty or twenty-five minutes. It got so bad the members of the band actually kept a running tab of the number of times they had to play "Cat

Mambo" waiting for her to perform one trick (the high was twenty-six, the low six). At that point, Kathleen decided to bring someone on the road with her to combat her loneliness. She invited an old high school boyfriend from Atlanta to visit her in winter quarters. He was a zoologist who had recently graduated from West Georgia College and had nothing much to do. He came for a month, he stayed for the season. The kept woman now had a kept man.

"When I first came I wanted to be with Kathleen," Khris said. "She was my first love in high school and will always be the love of my life. But after about the first month I grew attached to the cats and I couldn't see myself leaving. No matter what, I wanted to stay with them. No matter what, I wanted the act."

A battle for the center ring arose.

After two seasons in the ring Kathleen had begun to tire of the pressure. She wanted to give up performing in the ring but still retain control of the tigers' breeding and care. Khris, meanwhile, had begun to fantasize about performing, but he was reluctant to take the reins of the act without control of the tigers' welfare as well. Inevitably a split occurred: Khris moved to the couch in Kathleen's trailer; Kathleen started dating Khris's brother; and Josip, who by this time had taken up with another woman in Germany, got trapped in the middle: his ex-girlfriend had de facto abdicated his cat act, all but handing it over to her ex-boyfriend, whom he, the owner, had never met.

The situation came to a dramatic head just hours after the new tent was raised, just three days before the opening performance of the season. Josip had signed a contract, his cats would be in the show, but Kathleen refused to perform, even though her picture was in the program and her portrait was on the front of the banner truck along the circus midway. Johnny and Doug were in a panic: the show that still bore Clyde Beatty's name needed a cat act at all costs. Finally, on Wednesday, just minutes before the dress rehearsal, the owners announced the resolution: the act that was owned by the Legendary Josip Marcan, an act that had been trained in part by his former girlfriend, the Lovely Kathleen Umstead, would be presented for the upcoming season by her now estranged boyfriend, the Great Unknown, Khris Allen.

But one catch: Kathleen would still be with the show and she'd still be living in the same trailer as Khris.

•

After having the cats sit on their hind legs, Khris moves steadily through the heart of the program: a two-tiger rollover on the ground, a nine-cat walking carousel around the ring, and a hind-leg hop by Tobruk designed to show off the prowess of a full-grown tiger. In a further maturation of the European style, all the cats in Khris's act perform natural tasks—walking, sitting, leaping, rolling—with no jumping through hoops, no prancing through fire, and no wrestling with the trainer in mock jungle fashion. To exemplify this point, Khris liked to tell reporters along the route that he was not a "lion tamer" at all, but a "cat choreographer." He didn't teach tricks, he said, he "enhanced natural behaviors." In short, he was a diva of cat nouveau.

The cats, for their part, seem to love their new, ennobled status. With each behavior, they glide slowly, almost genteelly, through the routine as if they were walking through a Victorian parlor dance. Occasionally one will pause, slap a flirtatious paw at another cat, or growl menacingly at the trainer. When this happened, Khris would snap his eight-foot kangaroo-hide whip or flick his leather riding crop in the tiger's direction. Nothing too hostile, only commanding. He knows he must stay in control.

"The cats are very sensitive to my moods," he said. "If they know I've had a bad day, they'll toy with me and do stuff just to piss me off. Sometimes it's because there's a big crowd, and they'll think, 'Oh, he won't discipline me because of all the people.' If it's a small crowd, I can be a little bit more of a disciplinarian. It's just like if you go into a supermarket with a kid and he's pulling stuff off the shelf. If there are a lot of people around, you scold him. If there are not so many people around, you spank his butt. If he's been doing it a lot, and there are a lot of people around, you smack him anyway."

The act climaxes with a heart-stopping shoulder stand. Khris calls Fatima from her pedestal into the center of the ring. Standing slightly hunched over the full-sized tabby and holding a piece of raw horsemeat in each of his hands, Khris shouts, "Up, Fatima! Up!" and braces himself

for the tiger's four-hundred-twenty-five pounds as she plops her front paws on his narrow shoulders just inches from his face.

"In truth, it's a bit overwhelming to have this thing in your face. I'm five feet six; she's probably close to seven and a half feet. Her breath smells like a dog's. I give her meat from the right hand, then the left. Then what I'll do is put my hands on her paws and she gives me a kiss."

"A kiss?" I said. "What does that entail?"

"A kiss is a kiss. She puts her lips on mine, though tigers don't actually have lips."

"So what does she think she's doing?" I said.

"I have no idea. She just did it one day, and I thought, 'This is pretty cool, I'll do it again.'"

"Do you actually go so far as to pucker up?"

"Yes. It feels like I'm kissing a mustache. Her mouth is bigger than mine, and sometimes she'll lift her lip and slip me some tongue."

"Some tongue?" I said, thankful for not having to ask that question.

"Some tongue," he repeated with a wink of his eye.

•

At this point in the routine Khris sends Fatima back to her cage. Tobruk, Barisal, Simba, and Zeus are already in their home cages. Khris is nearing the finale of the act. He warms to the audience. He seems, for the first time, to be enjoying himself.

"There are two types of people in the world," he said, "those who don't mind stepping into the ring with nine tigers and those who do. I'm an Aries. I don't mind taking risks. I recently read that Aries men are casual types who like to feel comfortable and secure at home, but like competition in the rest of their lives. That's me. When I'm gone and through with the act, not very many people will remember Khris Allen as a cat trainer or cat performer, but I see myself as playing a little part in history. I've always been like that. On my volleyball team in college, on my baseball team in high school, I always wanted to be the one who made the play. Here I'm making the play every day."

Khris ends his act with a jumping display—no fire, no hoops, just the

cats on their own. He calls down two tigers from their pedestals and has them stand side by side in the middle of the ring. Next he beckons Orissa, the fierce snow white, who slowly cases the two upright tigers, then on command from Khris boldly leapfrogs over their backs, back and forth in near slow motion, to the applause of the audience, the cymbal crash of the drummer, and the eventual reward of a piece of horsemeat, personally delivered by the trainer himself at the end of an aluminum ski pole. The act is nearly over. Orissa is sent home. As the remaining cats follow, Khris climbs on the back of Tito, his anchor cat, and rides his majestic shoulders to the mouth of the cage line.

"Ladies and gentlemen . . . ," Jimmy James calls, *"from Atlanta, Georgia, . . . American zoologist Khris Alllllen."*

Khris skips to the middle of the ring and accepts the applause with a quick bow and a wave. Some people, he knows, are delighted with his performance, others are probably disappointed, a few maybe even upset.

"Let's face it, forty-five percent of the people are saying, 'Oh my God, look how beautiful those cats are,' another forty-five percent are saying, 'I wish he had gotten his ass chewed up.' The other ten percent are probably saying, 'Oh, those poor cats.' I try to focus on the positive. Sometimes there will be a very enthusiastic person who really enjoyed the show. When I leave, I'll walk up to that person and shake their hand, because they were appreciative and because they'll say, 'You know what I did at the circus? I shook the hand of the tiger trainer.' That makes it all worthwhile."

Though his performance is finished, Khris's work has just begun. Before he can remove his Captain Kirk outfit and settle down for a few minutes' rest, the cats must be removed from the tent, quickly watered, and fully fed. The props crew must dismantle the cage, stack it in piles, and pull it away. The tasks are awkward, the crowd needs distraction, in circus tradition the ringmaster calls: send in the clowns.

3

First of May

Few people are more cherished on a circus lot than a First of May. He, or even she, can be embraced, abused, ridiculed, or ripped off. All of these happened to me during my first four days on the show.

"Oh shit. Who the hell are you? And what are you doing here?"

When I drove my camper onto the lot the Sunday evening before setup, I was greeted by the show's official parking guru and grouch, Gene, a surly, swollen old-timer whom everyone on the circus called Hippo. With the physique of a bouncer and the charm of a tiger in heat, Hippo was the show's twenty-four-hour man. He taped red arrows to road signs along the route every other night to guide the drivers, laid out the stake line on the new lot, and directed the trucks and trailers to their parking spots as they arrived throughout the night. The first two jobs he did well. As for the third, well, Hippo has been lucky over the years that none of the performers has had very good aim when it comes to throwing stakes.

"I'm a clown," I said. "I'm new."

"Well, fuck," he said. "I don't have room for you. I think you better leave."

I laughed. He snarled. Then he gestured for me to follow.

My inaugural hours around the circus lot were like awkward moments in a new country where I didn't speak the language and didn't

have a map. More importantly, I didn't have a place to park. Before leaving home I had purchased an RV, the insider's term for a recreational vehicle, alternately called a motor home, a camper, or, according to my dealer, a honeymoon on wheels. While the workers (as well as some of the clowns and musicians) lived in sleepers—semitrucks with cots in the back like overnight Italian trains—the performers were required to provide their own accommodations. After a crash course on mobile living ("Think small," I was told by a friend and RV fanatic, "but not too small. If your milk falls out of the fridge during a drive you don't want to get wet"), I settled on a four-year-old, twenty-three-foot Winnebago Warrior. Essentially a Chevy van with a hotel room on back, it came complete with two miniature beds, a shower, a toilet, a stove, a television set, and a refrigerator more than four feet from the driver's seat. It also had a small table, which for me was a requirement, since I may have been the only person in history to run away and join the circus with a laptop computer.

After my initial encounter with Hippo, one that was repeated in one form or another every other night for the rest of the year, he decided that since I was a clown I should be parked directly behind Clown Alley, the small tent used for dressing that was located halfway down the line of trailers and near the side doors of the tent. While there was nothing wrong with this resolution in DeLand, where the lot was a large, open fairgrounds, this decision proved to be one of the worst things that happened to me all year. The reason: Hippo tried to park me in the same spot in every town, so even if there was a fence (as in Hinesville), a ditch (as in Hendersonville), or a Wal-Mart Dumpster (as in Waycross), the undisputed Mr. Least Congeniality of the Circus tried to squeeze, cajole, or harass me into the same place in every town we played. In the beginning I hated our thrice-weekly fights, but by the end I came to see them as a badge of honor. After all, he treated me just like everyone else.

Once I had my parking space—my own roving plot of land, as it were—I set out to explore the neighborhood. Despite its outward chaotic appearance, there was nothing random about the arrangement. Every vehicle had a set place, a set function, even a set smell: diesel exhaust, bacon grease, elephant dung, popcorn butter. At the front of the lot

were the ticket wagon and the concession stand. At the back were the an-imals—tigers, horses, and bears. The two elephant trucks usually parked farther away from the big top, near the closest thoroughfare for maximum publicity value. As for the human residents, performers lived behind one long side of the tent, workers behind the other. In addition to a bunk in the sleeper truck, each worker was entitled to take a cold shower in the back of No. 63, use the show's bank of port-o-johns, known as "donickers" (believed to be from the requisite process of pulling down knickers in out-houses), and eat his meals in the cookhouse, a tented paradise of culinary dreams that served three meals a day of the soupiest, greasiest, rubberiest food I've ever had the pleasure to complain about.

The performers, meanwhile, lived in their own trailers, ranging from $80,000, thirty-five-foot-long Teton Homes with pop-out living rooms, washer-dryers, and ten-piece home entertainment centers to fifteen-year-old, one-room, beat-up Prowlers that housed three people, two cats, a dog, and a baby squirrel, as well as sullied piles of outgrown wardrobe from some out-of-date act. The owner of the circus, whichever one was traveling with the show at the time, parked at the front of the trailer line, closest to the ticket wagon. Sean, the Human Cannonball, parked at the end of the line closest to the back door. All other parking spaces were determined by seniority and number of costume changes. The longer one had been with the show, the farther one got to be from the noise of the generator; the greater number of costume changes one had, the closer one got to be to the side doors of the tent.

In addition to these two hundred or so people, the show carried its own infrastructure, giving rise to its vivid nickname "The City That Moves by Night." At the turn of the last century Kaiser Wilhelm sent efficiency experts from the German army to study the way American cir-cuses moved across the land, and at this century's end this circus, at least, could still teach a thing or two about efficiency to the Japanese. Besides the basics of room and board, the show had its own mechanics shop, a carpentry, a short-order grill, even a part-time school for the children. The two most coveted services were water and power. For water, the show had a water man with a thousand-gallon tank who drove around the lot five times a day, bathing the animals, filling the tanks of the trail-

ers, and, for a price, even filling the portable swimming pools that some parents carried for their kids. As for electricity, the show carried two Caterpillar diesel generators that were turned on every morning at nine and turned off every evening at midnight. This meant that for hours every day, even nine of the hottest overnight hours in a New York City heat wave, nobody on the show had air conditioning, water pressure, television reception, or video games. Some people had their own personal generators, but these were so loud and unneighborly they had to be turned off before 2 A.M. Basically, for more than a third of every day, we lived the way they did in the Age of Barnum, relying on sleep, booze, and an occasional scandal to keep us from raping and pillaging the land.

It took me awhile to adjust to this new regimen. More than once I ran out of water in the middle of my shower or power halfway through a frozen pizza. I even posted a list in my RV reminding me of all the things I had to do before every trip: check the propane, turn off the pump, lower my antenna, raise my staircase. Kris Kristo, the juggler, and Danny Rodríguez, the flyer, laughed at how I struggled with many of the basic functions they had been performing mindlessly all their lives.

All of this novelty came vividly home to me on the morning after I arrived. I got up at five to watch the tent go up and decided to have cereal for breakfast. I took out my brand-new plastic bowl, opened my two brand-new boxes of cereal (Special K and Cranberry Crunch), used my brand-new plastic knife to slice up my still green banana, then opened my refrigerator to retrieve my brand-new half gallon of skim milk, which to my brand-new RV chagrin was frozen solid. I picked the bananas out of the cereal, opened my brand-new box of Saran Wrap, and returned my newly wrapped bowl of dry cereal humbly to the shelf. The tears of more than one clown, no doubt, were prompted by missing a meal.

•

"Well, well. What do we have here, a new clown in the neighborhood?"

When Buck Nolan stuck his face in my trailer on Monday afternoon,

his head almost poked through the vent in the roof even though he was standing outside on the grass. After Hippo, Buck was the first person I met on the lot. He was also the tallest, the loneliest, and the most eccentric. "Do you mind if I come in?" he said. "I always like to check out the First of Mays. I remember when I was one myself. The year was 1959."

To hear him tell it, Buck Nolan was always tall: a hillbilly childhood freak from Princeton, West Virginia, just waiting for the circus sideshow to run into him. At eleven, he was already six feet tall. At sixteen, he was approaching seven feet and was given the job of changing the letters on his hometown movie-house marquee. At eighteen, he was featured in *Life* magazine in a photo series called "The Giants of Schoolboy Basketball." In the middle of the page, at seven feet tall, was Wilt "The Stilt" Chamberlain, and on the end, at seven feet two, was Charles "Beanpole" Buxton, alias Buck Nolan. "Asked last week if he had ever hit his head on low doorways," the magazine reported, Beanpole replied: "Heck, I did that four times already today." After the article appeared, Buck turned down 155 offers to play college basketball. Still, he never forgot the photograph, and when *Life* magazine published its fiftieth-anniversary edition, "The Biggest and the Best," he was upset to notice that they didn't use the picture of the tallest high school basketball player of 1955, but the second tallest, Wilt Chamberlain. "I wrote them a letter and said he may have been the best, but I was the biggest. To hell with your magazine."

Partly because of his unnatural height, Buck was always a loner, and in 1959 when the Cole Bros. Circus visited his hometown just before his twenty-third birthday, he saw the circus not as a dream but as an escape. At least there he would be normal. "I heard they had short people, midgets and things, and they always fascinated me. I thought I would ask around. I was walkin' down the midway on my way to become a working man, when the butcher—that's the name for concessioners, you know—yells out at me, 'Hey, kid, where ya goin'? You don't want to be with them, they'll work your nuts off.' He took me by the arm and walked me toward the midway. 'Hey, Bill,' he called out to the sideshow manager, 'I got you a new giant.'"

Nearly thirty-five years later Buck was still on that circus, though he

had long since moved to clowning after the sideshow folded its tent. Though almost sixty, Buck still slept in a hollowed-out Ford van every night, still ate three meals a day in the cookhouse, and still walked out in particularly frightening white makeup twice a day and cracked wiseacre jokes as the "World's Tallest Clown." Even though diabetes and a bum back made him less than agile, Buck still played an important role among the nine men who comprised Clown Alley. He was twice as old as everyone else and twice as wily, and when the others started ganging up on me, Buck told me what to do. Of even more immediate importance, however, Buck told me in my first vulnerable days on the show how to watch my wallet.

"Everybody on the show has a way to make a little extra money," Buck said in his loopy, wry hillbilly drawl that usually culminated with some unexpected crack. "Sometimes it's from the rubes, the townies; sometimes it's from the people around here, like First of Mays. When I first joined the show I made eighteen dollars a week. Now I make ten times that amount. It's still not very much, so I make a lot of extra money on cherry pie."

"What's cherry pie?"

"Oh, it's many things," he said. "Taking down and putting up the big top. Carrying the ice. Anything you do to make extra money. They're what I call my sidelines. I work flea markets, I sell circus memorabilia, I have a few dirty videos I rent out. Also, drinks. If you're thirsty on this show and you run to the Coke house to get a cold soda, it costs you seventy-five cents. I sell them out of my van to the clowns for fifty cents. You go to the Coke house, they don't have any diet. I'm diabetic, that's the only thing I can drink. Hell, half the clowns in there I've trained to drink diet."

"So that's how you make your living?"

"I certainly don't make it off the circus. I have to make it off something. Just wait a few days, you'll see."

It turns out I didn't have to wait that long at all. Within hours of my arrival on the lot I became aware of a vast underground economy on the show. Even before I learned people's jobs, their names, or even their sexual histories (which was usually the second thing I learned), I heard about their rackets. Ora sold jackets. Bonnie sewed costumes. Southpaw

smuggled in beer. In some ways the underground economy was a model of communal efficiency. For a price, I could receive almost any service I might possibly desire and still keep my money within my own community: I could get my laundry done every week, have my oil changed every 3,000 miles, even have a copy of *USA Today* delivered every morning to my camper door. Seemingly complex commercial or civic enterprises were performed effortlessly despite the fact that we were in a different community three or four times a week. A circus postman, alias trombone player, went to the local post office every day to buy and send money orders as well as retrieve and send mail. He would then deliver the mail to your door for a fee of twenty-five cents a letter. The show had its own bank (the office manager), its own lending agent (the treasurer), even its own notary public (the stilt walker). With surprisingly little effort, a circus person could be born, go to school, learn a trade, get a job, take out a loan, buy a car, buy a house, find a spouse, have a child, raise a family, see the world, grow old, and ultimately even pass away in the arms of his loved ones in the place where he was born—without ever leaving the lot. He could even go to church if he wanted, since a traveling circus priest came to the lot every Sunday and said mass in the tent.

While this underground economy was one of the more impressive aspects of the circus, it could also be one of its more sordid. As I learned quickly, life operated much more smoothly on the show with a little tip here or a small bribe there. The problem for an outsider was trying to figure out whom to tip, when to tip, and how much to tip. The water man received a tip, for example. Johnny even mentioned this in the opening meeting. But some people insisted that since the show promised performers water once a day in their contracts, and since his job was to dispense the water, he should only be tipped for providing water a second or third time. Living by myself, I needed water only once a day. The electricians were tipped for plugging in the RVs to the generator on setup mornings, but only when the plugs were laid out on the grass. One evening I chose not to leave my plugs out because I had to go grocery shopping off the lot the following morning. When I woke up, my cord had been removed from its compartment and plugged in for me. I wasn't sure if this was kindness or capitalism.

What I was sure of was that, in those opening days at least, loyalty was only wallet deep. The workers on the show viewed a First of May, especially one with a bright, shining RV and clean fingernails, as a rube and a gold mine. When I first arrived on the lot, I was told that the external electrical cable on my Winnebago was not long enough and had the wrong kind of plug for the generators. The boss electrician, Jack, sent me to buy an additional fifty feet of cable. Don't bother with the plugs, he said, he could sell them to me cheaper. I went as instructed to purchase the cord, but just for my own First of May fun I asked the hardware-store attendant how much a pair of 30-amp twist-lock plugs would cost. The male was $12.11, he said, the female $24.85. With the standard circus discount, the total was a little over thirty-two dollars. Back at the lot, Willie, the colorful bearded wacky uncle of the electrical department, agreed to install my plugs.

"Jack told me to tell you that you are expected to tip me," Willie mumbled in what was probably the most coherent thing I heard him say all year.

"I understand that," I said. "I hear you like beer."

"Even better than the smell of a pussy," he said. "And almost better than reefer." At the mention of this Willie visibly swooned. "But you still have to pay Jack for the plugs, you know."

"And how much are they?"

"Sixty-five dollars," he said.

The next day I dutifully paid Jack for my plugs. And when I learned that he asked all the performers to tip him five dollars a week for their power, I never got around to paying that.

•

"Higher, higher. Lift your hands a little higher. . . . That's right. Now put your palms up, not down. You're not flying anywhere; you're not an airplane. The proper position is palms up."

"What about my feet?" I said.

"You can stand like you are now, with your feet not completely together. But turn your toes out a bit."

"And my head?"

"Head up, eyes out. Don't look at the first row, but the last. Remember, you're asking for something: you want their applause. The show is for them and you want their appreciation."

Elvin Bale is never more alive than when he discusses performing. On opening day he sat outside his sister's trailer, with a cellular phone in his hands and a tuna sandwich in his lap, and brought his forty-eight years of circus experience to life as he taught yet another newcomer how to style—the circus expression for taking a bow.

"A lot of performers don't know how to get the audience," he said, his ruddy cheeks blushing in the afternoon breeze and his thin blond hair flapping against his head. "You have to communicate with them even though you're not talking to them. You must look into their eyes and control them. To me, the audience was my lifeblood. They were the ones who gave me the daring to do some of the things I did. And no matter what I did, I always left the ring saying, 'God, I wish I could have done more.' That's a good performer—when you feel you haven't given enough."

As he spoke, Elvin searched the empty sky with his eyes as if he were looking for a spotlight. With his voice he could conjure up memories of a thousand circuses past. With his arms he could direct me in exactly how to stand. But with his legs he could no longer stand that way himself. Elvin Bale, the "Great Melvor," the Circus Daredevil of the Century, was sitting forever in a wheelchair.

"It happened in 1987," he recalled. "I was in Hong Kong to do a shot with my cannon. It was my biggest and best act. In fifteen years with Ringling I had done an ankle catch on the single trapeze, I had walked the 'wheel of death'—I even wrestled a giant mechanical monster. Every two years I designed a different act, but the cannon was my ultimate creation. It was my legacy."

For his signature act, Elvin would crouch in the steel barrel of the world's largest cannon and with a giant fiery explosion be propelled two hundred feet through the air and then land in a giant net. At every new site, he would calculate where to put the net by shooting a sandbag dummy from the cannon. In Hong Kong, however, it rained overnight and the dummy was left outside. The next day Elvin shot the sandbag

from the cannon, placed the net where it landed on the ground, then loaded himself where the dummy had been. "Halfway through the flight I knew," he said with the calm, abnormally stoic voice of a man who has been to hell and back and still can't quite believe it. "I knew I wasn't going to make it. I knew I was going to overshoot the net."

He did. In what turned out to be his farewell performance, Elvin Bale overshot the net and landed on the ring curb, rupturing his spinal cord with a career-ending, marriage-ending, seemingly life-ending snap. Recalling the episode more than six years later, Elvin still seemed haunted by his accident. Though his performing days were over, his circus life had continued. Overnight, he became an elder statesman in the community. He opened an agency and began representing many of the top acts in the country, including almost every act on the Beatty–Cole show. More importantly, he sought out his own replacement. He went looking for the next Elvin Bale. When he found him it was in the most unlikely place.

"He was my pool man."

"Your what?"

"My pool man. He cleaned my pool. I was lying there one day looking at him. He was blond, muscular. Not too tall, not too heavy, about a hundred fifty-five pounds, I'd say, almost the same weight as me. He had been a high school football star. He was wiry and reckless, always getting into fights at school, kind of a rough-tough kid, though spoiled in other respects. But the thing was, he had that all-American look. And then I realized it: he was me. Sean Thomas was *me*."

The bustle of opening day was just beginning to pick up around the end of the trailer line, where Elvin's three sisters parked their vehicles side by side. Elvin's older sister, Gloria, stopped by with new blue and white ostrich plumes for her Arabian horses. His younger sister, Bonnie, was home sewing costumes for her cloud swing. His twin, Dawnita, the only brunette in a family of blondes, was complaining that her Siamese cat was about to escape through the screen door. Just then the Bales's mother arrived from Sarasota bearing Cadbury Creme Eggs and a new costume for Sean. As they had done since they were children—first, on their father Trevor's circus in wartime London, later on Ringling Brothers in America, after that on Beatty–Cole—the Bales made their own

nest of sorts wherever they landed and pulled in a few stray fledglings like me and made them feel at home.

"Oh, Mom, the costume looks great," Elvin said as his mother bent down to kiss him.

"Isn't it magnificent?" she said, holding up a white bodysuit covered in red, white, and blue flaming stripes like something Evel Knievel might have worn. Her voice retained much more of the British accent that still lingered around the corners of her children's speech. "It's made with a new thing called a hologram. It's very expensive."

As she spoke, Sean arrived. Noticeably bowlegged and decidedly stiff, he was wearing blue-jean shorts, no shirt, and a Los Angeles Raiders baseball cap. Around his neck he wore a gold chain with a Florida Gator dangling from its center. On his left breast he had a tattoo of Mighty Mouse in flight. He thanked Elvin's mother for the costume and sat down on a beach chair to pull it on. The cellular telephone rang for Elvin, who answered it.

I turned to Sean. Like everyone else on the show, he had seen me the night before when Johnny introduced me to the cast and crew after the dress rehearsal, put his arm around me, and said, "He's one of us now. Treat him like a member of the family." Thus blessed, I was free to roam.

"So, are you doing anything special today?" I asked. "Any rituals?"

"Go to work, that's about it."

"Aren't you nervous?"

He shrugged. "What's there to be nervous about? I know what I'm doing. If I land on the ground, well, I land on the ground. It's a day-by-day act. You try your best to calculate everything, but you can't always be sure."

Sean stood up with the costume. The shoulder pads fit perfectly above his arms, but the legs were slightly baggy. Elvin's mother hurried to the car to get some pins for an emergency repair. The first show was now just two hours away.

"So you don't get scared?" I asked.

"Scared? Scared of what? Breaking a few bones?"

"Scared of having an accident."

"Falling's not scary," he said, bending down to lace up his high-top

boxing shoes. "Scary's catching AIDS. Scary is being poor." He stood up, nodded for me to follow, and headed toward the cannon, which was parked in the space next to Dawnita. Sitting quietly in the grass with no glitzy trappings from the show, the cannon looked potent but slightly out of place, like a plastic mobile ICBM I had once seen in a toy store in Moscow. The thirty-foot-long shiny silver barrel was attached to the back of a flatbed truck that had been painted fire engine red. On the passenger door was a message: GUN FOR HIRE. "Pain is not scary," Sean continued, now looking at me directly with a squint in his eyes. For the first time I could see his face. It was worn by the sun. His nose was sharp, his chin jaunty. His eyes were vivid blue. He was the picture of Marine Corps confidence. "No, pain is a feeling and it goes away. What I'm scared of is dying . . ."

I raised my eyebrows. Sean nodded his head. Then, as if alarmed by his own morbidity, he suddenly caught himself. "But I'm not going to die," he said.

"Why's that?" I asked.

"Because I'm good." He tweaked the cannon on the barrel. His voice assumed the mock-aggressive tone of a man pretending to wrestle with an inanimate object. "Aren't I, you big lady, you big beast? I'm good, and you know it." He hopped up on the sideboard and with a flash and jump was standing on the barrel above the mouth of the cannon, towering over the circus lot with his arms, Superman-like, at his waist. "I'm Sean Thomas, the Human Cannonball, the Daredevil of the Decade, the Big DD."

He looked down on me watching from the ground, recast his pose for a moment, then lay down on the barrel and removed the cover from the mouth.

"So," he asked, "do you want to have a peek inside?"

"Why not," I said.

"Because you can't." He grinned. "People offer to pay me to go inside, you know, but I don't let them. It's a secret. Only I can know." He bent down and kissed the barrel.

"We'll see," I said with a nod to the barrel. I turned back toward Dawnita's.

"Where's Sean?" Elvin asked when I arrived back under Dawnita's awning.

"I think he's making love to the cannon."

"At least he's not making love inside the cannon. I'd kill him if he did that."

"Thanks for the lesson," I said. "I'm off to put on my makeup."

"Good luck," Elvin declared. "And remember what I said: you're doing it for the audience. No matter how bad it gets around here—how muddy, or gossipy, or miserable—you can never forget that you're doing it for them."

I promised him that I would remember. "By the way," I said, "what do you say to a circus performer before a show? Break a leg?"

Elvin smiled at my question even as I winced at my faux pas. "Not really," he said, slapping his thighs. "We just say, 'Go get 'em!'"

Facing the Fire

As soon as the lights shine into the ring, I step out of the bright yellow cartoonlike house, stretch my back like an aching grandfather, and breathe an exaggerated puff of flames from the end of a two-foot cigar. Shocked at the inferno, I lurch back in surprise. Puzzled by the fire, I hurry back into the house. Thrilled at the confusion, the children shriek in delight as the bright orange roof above my head is engulfed in a cloud of smoke.

"Where there's smoke," Jimmy James intones, *"there's fire!"*

From the back of the tent a siren wails. All eyes turn toward the screaming uproar as a bright red fire cart with sunburst wheels speeds onto the hippodrome track. Pulling the handle in front, riding the ladder in back, even running desperately behind the cart are those well-dressed, well-trained public servants of the pyromaniacal: the Clown Town Volunteer Fire Department. At the sight of this band of Keystone Firemen, the children in the seats start clapping their hands. The band perks up with the sprightly "There'll Be a Hot Time in the Old Town Tonight." Speeding the long way around the track, the clowns arrive in the center ring just as the smoke reaches the top of the tent and an old-lady clown sticks her head out of the roof. The firemen come to a sudden stop, the driver does a somersault over the handle of the cart, while the rider in the rear flops off the ladder and lands facedown in the grass. The

drummer crashes his cymbals. The old lady spreads her arms in dismay. Putting out this fire will not be easy, for despite all those pairs of oversized shoes none of the clowns can stay on his feet. Still they rise and approach the house.

Though most of the performers on our show would rather burn to death than admit it, the clowns were probably, as a group, the hardest-working members of the show. A few of the other performers were in half a dozen or more acts. The animal people had round-the-clock responsibilities. But once the middle of every afternoon rolled around, the clowns were required to be in makeup, be in position, and be ready to go on at a moment's notice in case of emergency in the ring. This meant they had little time off every day between 2 and 10 P.M., little time out of greasepaint every week for nine months, and little time to be anywhere during the entire year other than their private canvas dungeon known affectionately as Clown Alley.

Clown Alley is an anthropologist's dream. Part tribal ring, part locker room, part fraternity, part day-care center, it was a tent the size of a generous closet that held nine steamer trunks, eight wobbly chairs, twenty-seven juggling clubs, seventeen pairs of clown shoes, hundreds of half-empty containers of makeup, and one recyclable piss jug—an empty baby-powder carton that was loudly and publicly filled every day with the exaggerated hand gestures and juvenile penile thrustings of nine grown-up teenagers turned childlike clowns. In the past, clowns were mostly drawn from the ranks of aging performers who could no longer do their acts or homosexual men who were running from convention and needed a mask behind which to hide. These days, gay men apparently no longer need clowning, and as for older performers, with the long hours, low pay (starting at $180 a week), and lack of respect from the other show members, most would rather tote their children's rigging or stay home and work at Wal-Mart. That leaves clowning to kids.

When I arrived on the show, the one unifying feature of all the clowns in the Alley was that they were young, ranging in age from nineteen to twenty-four. (Buck, although a clown, stayed mostly in his van and was not considered part of the Alley.) All had graduated from high school and most had wandered from one part-time job to another, from a few

months in school to living at home, before finally ending up in Ringling Brothers Clown College. For them, clowning was a hobby, not an art. And when they didn't receive an offer to join Ringling and came instead to Beatty–Cole, the circus was an adventure, not a career. Their stories, ranging from the bizarre to the macabre, would have made Margaret Mead ecstatic.

There was Joe, the oddest and funniest of the bunch, who wore flip-flops on his feet and a ponytail on his head, who ate his vegetarian meals with chopsticks, drank his generic sodas out of a plastic martini glass, and hoped to translate his wacky character, Arpeggio, into a Las Vegas nightclub act. There was Marty, a.k.a. the Village Idiot, who had the most energy, the loudest mouth, and the largest number of radio-station and iron-man bumper stickers on his costume trunk (the most prominent: YOU GOTTA BE TOUGH IF YOU'RE GOING TO BE STUPID) and who hoped to save enough extra money doing cherry pie to join the cast of *Up with People*. Finally there was Jerry, alias Ace, a four-foot-seven-inch dwarf whose father had been on the Ringling show and who in the midst of all the oddities, anxieties, and kinky obsessions of his mainstream dropout colleagues was the cleanest, preppiest, and probably the most likely to be able to find and keep a real "townie" job. In a world where close shaving is a job requirement, Arpeggio usually had shaving soap in his ears and a missed tuft or two on his throat; Marty, the Village Idiot, often just plain forgot; but it was Jerry who always had an electric razor and who earned the indelible nickname the Neck Shaving Dwarf by personally taking the responsibility of making sure everyone in the Alley went to work each week with no unsightly stubble on the back of his neck.

Not surprisingly, when I plopped down uninvited in the middle of this group I was the one who was considered odd. Not only had I not been to Clown College (Buck and Jerry hadn't either), but I had been to regular college, and to graduate school as well. Also, I was a little older, I hung out with the performers (most of the clowns were kept away), and I didn't pepper every other comment with "Fuck you," "Suck me," or "How about a dick in the ass?" As a result, most of the clowns wanted me out. To prove it, they went out of their way to make me feel like an outcast.

First it was my ideas. In the first days of the season we had a series of rehearsals to design the gags. In the beginning I decided that in these rehearsals, as in most situations around the lot, I would keep quiet as a way of fitting in. After lying low for a while, however, I decided that my silence seemed awkward and that I should wade into these brainstorming sessions. How about having the clowns do such and such? I shyly suggested. Never tried. How about having a clown do so and so? Ignored. In one session Marty and Rob, the two Young Turks, were practicing different versions of sliding down a ladder. When they asked for comments I stepped off the ring curb and said, "I hate to say this but it does look better if you do it closer to the house." The response was an appalled silence. "Fuck you," Marty blurted. "Go away."

I slunk back to being silent.

Next it was my makeup. During intermission on opening day, while the clowns were in the center ring signing autographs, Jerry came over and tapped me on the shoulder. I excused myself from the child I was greeting and stepped to the edge of the ring. It must be important, I thought, or he wouldn't be interrupting our time with the audience. "Don't you know *any*thing?" he said when we were just out of earshot. "Whiteface clowns are supposed to wear gloves. Also, your makeup is uneven on the back of your neck. You're a disgrace to the Alley."

The final insult came when their hazings entered the ring. As clowns we had various responsibilities in the show. We had to pull various carts in spec, do the firehouse gag in the first half, the stomach-pump gag in the second act, and appear in the finale along with the entire cast when Sean got fired out of the cannon. Also, in the first half we had to do what was known as a walk-around, in which the clowns walk around the track performing short gags for several sections while the prop crew readies the next act. In Wilmington, North Carolina, these walk-arounds spawned a change in my attitude. All day the boys had been abnormally quiet, almost conspiratorially so. Then the whispers started. Rob went to Marty, then to Jerry. Jerry went to Brian, who then went back to Marty. A plan was being hatched.

The show started as usual. The early gags went as planned, but I sucked up some baby powder during the firehouse gag and went back to

my trailer to get something to drink. Minutes before the walk-around I returned to the Alley to pick up my prop. It wasn't there. I went to the side of the tent where the performers wait to enter. It wasn't there either. By that time the walk-around had begun. Nellie Ivanov was just return-ing from her cradle act. She looked at me sympathetically. I felt a tinge of guilt. Earlier she had told me that no matter how many acts she had or how injured she felt she never missed a performance. Here I was missing something as simple as a walk-around.

I headed back to the Alley. As soon as the whistle blew Marty ap-peared from the tent and raised his hands as if to say, "Where were you?" This struck me as a little odd. During a walk-around there is usually no time to see what the other clowns are doing, much less whether they are even there. Back in the Alley the hounding started. Brian asked me where I left the prop. Marty asked me when I last saw it. Jerry thrust his finger in my face and said I would have to pay him twenty dollars if it didn't turn up. "It will turn up," I assured them. Finally, after what seemed like an eternity, Marty said they had found my gag inside the tent and had hid it to teach me a lesson. I wasn't exactly sure what the lesson was, since many props were left in the tent. But the lesson, I sus-pected, had less to do with the prop and more to do with letting me know who was in charge.

"The Alley has a certain way of doing things," Marty said. "If you don't do what you're supposed to do, if you let us down, you're going to be made aware of it. We have to be able to count on one another. We have to work together."

It was after I received this little speech that I knew the only way to be accepted into this group was to start speaking up for myself. All pan-tomime aside, it was time to become a talking clown.

●

Once the firemen are in the ring the clowns set about trying to put out the blaze. Inside the firehouse, I rapidly strip off my old-man pajama top, slip on black trousers, a red jacket, and a metal fire hat and run out to join the chaos. The first stunt involves a hose. Once in the open I re-trieve a coiled-up section of hose from Buck, spin it in the air like a lasso,

and toss it toward Arpeggio, who takes the end that slaps him in the face and tries to hook it up to a five-foot-high fire hydrant. Just as he approaches the giant hydrant, however, it moves. Arpeggio takes two steps to the left; the fire hydrant takes two steps to the right. Finally, as an exasperated Arpeggio storms toward the fixture, the hydrant spits out a stream of water, rises up on the shoulders of the dwarf inside, and sprints out of the ring. At this point the clowns have had two run-ins so far—one with the cart, one with the hydrant—and the inanimate objects have won both. The audience could not be more pleased.

"People have a negative image of clowns these days," Elmo said to me at the beginning of the year. A fifteen-year veteran of the circus, Elmo, a short blond idiot savant of a clown, designed the gags, built the props, then left the performing to us as he traveled one week ahead of the show doing advance publicity. Like the other clowns on the show, he was temperamental and moody; unlike the others, however, he had a clear philosophy of clowning. "Krusty the Klown on *The Simpsons*, Homey the Clown on *In Living Color*, even Stephen King's *It* are all maniacal and just plain odd. They never do anything funny. If we can do something funny, then we are doing our jobs. Remember, most people come to the circus to see clowns and elephants. If that's the case, the elephants better be big and the clowns better be funny."

For clowns, being funny means being silly. The firehouse gag is one of a dozen or so traditional gags that have been around the American circus since early in the twentieth century. (The most famous clown routine of all, the overstuffed clown car, was actually first performed on the Cole Bros. Circus with a specially constructed Studebaker in the 1950s.) The key to the firehouse gag, Elmo explained, is the incompetence of the clowns, who can't even perform simple tasks that every child in the audience can do. If the clowns can't ride in their cart, if they can't even hook up a hose, woe is the woman who stands on the house screaming for the clowns to save her baby.

With the fire hydrant out of the ring and the hose lying on the ground, the clowns decide to use it for some fun. Marty and Rob grab the ends of the hose and the three of us watching from the side come skipping to the center and perform an elaborate jump rope—one, two,

three, four—until we get tripped up in midair and go tumbling to the ground like living dominoes. Left holding the rope, the two clowns on the end then go racing in opposite directions until the hose between them recoils like a rubber band and flings them to the ground. With each fall the audience laughs louder. The act is building to its blowoff.

"The firehouse is a slapstick gag," Elmo explained. "A 'slapstick' is something you hit someone on the rear with and it makes a loud noise. During the Renaissance, the commedia dell'arte troupes used a pig bladder on a stick to make that sound. Today slapstick is just another form of that—a kick in the behind, a slap to the face, a bucket over the head."

Indeed, once the clowns pick themselves off the ground and start to assault the house the gag moves inexorably toward the one action that always got a laugh: the bucket of water on the head of a clown. Before that, however, most of the clowns end up on the ground at least several more times. Four of us run toward the house and get knocked off our feet by an opening door. One person tries to climb the ladder only to be punched by the lady. And in the most dramatic incident of the act, Arpeggio enters the ring waving a four-foot ax, trips, swings around, and accidentally decapitates a seemingly helpful fireman. After a moment the audience realizes the head is fake and the fireman is only a dummy on top of the dwarf. Still the horror thrills.

"It's violence," Elmo explained. "Violence is funny to people if it happens to somebody else. They are not laughing with you, they are laughing *at* you. Let's say you hate your boss or your teacher, and we have a gag where an authority figure is picked on. People love it. The audience lives vicariously through you. They can step out of their own parameters of good behavior. Why do you think Road Runner is so popular? Or Tom and Jerry? It's because we like to watch other people getting hit. Clowns are like that. We are living cartoons."

It was this transition from person to cartoon that was the most interesting and challenging for me. As a teenage actor, I was taught to be realistic; as a mime, I tried to be reflective; but as a clown, I had to learn to be exaggerated, in a sense unreal, beyond gender, beyond human, beyond constraint. Running around the ring in the firehouse gag day after day, week after week, I slowly began to make this transition, but to do it

properly I had to get beyond the confines of my own body. The shoes helped in this matter; they were caricaturish and surreal. The costume helped; it was wider and taller than what any conventional person would wear. But the key to feeling less like a human and more like a clown, indeed the key to looking less like a person and more like a cartoon, was the same. In the end, it all came down to the face.

•

"Take a dab of white with your fingers. More than that, cover the tip until it's dripping off. Good. Now take another finger. And a third."

It was a little over two weeks before the season would begin when Elmo came to my apartment in Washington, D.C., to help me design my face. Dressed in blue jeans and a white T-shirt, I sat before a mirror on the ottoman in my living room. Elmo lent me a woman's knee-high stocking to pull over my head and hold my hair in place.

"So there it is," I said when my hair had disappeared. "My face unadorned. How would you describe it?"

"It's a plain face," he said. "Not many lines. No outstanding features. You would make a great spy."

I began to apply the clown white, a mix of petroleum jelly, titanium oxide, zinc oxide, and paraffin, which Elmo brought for the day. "Put a dab on your left cheek, then your right," he said. He was dressed preppy in a white button-down shirt with his natural blond hair pulled back in a ponytail. He looked like a cross between a high school biology teacher and a surfer. "Then move to your forehead, your chin, your nose. Don't be afraid to put it on thick." The makeup felt milky and cold against my skin, sort of like a dab of Crisco shortening, or worse, curdled milk. I resisted rubbing it into my pores. "Rub it around quickly," he said. "Don't waste any time. There will come a time when you're late for a show and you don't want to be too slow. My makeup takes me thirty-five minutes and I hate it. We're going to design you a twenty-minute face."

After a while the clown white covered my skin. It made me feel excitedly messy, like spreading finger paint where it didn't belong, but also slightly constrained, like dunking my head in a vat of Vaseline. Unlike my oval mime face a generation earlier, this face had the white right up

to my hairline and underneath my chin. "In the show you'll have to do your ears, your neck, the insides of your nostrils as well."

"What about my eyelashes?" I said as I started to work the white into the crevices beneath my eyes.

"You'll find out," he said, and indeed I already had.

"Once it's evenly smeared, take your open hand, the whole hand, and begin to pat out the rough spots. That way you'll eliminate the streaks. It's like putting your hand on a soft pat of butter and pulling up a thousand stalagmites. Later, those stalagmites will grab the baby powder and keep your face dry."

As I proceeded to smear white around my face, Elmo began sketching some of the history of clowning that I would have to know. The first known instance of using humans as comic diversion, he said, was in the Dilemma festival of ancient Crete, in which slaves were offered freedom if they jumped over charging bulls (thus giving rise to the term "on the horns of a dilemma"). Later the ancient Greeks needed performers to get people in the mood for their outdoor festivals. They came up with the *phalla phoria*, men who strapped on giant phalluses and red noses and acted as if they were drunk. *Phalla phoria* were captured and turned into one of a dozen or so stock characters, characters that reappeared centuries later in the commedia dell'arte of the Renaissance. These traveling theatrical troupes, with the comic Harlequina, the young couple in love, and the villainous rival, soon spread throughout Europe. In France, they liked the characters but not the language and moved in the direction of pantomime. In England, they liked the characters but not the scripts and created their own story lines with enduring personalities such as Punch and Judy or Jumping Jack, the modern day Jack-in-the-Box.

The first person to link these characters with the circus, Elmo continued, was Joe Grimaldi, who in the 1760s put on a grotesque costume, chalked up his face, and performed in the English riding shows. It was this mix of styles that John Bill Ricketts copied in the first American circus and that continues to define the circus today: highly skilled performances by acrobats and animals juxtaposed with the humorous and bumbling antics of the clowns. The word "clown" itself, which derives from the Danish word *klunis*, or "clump of earth," suggests this tension.

Clowns were clods. They were the rustics or boobs, the ones who were laughed at when they came into the city or suddenly found themselves in the middle of the ring following an outstanding display of equestrian skill. They also stole the show. In addition to performing their standard routines the clowns often joked with the ringmaster or director. The ringmaster would be prim and formal in his red tie and tails, while the clown would be the foil in his mischievous costume and devilish white face. A century and a half later, it was this traditional type of whiteface style that I was trying to develop.

With the white now covering my face I looked like a piece of un-formed clay. I began to move my muscles into various expressions: happy, sad, surprised, goofy. As I did, Elmo looked at the grooves above my eyebrows, searching for their range of movement. After a moment he sprang up from the couch, picked up a Q-tip from the table, and put a dot on my forehead half an inch above my right eyebrow. "You see that dot?" he said. "That's the point at which your eyebrow moves the high-est. That will be the peak of your clown eyebrow." A good clown face, he explained, is divided into separate regions: eyes, nose, mouth. My eye-brows would begin at that point, then slowly cascade downward, echo-ing the curve of my eye and focusing attention ever so subtly on my nose and mouth.

We began to look at my cheeks. They were basically flat, though when I smiled a distinctive mound appeared at the height of my cheek-bones. Elmo put a dot just above that mound, then drew a line with a slight curve that ended at the base of my chin. He asked me to repeat it on the other side. I did, a bit wobbly, and he sat back to look. Again I logged through a range of faces. "Too narrow," he declared. "Pat it out and start over." I patted out the lines and drew two more that arched more strongly on their way to my chin like a pair of inverted bass clefs.

"Better," he said. "Now bring the tops in like the lines of a heart."

"I get it. That way they'll point to my nose."

"The nose is going to be the highlight of your face."

I was starting to get warm. I could feel my skin itching underneath the makeup. I had developed a headache. Suddenly my whole body, my hands, my neck, even parts of my legs, seemed to be covered in white.

Clowns, I realized, quickly become aware of the margins: white under the fingernails, white in the nostrils, white behind the ears and inside the lips. Clowning may literally be a white-collar job, but with all the grease in the nostrils it has a distinctly blue-collar smell. Moreover, just as a pizza lingers on the tongue for hours after it's eaten, so a clown face lingers in the nose, the mouth, and especially the ears for days, even weeks on end. For months after I left the circus I could still feel the makeup lines on my face and feel my character living literally just beneath my skin.

Back in the mirror, we moved to my mouth. With my right pinkie I made a fingerprint on the left hinge of my mouth; with my left pinkie I repeated the step on the right. Then I cleaned the white off my bottom lip.

"Why only the bottom lip?" I asked.

"It preserves the distance between the nose and the mouth," Elmo said. "Sometime when you're driving, watch for a picture of Ronald Mc-Donald. It looks like someone threw a tomato at his face, there's just this big red blob. Remember, simplicity is best. You can always tell a circus clown from a birthday-party clown. Party clowns have those big banana mouths with little hearts and flowers all over their face. It gets too cluttered. It doesn't read."

When he talked about the purpose of a face, Elmo kept using words like "read," as in "How will the face *read* from the back of the tent?"; "catch," as in "How will that feature *catch* the attention of a child?"; and "sell," as in "How will you *sell* an emotion during a gag?" A good clown face, he explained, has the ability to expand and contract, like Charlie Chaplin spreading his legs when he gets kicked from behind. Indeed, when we stopped to review the progress of my face it appeared to be quite flexible. The cheeks moved well. The negative space between my eyes and my eyebrows truly seemed to dance. But something was missing. We had two dominant elements that would be black—rounded eyebrows and curved cheeks—but nothing striking to bring the face together. I tried a star on my chin. "Too much like a party clown." I tried an exclamation point between my eyebrows. "Too busy." Finally I tried a triangle on my chin. Suddenly the face seemed to vibrate, to move the eye around more quickly, as if jolted by a bolt of electricity. The triangle,

so unassuming, provided two elements: contrast to the loopy curves and opposition to the tapering lines. The triangle stayed. We were ready for color. Elmo went back to his story.

While talking, whiteface clowns thrived in the one-ring circuses of the early nineteenth century; when the circus expanded to three rings, they could no longer be heard in all seats of the tent. A new type of clown—more physical, less talky—was needed. It was about that time that American Tom Belig, who was performing a riding routine in Germany, changed clowning forever. According to lore, one day when Belig was late for his act he threw on a baggy costume and wig, rubbed brick dust on his cheeks and soot over his eyes, and went out to do his routine. He was so frazzled he kept falling off the horse and jumping back on. The crowd roared with laughter, calling out the name of the popular comic-book character Der Dumme Auguste, Dumb Gus. This new persona quickly spread and eventually came to dominate clowning in America (nine of the clowns in our Alley were this type—with redder makeup and brightly colored wigs—while only two were whiteface). Forever after, whitefaces would endure as the new straight men, the foils, but their look would have to be sophisticated compared to their more frivolous and bumpkin cousins, the country-comes-to-town "Auguste."

After bathing my face in baby powder that was stored in a girl's ankle sock and brushing off the excess with a badger-hair shaving brush, Elmo began to paint the black lines and red nose. Even without looking I could feel the lines changing the dimensions of my face. Unlike the white, which was sloppy and greasy, the black was sharp and crisp, sealing the pores on my face like a fixed expression under wax. The red was equally vibrant and sure, an exclamation point on my lips and nose in contrast to the black clefs on my cheeks.

"So why is the mouth always red?" I asked.

"Tradition," he said. "Also, you don't have to touch it up as often."

"Is that a problem?"

"Well, try not to eat fried chicken." I laughed. First it was Ronald McDonald, now Colonel Sanders. Was any American icon safe from the wrath of circus clowns? "No, I'm serious," he said. "We used to have a guy on the Ringling show who loved Kentucky Fried Chicken. He called

it K Fry. But you can't have chicken between shows. Eat your chicken for lunch."

"What else can't I eat?" I asked.

"Spaghetti sauce, pizza. Anything with grease that will cut the makeup. Also anything eaten with a fork. You can always tell a clown by the way he slides food off a fork without letting the food or the fork touch his lips. Even when the makeup is off. It's changed the way I eat forever."

After he finished painting the color on my face we marched to the bathroom for the final powdering. When I looked at myself in the mirror I was amazed by what I saw. My plain white face had been transformed. Now my cheeks were cradled in snappy black curves. My eyes were lifted with beaming brows. My mouth was as plump as a lobster claw. All together the simple strokes were like lines from a limerick that leapt happily off a blank white page. My immediate reaction was to tilt my head, lift my eyebrows, and stretch my lips into a smile.

"Oh my God," I said. "I look like a clown."

Elmo smiled. "But you're not a clown. You're just a person in makeup. I'm afraid there's a big difference. Only a child can decide who is a clown. The key is persona. A persona is what distinguishes a person in makeup from a clown."

Thus chastened, I closed my eyes and held my breath as Elmo blasted my new face with his powder sock. Even before I could work on my persona, the first step to being a clown, I realized, would be getting used to this onslaught of powder. The second step would be getting used to the onset of mud.

•

As the end of the gag approaches, the clowns gather themselves together and move one last time to save the lady, who at this point is standing on top of the house wailing and flailing her arms and screaming for the firemen to save her baby. "Don't worry!" Arpeggio calls. "We're trained professionals." "I hope you have insurance," Rob adds. The audience cannot hear these lines, they are just for our own amusement. "Hurry up," Henry says, "I have to fart."

"Firemen, firemen, save my baaaaby . . . ," Jimmy cries over the microphone.

Our first task is to save the baby. Christopher, who is playing the old lady, holds the blond baby doll above his head and tosses her in one giant arching motion toward the top of the tent. As the audience gasps, the baby comes somersaulting toward the firemen's net, where the clowns bounce it with a grunt and send it back into the air. Sometimes Henry would catch the baby at this point, at other times it would land on the ground. When this tragedy happened I would run to the side of the baby and give it one last chance at life with a desperate rendition of clown CPR.

All eyes turn back toward the lady. She powders her cheeks, looks down at her house, and bends over in preparation for a final dive to safety. When she is just about to make her leap for life, a bright red fireball of nearly nuclear dimensions comes blasting up from inside the house and nearly consumes her exaggerated rear end. The audience shrieks in delight. Now greatly alarmed, the lady bends over one more time as another burst of flames, this time even brighter, fills the ring with terror and the clowns with fright. The audience cheers again.

"It's the danger," Elmo explained. "Look at some of those old Charlie Chaplin movies. He's walking on a high wire with a monkey on his shoulders that has its hands over his eyes and there's a banana peel thrown on the wire. People love to watch others challenge death. The fire emphasizes that."

In truth, the fire itself was hardly dangerous. It came from a substance called lycopodium, a dried Mexican fern processed in New Jersey that American midwives used to put on umbilical cords to dry them after birth. In the container lycopodium is not flammable, but when it is blown into the air and comes into contact with a flame (in our case a lighter) it makes a dramatic fireball that looks real but doesn't burn. Magicians discovered it, Elmo said, and it was used in *The Wizard of Oz.* In our gag it received the biggest laugh.

"People don't expect it," Elmo said. "Also, it hits the lady on the behind. The tushy is very funny, especially for little kids. Where do they get punished? Where do they get spanked? A behind is a sacred thing for

a kid. It's never shown to others. It's never touched. Therefore we want to make fun of it."

After two bursts of fire the lady is desperate. The audience is crying for her to jump. The clowns holding the net begin sprinting toward the house. The lady bends over one last time, when out of nowhere a deafening blast jars everyone in the tent, one last fireball spurts out of the roof, and the lady jumps for her life, hoping against hope to be caught in the net, but only to land miserably in the mud. Just as she lands, a clown appears from the house waving his hands in distress: his pants have caught on fire. This is the ultimate defeat. Not only could the clowns not put out the fire or catch the baby or save the lady but we also managed in our bungled confusion to set *ourselves* ablaze. Undaunted, we jump to our feet in unison and run out of the ring to the traditional romp "Happy Days Are Here Again."

4

Outsiders
Always Make Mistakes

Kris Kristo had a certain way he went about preparing to go out. First he pulled on his skintight white jeans, his white T-shirt with the pack of Marlboros in the sleeve, his satin tiger-skin vest. Next he slicked back his hair, lightly spritzing it with Brut and gently tugging a few strands over his dark brown eyes and the small seductive scar across his left eyebrow. Finally, on special nights like this, he applied another layer of black spray paint on his well-worn biker shoes, giving them a five-cent patent-leather shine. Once primped, he would slowly make his way down the trailer line collecting his posse for the evening prowl: first Sean, in a neon-pink shirt and cowboy boots; then Danny in purple silk top and black Ferragamos; finally me in orange Gap button-down and shiny penny loafers. On the surface I looked as if I didn't belong with this group, yet I had two things that Kris Kristo usually needed for a night out. First, transportation; and second, prophylaxis.

"Hey, Bruce," Kris said when he arrived at my RV, "mind if I borrow a condom?"

•

My first week on the show I was overcome by the grind. With no day off and no break from the routine, all I could talk about was how tired I was, how much work there was, how hard this life was to lead. I got sick.

I didn't know when to sleep. I lost several pounds. My life was turned upside down. By the second week, when we moved from central Florida to the seaboard coast of Georgia, I noticed that when people asked how I was doing I no longer spoke only about the grind. I developed a routine. I ate breakfast in midmorning, my milk no longer frozen. I ate lunch in early afternoon, with my makeup to follow. I ate dinner after the 7:30 show. By the third week, when we jumped to North Carolina to play the Azalea Festival in Wilmington and Camp Lejeune around payday, I began to look forward to performing. I no longer missed my *New York Times* or *MacNeil/Lehrer*. I felt naked without my makeup. In short, I began to feel at home.

The real reason was my neighbors. Any fears I had about not being accepted because I was a writer were quickly quelled. First, instead of trying to conceal their true identities, many people on the show flocked to my trailer in those opening weeks anxious to confess their deepest vices and gravest misdeeds (not to mention a few federal crimes). Their motivation, it turns out, was simple: they were worried that someone else would tell me first. In the span of several weeks, from mid-March to early April, I had intimate, almost confessional conversations with nearly every performer on the show and had already begun to develop a sense of the multilayered and sometimes dark personal fabric that ties members of the circus world so closely to one another.

Second, instead of viewing me as an intruder, the people on the show reached out to embrace me once they realized I was prepared to do the show alongside them every day. Nellie and Kristo Ivanov, Bulgarian aerialists and parents of nineteen-year-old Kris and his younger brother, Georgi, lent me aspirin, fed me soup, and laughed along with me as I stumbled, eyes agog, from one shocking circus discovery to another. Pablo Rodríguez, fifth-generation acrobat and retired father of Danny and all his seven siblings and half siblings, put his arm around me every afternoon and told me how much I was worth that day: sometimes I was merely a twenty-five-cent clown, other days a million bucks. Dawnita Bale, Elvin's twin and owner of the show's largest collection of wigs, shared her daily complaints about the weather, the drive, or the general agony of deciding what shoes to wear in the ring.

The closer I got to the people around me, the more I discovered the unspoken social order that dominated their lives. In the 1950s, Dawnita told me, married performers were kept away from single performers, single men were kept away from single women ("accidental meetings at the picture shows were not tolerated"), and all performers had to sign back in by 11 P.M. Performers were not allowed to socialize with "roustabouts" (the former name for workers), and roustabouts were not allowed even to speak to performers unless they were spoken to first. On our show, the rules were less rigid, but still firm. Performers were advised to be friendly with the workingmen, but not to become friends with them. Animal people tended to socialize with animal people; performers with performers; clowns with clowns. Particularly crimped by these rules were the single male performers. Since there were few single women in the circus (and none in their late teens or twenties), since most of these guys easily tired of watching borrowed videos with their parents, and since all they seemed to want to do anyway was get out, get drunk, and get laid, the single men in the show banded together most evenings in one common pursuit: chasing townie girls. It was on one of these nights in Camp Lejeune that I ended up in an unlikely clash of wills with the Human Cannonball on the grounds of the Marine Corps base.

As it happened, I didn't want to drive my RV that night. The ground was muddy and I didn't want to get stuck. The day had already been unlucky. Earlier, two hundred Marines had come to the lot to challenge two elephants to a tug-of-war in a mammoth publicity stunt and battle of the sexes (though referred to as bulls, all the elephants on the show were female). At the start of the face-off the two hundred Marines lay flat on the ground on either side of the rope just inches from Pete and Helen, the pride of Fred Logan's herd. As soon as one of the clowns ordered the bout to begin, the leathernecks popped to their feet and started grunting, straining, and pulling the rope with admirable esprit de corps. Within seconds, just when the GIs seemed to be gaining the advantage, the rope suddenly split in the middle of the Marines and ricocheted up the line, sending the entire company to the ground, singeing the hands of nearly two dozen men, and burning off large chunks of the neck and face of eight unfortunate USMC warriors, who had to be sent to the emergency

room. For their part, Pete and Helen hardly flinched but forwarded their regards.

Instead of driving in my RV, we took a cab to a place called Club 108, an unassuming cinder-block building on the outskirts of town just past the longest strip of machismo—auto-parts shops, gun dealerships, dirty-magazine outlets—that I had ever seen. It was four dollars for members, six dollars for nonmembers. Kris tried to talk our way in by offering free circus tickets, but they refused. "Show us your IDs and give us your six bucks," the manager barked. As we did, one of the bouncers, a man with steroid-inflated arms, tight blue jeans, and suspenders (no shirt), pushed through the line. "Get the fuck out of the way," he said. "I've got a knife." Two particularly burly guests were herded out of the bar, followed by a third with blood spewing from his nose, which in the course of the evening had been thoughtfully relocated alongside his ear.

Inside it looked as if we had suddenly been transferred from eastern North Carolina to downtown Tokyo. There was a three-tiered sound system climbing the wall like aluminum ivy, covered with multicolored lights, a fog machine, and rotating sirens. A towering scaffolding structure, a sort of jungle gym for grown-up GI Joes, stretched from one end of the playpen to the other, from the ceiling to the smoky sky. Inside, outside, and all around this metallurgic monstrosity stood four hundred freshly shaven, freshly paid Marine neophytes and no more than fourteen scantily clad young ladies. The whole scene looked like a beer advertisement gone berserk. We walked in, bought drinks, and surveyed the scene. Sean and Kris sat down and started moping because there were not enough girls. I got up and started dancing by myself; soon Danny followed. In this menagerie no one seemed to notice that the circus was in town.

•

Even though I wasn't able to put it to much use myself, in the annals of pickup lines there can't be many opening remarks that receive a better response than "So, did you see me in the circus tonight?" Kris Kristo, a master of lines himself, also had devised one of the best closing lines that I had ever heard: "So, would you like me to give you a tour of the ani-

mals?" Elephants, it seems, make a great aphrodisiac. Tigers are even better.

As I had observed from my first days on the show, there is a curious, almost palpable sexual energy surrounding the circus. The costumes, the music, the drumrolls are all part of a gradual seduction that performers play out on the audience, trying to satisfy every dream, daring to titillate at every turn. In Henry Miller's Paris, circus performers lived and performed in the red-light district, among the vaudevillians, strippers, and prostitutes. In some ways the association is fitting. The ringmaster, king of the cathouse so to speak, leads the customers through the show—building tension, enhancing the excitement, and finally releasing the performer for his or her climactic trick. The word "trick" itself, from the French "to deceive," is applied equally to streetwalkers and wirewalkers, harlots and harlequins. At the end of the night the customers float out of the house with their dreams fulfilled—their fantasies realized—and return to their daily lives.

For many of the performers and audience members alike the show is just a tease—and artificial exposition removed from reality. But for others the tease is irresistible. Many of the young men who grow up in the circus are particularly seduced by their magical power. "Circus people are performers," Jimmy James said to me. "They know people are looking at their bodies. They know people are fantasizing about them. When they get out of the ring they are no different. They tend to enjoy themselves." Kris Kristo, who was one of the first performers to befriend me and welcome me into his family, was a well-traveled, well-toned, well-endowed performer equally at home in the ring and on the dance floor. Born in Bulgaria, raised in Western Europe, and now coming of age in America, he had established a peerless seduction routine. In the show he would use his muscleman juggling routine or his motorcycle-on-the-high-wire act to pique the fantasies of women in the audience; then afterward he would use his innocent-waif-wronged-by-an-ex-girlfriend story or his Italian-wine-connoisseur-Romeo pose to win over their hearts. The outcome was a different girl almost every night and a lot of borrowed condoms.

As a result of playing this game daily from Milan to Montana ever since

he was a boy, Kris was one of the most charming, easy-to-get-along-with people I had ever met. Also, because he knew he would leave town every couple of days, he was one of the most reluctant to get attached. He and Danny had even devised a set of standards for girls. *Springwater* was the highest grade, meaning a girl was beautiful, a ten, "fuckable without a drink." That was followed by a *wine cooler*, which meant cute, nice-looking, one needed only a wine cooler to get in the mood; *Mad Dog 20/20*, meaning you needed to be drunk; and finally a *bottle of tequila*, meaning you needed to be dead to the world. They had also devised a set of rules for themselves that early on they conveyed to me: never fight over a girl, never pay for a drink, and never, ever, fall in love.

To be sure, it takes two to turn a trick, and most of the women who broke through the fantasy and dated circus hunks understood that their affairs would be short-lived. There was the married mother of two in Goldsboro, North Carolina, who had had a one-night rendezvous with Kris every year for three years running, and the year I was there showed up with the breast implants Kris had recommended even though her husband despised them. There was the stripper from Mobile who said she never dated clients, but in his case made an exception. At times, of course, a woman got caught up in the illusion. In Virginia a woman Kris had met during intermission and taken back to his trailer after the show showed up the following night with a suitcase under her arm. "What are you doing here?" he asked. "I'm coming on the road with you," she said. "No, you're not," he answered. "Go away." Kris had special names for these women: he called them "psycho bitches from hell."

On rare occasions everyone's fantasies got out of hand. In Princeton, New Jersey, Sean and Kris were in a Red Lobster one night after the show. Sean was coming out of the men's room after dinner when a woman at a nearby table did a dramatic double take. She had been to see the show earlier, she told him, and had been hoping to meet him. With this kind of introduction, he asked her if she would like to go back to the lot and make love in the cannon. She agreed, saying it had always been her fantasy to have sex with circus men. Back in Sean's trailer (the cannon unfortunately was wet and Sean nearly broke his neck trying to take off the cover), Sean went first and Kris followed. Kris asked her if she

wanted others; she said sure. Before long there were six guys in all, including a fourteen-year-old boy invited for his first time. The performers took turns. One person took a video. Sean toyed with his hairbrush. But just as the evening approached its peak the woman abruptly announced that she was a devil worshipper. As soon as she said this, Kris noticed an upside-down cross on the back of her neck. Suddenly everyone got scared. The boys bolted from the truck as quickly as possible. The following day, after one of them nervously told of the incident, all the participants were summoned to the manager's trailer, where he reprimanded them for their indiscretion and promptly erased the tape (though not before viewing it first).

"Why didn't you just throw the tape away?" I asked Sean.

"Because it was perfectly good," he said. "You could use it again."

•

When Sean arrived for his first season the previous year, he had fit instantly into this carousing crew. He and Kris became partners in conquest. The two of them looked quite different—Sean had blond hair and freckled Irish-American poster-boy looks, while Kris had a dark, brooding, misunderstood Italian Casanova aura to him—but in crucial ways they were similar, at least when I first met them. Both were moody, often depressed when out of the spotlight, but invariably cheery around women. Kris could bicker with his parents in Bulgarian and punch his little brother in the face, all the while politely escorting a young lady through the mud to his room with a touch of continental grace. In the light of day he was awkward, on a basketball court he was inept, but on a dance floor at three in the morning he was as smooth as a mug of Irish coffee with a kick most women didn't feel until the following day.

Sean, meanwhile, who was part cracker, part crooner (he looked strikingly like a blond version of Elvis), could throw me into the mud for fun, toss a stake at one of the workers, insult the rear end of his boss's sister, then turn around a moment later and name the perfume of a woman in the audience a hundred yards away. The first time I was in his trailer, after putting on the tape of his national television appearances, he showed me a list of every woman he had slept with. The list was several pages

long and had over two hundred entries on it, some as vague as "the black girl in the bar in Louisville" or "the twins on the beach whose legs hung over the back of my Jeep and scraped the finish off my door." In those awkward early days of the year, Sean called me Lucy because I didn't boast of such a list. I called him Mr. Sensitivity of the Circus. We couldn't have been more different. We should have avoided each other.

•

After nearly an hour when nothing much happened in Club 108, the disc jockey perched high in the scaffolding cage announced the start of the first round of the annual Eastern Carolina Hawaiian Tropic Bikini Contest. The Marines let out a resounding whoop. The circus contingent was nearly as thrilled and joined the tidal wave of testosterone that surged toward the narrow stage.

"Now we're talkin'!" Kris exclaimed. "We're gonna get FUBAR tonight."

"FUBAR?" I said.

"Fucked Up Beyond All Recognition." He and Danny exchanged high fives.

In their first parade in front of the troops the contestants came out in casual wear. Kris liked Number Two. She was dressed in a virtually see-through Budweiser hand towel barely stretched across her vital statistics. Sean liked Number Three. She was a nurse. She was into shopping, tanning, and hair care. "I like 'em just like that," he said. "I like 'em thin. I like 'em blond. Hell, I could eat her pussy now. I could eat it onstage." I laughed. He looked at me, insulted. "You don't believe me," he said. "Oh, no," I replied. "I do."

After taking applause from the audience the contestants marched off to change into their bikinis. The boys in our corner started comparing notes. I voted for Number Nine. She identified herself as a writer and editor for a local newspaper, which I took as sufficient evidence that at least she could read and write. Later, when she came out in her swimwear, Number Nine wore a yellow bikini that was short, pert, and considerably more subtle than those of her fellow combatants. Suddenly Sean shifted from the nurse to her. "I like her, man. She's about my height.

She's got some tight titties there. I could eat the spinach out of her shit."
It was the highest compliment he could pay.

After the winner was announced (ironically it was Number Three, whom Sean then claimed he had liked all along), we broke up and started circulating. I saw the now famous Number Nine standing with a friend in the other room and went up and asked her where she worked. She said she was an editor for a weekly paper in nearby La Grange and, now that I mentioned it, was coming to the circus in several weeks to do a story on some clown who was a writer. At last, I thought, here was my chance to test the marketing charms of the circus. But just as we started speaking Kris appeared magically at my side, put his arm around me, and introduced himself to her. There went my chances: the best marketing plan in the world was not enough to distract her from his muscles. Indeed, his approach didn't take long at all. It was so smooth as to be imperceptible. It was also a little bit greasy. He started flirting with Mademoiselle Neuf, poking fun at me, gently stroking her thigh. He didn't realize he might be encroaching. In truth, he didn't even care. Then he asked her to dance, and to make matters worse, asked her friend to dance with me. On the dance floor, the friend couldn't keep her eyes off Kris. "What does *he* do in the circus?" she drooled. "Why don't you ask him yourself," I said, excusing myself to use the rest room. Kris didn't have to fight over girls, I realized, they all but fought over him.

Sitting in a cab an hour later, everyone was upset. Kris was disappointed that Mademoiselle Neuf wouldn't go home with him that night. "Hell, she didn't even buy me a drink." Sean was disappointed that nobody was interested in him. "Bunch of jarheads in there tonight," he said to the driver. Danny was disappointed in himself. "There was no way to pick up a girl without getting drunk," he said, "and I didn't even want to." I was disappointed in my friends—maybe I'd never become part of this circle; maybe we were too different after all.

Approaching the base, I told the driver to go straight. "Don't listen to him," Sean said. "He thinks he knows everything. Just take a left." I encouraged the driver to continue on; Sean insisted he turn. Since Sean was closer, and louder, the driver agreed. "Now, how much do you want to bet?" Sean asked me.

"The fare is eight dollars," I said.

Fifteen minutes later, after twice losing our way, we finally located the tent. The fare had climbed to seventeen dollars. "How did that happen?" Sean said as he got out of the cab and walked away. "We got lost," I said, handing the driver twenty dollars. "Look at that," Sean called. "He's got a twenty. He must be a Jew."

"That's right," I said. "I've also got horns."

The three of them stopped to relieve themselves. I headed back to the tent. At this point I was fed up, partly at Kris for being so young and aggressive he didn't even realize he was violating his own rules, partly at Sean for being so loudmouthed and self-centered he managed to insult everyone he met. Earlier at the club he tried to make a pass at one of the bartenders. "So, Deb," he said to the woman whose nametag identified her as Debbie. "What time do you get off?" Seven A.M., she told him. "That doesn't leave much time for fun, now does it?" Guess not. "Well, honey, if you were my wife and you came home at seven o'clock in the morning, I would just be getting up and I would have one of those early-morning pop-the-tent kind of boners. You'd come home and be all tired and I'd just knock you up good. Then you'd just lay around the house all day, saying how tired you were but how good you felt." Is that right? she said. "Yep, bitch. That's right." Well, then, she said, I'm glad we're not married.

Back at the lot, the boys started shouting as soon as they saw me walking away. "Hey, where are you going?" Sean called. "Look, he's mad at us 'cause we insulted him. 'Cause we made him pay."

I walked around the tent and went back to my camper. Several minutes later there was a knock on my door.

"Hey, man, what's wrong?" The three of them climbed inside and sat down. "Why are you so mad?" Danny said. "Do you not want to go out with us next time?"

"Who are you mad at?" Kris asked. "Me?"

"He's fucking mad at me," Sean said. "'Cause I made fun of him. Man, what's wrong? We're all men here. We can take it, though maybe not you."

"I can take it," I said, more snidely than I had intended. "I just don't need to."

"Don't need to? Man, shit. This is the circus." He picked up the white plastic brush he had left in my camper and started brushing his hair. I was sitting on the bed. The show's generator had long been turned off, so we were without lights. "You want to be part of the circus, bitch, you got to take shit. That's all we do is give shit to each other."

They started telling stories. Remember the time we put a pile of shit on someone's door? Remember the time we came in and trashed your trailer? Remember the time we drove that girl's car down the stairs?

"So you see, that's the rules," Sean said when the recollections dribbled to a close. "I'm only teasing you because I like you. If you want to be friends with me, you got to learn to take shit. You're just a little too sheltered. You've never been around people like us. You were over there in Japan and England. We're real American men and we give each other a hard time."

Perhaps he was right, I thought. Perhaps Sean, the Human Cannonball, was just another self-proclaimed hero on the frontier of American ego—abrasive, self-centered, and supercilious from the shiny tips of his alligator boots to the glistening wings of his well-moussed hair. Earlier in the year Sean and I had a conversation about Elvin, about how he was thought to be a prima donna when he was on top—yelling at people, getting in fights, throwing a punch or two. After his accident, Elvin had become soft-spoken and kind. Now I realized how prescient Elvin had been. Sean was indeed Elvin, but ironically it was the old Elvin. He was young, brash, on top of the world. In the cab he had said to the driver, "Oh, you're from Philadelphia. I was on the front page of the Philadelphia *Inquirer*." In the club he had said to Number Nine, "I'm the Human Cannonball. Did you see me on TV? I was on four shows: NBC's *I Witness Video*, CBS's *Street Stories*, ABC's Peter Jennings, *Regis & Kathie Lee*." In a way he was the embodiment of fame, a sort of Frankenstein of the modern circus, a clone so perfect he fit too well. When I first met Elvin I asked him, "Can you do it? Can you take any regular Joe and turn him into the circus star of the decade?" Elvin thought for a second, then said, "I did." Not long after, I was talking to Sean. "So can you do it?" I asked. "Can a person come from the other side of the tracks and become the circus star of the decade?" He thought for a second, then said, "I did."

The boys got up to leave. "So next time we go out, are you going to go with us," Danny asked, "or are you going to say, 'I'll think about it'?"

"I think about everything," I said.

"If you're sitting in front of a girl and you get her legs spread open," Kris said, "and all you got to do is stick your dick in her pussy, man, do you think about that?"

The boys were so busy giving themselves high fives in congratulations for that retort that they didn't wait for a response. Finally, they looked at me, and I said, "Yes."

•

The rain started around midnight. I could hear it pattering on the top of my trailer. I had left Camp Lejeune around 7 P.M., following two sold-out shows on Sunday afternoon. The whole crew was in a hurry to get to Murrells Inlet, a small South Carolina tourist trap south of Myrtle Beach, and enjoy the one night a week we had off. Buck had already been there the day before to sell circus memorabilia at a local flea market and had scoped out the lot. He reported back that Inlet Square Mall had a movie theater on the same side as the circus. He wrote down all the movies and put one to four stars by the ones he had seen, then taped the list on the bulletin board by the back door of the tent, right beneath the sign that reminded everyone to turn their clocks ahead one hour for the beginning of daylight saving time.

The grassy lot was mostly dry when I arrived, though already showing signs of bogging down in some places. The cannon got stuck where the back door would be and an elephant had to come pull it out. It took the elephant only several seconds but cost Sean five bucks. Other drivers got stuck, too, but didn't want to part with their money. Harry Hammond, the legendarily frugal treasurer, got stuck as well but stayed put several days rather than pay the five-dollar toll. Chava, an aerialist, got stuck, but she didn't have to pay. She got her husband, Royce, the manager, to pull her out with a forklift. The Rodríguez Family truck got stuck. But all they needed was to gather the whole family, which numbered close to twenty with wives, cousins, and kids, and they could push it out themselves.

By the time I woke up around ten o'clock the next morning, the tent was already halfway up and the water two inches deep. "What a beauti-

ful day in the neighborhood," Willie, the electrician, said to me as I emerged from my camper and surveyed the wasteland, where the blithe expression "April showers" began to take on a new level of cruelty. "Wouldn't you just want to punch Mister Rogers if he said that today?" As the afternoon progressed and the rain continued, the circus lot began to transform itself into an elaborate constellation of rings that reminded me of Dante's Inferno. The three performance rings themselves were surprisingly dry, while the hippodrome track was muddy. The area under the seats was also dry, whereas the road around the tent was soupy. Under the trailers was dry, yet the outermost ring was the gloppiest of all.

"They say that Eskimos have a hundred words for snow," I said to Bonnie Bale as I slopped off toward Clown Alley that afternoon. "Do circus people have a hundred words for mud?"

"I have only one for it," she said.

"What's that?"

"I think you can guess."

By showtime the lot was covered with four inches of standing water that gathered in elephant tracks, tire tracks, even the tracks where previous walkers had left boot prints on the firm ground below. The tent looked unplayable, but a truckload of gravel was brought into the back door, several bags of cedar shavings were sprinkled around the ticket wagons, and a half dozen bales of hay were scattered around the track where guests would walk to their seats. Backstage, where the performers gathered, remained mired in mud. It was a grimy greenish-gray kind of mud that glurped when anyone stuck his foot in the ground and growled when he took it out. It smelled like a combination of fetid earth and stale horse urine, made only worse by the presence of elephant manure, which ironically stood out on account of its unnaturally yellow color and its uncanny ability to stay firm. You know you have arrived on muddy ground when elephant stool is the firmest substance around.

"Now, this is the real circus," the clowns crowed to me. "Are you sure you don't want to leave?"

The rain seemed to bring out the best and worst in everybody. The houses were packed and the shows went on with only a few minor glitches. The performers wore their special "mud show" costumes, cov-

ered themselves with worn-out bathrobes, and hurriedly sloshed from their trailers to the tent with knee-high boots over their performing tights. In some ways it was funny watching people who could otherwise dance on horseback or fly through the air tiptoe around the lot like a bunch of amateur tightrope walkers.

At the same time the rain made people crabby, and when performers get crabby they start to bitch—usually about one another. "Did you see how she cut her act today? Not very professional." "Did you see him wear mud boots in the ring? Nobody pays to see Wal-Mart waders." "Did you see how Sean got pulled in by the elephants? It sort of undermines the mystique of the world's largest cannon if it can't even drive through a couple of inches of mud." At moments like this, the circus community seemed to splinter along its natural fault lines as everyone became an expert on everyone else's job. In particular, longtime show people liked to criticize the "gauchos"—people born outside the circus who took a job within. On our show, this included Douglas Holwadel, who was running day-to-day operations during Johnny Pugh's convalescence, Kathleen (always a favorite, even after she stopped performing), Sean, and now me.

I heard a variety of reasons why gauchos should not be allowed on the show. First, gauchos don't know how to play a crowd, I was told. Moreover, they complain a lot. "They will not perform with a hangnail," Dawnita Bale told me, "while a circus person would perform with a broken hand. A gaucho almost closed the show several years ago after complaining to OSHA that the beds were too short." But the biggest fear of all is that a gaucho will commit a blunder and cost a performer his or her career. The rain and cold of South Carolina, coming so early in the season, only heightened this alarm. "You just watch," Dawnita told me at the end of that first day of mud as we waited to wade into the finale. "Something is bound to happen this week. Outsiders always make mistakes."

•

That something happened in Rock Hill. The occasion was Easter weekend.

The rain continued throughout the week as the show moved down

the South Carolina coast to Ladson before heading north again. Now three weeks into the season, I was struck by how each town took on its own narrative. Even though we might stay in one place for only two days, or three days, or even one day, a small story would develop in each location. In Waycross, Georgia, the story centered on a Chinese restaurant. On Sunday night sixty members of the circus crowded the eight-table restaurant for an all-you-can-eat buffet; the next day at lunch Kris Kristo returned with Danny and the two of them ate so much they got sick in the bathroom. In the morning everyone was talking about the previous night's dinner; in the afternoon everyone was talking about that day's lunch; that night we moved on to Hinesville.

The narrative was usually driven by one or more factors: the place we played, the people we met, or the weather we encountered. In Ladson, South Carolina, the show played an oyster-shell lot adjacent to a flea market, just up the road from a strip shopping mall. For three days, the workingmen went back and forth to the liquor store; the clowns went back and forth to the Laundromat; the Americans went back and forth to Burger King; and the Mexicans went back and forth to Taco Bell. As for people, Kris met a lingerie model named Angie during the first show who proceeded to drag him, Sean, and me on an elaborate three-day scavenger hunt/striptease that resulted in little but frustration and a crossed-off name in Kris's spiral-bound black book.

But the big story was weather, "weather" being the circus euphemism for bad weather. Rain is tolerable in this worldview; wind is not. We heard both were coming. Doug was worried about Rock Hill. The first time I met him he had told me that certain lots were dangerous and Rock Hill was one of them. Located behind a mall, it was a clay lot two hundred feet by six hundred feet: plenty of room, but long and thin, and "unable to take rain." All week long people were speculating. Kris was hoping we would have two extra days and he could continue chasing Angie. Angel Quiros, the wirewalker, wished for the ultimate fantasy—a day off. But by early evening on Good Friday, when we knew we were going to Rock Hill anyway, the talk had shifted from if the "weather" would come to when it would come, what it would be like, and how much it would affect the next lot. As it happened, a drizzle came during

the final show in Ladson, but the downpour held off until just after the finale. As we moved northwest, along I-26, then I-20 and I-77, from the southeast corner of the state to the lip of the North Carolina border, the weather reports became more ominous—steady showers overnight, tapering off the following morning, accumulation of several inches. The narrative was under way.

By morning the rain had stopped, but the lot was unplayable. The mall, however, refused to let the show move onto its new asphalt parking area. Doug was furious: the ads had run on the radio, free kids' coupons had been distributed, the newspaper had run several promotional stories, including one inviting farmers out to the lot to receive free all-you-can-haul elephant manure for their gardens. At the final moment a compromise was reached. The show could play on the asphalt, but we could drive only a limited number of stakes into the blacktop. This meant the show would be done without the tent. It would be an open-air show, known colloquially as a sidewall, in which the four center poles would be raised, limited rigging hung from them, and the rings, seats, and sidewalls laid out as normal.

An open-air show was a rare occasion and added a certain amount of stress to the weekend. The clown tent was not pitched and we clowns had to dress, prepare our props, and put on our makeup in the back of a crowded semi. The juggling act was cut from four jugglers to one, and the high-wire act didn't perform at all, forcing the clowns to move the second gag to the end of the show. All of this confusion meant the clowns didn't have time to change costumes before the finale, and since I was the announcer for the gag, I would have to lead the parade of performers who ushered in the world's largest cannon for the final bang. This was not my normal spot.

Waiting behind the curtain, I was cutting up a little, and when the flaps opened for the cast to enter, I went shooting onto the track and started lifting my hand to wave at the audience. My hand never made it. As soon as I stepped onto the track I felt the elongated legs of Barrie Sloan, the veteran stilt walker and surrogate godfather to the show, brush against my side. Before I could free myself from his towering green silk leggings, Barrie, a virtual tree of life, was falling fifteen feet toward the

pavement, clutching his arms around his knees and crying out in terror. As soon as he hit the asphalt several people rushed to his side. I reached for his top hat, which had spilled from his head and was wobbling drearily on the ground like a penny in a mournful spiral. Jimmy James came hurrying to the scene and urged us all to go on with the show. I felt sick to my stomach, a swell of fear in my throat. At the moment I didn't know how hurt he was: I knew he had undergone two knee operations in the past and had recently survived a heart attack. I didn't know if I had caused him to fall. What I did know was that I felt responsible.

After the show the performers rushed to the cabin of Barrie's truck, where he was lying on his back cradled in the arms of his wife, Shelagh. The long legs of his costume trousers dangled helplessly off the back of the truck. His face was covered in perspiration and his nose was already starting to bruise. He was all right, he said, nothing broken; I felt a surge of relief. He didn't know what had happened, he added, though Shelagh said she thought someone had run into him. I took a step backward and hurried to my camper. I didn't bother to take off my makeup and just locked myself in the one place on the lot I knew I could be alone. At that moment I was ready to quit. My joining the show seemed like a horrible conceit. These people were professionals; this world was dangerous; I clearly did not belong. I had confirmed what Dawnita had said: I was an outsider, I had made a mistake.

•

Fifteen minutes later I stepped out of my camper. The first person I saw was Guillaume, Fred Logan's teenage grandson, who worked in the elephant department.

"Hey, I heard you pushed Barrie Sloan over," he said.

"You did?"

"Marcos told me."

I closed my eyes in despair. I had seen gossip fly around the lot, but never this quickly. The ring of rumor proved even more powerful than I could have anticipated. Shaken, I had two immediate concerns: first, dealing with what might or might not have happened in the tent; second, coping with everyone blaming me. I wandered around the asphalt

for several moments in a daze. The lot was ominously empty, the water mirrored on the pavement. After a moment I knocked on Dawnita's door. A longtime friend of Barrie's who had known him since their days in England, she seemed shocked when I told her what people were saying. She told me to knock on Barrie's door immediately and talk to him directly. I went to do as she said.

The Sloans were remarkably cordial under the circumstances. Barrie was lying on the sofa in their dimly lit Holiday Rambler wrapped in a blanket with a wet towel over his head. When he fell he hurt his elbow and bruised his chest, he said, but he would never truly know what had happened. I told them I had been upset by seeing the cliché "The Show Must Go On" come to life so vividly, so uncaringly. Barrie said he was once knocked over during spec on the Ringling show and they just dragged him out of the way so the elephants could pass. After several minutes Shelagh announced she was serving dinner and I turned to go, feeling better but still slightly queasy. She came over and put her hand on my arm. "Just let them talk," she said. "They always will. Whatever happened, it was an accident. Barrie will be okay. It was nobody's fault." It was less than half an hour after showtime. I was still wearing my face.

Outside I ran into Kris. He came over to my place to have a glass of milk and some ginger snaps. He told me he had heard somebody knocked Barrie over, but he didn't know whom. I knew he was lying to protect me. He told me I couldn't possibly feel worse than he did when one of his girlfriends the previous year was accused of stealing a hundred dollars from Sean's trailer. He made me take off my makeup and dragged me to the movies, where, one after another, various performers shared their versions of the episode with me. That night was the first time I felt the power of the circus community in all its intensity. Some people reached to embrace me—Dawnita, Kris, ironically even Shelagh—while others seemed willing to let me remain outside and feel the cold slap of the group on my face. Walking back home, I stopped by the back door to look at the open-air skeleton of the tent. With no big top to contain them, all the colors, smells, and illusions of the circus seemed to evaporate into the sky high above the rings.

Swings of Fate

Like lightning, a spangled burst of bright pink tights ignites the blue-and-white-striped tent as two troupes of warriors, close to twenty in all, come blazing into rings one and three. All available light floods the sky. The brass ensemble erupts into a flare, a polka caliente. The ladies shake their hips and dance on the floor. The men slap their hands and pirouette in the air. An older man with graying mustache even turns a flip for show. Out of pure exhilaration the masses applaud as the great red-coated ringmaster himself steps forward and erupts with a noble call.

"On the Russian swings, the Rodrinovich Flyers, the Romanoff Aaaacrobats . . ."

The combatants bow and gesture toward the swings—two enormous pivoting platforms that slice forebodingly through the air. Soon daring young men will fly into the sky from these three-hundred-pound planks, gravity's foe. The whole scene seems thrilling, grandiose, even mythic, yet one detail in the picture still vexes the mind. Rodrinovich Flyers? Romanoff Acrobats? These costumes aren't Tartar, they're cancan at best. And these warriors aren't Russians, they're Mexicans for sure—just dressed in Slavic headbands.

"To tell you the truth, I think the name is stupid," said Pablo Rodríguez, one of three people in the pseudonymous Rodrinovich Flyers with the same first and last names. There were his father, whom everyone called Papa Pablo; his younger brother, whom everyone called Little

Pablo; and him, whom everyone called Big Pablo. Though not the old-est, Big Pablo was the largest of the siblings (175 pounds), his mouth was the loudest (not to mention the dirtiest), and his trailer was the longest (over thirty-five feet). When his father retired from performing several years earlier, the twenty-seven-year-old Pablo had seized control of the family in an unspoken, bloodless coup.

"Just because the apparatus is called a Russian swing doesn't mean you have to be Russian to do it," he scoffed. "They wanted us to dance Russian, to use Russian music. That's where we drew the line. Let's face it, you can't turn a Mexican into a Russian. Do they think people are that stupid . . . ?"

The answer to that query was probably yes, but sitting one afternoon with Pablo, his wife, and their four-year-old son, none of us wanted to af-firm it. One hundred years (and fifty million minutes) after he probably didn't say it, Barnum's theory of the birth of suckers was alive and well.

"Actually, I've grown sort of fond of it," said Pablo's wife, Mary Chris. Originally from a Spanish circus family, Mary Chris had married into the Rodríguez troupe a little over eight years ago. At the time of their en-gagement, she owned sixty bottles of fingernail polish, she told me; now married, she was down to five. "Johnny Pugh said he wanted a Russian name, and we thought it wasn't a big deal to argue about it. Some things you do for the sake of the circus, because as far as we're concerned, right now, if it's good for this circus it's good for our family."

In truth, if it was part of this circus it was probably part of their family. The presence of the Rodríguezes in ring one and their cousins the Estradas (a.k.a. Romanoffs) in ring three was just a hint of the blood con-nections that flowed throughout the tent. Indeed, one of the most surprising things about the show was this exhaustive, truly labyrinthine family net-work that links nearly everyone in the circus business to everyone else. On our lot, for example, Big Pablo and Mary Chris often parked next to Michelle and Angel Quiros. Michelle hung by her hair in the first half of the show, while Angel walked the high wire in the second. In real life, Michelle's grandmother and Pablo's father were siblings, while in the business, Mary Chris's mother and Michelle's mother were working on the same show. Also, while Pablo's second cousin Michelle was married to An-gel, Angel's sister Mary was married to Pablo's half brother, Little Pablo,

making Big Pablo and Angel half brothers-in-law, if there is such a creation. To make matters even more complicated, Little Pablo performed not only in the Russian swing act with his family but also in a cradle act with his wife, in the flying act with his brothers and sister-in-law, and in the wire act with his brother-in-law, his wife, and his brother-in-law's wife, who, for the record, was also his cousin—that, of course, being Michelle.

After several weeks of trying to untangle these offshoots, I decided to attempt a family tree of the show. What I discovered was that, leaving aside the clowns, seventy-five percent of the people who set foot in the ring were related to one another. Considering that these people hailed from thirteen different countries, this common lineage was stunning. It also had unexpected consequences. On the positive side, families that fly together, well, fly. The interdependence that families enjoyed almost seemed to make up for many of the hardships of life on the road. Papa Rodríguez's wife agreed to drive their trailer on jump nights, for example, so her husband could pull a separate trailer for his two daughters by a previous marriage. Big Pablo was excused from carrying any rigging and in return carried a generator for his sisters to use at night. Little Pablo and his wife, meanwhile, agreed to caravan with Angel and Michelle, and the four of them went so far as to buy CBs so they could pass the time during long jumps playing "Name That Tune" in Spanish.

This closeness, of course, comes at a cost. Nothing is secret on a circus lot—no act of lovemaking, no intramarital squabble, no extramarital affair. Danny Rodríguez would learn this lesson well. Others had learned it already. The previous year, one performer, whose father was a disciplinarian and whose mother was a Jehovah's Witness, became unexpectedly pregnant. Afraid of offending her parents, the woman, who, it must be said, had a slightly rotund figure that ran in her family, actually kept her pregnancy secret and continued to perform twice a day on the back of an elephant until five days before her baby was due. When she could hide it no longer, the mother-to-be told her parents she had appendicitis, checked into the hospital, and had her baby. While horrifying to the community, her exploit was a brilliant sleight of hand, for faced with the baby instead of a scandal, her parents overlooked their instinctive outrage and embraced the newborn child.

As for me, I kept bumping up against this juggernaut of invasiveness and gossip that shadows everybody on the show. My brush with ill will after Rock Hill passed as soon as Barrie recovered, but it was followed by a series of speculative stories that worked their way around the lot—rumors I was leaving, rumors I was fired, rumors I was spying for the Bureau of Naturalization and would try to deport some of the performers. I could mark my adjustment to circus life by the gradual decline in how much these rumors bothered me. One incident in particular finally thrust me over the top into a nirvana of indifference, at which point I gave up any hopes of privacy. It happened the first day in Hagerstown, Maryland, about two months into the season. During the previous night's jump I had stopped to eat a Whopper and a carton of Burger King onion rings, which over the course of my night's sleep had given me a bad case of gas. The gas was so bad, in fact, that in the middle of the night I actually set off the propane gas detector inside my RV. This was pretty funny, I thought: yet another private moment of bonding between me and my Winnebago.

But the incident was hardly private. After lunch the next day I walked up to the ticket wagon to say hello to Mary Jo, a usually gentle and generous woman who is Fred Logan's oldest daughter. "Are you parked next door to me?" asked Mary Jo. "Yes," I said. "I believe so." "Well, in that case," she said, "no more loud farting." Dumbfounded, I tried to ignore her comment: all of my years learning manners in Japan were not enough to prepare me for this situation. But Mary Jo was not to be denied. "Did you hear me?" she repeated. "No more loud farting." And so I learned *my* lesson that day: in the circus even one's privy behavior is part of the public domain.

•

Once the flyers complete their opening style, the act is ready to begin. In ring one, the Rodríguezes' anchor man, Antonio, hops on the back of the swing, pushes off from the ground, and begins building a gradual momentum. With a triangular structure eight feet tall suspending a platform five feet long, a Russian swing looks like a cross between a giant medieval battering ram and an oversized version of one of those

1970s coffee-table souvenirs with a row of suspended silver balls that spring outward when boinked on the opposite end. In the act, the silver balls are the Rodríguezes themselves, and when one of the boys is boinked from the platform, he soars into the air and turns a series of somersaults, layouts, pikes, and pirouettes before landing in a vertical blue nylon net and sliding to the ground.

"With a Russian swing you can land your tricks in one of three ways," Pablo explained in his definitive, slightly bombastic big-brother style of speech. "On someone's shoulders, on a mat, or in a net. As high as we're going, shoulders are out of the question. With a mat you risk ruining your legs. Let's face it, you can come turning two somersaults from thirty feet high, but how many times are you going to land perfectly? Your ankles just aren't meant to do that. Look at those guys in the Olympics, and they don't even go that high. When Johnny told us he wanted a Russian swing, we said sure but we're going to use a net."

After an initial thrill in which Antonio rotates the swing 360 degrees around the central bar, the family is ready for the first trick of the act. The honor falls to Pablo the Big.

"Of all my brothers I am the one who knows how to turn the best somersaults. It's really very simple. First of all, I concentrate on the height of the swing. When that's set, I bend down in a crouched position so I'll be able to shoot myself into the air. When the time comes I push off with my legs and try to create a tunnel, focusing only on where I'm going to land. I never look at the air, only the net, and if I concentrate correctly it just clicks, it comes to me. Let's say I'm doing a forward somersault with a one-and-a-half pirouette. I do my forward somersault and as soon as I come out of it I'm already judging how high I am. If I feel I have to hurry my pirouettes I tuck my arms tighter, but if I feel like the trick is going okay I can go slow so the people can enjoy it."

"And all you think about is the net? Not the audience, not your wife?"

"Nothing. I think only that I'm going to land right there, and if I do land right there I'll have no problem. There's no emotion, no anxiety. Just concentration."

"Do you get dizzy?"

"Sometimes I get lost. But that doesn't bother me. When I'm actually doing my somersaults my eyes are closed; it's all feeling. If you close your eyes, the feeling never changes, but once you open your eyes—well, what if the lights go out, what if somebody throws a balloon, what if somebody moves and your eyes go with them?"

What if? Indeed. Talking to an acrobat is like talking to a pilot—either one can have his craft totally under control but lose it in an instant with an internal glitch or an external gust of fate. For Big Pablo, the cocky one, the number one son, this brush of fate happened in practice. He was trying to do a double. The push wasn't right. He came out too soon and landed short. By the time he came to a stop at the bottom of the net the weight of his body had completely squashed his foot. "The bone was twisted all around," Mary Chris remembered. "His toes were pointing back and his heel was in the front. It was New Year's Eve, our first week of practice. We didn't have any insurance to pay for an operation."

"We knew at that moment we had to change the act," Pablo said. "Even after I recovered, someone else had to do most of the jumps. We decided Danny was the one with the best timing. Little Pablo could do a few tricks he always did on the trampoline, but we looked at him on the swing and it was obvious that Danny had more technique. But you have to remember what I said: technique is not the only thing. Concentration is also important. Danny has never had that."

•

The accident took place in Frederick, Maryland, on one of the prettiest, flattest lots of the year. The grass was smooth and green—a baseball paradise. The crowds were thick and loud—a grand-slam house. The rain didn't begin until after the show started, and even then the spring shower was unable to soil the colorful grandeur underneath the tent. Danny climbed onto the swing for the second trick: a backward double somersault into the net. He had already done it perfectly over one hundred times since the start of the year. But unlike on the diamond, percentages don't count for much in the ring. When you walk a high wire, or set foot in a cage with tigers, or jump off a Russian swing, you can't afford to have a bad day.

With all eyes on his slender, well-toned body, Danny hung on to the front of the platform as it knifed relentlessly through the air.

"Take it easy," he said to his siblings; the cue to prepare.

Danny bent his knees into the takeoff position as a wisp of ponytail swung behind his neck and distracted attention ever so slightly from his deep-set stare and slight overbite.

"Ready," he called; the next time was the launch.

As the swing rose to its zenith for the final assault, his brothers and sisters pushed the swing on command and were readying to exclaim their traditional "Hurrah!" when suddenly . . . "Danny? Daniel! *Mira. ¡Cuidado!*"

"As soon as my foot slipped off I blanked out," he said. "My right foot went first, then my whole body followed. My legs lifted up like I had stepped on a banana peel and I went hurling through the air. When I came down I landed on my neck. It happened so quick all I could think about was moving out of the way so the swing wouldn't hit me when it came back. Everyone was screaming at me, but I couldn't hear what they were saying. I rolled toward the seats and closed my eyes. I knew something was wrong."

Compared with his brothers', Danny's English is nearly perfect. Born in America during a family tour, he was raised in the lap of a Mexican family who had made it in the seat of gringo luxury. As proof of his upbringing, he liked to wear a uniquely American wardrobe: Deion Sanders high-tops, Michael Jordan T-shirts, Arsenio Hall baseball caps. He was only twelve when his family spent a year as pampered stars at Walt Disney's EPCOT Center; his personal hero was Marvin the Martian from *The Bugs Bunny Show*.

"By the time I came to, my dad was there. He helped pull me out of the way. He tried to pick me up, but I told them not to move me. I knew something was broken. My body was all hot. I felt a lot of pain. He asked me if I heard something pop or break. I told him I didn't hear anything at all."

Danny looked limp lying on the ground. His slender body was writhing in pain. His fingers twitched at his side.

"It was just about then that I started losing control. I could hear everyone talking to me, but I couldn't concentrate. My mom was hold-

ing my head. My dad was holding my legs. I opened my eyes once and it was all blurry. I couldn't see straight. I was having a lot of trouble breathing. I couldn't feel my fingers, or my toes. That's when the doctor came from the audience."

To the ringmaster, the doctor was hardly a welcome sight. "As soon as the doctor came from the audience I knew we were in trouble," said Jimmy James. "Real doctors don't do things like that anymore. It's a new ball game out there. These days you can't say, 'Is there a doctor in the house?' Because they won't touch you for insurance reasons. As a result, you don't know what's coming out of the audience. You have to be very careful."

In a maelstrom of European and Latin excess, Jimmy James, from Columbus, Georgia, was a paragon of Southern gentility. Between phrases he paused to let his vowels stretch out to their full magnolia glory. Between shows he hung his tailcoat on a seat wagon so his tails wouldn't sully themselves in the mud. Between sentences he thought before he spoke.

"At the time, I was standing in ring three. I saw the accident right away. The first thing I did was signal Willie to have him kill the lights. The second thing I did was make sure the next act was up and ready to go. In this case we had a few minutes while the Estradas finished their act, but unfortunately the act after them was the bears. The bears couldn't work because of where Danny was still lying, but the bear man didn't tell me that until he was in the ring, which made it worse. I considered going to a clown walk-around. If I had really gotten into a jam I would have just called for a blackout and introduced the band to play a march. But in this case I got lucky; the Ivanovs were ready. I announced the cradle act and they went up in the center ring. At that point I could turn my attention back to the ground."

While Jimmy was struggling to rearrange the show, Danny was being swarmed by a growing number of family and friends. His sister Elizabeth started to cry. His mother stroked his cheek. The emergency personnel had to push their way through the assembled crowd.

"When the paramedics came they asked me if I could move my fingers, my arms," Danny said. "They pushed particular places around my head and asked if it hurt—my neck, my back, my spine. One dude knew right away, but he wasn't allowed to say. They couldn't move me until they

got me on a stretcher with a neck brace. At the hospital I waited for about an hour. The brace was pinching my nerves. I asked them if they could please take it off, and they said the only way I could take it off was to sign a paper saying they weren't responsible. I decided to leave it on. . . .

"All that time I kept telling my mom how stupid I was. It was my fault and I could have prevented it. What happened was there was Sno-Kone juice on the swing. After the act they shove the swings back into the corner, and someone must have dropped some Sno-Kone on the part where we stand. By the time I noticed it I was already swinging. I lifted my foot and mentioned it to my brothers. While I was talking to them it was time for me to go off but I wasn't paying attention. That's when they knocked me off. Shit happens. But I still could have prevented it. That's why it upsets me more. The truth is, I fucked up."

A little over an hour later the X rays arrived and confirmed what the paramedics had suspected all along: when Danny flew off the Russian swing and landed on his neck he snapped his collarbone. It would take eight to ten weeks to heal, the doctors said. After that he should be okay. But after that he wasn't, for Danny, it turns out, might have fallen off the swing for reasons other than the one he confessed to.

•

Meanwhile the act must continue. With Danny disabled the family was forced, at least for a few months, to shuffle its lineup again. Little Pablo started doing a straight jump along with his brandy in, back somersault out. Mary Chris even considered doing a trick or two herself. But most of the slack was taken up by Big Pablo, who returned to jumping despite his still crippled foot and now aching knee. Because he was twenty pounds overweight and difficult to push, the family had to recruit Kris Kristo to join their act for added weight. He donned a black Howard Stern–like wig, slipped into Danny's old costume, and learned to dance the mambo. Now the Rodrinovich Flyers were not only Mexican but part Bulgarian as well.

For the finale, Papa Rodríguez, who up to now has been holding the net, hands it off to a prop man and fetches two twelve-foot-high aluminum poles connected at the top by a slender cable wrapped in bright pink tow-

els. He douses the towels with lighter fluid and sets the wire ablaze. The crowd breathes an audible "ahhhh." Jimmy James responds on cue.

"From the Russian swings, a backward somersault, bliiindfolded . . ."

Big Pablo slips a black cotton pillowcase over his head, squeezing his arms through two narrow holes and pulling the remainder almost to his chest. His brothers and sisters start clapping their hands until the entire tent catches on. The brass flare gives way to a tympani roll.

"The last trick is always a safe trick," Pablo explained. "You can't afford to end with a miss. But you want something that the people are going to enjoy. That's what the fire is for. It's not a threat. You can see fairly good with that blindfold anyway. But people like it. It makes them go 'ahh.'"

"So how do you know what makes people go 'ah.'"

"Fire makes people go 'ah.' Darkness makes people go 'ah.' Somebody jumping over something high makes people go 'ah.' Our last trick has all of that. It's the perfect ending."

After four swings the platform reaches the ultimate height and Pablo tells his pushers he is ready to fly. On the next rotation he pushes off with his legs and vaults his body into the air, searching for that elusive nirvana, that tunnel of air, which will carry him to his destination. With a cymbal crash for flourish and a communal 'Hey!' for effect, his back is sucked into the vacuum of the net and he comes sliding down the blue nylon chute and lands upright on his feet. He peels off the blindfold and beams at the crowd. He looks confident. He looks poised. Deep inside, he wants more.

"At first I feel pretty good, like I just hit a home run. It's like after a big ride at a carnival you say, 'Damn, that was cool.' It's a feeling of, well, accomplishment. I have done something right. I have done something good. . . . But after a moment that high goes away. That's when I realize I'm not satisfied. The act could be better. The swing needs to be two feet taller. I need to be fifteen pounds lighter. The way the act is now I would not want anybody I think is somebody to see it. Not in my business, which is somersaults. As soon as it's over I'm thinking, I want to do more, I want to give more. I want to shout out to the audience, 'Just wait until the flying act. That's when I know we'll show you something. That's when we'll really show you how to fly.'"

5

This Is When
They Become Real

"I woke up at seven this morning, just as I do every day. I looked around the room for a moment. I hadn't moved any of my clothes. I hadn't even changed the sheets. It seemed strange to be in her bed. We hadn't slept together for several months. And now, well, she's gone."

Khris Allen sat upright in a blue director's chair and stared at a pile of bullwhips and kangaroo crops on the futon sofa of Kathleen's trailer. Only now the futon was empty and the trailer belonged to him.

"Kathleen really didn't do housework," he said. "She dusted every now and then. She could cook. But just smell this place: it's all dog hair and tiger urine. I don't know how Josip stood it. I don't know how *I* stood it . . ."

Khris rubbed his hands across his face. He was dressed in a pair of plaid Bermuda shorts and black canvas slippers. He wore no shirt, revealing a taut, wiry torso made strong from practicing jujitsu for the previous ten years and from pushing tiger cages for the previous two. He was roughly the same size and shape as Sean. "They look exactly the same," commented one friend of mine. "They're both hillbillies with good bodies."

"I decided I should try and clean up a bit, but everything still reminds me of her. Those are her tiger pictures on the wall. That's her calendar. Even the cats still remind me of her." He reached toward an

overturned wall lamp and pulled down an Atlanta Braves baseball cap. Not far away on another sideways lamp hung a cap from the year the Georgia Tech Yellow Jackets shared the national championship in football. Above it was a comic strip showing a man standing in front of a tiger. "Fellow Animal," the man proclaims, "I am Hugo Flealover, Animal Rights crusader, come to free you from bondage." In the next frame the tiger is eating the man.

"Come on," Khris said. "Let's go feed the cats."

Outside the trailer the late-afternoon sun was just dipping behind the Shenandoah Mountains. The air was still warm with the faint blush of spring. The sound of squealing laughter from children leaving the early show still lingered in the valley around Harrisonburg, Virginia, where Washington, Madison, and Jefferson once traveled. The tent was quiet in its chameleon pose as it gave up the bright stripes of afternoon sun to its silhouette before the stars. The season was now in full bloom. After the Easter rains in South Carolina the show had trekked north into a cold snap in the coastal plains of North Carolina. In Henderson, Sean almost missed the bag. The air was cold, the mud nearly frozen. He turned on the heater inside the barrel to 70 degrees. Checking his logbook, he adjusted his power level (its true function, like the rest of the cannon, still a secret to me, but less so every day) to what he thought was the correct level to get him to the middle of the air bag. Still, it wasn't far enough, and he barely caught the front lip of the bag and skidded to the ground. "You can mark my words," he said after limping out of the finale. "If the weather stays this cold I'm going to land on the pavement before the year's out."

In Virginia the weather got warm again, and by the time we crossed the Appalachians it was almost ideal. Yet somehow all these changes were maddening, like a case of schizophrenia shared by two hundred people at once. On certain days, when the sun was shining brightly, the breeze was blowing softly, and the temperature was just this side of perfect, when the boys walked to a nearby field to play baseball, the girls sat under a veranda having a baby shower, and the cookhouse was serving meat loaf, macaroni and cheese, followed by chocolate cream pie for dessert, nothing seemed more ideal than the circus. But a day later, when

the rain started falling, the mud began rising, and the temperature was just this side of freezing, when the men complained about their shoulders being bruised, the women griped about their husbands losing money at poker, and the cooks in the cookhouse were so busy frying crack in the pans that they ran out of spaghetti for dinner, nothing seemed more miserable than the circus. Often both these days would happen at once. In Harrisonburg, I was having the former kind of day; Khris was having the latter.

"I hope you don't mind a little smell," Khris called as we wandered over to a wheelbarrow near the twin lines of cages where fifteen servings of meat were thawing out on an open board. Each portion was about the size of a fire-starter log and the consistency of leftover meat loaf. Little starlights of ice still glistened in the center of the meat, and a virtual road map of dark red blood dripped from the plywood board onto the grass. The entire compound smelled like rancid hamburger meat.

"It's a combination of beef, chicken, and beef by-products," he explained, "fortified with vitamins A, E, and B." He slid on a pair of bright yellow dishwashing gloves and began transferring the meat from the board into the wheelbarrow. "It's what they call Grade B meat, not for human consumption. We order about forty thousand pounds a year. It's actually made for racing dogs."

"Forty thousand pounds," I said. "That sounds expensive."

"Last year we spent thirty-two thousand dollars on food alone."

"And what does this meat taste like?"

"Well, it's not tenderloin or sirloin. It's basically fatty meat mixed with bonemeal to give it marrow. The USDA makes us put charcoal in it so we can't sell it to humans."

"And what happens if you eat it?"

He smiled. "Let's just say it gave me the runs."

Laughing, he rocked the wheelbarrow onto its wheel and headed toward the cages. Laurie, now the last-remaining groom, was just clearing the final remnants of sawdust from the cages with the help of an electric leaf blower. As soon as she finished, the two of them went to work. Their routine was precise. Laurie would slide open the small door on the seven-and-a-half-foot-long steel cage that was five feet high and four feet wide,

while Khris would toss in the meat. If Laurie opened the door too early or kept it open too long, the tiger would have time to swat at Khris's body.

"You always have to be careful with the cats," he said. "You get a false sense of security around them. Whenever they go after you, they're probably playing. But sometimes that develops into maliciousness. You can't let them see you scared."

As soon as Khris rolled toward the cats all nine of them sprang to their feet and started pacing excitedly in their cages—rocking back and forth, panting with their tongues, growling in a bloodthirsty way that no doubt came from their grumbling stomachs but made my own stomach churn.

"This is when they become real tigers!" Khris shouted over the roar. "This is when I love it the most."

Laurie put a metal hook on top of the first door, opened the slot, and counted slowly to three. By the time she finished and dropped the door, Khris had already tossed the meat onto the plywood floor and Tito had already devoured his first log. Being the biggest, Tito got the most: twelve and a half pounds. Orissa got seven and Zeus ten. "He was getting chubby, so I just put him on a diet," Khris explained. Down the line he went. Taras, ten pounds. Fatima and Simba, seven. As each tiger was fed, the noise level declined. Toshiba received only five pounds because she had just had a hysterectomy and had begun to gain weight, while Barisal received a hefty eight and a half pounds because she was thought to be pregnant. Before Kathleen departed she had left explicit instructions on what to do should Barisal give birth to a litter.

For now, other concerns were more immediate. As Khris approached Tobruk in the last cage, he was slightly distracted by another tiger and wasn't looking when Laurie opened the door. When Khris finally did turn around, Tobruk flung himself against the cage and thrust his outstretched paw through the door, missing the sagging loaf of meat but snagging instead the back of Khris's hand. Almost immediately Tobruk's curved claw slid deep into the tendon behind Khris's index finger. Khris winced in pain, but didn't shout. Laurie dropped the door. I instinctively reached out to help, but Khris merely waved me away. He dropped the

log of meat on the ground and with remarkable composure grabbed the back of Tobruk's paw and carefully pulled the claw from his hand in the same direction the nail had entered. With blood pouring from his wound and his jaw tightly clenched, Khris calmly picked up the meat from the ground, waited for Laurie to reopen the door, and continued feeding the cats as if nothing had transpired. "You can never let them see you scared," he had said. His manifesto come to life.

When the feeding was done Khris walked slowly back to his trailer and asked me to help him wrap his hand. His face was pale by the time he sat down. His leg was stained with blood. The second show was scheduled to start in less than an hour.

"To be frank with you," he said after several moments of silence, "Kathleen was the first woman I ever had sex with. She wasn't beautiful, but she had an aura about her. She was sexual—sensual even; I was extremely attracted to her. She was a little confused. But of course I knew that when I came down here. I had just broken up with my college girlfriend, Kim. I had considered getting married, doing the picket-fence-and-children thing. But still I had this secret part of me that wanted a little adventure."

Outside, the cats were busy licking their paws and clearing their throats with low, guttural cries. Laurie had finished giving them water and had wandered off to her camper. Khris was tugging at his hair.

"On my first night in Florida the flame reignited and I knew I could never leave her. Then we went on the road. Everything was good for a while. We became friends, in addition to the physical thing. But then problems started happening. We are different people. Kathleen is fiercely independent. She doesn't like to talk about her problems. I'm the opposite. If I have a problem I want to sit down and talk about it right away. Let's put it this way: If Kathleen wanted something from the mall right now, she would just go and get it. If I needed something, I would ask somebody to go with me."

He put his cap back on the lamp and slid off his Chinese slippers. It was now totally dark outside, and a small light over the stove produced the only shadows.

"Over the last few months, when we knew she was going to leave, we

were on friendly terms, but it didn't take long for the daggers to start flying. The last few weeks she started blaming me. She wanted to leave, to go to school, to grow, she said, yet she still didn't want to leave the cats. I wanted to stay. If you had asked her last night why she was leaving, she probably would have said I pushed her."

"Did she say goodbye?"

"Sure. It never got so bad that she would walk away and never talk with me again. In our greatest time we would call each other sweetheart and baby. Yesterday when I went to give her the final hug she got emotional. I choked up. I'm choking up now just remembering it. I said to her, 'Kathleen, I'll always love you.' She said to me, 'I'll always love you too, baby.' I told her I would take care of all this for her, and she said, 'Take care of it for you now.'"

Tears coated Khris's light blue eyes. For a moment he couldn't speak, until he was coldly brought back to the present by a crisp metal bang and a growl from his front yard. "Fatima!" he shouted, swinging open his screen door. "Fatima. Be quiet!" The door slammed back into place.

"What makes me the saddest," he said, his voice turning more Southern as his story went along, "is that the people in this circus don't realize how much she did for these cats. How she trained them. How she loved them. I remember last year Mr. Pugh and Mr. Holwadel came to see me practice in DeLand. I had only practiced the act once or twice. I was scared shitless. I took a deep breath and went into the cage. To my surprise everything went perfectly. They applauded after every trick. Kathleen got so upset watching them approve of me that she ran into the trailer and hid. Later I had dinner with Mr. Holwadel in a restaurant in DeLand. He said, 'Khris, I'll be honest with you. I think we'll have a better cat act this year.' Outside I was very proud. I said, 'I'll do my best for you. I'll try not to let you down.' But inside I felt so bad for Kathleen. She trained these animals. She raised many of them by hand. She had been with them for six years. And still no one ever respected her."

"Do you think they'll ever respect you?" I asked.

"Yes," he said without hesitation. "I'm a man. Just the other day Mr. Holwadel stopped me in front of the tent and asked how things were going. I told him they were going okay. 'Good,' he said. 'Now that you're a

member of the team I want you to do me a favor.' I said, 'Sure, Mr. Hol-
wadel, what's that?' 'Start calling me Douglas.'"

•

Buck knocked at my door at a little after eight.

"Get up," he said. "We're going shopping."

"But the mall's not open for another two hours," I protested.

"We're not going to the mall," he said. "This is Hanover, Pennsylva-
nia: Thrift Town, U.S.A."

The show crossed the Mason-Dixon Line at the end of April and for
many it wasn't a day too soon. To landowners before the Civil War the
famed surveying line may have been a divider between slave and non-
slave states, to officers during World War II it may have been a warning
of when to segregate their troops, but to butchers on the Clyde
Beatty–Cole Bros. Circus nearly fifty years later the line was the signal
that for the first time all year they could raise the price of popcorn. Pop-
corn wasn't the only thing. The coloring books that the clowns sold dur-
ing intermission jumped from one dollar to two, programs went from
two dollars to three, and Cokes, cotton candy, and hot dogs all surged
fifty cents to two dollars apiece. Look out, Yankees, one almost wanted to
shout, a herd of carpetbaggers from Dixie are coming to cart your money
away.

Moving north also heralded other changes—first among them, the
crowds. All through Georgia, the Carolinas, and southern Virginia we had
seen mostly all-white audiences with few blacks and even fewer Hispanics.
In addition, Southern audiences tended to sit in the general admission
bleacher seats in the corners, which cost nine dollars for adults and six for
kids, instead of paying two dollars more and receiving a reserved chair
alongside the three rings. Moreover, they would sit quietly, without
much emotion, and during the Ivanovs' balletic hand-balancing act late in
the second act many would hurriedly exit the tent. As we headed north,
through Baltimore, Philadelphia, and Boston, before the climax of the
summer in New York City itself, the audiences began to diversify.
Crowds were more ethnic and much wealthier; they purchased better
seats, bought more concessions, made more noise, and stayed until the very

end. This made everyone happy, especially Sean, because with fewer people leaving after the spaceship act more people would see him fly.

While the shows became better, daily life became worse. The roads deteriorated (Jimmy insisted Pennsylvania had the worst roads in the country: "They ought to pay us to travel on them," he said), gasoline became more expensive, and the building inspectors started forcing performers to move their trailers in the morning to add a few inches to the fire lane. It made some veteran performers long for the days of simple bribes. Karen Rodríguez even complained that in the ritzy suburbs around Washington, D.C., she had to drive thirty miles to find a Laundromat. One person who particularly dreaded going north was Buck, because once we headed into New England there were fewer flea markets where he could buy or sell his wares. Hanover, Pennsylvania, was his last chance to stock up, and he didn't intend to let it pass.

"Now there are two things you have to remember about the flea-market business," he said as we sat down for a breakfast of biscuits and orange juice at a Roy Rogers across the street from the tent. "First, you can never have too much of a good thing." The previous day, Buck said, he had driven one hundred miles to a library sale in Camp Hill, Pennsylvania, where he had purchased thirty-four books for a total of three dollars, which he would later resell for six dollars apiece. "The second thing is, you should always use psychology. Every flea market I go to I put up a sign saying since it is my first visit I'll sell all my books at half price. It works like a charm. Everybody just stops to talk."

In truth, there were probably other reasons everybody wanted to talk to Buck. Even without his makeup on he looked like an alien—a quaint, rather awkward alien that had stepped out of a B-grade 1950s science fiction film. Everything about him seemed to accentuate his height. His black hair with streaks of gray on the side was always standing on its end from where he slept on the eight-foot foam mattress that occupied most of the back of his van. He wore black horn-rimmed glasses that looked as if they were hand-me-downs from a comic-book science teacher. Plus his neck, shoulders, and even his waist all slumped continually from crouching every day for half a century under doorways and signboards in six-feet-and-under America. Whether it was an optical illusion or not, I

don't know, but even though Buck was well over seven feet tall, his hands always seemed to drag on the ground.

Beyond his appearance, there was something a little unnerving about Buck. As a clown, he was definitely a relic. He didn't move much or particularly make faces. Instead he liked to make fun of children, play tug-of-war with their arms, or shock them with his personal brand of bathroom humor. His favorite walk-around was to carry a large piece of granite and a roll of toilet paper with a sign that said: "Old-Fashioned Rock and Roll." It was hardly clean family fun, some complained. Around the lot his behavior got him into even more trouble. Perhaps as a result of having people gawk at him his whole life, Buck had become something of an exhibitionist. Without access to a shower, he regularly bathed out of a bucket directly in front of Clown Alley. Also, he had a well-known and mostly disapproved-of habit of sunning himself nude up and down the East Coast. He also urinated at will in public. As a result, many of the performers thought him perverted and kept their children away. They even complained to management. They feared that one day a paying customer would as well.

Finished with breakfast, we headed into town on Route 94, a typical congested semiurban highway with strip malls, gas stations, and fast-food playgrounds all clamoring for the best frontage and median cut. But here there was a difference: many of the signs were local in nature. According to the neon vernacular, Hanover was the home of Snyder's Pretzels, Utz Potato Chips, Hanover Shoes. Stores touted discount clothing, discount auto parts, even discount beer. Arrows beckoned drivers into darkened streets promising cheap thrills. It all seemed like bargain heaven for Buck. "I like to drive in alleys," he said, finally pulling off the main drag closer to town. "People throw out all sorts of interesting stuff in alleys." Sure enough, a few minutes later he pulled over behind an abandoned hotel. "Why, look at that." He stretched his arm through the driver's window, reached into the top of a dark green Dumpster, and pulled a mangled object out of the pile. "It's a CB radio!" he exclaimed, tinkering with the buttons and putting it up to his ear as if he really was a science teacher. "You can hear it, but you can't talk. I'd say it's worth about five bucks."

As we moved on, our first stop was the semiannual factory outlet sale of the Hanover Shoe Company, just off Main Street. Buck rummaged around the second-floor rows of mismatched moccasins and patent-leather dress shoes but found nothing in his size. This was not uncommon, he said. Several years earlier he had gone to a similar sale in Brockton, Massachusetts, the self-proclaimed shoe capital of New England. " 'What size shoe do you wear?' the woman asked. 'Sixteen,' I said. 'Well, you're in luck. Go to the back wall and look there.' I went back there and they had a whole wall of perfectly new shoes. 'They say those are seconds,' the woman said. 'But I can't find anything wrong with them. The price is two dollars a pair.' I tried on one pair and they were comfortable enough, so I handed the woman a hundred-dollar bill. 'How many would you like?' she said. 'That's a hundred-dollar bill, ain't it?' I said. 'I'll take fifty.' 'What are you going to do with all of them?' she asked. 'Save them for future use.'" He smiled with wicked delight. "I walked out of that store, kept two for myself, and sold all the rest for forty dollars a pair."

Our next stop was the Salvation Army, two blocks up Main Street. This time Buck didn't bother with the shirts or jackets, but headed straight for the kitchen supplies. Half an hour later, he walked out with two belts for a walk-around Arpeggio was making, an eggbeater for the chef in the stomach-pump gag, and a slightly rusty Sterno stove. "Look, it still has the fuel cartridges," he boasted. "I'll use it to heat up my makeup when the weather is cold." Altogether he had spent $1.75. "Boy, the books in there were terribly expensive," he said as he tossed his purchases into the back of his van, the atticlike space where he slept, ate, watched television, and gave himself insulin shots, as well as kept his sodas on ice, stored dozens of pairs of secondhand shoes, and maintained what was reported to be the most extensive supply of pornographic videos of anyone on the circus. "They had some Westerns and even a Civil War book. I opened them up and they wanted three dollars apiece. I would never pay that much. I would pay a buck a book and sell it for two. But three dollars? How do you make a living off that?"

We headed back toward Route 94 and the Goodwill Mission Store. Once again he found little of interest—no china elephants, no clown

books, no round Coca-Cola signs, but as we were leaving he noticed several boxes of day-old bread, muffins, and pies. "Why, look at this," he said, bending down at the waist like a mechanical cherry picker and filling up most of the aisle. "Five to a family. Get you five, we're from different families." He picked out a loaf of raisin bread, an angel-food cake, two cartons of English muffins, and a shoofly pie. "Ever had one of these?" "No," I said. "Well, you're in for a treat. It's Amish. Feel how heavy it is . . . It's made from turkey syrup, eggs, and brown sugar. In the thrift store where I work in the winter I could feed five families with this stuff."

Back in his van heading home Buck was philosophical again. "There are not many thrift stores I leave without buying a book. Their selection was real bad. They had a lot of Bibles and blooper books. You can get rid of Bibles in the South, but not up here around New York. Also, you would think blooper books sell, but they don't. It's a real art to knowing what books'll sell. At the store back in West Virginia where I work in the off-season I throw away a lot of books. Clear up the shelf space. I put the books in boxes and give them away as heating fuel. One guy came back once a week for several months. Finally, he told me he was feeling real guilty for heating his house with books, so he decided to read each book before he burned it up. People in West Virginia know how to get by with very little."

"So do you miss that life?" I asked. "West Virginia. Home."

"My mother's still there. I go back a couple of times during the season to visit my doctor. But my life's out here now. When you've been living on the road as long as I have you learn to like it. I have special parking lots I like to sleep in in every city. I have special treats I know where to find, like shoofly pie around here or clams in Boston. I know this great place that has scuppernong jelly with no added sugar in Columbus, Georgia."

Soon the tent came into sight. Surrounded by a mall on three sides and a Roy Rogers and discount fabric store on the other, it looked as if it belonged to a bloated used-car sale instead of the world's largest circus. "And for how much longer can you live like this?" I asked.

"I suppose I can do it till I die. I do want to go to a smaller show, though, with one or two clowns, and produce again."

"Have you done that in the past?"

"Sure. I've done all sorts of things over the years. I've produced. I've done advance. I've even been in a few movies or so. I tell the boys in the Alley it's important to move around a lot. If not, you'll get stale. The worst thing you can do is be on the same show all your life. Hell, I myself have been on Carson & Barnes, as well as Hoxie Tucker. I put in a lot of years at Great American. But still, I think I like this show the best."

"Why's that?"

"I can get away with murder."

I laughed. "What does that mean?"

"It means exactly what I say." He didn't seem to be laughing with me. "I always say, you haven't lived until you've spent a week in jail."

"And you've spent a week in jail?"

"Oh, sure. I've spent more than that. It's not until you've lived in jail that you know what you can do without. Oh, you can run, you can escape a few times, but sooner or later they're going to catch up with you."

"Who's they?"

"The police. The customers. The parents."

"The parents?"

He pulled his van in front of Clown Alley and turned off the engine. "I'm afraid that's all I can say," he insisted. He stepped out of the van and slammed the door behind him, speaking to me through the half-open window. "I'll just have to leave a little mystery in the air." He turned and lumbered away, leaving the door rattling in its sockets and me sitting in the dark.

●

"You want to know what I really think of these clowns? They don't put one penny of what they earn back into their art. I don't know where the money goes, because they sure get enough of it. Their costumes look like they came from the Salvation Army. Their makeup looks like it came from the Clown College assembly line. And above all they don't look clean. In my day every clown was required to have at least one white costume. These guys don't know white from their ass. They're dirtier than the workingmen, and that's pretty dirty."

Jimmy James was angry. Earlier in the day, during the 4:30 show in

York, chaos had struck the firehouse gag. Joe couldn't find the ax for the knockoff head. Brian fell on the first hop over the jump rope. Marty couldn't get the fire going for the blowoff. And worst of all, Henry ran into Rob during the run-around and chipped off the bottom half of his two front teeth. Back in the Alley, Henry threw his helmet on the ground, examined himself in the mirror, then slammed his chair into the ground. Moments later Jimmy came storming into the Alley. It was his first appearance all year.

"Where is the fire?!" he demanded. "This gag is nothing without the fire. I want to see the funnel." He examined the funnel that Marty was using to blow the lycopodium into the air. "It's a wonder you don't burn yourself," he fumed. "Go to the store. Buy a tea strainer. Pour the powder into the strainer, then blow once into the lighter. A small flame comes up and the girl rubs her ass real hard. Then blow again, harder. She lets out a big faggot scream. There's no need to pour powder into the funnel every time you blow. Then there should be a big bang, a big flame, and the girl should jump with her feet in the air like in a cartoon and land in the net. Nothing beats fire, friends. And nothing beats a girl dropping her pants. You boys are relying on slapstick and knocking each other's brains out for laughs. *Sight comedy*," he boomed. "Simple gags that everyone can understand. That's the way you ought to work." He threw his hands into the air like a trained actor making his grand farewell and marched out of the Alley. Once outside he turned quickly back toward Henry. "Get those teeth capped and send the show the bill."

After the show, he came into the cookhouse. "Let's see what culinary arts Pops has prepared for us this evening," he said. Inside the sagging, sievelike tent, Arpeggio had spread his broccoli and cheese on a piece of white bread with margarine. Pops, the grizzled former Marine turned grease gourmand, had actually run out of cheese and substituted Nabisco Cheez-Its. It was broccoli and Cheez-Its for the boys. Jimmy spooned out his serving into a trash can. "But, Jimmy," Arpeggio protested. "Those are vegetables. They're good for you." "I'm on a diet," he said. The previous night, during a rare rehearsal to tinker with the finale, he had announced that he had lost some weight. "Your ringmaster, your *fat* ringmaster, has lost twenty pounds since the season started." The cast

applauded. Later he confessed he had actually lost twenty pounds since January. In the circus Barnum's humbug does not stop with the show.

"We'd like to see a dessert list when you have a chance," Arpeggio said to Pops, who stared back at him, baffled.

"And how about a glass of your house wine?" Jimmy added.

Pops wandered off shaking his head. Jimmy sat down across from me.

"I hate yelling at the boys," he said. "But I have no choice. Sometimes they don't have the proper respect for tradition. For most of them it's just a lark. But for me it's something else . . ." Jimmy quietly poured salt on his soggy corned beef, the only thing left on his plate except for vanilla pudding from a can. He was dressed as he always was between shows, in black formal trousers, ankle-high boots, and an open-necked white dress shirt. On the pocket of his black waistcoat was a barely detectable clip-on pin displaying a pink triangle. "My friends at home think it's glamorous. If only they knew that for years I lived in a two-by-two room and poured buckets of water over my head for a shower. Like many people, I came here to get away, you see. From the witch-hunts of the 1950s. If I had it to do all over again I probably would have stayed in school. But I was never a good student. In high school I had so many other things on my mind I could never concentrate on my studies. I got C's as a result. And by then it had started to ooze out."

Jimmy ate a spoonful of corned beef and winced at the taste. He took a sip of Kool-Aid to wash down the food.

"For me it was an escape. Nobody here asks any questions. Look at Buck. Look at me. You haven't learned many of the secrets yet, but you will. You'll learn about the animals, the workers. Hell, a few years ago a clown was raped by the elephant department on another show. He came to work on Clyde Beatty but was never the same. I'm afraid to say it, but most people here are running from something. There's mystery everywhere. Just look at the people around us. My mother would turn over in her grave if she saw the people I eat with every night. She used to always say, 'James is away at school.' My father used to say he could *introduce* me to someone, which was his way of trying to get me into industry. But I stayed."

"I bet they'd be proud of you today," I said. "You still have something, something from the outside . . ."

He looked at me primly. "Class." His back was straight. His hair was neatly trimmed. Earlier that day I watched him get out of his pickup truck carrying pies to the office. I noticed that his hair was shorter, straighter, and, well, darker. "What are you looking at?" he said. "I'm admiring your haircut." "You mean my dip job. I got up this morning, looked in the mirror, and said, 'Jimmy, you look like a dead Communist leader,' so I went into town and got my hair dyed." Within a week it had begun to gray again.

"I was raised in a proper Southern home," Jimmy continued. "I'm sure you know what that means. I was taught to say 'Yes, ma'am' and 'No, sir.' To this day I still feel that manners are appropriate. It's because I was raised an Episcopalian. We were taught there was a place in hell for anyone who eats their dessert with a salad fork. And of course we had a servant. Lulu was her name. I loved Lulu. I went to her funeral and tears streamed down my face. She bathed me, rubbed my back, even touched my privates. After all these years, I have never used that word." He gestured at the black men sitting at the table across the tent. "We were always taught they were *colored* men and women. And I still believe a person is nothing without compassion."

After thirty years on the road, I mentioned, he still seemed to be, at heart, the same person he was when he left home.

"I sure hope so," he said. "I love the South. I love my hometown. I can't stand all these Northerners, these New England roads. I'm still my mama's boy. At heart I'm still Agnes's child." He became silent and pushed away his tray. After a moment he looked up at me. "Bruce, have you lost your mother?"

"No."

"Prepare for it, son. It's the most difficult thing that has ever happened to me. I've lost my friends. I've lost my religion. But nothing was like losing my mother. We did everything together. We played games. We saw shows. She was my best pal." We got up to clean our trays. "My father died when he was in his late fifties. He was a chain smoker. My mother died when she was in her early sixties. Heart disease." We dumped the leftover food in the garbage and dropped our trays into the dirty metal tubs.

"I've got it as well," Jimmy said, "a serious case of heart disease. That's why I'm so passionate about this show. Did you know that my paycheck hasn't gone up in ten years? They even stopped giving me contracts several years ago. I was upset about that. I used to get fifty bucks by selling them to circus fans." Out of his modest weekly salary Jimmy had to pay health insurance, mortgage insurance, and the insurance on his truck and trailer. "As it is, I'm already cutting into what I have set aside for later."

"Why's that?" I asked.

"Because they don't pay me enough money."

"Then why don't you leave?"

He smiled and lifted his hand in the air as if he were about to start the show. His tone was wistful, almost ironic. "Because I can't. . . . And that's the circus, my friend. Don't get me wrong. I love the Clyde Beatty–Cole Bros. Circus. I wouldn't care who owned it, a corporate sponsor, Mr. Pugh and Mr. Holwadel, the state of Florida. I love this show. But the fact is, it takes your life away. Sometimes the circus is a ball and chain around your legs."

In the distance three whistles blew, indicating ten minutes before the start of the evening show. Jimmy blew three whistles in return, indicating he was on his way. Without speaking we both stepped back from our conversation and moved in the direction of our separate worlds: he to the big top, I to Clown Alley. And in that movement was the essence of the circus. Stop talking, stop thinking, stop trying to put it into words and get back to the show before it goes on without you.

Back in the Alley there was an envelope on my trunk. It was addressed to Ruff Draft, my official clown nickname given to me by the band. My other nicknames included Bruno, Rewrite, and, from one of the butchers, Hemingway. Inside was a card showing a duck on the front with his arms outstretched. CONGRATULATIONS! it said. YOU DID IT! Inside was the message: . . . NOW AREN'T YOU GLAD YOU TOOK A QUACK AT IT?! Below the printing was a handwritten message: "Happy 1st of May on the 1st of May." It was signed: "Li'l Buck."

Give the Bear a Dog

If there isn't an old circus saying that after a while an animal trainer begins to look like his animal, then there ought to be. After Venko Lilov there probably will.

As soon as the allegedly Russian swingers go sprinting from the rings, the lights go dim, the bass drum thumps proud, and the spotlights come up on the back door of the tent, where a dour, doughy wrestling hunk of man swathed in an alarmingly bright yellow tuxedo is leading behind him a burly dragoon of actual Russian bears. Hardly Mexican wolves in sheep's clothing, these bears are the genuine face-slashing article. Venko's wife, Inna, who walks next to her husband in a lavishly low-cut yellow evening dress and well-styled burgundy hair, has a forty-stitch scar and a recrafted face to assign to the wrath of her love.

"In the center ring, the children's favorite, those lovable Russian bears, presented by the Lilov family . . ."

Arriving in the center ring with his bears, the forty-six-year-old Venko looks like an overgrown stuffed bear himself, like a kid with a black eye and broken nose who had been plucked from outside the principal's office, stuffed into an ill-fitting rhinestone jacket, and thrust onto the stage as Papa Bear in an elementary school production of "Goldilocks and the Three Bears." Next to him, his wife looks like a luxurious Mama Bear with fingers slenderly stretched in the air, toes gracefully pointed

toward the ground, and face shyly adorned with the beatific smile of an aging Bolshoi star. Between them, the person who leads the first bear into the ring is Danny, their fifteen-year-old stick-figured Baby Bear of a son who despite a hint of adolescent fur on his upper lip looks more like a chess prodigy than a wrestler. Earlier in the year he had earned the indelible nickname Danny Busch after drinking his first can of beer one night and walking stone drunk into the side of the tent. The Lilovs' rather grim appearance may not be Hollywood in style, but their personal story is certainly fairy tale in scope.

"When you live in a Communist system," Venko explained, "any way out is a miracle. Kenneth Feld was our miracle maker."

Venko Lilov was born in Sofia, Bulgaria. Because of his prodigious size, he was selected as a child for special athletic training schools, eventually rising to become three-time heavyweight wrestling champion of the country. Championships, however, did not guarantee him freedom, and one day at the height of his career a friend suggested he try out as a catcher for a famed teeterboard troupe that was leaving for the West. "I went to the practice like it was a joke," he remembered. "Two weeks later I was in America." Overnight he knew that's where he wanted to be. Returning home two years later, Venko married Inna, a Russian wirewalker born in Tbilisi, and the two of them set out to develop an act. Starting with two Russian bears her father had presented to them as a gift, they went to work. In no time they had a family, an act, and a way out. They also had an enemy. "It was a nightmare," Venko said in his beefy Slavic accent. "The director was fucked up. For some reason he hated us. I had an offer to go to Italy. He said, 'No, you go to Czechoslovakia.' I had a contract to go to France. He said, 'No, you go to Russia.' He didn't want us to get out. This lasted nine years."

Until one day Kenneth Feld appeared. "He came to the office and said, 'I want that act.' He was the producer of Ringling Brothers. He saw our pictures and wanted us on his show. It was that simple. We got hired by photographs. The director didn't dare turn him down."

"So why did he pick you?"

"Because we were different. Our act was based on sports—rings, hurdles, parallel bars. No bears in dresses. No waltzing in the ring. One month later we flew from Sofia to Paris, from Paris to New York, and from

New York to Sarasota. The bears went to sleep in Bulgaria and woke up the next morning in Florida. They never knew the difference. I did."

In America the Lilovs once again began to build a new life, though at the time they were making little money. Kenneth Feld paid the Bulgarian government, and the government in turn paid them—$105 a week. Undaunted, they began to breed their bears and cultivate a stable of well-trained animals. Within six years they had developed enough of a reputation and saved enough money to break away. They left Ringling Brothers and moved to Mexico. This proved to be a near-fatal mistake. Once they left the United States, the bottom fell out of their dream—their banks recalled their notes, their working visas ended, and they were stranded with five bears, two loans, and no resources. It was at this point that Douglas Holwadel stepped into their lives. Having promised them a contract, he guaranteed their notes and arranged for working papers. The next year Venko Lilov's Performing Bears would find a home on the Clyde Beatty–Cole Bros. Circus.

•

After the first trick, in which Jackie, a two-hundred-pound toddler, jumps over track-and-field hurdles, Venko leads his bears through several displays of gymnastic skill—turning somersaults, jumping rope, balancing on the parallel bars. This series climaxes when Venko unhooks his prized patriarch, Dobush, an eight-hundred-pound, sixteen-year-old behemoth of a bear, and leads him to a set of gymnastic rings suspended from a bar. Dobush lumbers slowly to the front of the apparatus, places his paws tentatively on the rings, and with a gentle kick with his legs leaps up onto his forearms and performs a towering handstand two feet above the ground. The trick elicits gasps of approval.

"A good trick has to be close to the people. Something they can relate to," Venko told me. Unlike the Rodríguezes or the Bales, Venko had originally been unfriendly toward me. He was hostile toward outsiders, and, even though I mostly stayed clear of him at first, he actively sought me out around the lot to deliver a series of dire admonitions. "I'm warning you, man," he liked to say, "these people will kill you once your book is published." About two months into the season he finally confronted me directly one night on my way back to my trailer. How could I write

a book about the circus business, he wanted to know, when I was only traveling with one show? I'm not writing about the business in general, I told him, but about this show in particular. Well then, how could I write about this show at all when I didn't know anything about animals? That's why I'm interviewing performers, I told him, because I didn't know anything about the acts. Interviewing? he said. I didn't know you were doing that. And with that he offered me a beer.

"For the last few years I've been working on a new comedy car," he went on to explain in that first of many late-night drinking sessions. "In the act the car breaks down and the bear and I try to fix it. When the bear sticks his head under the hood and pulls out the radiator, the people will go crazy. Why? Because everybody in that audience—at least the adults—has a driver's license. They've been dicked around by service people. They will think it's funny."

"And does the bear think it's funny?"

"Are you crazy? She doesn't know it's funny, She does it for the cookie. She wants the reward. Now she likes it, of course. You can't make a bear do something it doesn't want to do. But all these animal rights people who say we force the bears to do the tricks, they don't know what they're talking about. They say that we teach the bears to jump rope by using a heat pad. That's crazy, my friend."

"So how did you teach them to jump rope?"

"The bears, they were young. I had some bread one day and I was waiting to feed them. Jackie jumped up to get the bread. I ran and got another piece of bread and she jumped up again. The next day I got a rope. She jumped up to get the bread, I gave her the bread and pulled the rope underneath her. And that's it. Once I have the trick I don't practice it anymore. I wait a couple of days, maybe a week or two, and let her remember what she did. Then I go back and do it again and she's learned the trick. I don't teach them the tricks, you see, they teach me."

"And they do all of this for a cookie?" I asked.

"All for a cookie. Just like the ones you buy in the store. Gingersnaps, sugar cookies. We can't use raisins or chocolate chips because they get stuck in their teeth."

"So why don't they ask for more?" I said. "When I was a child and got

rewards for doing something I would ask for more the next time. Will they do the same trick for the rest of their lives all for the same reward?"

"Bruce," Venko said. "You sure are a dumb fuck, aren't you? Use your head. You have to think about what you're doing in order to get a higher reward. You have to think, 'Today I get five dollars; tomorrow I'll ask for ten.' The bear doesn't think that way. For him it's all a reflex."

"If that's the case, then why are so many people upset about having trained animals in the circus?"

"Because we have them on leashes. Because they wear muzzles. Of course, the people don't realize that the bears can walk without the leashes, they can work without muzzles. It's all for safety."

"So why don't you just explain what you're doing?"

"You can't rationalize with the public. People are fucking stupid, my friend. You just don't understand. They come up to me every day and say things like 'Wow, man. Where did you get those monkeys?' Just this morning I was opening the cages to feed the bears and a woman behind me called, 'Excuse me. Excuse me, sir!' I ignored her but she kept on calling, 'Sir, sir. Can I ask you a few questions?' She wouldn't shut up, so finally I turned to her and said, 'Lady, don't you have a fucking brain in your head? What are you thinking? I have an eight-hundred-pound bear in my hands and if I turn around and talk to you he just might decide to eat me.' She pressed her lips together and shot me a bird."

"Does this only happen in America?" I wondered. "Or all over?"

"It's worse in America," he said. "Also, it's worse now than it's ever been. You just watch, it's bound to explode."

•

"CLOWNS, YES! ELEPHANTS, NO! CIRCUS ANIMALS HAVE TO GO!"

The chant was faint yet clear as it wafted up from the parking lot of the Apple Blossom Mall in Winchester, Virginia, a little after three o'clock in the afternoon. The show had arrived the night before in the pedigree-perfect pink-and-green town just across the West Virginia border from famed Harpers Ferry, and for the first time all year a small group of protesters showed up on the lot to picket against the show's alleged violation of animal rights. One of the women wore a polyester

tiger costume. Another carried a cardboard sign that said: "MAKE THIS YOUR LAST CIRCUS." A man was dressed in a saggy pom-pom clown costume with runny makeup on his cheeks that already raised my territorial ire: Don't you know how to powder? I thought.

The first person to notice them was Sheri from concessions. She came climbing over the hot-dog counter and screamed at the protesters to get off the property. The second to arrive was Dave Hoover, the former tiger trainer turned "chief safety officer." He waved his soggy cigar in their faces and threatened to have them arrested. Doug was much calmer when he appeared. "You are welcome to picket," he said. "But this is private property and you are not allowed here." They quietly moved toward the parking entrance.

"This isn't private property," I said to Doug after they had left. "Do you have the right to ask them to leave?"

"No," he said. "I just bullshit a little."

Several minutes later I walked toward the parking area to speak with the protesters. When I arrived they were discussing the best place to stand. Jimmy told me that in one town the picketers stood at the stoplight and directed people to circus parking "just up the way," which actually led them out of town. This group was less destructive, but equally adamant. They were from PETA, People for the Ethical Treatment of Animals, and had driven in fifty miles from Washington, D.C. A reporter had told me earlier that they had sent a press release to the local newspaper announcing their picket. As they were settling into a location, several children stopped in front of the man in the clown costume with his polyester orange wig and said, "Look, a clown!" The man frowned. I grimaced. The children walked away. In the meantime his partner handed me a pamphlet. CRUELTY IS NOT ENTERTAINMENT, it said over a photograph of an elephant in shackles. "Although some children dream of running away to join the circus, it is likely that most animals forced to perform in circuses dream of escaping them."

After glancing at the pamphlet, I asked the woman whether she had seen the show. She said she had not. Had she spoken with any of the animal trainers on the show to see how they care for the animals? I said. Again, she said no. Did she picket all circuses, I wondered, or only this one? She said they picketed all places where animals are cruelly treated. As we were speaking, Doug appeared at the edge of the lot and looked at

me with harsh, disciplinary eyes. He gestured for me to follow him. "I'm only speaking with them," I said when we met at the top of the stairs. "There's no harm in that, is there?"

"Just don't pay any attention to them," he said. His voice wasn't angry, only firm. "The people on the lot get all excited. The best thing to do is ignore them. They're all vegetarians and don't respond to reason."

We nodded goodbye and I returned to my camper.

Back at home I continued reading the pamphlet. NO FUN FOR THE ANIMALS, it said across the top. "Colorful pageantry disguises the fact that animals used in circuses are mere captives forced to perform unnatural and often painful acts. Circuses would quickly lose their appeal if the details of the animals' treatment, confinement and training became widely known." To support this claim the pamphlet listed five alleged abuses.

1. Animals are forced to travel thousands of miles with the show for 48–50 weeks every year. Although the length of our season was only thirty-four weeks, the fact of the travel was accurate. *2. Tigers live and are transported in cages only 4' x 5' x 6'—barely enough room to turn around in.* This statement was also essentially true (even though the cages were slightly larger), but it failed to mention that the size met USDA regulations. *3. Animals perform unnatural acts like balancing on one foot and jumping through flaming hoops only under threat of punishment.* While the animals on our show did perform some unnatural acts, most of what they did were natural behaviors, and in any case they didn't do them under the threat of punishment, but in the promise of a reward. *4. Elephants are chained in filthy railroad cars which are often left in the sun in 90 to 100 degree weather.* Our show did not have railroad cars, and the animals were never left in the truck on hot days but kept under canopies. *5. Elephants are beaten across the eyes, on their trunks and on the backs of their legs with "bull hooks" and whips.* Elephants on our show were not beaten across the eyes, and in my experience were not beaten at all, although they were prodded and slapped frequently in the other places mentioned.

All in all, I was left with the feeling that the pamphlet was overstating its case and was ultimately not very convincing. This came as no surprise. After several months on the show I had gleaned enough about the animal rights movement to realize there were two camps: first, a moderate camp that doesn't mind animals in circuses as long as they are well

treated; and second, a more radical camp that doesn't approve of animals in entertainment at all. The picketers from PETA belonged to the latter group. After observing them in Winchester, as well as two dozen locations around New England, I was left with the distinct impression that they were more interested in stirring up controversy than in engaging in a dialogue with the circus to address their concerns. While their lobbying in Washington has at times been extremely effective, their grassroots efforts around the show were ineffective at best and often laughable. In Ithaca, a group of PETA protesters appeared on a nearby bridge during a heat wave to claim that it was too hot for the elephants (who are from Southeast Asia, after all) to work. After twenty minutes the protesters themselves got so hot they gave up and went home.

As for the circus, its treatment of the animal rights issue seemed just as bad. While the circus has many points in its favor—many Americans clearly like seeing animals perform; circus animals often exercise more and live longer than their counterparts in zoos; circus animals, by and large, are in fact well treated—circus people have generally ceded the platform to the protesters. Instead of reaching out to moderate groups and inviting them to inspect the animals (as the USDA does several times a year), circus owners and animal trainers alike have treated all concerned people as irrational rabble-rousers and refused to engage them in any reasonable discussions. As a result, public sentiment is slowly but steadily moving in the direction of keeping animals out of circuses altogether. It was a widespread assumption around the lot, for example, that if the show itself survived for another ten years the number of animal acts would be severely curtailed if not eliminated entirely.

In Winchester, meanwhile, the first arrival of the protesters prompted all sorts of agitation on the lot. Khris Allen, who after all called himself a "cat choreographer," was the least ruffled of the trainers. "I actually consider myself more of an animal rights activist than most," he said. "I'm actually doing something for these animals. If any protester wants to see how we care for our tigers, I have a standing offer that they can travel with us for a week. We'll even pay their way. But they don't even come and talk with us. They'd rather stand in front and picket."

Dawnita Bale, whose father was a cat trainer and who with the aid of her

sisters cared for and presented the horses, was less sympathetic. "These pro-testers have nothing to say to me," she insisted. "These horses are my liveli-hood. Why would I want to mistreat them? Sure, there are some bad trainers. There's one bad apple in every bunch. But I make sacrifices in my life to make their lives better. And what bothers me is the unprofessional attitude of these protesters. Why don't they get current information? Their pamphlet is the same one they've handed out for six years. They've got a picture of one of Gunther's elephants and some outdated information. Remember, these are people who wear leather shoes. They eat at McDon-ald's. They wear perfume, which, after all, is tested on animals. Why don't they do something about the cat and dog populations in their own hometowns? That is a problem they can have an impact on, not circuses."

Venko, of course, was more blunt. "These people piss me off," he said. "They come on a beautiful morning, with sunshine and everything. Then as soon as it starts raining they leave. Why don't they stay when the goddamn tornado is coming, or a big windstorm. We have to be with the animals all the time."

"Is the problem getting worse?" I asked him.

"It wasn't this way ten years ago. Now they've started making rules. The people who make the laws know nothing about the animals. Some-body sits at his desk, gets letters from the animal rights activists, and says, well, we have to make bigger transportation cages. This is god-damn crazy. If you have bigger cages, as soon as you hit the brakes the animals will fly from one side of the cage to the other. As it is, the ani-mals have to exercise every day. They practice in the morning, they have the shows in the afternoon. The rest of the time they sleep. Also, they en-joy it. When we go to work they like it. As soon as the music starts they jump all over the place. For them performing is play."

For all the huffing and puffing about animal rights activists, in the end they had little immediate impact on the day-to-day operation of the circus, except for one dramatic showdown halfway through the season on Long Is-land. Instead, the circus faced a greater immediate threat from the activi-ties of naïve animal lovers. This was the cause of the most tragic event of the year, in Fishkill, New York. And this was also the source of the most shocking event of the season in West Barnstable, Massachusetts.

"I finished my act in the four-thirty show," Venko recalled about that afternoon, "and returned to my trailer. Usually one of us will watch the bears, but in this instance we all decided to change clothes as quickly as possible. I was changing into my blue Ringling coveralls, the ones I wear when I do my welding, when suddenly I heard someone shouting, 'Help, help!' As quickly as I could, I went running toward the cages. I was wearing only my socks and saying to myself, 'God, please don't let anyone be hurt.'"

As soon as he got outside he saw the blood. Then in front of the cage he saw the woman. She had walked from inside the tent in the middle of the show. Arriving in front of the Lilovs' truck, she decided to feed a hot dog to one of the bears. They look so cute, she must have thought. Surely they must be hungry. Undeterred by the multitude of DO NOT ENTER signs, the woman climbed over the portable orange fence, stepped up to the truck that held the bears, and stuck her hot dog through the narrow gap at the bottom of the cage.

"She picked our worst bear," Inna recalled. "That one doesn't like anyone but me. She hugs me. She kisses me. But she doesn't even like my husband. The lady went right for her cage."

Predictably, once the bear caught sight of the hot dog she immediately lunged for the treat. When she did, her paw got stuck in the woman's bracelet and her claws dug deep into the woman's hand. The woman started to scream. Venko sprinted from his trailer. He grabbed a shovel from the side of the truck and swung at the bear. As he did, the bear let go of the woman, but not before tearing a hole in the top of her hand and ripping her index finger to shreds. Blood was spewing everywhere. The woman fell back in horror. For a moment there was silence, then suddenly, inexplicably, she got up to leave.

"She was drunk," Venko said. "She was trespassing. She was attacking my bears. I told her to fucking stay where she was."

Inna came running out with a camera. The police showed up and made a report. Eventually an ambulance arrived and drove the woman to a hospital. For the time being everyone was in shock. The encounter was the worst nightmare of everyone on the show. It seemed to highlight all of the hazards of life in the circus: the danger of working with animals, the perils of dealing with the public, the threat of disaster at any moment—even outside the ring. Like anxious parents who fret for their

children as soon as they step out of sight, performers live in constant fear that their families will be taken hostage by events such as this. But what developed next in this episode surmounted everyone's past experience. In fact, it seemed to transcend the rich history of the circus and embed itself firmly in the culture of the present. The one fact that haunted all of us for months, the one detail that made this incident with the bear representative not just of the circus but of American society in the 1990s, was that the boyfriend of the woman who fed her hot dog to the bear announced to doctors at the hospital that the woman was HIV-positive. As a result, in the harried days that followed this already horrid episode, the show had to get not only the three members of the Lilov family but also their five Siberian bears tested for the AIDS virus.

When I heard this news, all I could think of was Venko's beleaguered admonition: "People are fucking stupid, my friend. You just don't understand."

•

As soon as Dobush completes his handstand on the rings the act accelerates through a series of increasingly complex tricks: Tampa rolls backward on the parallel bars; Peggy walks on a spinning barrel; Dobush catches a series of juggling rings and slips them necklacelike over his head. For the final trick the prop crew brings out a giant trampoline and sets it in the center of the ring. Venko leads Dobush onto the bright red trampoline. With the drummer accenting the bear's every bounce with his lower toms and sixteen-inch cymbal, Dobush springs several feet in the air like a giant furry version of one of those juvenile bat-a-balls. The audience applauds enthusiastically, but Venko barely smiles. In truth, his heart is no longer in the ring.

After the disaster on Cape Cod, Venko slowly descended into a low-grade rage about the circus. The HIV tests on the bear, performed by a special veterinarian, proved negative. The tests on his family were negative as well. But still Venko had had enough. "I'm preparing myself to leave show business," he said. "I don't need this anymore."

"Are you sad?" I asked.

"Bruce, you've been here too long," he said. "You are starting to think like these people. Just because I live in the circus doesn't mean I have to

die here as well. Do I want to be seventy years old and driving two hundred miles to the next lot and arriving at five in the morning? I want to have a normal life. I want to have a house. I want to work five days and have two days off. I want to go fishing. Now I must work twenty-four hours a day, seven days a week, three hundred sixty-five days a year. When I go to a Chinese restaurant I must be thinking what would happen if the cages came open. When I go to the supermarket I must think what happens if my fence breaks. Sometimes I do not sleep at night. The reason is if something happens to my bears I am lost. And if something happens with the public they sue me."

The lady who fed the hot dog to the bear did eventually sue the circus. Even though she was trespassing, the show settled out of court for $9,000.

"This is a great country. You can work very hard and make a good living. When I first came to this country in 1973 I was making four dollars a week. Ten years later I was making only $105 dollars a week from Kenneth Feld. Now I make a good living but I have $1,000 a week in fixed expenses. That is okay when I get paid, but when I have three weeks off in the winter that starts to cost a lot of money. Every year I have to begin the season with no money. This is no life for a family. I'm just happy I'm not like the rest of these people. I have something else I can do."

When he did leave, Venko said, he planned to give his bears away to zoos and open a twenty-four-hour trailer repair business in Florida. Still he vowed not to forget where he came from, or what caused him to leave. "I'm going to call my company Royal Bear Trailers," he said, "and I'm going to ask every customer that comes in if they are animal rights activists. If they say yes, I'm going to charge them triple."

6

Death of a Naïf

Soon after Ahmed's wife, Susie, had her baby, something happened to the show. We were in New Jersey by then. June was on its way. Suddenly the show was losing its freshness. Overnight a sort of seven-week itch consumed the cast and crew.

In Clown Alley, meanwhile, discord still reigned, though I was growing more settled. In the two months I had been clowning I had slowly warmed to the ring. At the start of the year I had often stared at the ground during shows. It wasn't nerves, just concentration. With every lot a different surface—asphalt, mud, grass, or gravel—every day presented a different danger. Sometimes I would slip on an anthill during the firehouse gag and land on my back. Sometimes I would trip on a rock and land on my face. This was hilarious for the audience but painful for me. Finally Elmo pointed out during one of his visits that I should stop playing to my feet and play to the audience instead. "Don't make eye contact with anyone," he said, "but make faces in their direction. If you don't look at anyone in particular, everyone will think you're looking at them."

As a performer, my relationship with the audience was not what I would have expected. In many ways the performers don't do the show for the audience. The size of the crowds varies widely, from frequent packed houses of over 3,000 to the occasional dismal showing of under 200 (Rock Hill, at 157, was the lowest of the year), and performers can't rely

on them for motivation. As a result, they must rely on something higher—like a love for the circus—or something lower—like the promise of a paycheck. Moreover, the size of the crowd is often less important than its enthusiasm. In Phillipsburg, New Jersey, near the Pennsylvania Dutch country, the show sold out but the people were taciturn. In Willingboro, closer to Philadelphia, we had only half houses but they were mostly Latin and cheered with zeal. When the Flying Rodríguez Family was introduced as the "Pride of Mexico," the crowd whooped and whistled with patriotic hysteria. Unfortunately they were less adoring of the Rodrinovich Flyers, not realizing they were Mexican as well.

For me, each particular audience was less important than my overall attempt to develop my clown persona. I learned early how to turn on and turn off my clown on demand—"on" when I stepped inside the tent, "off" when I stepped out. Not particularly limber, I had been developing a character that was upright, almost formal: an inept maître d' with a relentlessly sunny spirit, blind to the restaurant burning down around me. Ironically, even though the historic distinction among clown categories (whiteface, Auguste, and a few minor characters, such as the tramp) has all but disappeared in recent years, I fit naturally into the role of the traditional whiteface: a straight man and perfect target for all the manic Augustes around me. This was particularly true in the firehouse gag.

Like everyone else in the Alley, I joined in the rush to find new bits to add to the gags. During the ladder routine in particular I needed something to do. I considered normal things that firemen do that would be funny when done around a burning house, such as selling tickets to the firemen's ball; as well as things that normal people do over a fire that would be funny for a fireman to do, such as roasting marshmallows. In the end I settled on a normal thing that people do to a house that would be funny for a fireman to do, namely, painting the outside. This idea was made possible by the fact that Marty had the perfect prop, an oversized painter's palette with a giant scrub brush on a stick. A few days later Jimmy was lecturing a few of us over dinner about the virtues of sight comedy over slapstick when he asked, "By the way, who came up with the painting?" I signaled that I had. He raised his eyebrows approvingly, but didn't say anything further. He didn't have to. I was learning my way.

Unfortunately, no sooner had this prop come to symbolize all the virtues of the Alley than it came to represent its faults. While the clowns pretty much cooperated during the gags, once out of the ring the boys would usually just return to the Alley, take off their wigs and pants, and sit around in their undershorts telling off-color jokes. I had been trying to counter some of the tedium and improve my relations with the Alley by asking a few of the boys—particularly Marty—to give me some pointers on being a clown. Although at nineteen he was the youngest, Marty was also one of the hardest-working and most talented of the clowns. In his loudmouthed persona of the Village Idiot he was also the most outspoken, the most conceited, and the most resentful about my being considered a clown. He would constantly complain about my makeup, the way I pulled the cart, even my driving. After passing me on the road one night in the truck he drove for the electrician, he sought me out on the lot. "Bruuuuce," he said in his whimpering Village Idiot drawl that he never seemed to put away. "It's considered courtesy to blink your lights at somebody when they pass you." After several incidents like this, I decided to treat him with the respect he craved and asked him to teach me about taking falls, making bangs, and building props. He eagerly obliged. Soon the problems got worse.

First, he started giving me little pieces of niggling advice. "This is the finale," he would say. "I think you ought to look more spiffy." Next he tried to change my makeup. "Your face is really boring," he would say. "I think you should change it." Finally, one Sunday evening in Exton, Pennsylvania, he went over the top. The weather had been gorgeous all weekend, but suddenly during our final show the sky darkened and a light rain started to fall. We had already dismantled the firehouse and only the fire cart remained to be loaded into the prop truck for the jump. The palette and brush that Marty had loaned me remained, as they always did, at the bottom of the cart. As the show ended Marty came into the Alley.

"Bruuuuce," he said in his ingratiating whine. "Will you do me a faaavor?"

"Sure," I said, "what is it?"

"Tomorrow, take the palette and brush out of the cart, wash them off, put them in the truck, and never use them again."

Then he spun around and left.

For a moment I was stunned, then dumbfounded, and in the two-and-a-half-hour drive to New Jersey that followed, I slowly became annoyed. The next day, after putting away his prop and replacing it with one I built myself, I pulled up a chair beside him in the Alley when no one else was around. I understood that my presence in the Alley was somewhat unusual, I told him, but I wondered if he would treat me with respect nonetheless.

Marty was caught off guard by my directness. He said he had learned in the circus that you can't ask people nicely to do things but must treat them like children. Then he apologized. Later that night he complimented me on my bow tie. The next day he asked for my help with his trunk. As with Sean and Kris several weeks before, the less I acted like some silent cartoon (or even a distant writer, for that matter), the more I was accepted into the circus.

•

In Willingboro, Sean asked me to go to the mall. He was looking for a new pair of high-top sneakers to replace the ones he wore in his act. The twice-daily impact of the cannon launching pad against his feet had completely wrecked the soles of his shoes. It had also all but eliminated his arches and almost ruptured his knees, thereby aggravating what he referred to as his rickets, the euphemism for his bowleggedness. When he was on CBS's *Street Stories*, Sean had mentioned the problems he was having finding shoes with sufficient support and afterward had waited expectantly for several weeks for an endorsement contract from Nike. Unfortunately, it never came. Michael Jordan got millions for jumping fifteen feet from the foul line and dunking a ball in a net; the Human Cannonball can't even get a free pair of shoes for getting shot one hundred and fifty feet twice a day from a cannon and dunking himself in a net. Clearly the scales of justice don't weigh all acts the same.

In the mall our subject wasn't feet, but guts. By late May we had entered a several-week stretch of towns where we played only mall parking lots—York and Exton in Pennsylvania; Voorhees and Princeton in New Jer-

sey; Fishkill and Middletown in New York; Danbury in Connecticut. The circus likes playing malls because they are central, easy to find, and mothers feel safer bringing their darlings to a circus in front of TGI Fridays than across the street from Al's Hubcap and Fender at the fairgrounds three miles out of town. The malls like having the circus because it brings in customers, generates publicity, and enhances their reputation as the new town centers of suburban America. The performers like being at malls because the men can find bars to watch sporting events at night, the women (and men) can go shopping during the day, and the kids can escape their mothers' trailer cooking and enjoy a Chick-Fil-A for lunch.

Sean liked malls because of the mirrors. Considering his penchant for fistfighting and mudslinging, Sean was remarkably vain—particularly about his hair. His blond locks were short in the front with Little League–type bangs and long in the back with rockabilly-like ducktails. In every place he spent more than a passing moment he liked to keep a brush—in his trailer, in my trailer, in the front seat of the cannon. Before his act he would usually brush his hair for ten or fifteen minutes in a combination of Herculean narcissism and Samson-like fortification. In Lynchburg, during one particularly marathon grooming session, I noticed with some alarm that four of the metal bristles of his white doggy-style brush were missing. "I bit them off," he said from the top of the cannon. "The rubber was missing off the tips and the metal was hurting my head. When you brush your hair as much as I do you have to be careful." In a stately gesture he took one final sweep of his bangs and tossed the brush down to the ground. As he did, Arpeggio appeared alongside the cannon and caught the brush in his hat. "Oh, Mr. Thomas," he squealed. "Thank you so much. I'll treasure it always." "There are a few hairs left in it," Sean kindly pointed out. "You can keep them if you want."

Going to the mall with Sean, even a run-down one like Willingboro Plaza, was to be a bit player in this ongoing parody of self-aggrandizement. On the way to Pic-n-Pay we passed a mirror. "Sometimes I look at myself in the mirror and wonder why God was so good to me," he said. "And the other times?" I asked. "I *know* why." To get around this seemingly impenetrable wall of self-confidence, I asked Sean during our walk through the mall to tell me how he met Elvin. He responded with surprising modesty.

Sean's first brush with the cannon came in 1989, two years after Elvin's accident, when Elvin first asked his unsuspecting pool boy if he would be interested in joining the circus. Sean said yes; his girlfriend, however, said no. The idea was quickly dropped. Two years later, with no replacement in hand, Elvin again approached Sean. Once again he said yes; more importantly his girlfriend was no longer around. Within a week he was practicing.

"I remember the first time I got inside the cannon," Sean said, his voice unusually respectful. His posture was much less sure. "The net was up against the lip of the barrel. That was before we had the air bag. I was wearing sweats and Reebok hiking boots. I slid into the capsule and got situated—my legs on the platform, my butt on the seat, my arms crouched at my side. My whole body tensed up. I took the hit—the initial bang when the capsule slides up the track—and I almost passed out. By the time I knew what was happening I was already coming out of the barrel. My heart was beating. I was scared. I ducked my head like Elvin told me to do and the next thing I knew I had landed in the net. You're supposed to land on your back. Only that time it didn't work that way. I dragged my feet when I was leaving the cannon and my left foot caught the bottom of the barrel and my shoe was ripped off. I was lucky my foot wasn't taken off as well."

"Were you hurt?"

"No. I got up and Elvin said, 'Are you all right?' and I said, 'Yeah, I got my foot caught on the mouth of the cannon.' 'You've got to keep your legs together,' he said. So I got in again. That time I was concentrating so hard on keeping my legs together that I spread my arms apart too soon. When I opened up I caught the last two fingers of my left hand on the edge of the barrel and split the webbing between my fingers. My wrist got hurt as well. Elvin gave me the rest of the day off. That's when I got really frightened. On my way home an old lady pulled out into the road in front of me and I had to swerve my Jeep to avoid getting killed. By the time I arrived at my friend's house I was shaking like a leaf. 'Sean, where have you been?' he said. 'You're covered in gunpowder.' I looked down at my body. My black sweats and red T-shirt were coated in white with splotches of blood everywhere. It looked like I'd been shot. But it

wasn't the shot that freaked me out. It was the lady. She had almost killed me. That's when I realized my life was about to change."

For the next several months Sean drove out to Elvin's house every afternoon at 4:30, took a couple of shots, and slowly learned his way around the cannon. Elvin guided him through the mechanical operations part by part, piece by piece. "It's kind of Neanderthal," Sean said, "but it's brilliant." Elvin also guided him through the mechanics of flight: keep your back stiff, your legs straight, your toes pointed. Shoot straight ahead, look where you're going, reach for an imaginary track. Gradually they lifted the cannon higher, Sean flew further. Now his head was straight, his back was firm, but his legs were still lagging behind. "For most people who aren't gymnasts it's hard to control your legs," he recalled. "When you watch somebody dive off a diving board, they can usually control their upper body—their arms and their head—but their legs are always sagging. They have them apart or their toes aren't pointed. In the air you have to stay perfectly straight, then at the last second, in order to get over, you have to squeeze your butt and point your toes so you rotate over onto your back."

Within several months opening day arrived. Sean's parents came to DeLand for the show. His ex-girlfriend was there as well. Sean marched in the opening parade, then almost immediately came out for his act, which at the time followed the tigers. Elvin was frantic with nerves: Sean had never done a shot in the tent, only in the open air. Everyone else was nervous as well. Sean, however, was a beacon of càlm. "Elvin said to me, 'Are you sure you're not going to freak out? Are you sure you're not stiff?' I said, 'What's there to be afraid of? Let's just do the shot.' So I did the shot. It was perfect, beautiful. Elvin was so excited. 'I told you I could do it,' I said to him. He just started to cry . . ."

Sean went silent for a moment. We had stopped for lunch at a Chinese takeout—chicken with peanuts, Oriental vegetables. He put down his fork. "I can't say Elvin's like a father to me because my dad's an incredible father. Elvin's different. My dad's like my best friend, a real-guy kind of father. Elvin's more like a *Leave It to Beaver* type of father. My dad was never really strict with me. Elvin's very bossy. When we left DeLand last year and drove to Brunswick, Elvin asked me to call every day, but I

never did. He gets mad, but I tell him I have it under control. He says, 'That's why I worry about you. You only call when there's a problem, so when the phone rings and it's you, I know that there's a problem.'"

For Sean's first several months on the show Elvin's phone never rang. There were problems, but nothing Elvin could solve. For Sean, cocky about his body as well as his virility, the primary problem was dealing with his colleagues. "I wasn't from the circus," he said. "My family wasn't from show business. They all knew that. I had to be accepted. That was hard, especially on this show where everybody has grown up together. They all said he's not a performer or anything and now he's automatically the star of the show. He's always on TV, he's got girls in his trailer every night, and he's got a full page in the program, which, ooh-ooh, is a big deal to these people. To me I couldn't give two shits, but to them . . ."

Everyone thought Sean was a snob because he did the cannon. To make matters worse, they thought he was English. "They just wouldn't speak. I would say, 'Hi,' and they would just be cold. It's that snobbery thing. You know how it is."

"So how did it change?"

"I kicked a few butts. There were a few rumors around, and finally one day I got mad. If I've done something and you've seen me do it, tell the whole world, I don't care. But if you don't see me do something and you make it up, then I'm gonna get some revenge."

The first rumor involved drugs. At the beginning of the year Sean made the bang that accompanied the cannon shot by pumping acetylene gas into a balloon. He would turn on a torch, snuff out the flame, then inflate the balloon with the gas. One day he snuffed out the flame incorrectly, and when he went to squeeze the gas the balloon exploded in his hands, shredding his shirt and burning half the skin on his stomach. Nellie Ivanov gave him some baking soda to put on the wound. That night he was sitting in his trailer when some of the workers came by. "They saw me with this pile of baking soda on my table and said, 'Man, sell me some of that.'" The following day Kris came up to him and said, "Sean, you better watch what you do. Word travels fast around here." "What are you talking about?" Sean said. "I heard you were selling cocaine to the workers."

A week later the rumors had him in jail. In Utica, New York, Sean went to watch a Chicago Bulls game on television with Jerry, the clown. In front of the lot they asked a policeman for directions and he offered to drive them himself. "The next morning I got the manager knocking on my door," he recalled. "Boom, boom, boom! 'Sean, Sean, are you in there?' I said, 'Yeah.' 'Really?!' he said. 'How did you get out of prison?' As soon as I got out of my trailer everybody was going 'Hey, jailbird. We heard you got arrested. Big cannon man had a little too much to drink.'" One of the young workers on the front door told everyone Sean had been arrested. "I wouldn't have been mad," Sean said. "But word goes back to Elvin. You get one of these shit-ass workers who goes to another show. Say these people want me to work there. 'Oh, man,' they say. 'That guy's a troublemaker. He's a bum.'"

To prove he was not a bum Sean decided to beat the guy up. Unfortunately for Sean he never got the pleasure. The man, sensing danger, blew the show first. Sean responded by beating up the man's friend who had earlier confessed to spreading the rumor. In the prison mentality of the circus, Sean was now considered a man.

"Suddenly people started talking to me. 'So, how did you get into the business?' they asked. 'Tell us, how did you get hold of Elvin? Are you family with the Bales?' First I couldn't get a 'Hi' from them and now they're asking me questions. It's just like they're doing with you now. 'So, why did you join the circus? What do you think of life around here?' As soon as that starts happening you know you're one of them."

By the time Sean had finished his story we had finished our lunch and decided to check out the one remaining possibility for shoes, Boscov's department store. As we cut through Women's Clothing on our way to Sporting Goods we overheard two women who worked at the store, which was located directly next to the lot. "They must be really weird . . . ," one of the women said. "You better believe it," her friend added. "Just wait until they come in here and start washing their babies in the sink." As soon as we heard this, Sean stopped in place and walked back in their direction.

"Are you two talking about the circus?" he asked.

"Yes," they said.

"Well, ladies," he said, yanking up his sleeves, "have you looked out the window? You see those trailers out there? In the circus we live in those, and, for your information, they all have bathrooms. So we don't need to wash our babies in your sink." He hesitated for a moment. His skin was becoming flush. Should he stop, he considered, or should he continue? But by now he realized these women weren't talking about *them* anymore. They were talking about *him*. "You see this watch?" he said, now getting caught up in the hyperbole of the moment. "It costs three thousand dollars. This bracelet costs five hundred. That's more than you make in a week. In the circus we all live in three-hundred-thousand-dollar homes on the beach. We work nine months of the year. In fact, we make more in a week than you make in a month. We don't need to wash our babies in your sink, and we don't need to buy anything in your store. And if I were you, I would just shut up."

He spun in his tracks and stormed out the door. I followed him outside. Later that day a man from the big top department walked into the store through the exact same door and shoplifted two cassette tapes.

•

Danny Rodríguez knew why someone would steal. Sitting up late the following night in a plastic beach chair near his half brother's trailer, he was complaining about a lack of money. Hardly starving, he was wearing blue-jean shorts that reached to his knees, black high-tops that climbed to his ankles, and a red Chicago Bulls tank top that hung halfway to his thighs. Basically he looked like a rapper, albeit an immobile one, for underneath his oversized duds he was still wearing a neck-and-shoulder brace from his tumble off the swing.

"Do you know what time it is?" he asked.

"No," I said.

"No?" he mocked. "You're not supposed to say, 'No.' Don't you know anything about the circus by now? You're supposed to say, 'What do I fucking look like, Big Ben?' or 'What am I, a fucking watch or something?' That's the way to be a member of the Clyde Beatty family."

Actually Danny Rodríguez wasn't feeling particularly close to the family these days. Since the accident it had turned on him full force,

starting when his immediate family had rejected his explanation for his fall. Feeling beleaguered, Danny was considering splitting the show. For him it was a matter of money.

"I tell you, this show is rolling in cash. Everyone gets it except us. They have to pay all the marketing people, the cookhouse, and don't forget the band. Also, it costs over a thousand dollars every time they fill up the trucks with diesel. And all that hay and shit for the elephants. The performers don't get anything, man. Sean makes less than five hundred dollars a week."

"A friend of mine came to see the show," I said, "and I was telling her how much work there is. 'And of course you make ninety grand a year to do it,' she said."

"Shit," Danny said. "What did you tell her?"

"I told her the clowns make one hundred and eighty dollars a week."

"Tell her I wish I made that . . ." As he spoke, a loud crash came from No. 63, where the workers were having a payday bash. Meanwhile one of the bears was wailing in his cage because his brother had been donated to a zoo. "Do you know the only people who make any money on this show? The butchers. One guy made three hundred dollars last Saturday selling hot dogs. You can make six hundred dollars a week selling peanuts. Just look at the trailers. The concession people—Larry, David—they're the ones with the expensive trailers. Look at what the performers have, driving around in these pieces of shit."

"But those jobs are hard to get," I said.

"My cousin is assistant manager of concessions on Ringling. He could get me a job selling Sno-Kones or something. You can make good money butchering, I'm telling you. Somewhere between forty-five thousand and a hundred thousand a year."

"But why would you leave your family?" I asked.

"Because I want to buy a house, a car. I don't want to raise my kids on the road. Let's just say I get married—" Danny halted himself in mid-sentence. Maybe the rumor was true, I thought. Was Danny not telling me something? He returned quickly to his tale. "I couldn't afford it. My father gets okay money, but it has to support four families. He couldn't afford to give me more right now, and the truth is, he'll probably never be able to.

There used to be a lot of large families around the circus. But look around, we're one of the only ones left. Nobody else can afford it." He sat up in his chair and straightened his brace. "Look, man, I want my children to go to school. I wish I had gone. I wish I could have played football, baseball. I might have sucked, but at least I would have had the chance. Here, you work every day, you live on the road, and for what? You wake up every morning hurting, all sore and shit. You're ruining your body. When I first arrived here I bruised my body and couldn't work for a month. Last year I tore all the ligaments in my shoulder. This year I broke my collarbone. My brother broke his foot. This is a dangerous business."

Shelagh Sloan came out of her trailer in a bathrobe and slippers and asked the workers to turn down the music. For a moment the sound of rap disappeared, only to return as soon as she left. The smell of exhaust from Big Pablo's generator permeated the air.

"But you're good at what you do," I said. "How can you give it up?"

Danny slumped back into the chair. His arms dangled between his knees. Since his accident several weeks before he had let his ponytail grow raggedly uncut and his postadolescent fuzz grow spottily unshaved.

"I might have been good," he said. "But I'm too tall. I used to do the three-and-a-half in the flying act. I might have done the four, or the four-and-a-half, but for what? They don't give you more money or shit. Let's face it, people don't come to the tent to see the quadruple somersault. I don't mean to put anybody down, but look at the program. When you open it up, who are the stars: Kathleen Umstead and Sean Thomas. Kathleen is finished. Nobody remembers her. And Sean? He has a good act, but all he does is get into a cannon and get shot out every show. Anybody can learn that. All it takes is several months."

"So why are they the stars?"

"Because they're blond, because they're American, and because the owners don't want this place to look like a lettuce farm."

It took me a moment to realize what he was saying. "They're stars because the show says they are stars. And because the public likes flashy acts. Yet to be a flyer, to be an acrobat, even to be a juggler you have to practice for many years. But the owners don't care about that, and the public doesn't either."

"So how are you going to decide what to do?" I asked.

"My cousin already said I could come join him. I've been thinking about it for the last several weeks. I spoke with my parents about it and they really don't want me to go. My brothers tell me it's up to me, as long as I serve out the contract. Basically I don't know what I want to do, but I do know I have to decide soon . . ." Danny drifted into silence. He was staring at the ground. After a moment he looked at my feet.

"Those are ugly shoes," he said.

This time I didn't hesitate. "That's an ugly face."

Danny looked up from the ground. "Well done," he said. "You're almost there."

•

"So what happened?"

"What do you mean what happened?" Big Man said. "I stole some tapes, and I got caught. Cost me three hundred dollars and eight days in prison. I didn't get any help from the show. It all came out of my pocket."

Actually his mother's pocket. The man they call Big Man was standing in front of the side door of the tent making sure no one along Route 1 in Princeton decided to sneak into the circus. In truth there weren't any seats available inside the tent even if anyone did get in, and in any case they didn't stand much of a chance of getting by Big Man. Big Man was, as advertised, big—close to three hundred pounds, in fact, with dark black skin, off-white eyes, and one prominent gold incisor. Somewhere around thirty years old, he had first joined the show when we were in North Carolina. Before that he had been working at a warehouse and living in a mission in Orlando when Bill Lane, the man known as Buddha, made his monthly run of homeless shelters, halfway houses, and Salvation Army hostels in South Florida looking for potential workers. Receiving one hundred dollars for every man he delivers to the circus, Buddha promises his prospects a world of travel and adventure in order to get them into his van. Once they arrive at the tent, however, many find themselves only halfway over the rainbow. Some quit on the spot, some hang on until the first rain, but a few manage to enjoy the routine.

They get a job, a bed, three meals a day, plus seventy-five dollars a week. And for better or for worse, they also become part of one oversized, slightly racially segregated traveling soap opera and circus sideshow.

Big Man had been one of the few newcomers in the course of the year who openly enjoyed the camaraderie of show life. After one of our gags he would usually comment on some detail we had changed on a whim. He loved the big-breasted nurse in the stomach pump. He laughed at my painting the burning house. To me he seemed to be making an effort to feel a part of the circus.

"What happened was, they caught me on one of those overhead cameras. I had my Clyde Beatty T-shirt on. The one that's a little too small." I smiled at the thought: wasn't everything he wore too small? "Anyway, they brought me into the station. I agreed to come to court, but that night the show moved to Vineland. I had no way to get back to Voorhees. I thought they would just let it slip."

The police didn't see it that way. The next day, minutes before the 4:30 show in Vineland, the local sheriff rolled onto the lot, walked up to Doug's daughter, Blair, who was selling elephant ride tickets, and demanded a halt to the show. Someone on the lot was in contempt of court, he said, and the circus could not go on until the fugitive was apprehended. All this seemed a bit histrionic for two cassette tapes, but five minutes later Big Man was guarding the big top from the backseat of a patrol car. By that evening he was dreaming about it from jail. From this vantage point, even Truck No. 63 seemed like paradise, and a week later, having served his time, Big Man walked out onto Route 1 in South Jersey and began hitchhiking north. The next morning he arrived in Princeton.

"I actually never lost my job," he said. "When I got back the manager told me I couldn't go into malls anymore. Later Mr. Holwadel gave me permission. He told me next time I want something I should just go ahead and pay for it."

"So how long are you going to stay this time?"

"Until I get some money. I only make seventy-five a week, you know. I try to save as much as possible, but that's hard. Now if I could sell popcorn or something, that would be easier. But they won't let me."

"Why's that?"

"They might tell you something else. But put it this way: I'm the wrong color."

"The wrong color?"

"White people don't want to buy popcorn from a black man. Look at the butchers, all of them are white. I don't have anything against the circus. I like it, but it's a prejudiced place. The only black man who makes any money is New York, the crew boss, and he has to work for it . . ." Big Man straightened his glasses. "Look at you," he continued. "You've got it made."

"Me?" I said, awkwardly.

"You. You get to work in the ring and make everybody laugh. You live in a nice Winnebago. You can take ladies in there. Look at me: I live in that sleeper and if I want to have a lady in there I have to put five people out. And hell, I wouldn't want to take a lady in there anyway."

"So do you think you can save money?" I asked.

"Unfortunately I have to take a draw tomorrow. I need fifty dollars to have a tooth pulled. I went to the dentist in the last town and he wanted sixty-seven. I didn't have it. New York said he didn't have it either. I even went to Rob the clown. I can't wait any longer. This morning I almost couldn't work. After we put the tent up I had to go lie down under the truck and go to sleep. When I woke up it was time to go to my door. I didn't even have time to change my clothes." He was wearing blue jeans covered in mud and a dirty blue mechanic's shirt. "I think I'll have enough saved up to leave this fall."

"And then what will you do?"

"I'd like to work in a warehouse again," he said. "I can make about nine or ten dollars an hour. I can live on that, help out my mother. She's not doing too well. I can get an apartment, fix it up real nice, and start changing my life around. I'd go to church."

"Church?" I said, surprised.

"Yes, I'm a church person, child. I come from Carolina originally. What I'd like to do is get me a job, find me a lady, and have us a nice wedding in a church. I could turn my life around, you know. All I need is a real job. Right now this is the best I got."

The Amazing Art of
Hair Suspension

"Oh, my God. I don't believe it . . ."

"You mean she's going to . . ."

"Wait a minute, this can't be real . . ."

Michelle Quiros, like a bird of paradise, glides from the wings of the darkened tent into a light that ignites the plumes that sprout from her Napoleonic hat. Dressed regally in a flowing black cape embroidered with pink-and-white fleurs-de-lis, she drifts into the ring with a silent flutter of chiffon, ruffling the feathers of her never-ending train with a not quite flirtatious quiver. Draped on the arms of her tuxedoed chaperon, she appears for a moment like a lithe ballerina in the pastel fantasies of Degas. That is, before she takes off her hat.

"Ladies and gentlemen, what yoooou are about to seeeee, is an amazing display of haaair suspension . . ."

Michelle steps forward into the center of the ring, flitters her arms like a butterfly, and in one dramatic sweeping motion flings the cape off her shoulders and into the arms of her consort. For a moment she poses—both arms in the air—as the next layer of costume, long black pantaloons, settles over her fragile body. Then, almost coyly and with no apparent chagrin, she carefully removes her hat. And suddenly there it is: it's almost imperceptible, it's draped in black velvet, many find it fasci-

nating, a few even revolting. Sticking out of the top of Michelle's well-oiled head of hair is a three-inch solid-steel ring.

"You don't really think . . ."

"I'm going to be sick . . ."

"In ring three . . . ," the ringmaster calls, *"from Brazil, Elizabeth Crystal, and in ring one"*—his voice escalates—*"from Mexico, Margarita Michelle . . ."*

Elizabeth Crystal, alias Lupe Rodríguez, struts to the center of ring three, while her cousin Margarita Michelle, alias Michelle Quiros, walks to the middle of ring one. Michelle takes a bow as her attendant attaches the ring sticking out of her head to a three-quarter-inch cable hung from a pulley at the crest of the tent. With a slight lift and a gentle push around the ring, the twenty-three-year-old Michelle slowly rises into the air and begins to slither out of her next layer of clothes. First she takes off her left shoe, then her right, and tosses them to her attendant, who is actually her husband. Next she unzips the pantsuit down her back and lets it ripple down her legs and drift teasingly toward the earth.

"It's all a matter of presentation," she told me in a voice as elegant as her act. "I'm trying to gather attention, to draw your mind to my act. When I take off my cape I'm still wearing my pantsuit, but when I take off my pantsuit all I have on is my bikini. At that point you look at my hair."

And look at her hair people do. Though naturally brown, it has been dyed black for the act. Though fairly brittle, it has been wetted down for pliancy. And though relatively thin, it is clearly strong enough to support her body weight. Still there's the trouble of that ring: How did it get there? What does it do? And where does it go at night? These questions, like Michelle, just linger in the air, cryptic and aloof. Indeed, as she hangs in the dark for a moment before turning her own set of tricks, Michelle's hair pulls up on her scalp, which in turn pulls up on her forehead, which in turn pulls up on the edges of her eyes, giving them an oddly Asian look—the essence of enigma.

"The act was originally done by Chinese acrobats hundreds of years ago," explained Michelle. "When they did it they used to drink tea and fold their legs, sort of like having a tea break in the air. In Mexico they bring a lot of Chinese acrobats into the circus. My grandmother learned

it from one of them. She taught it to my mother, and my mother taught it to me."

Michelle started practicing the act when she was eleven years old. "I told my father one day, 'I want to tie my hair up like Mom.' I stood on a chair and he hooked my hair to a cable. At first I didn't even kick my feet out, but then, little by little, I slowly lifted my body weight to see what it felt like. At first it hurt, it hurt a lot, but I wanted to do it so much I didn't care. I vowed I wouldn't cry."

After a few months Michelle was ready to kick out the chair and hang alone for several minutes. Within six months she was ready to try a few tricks. Then tragedy intervened.

"We were on Ringling at the time. My mother was doing her act in the center ring. She was spinning in the air one night when the cable holding her up suddenly snapped, dropping her thirty-five feet to the floor. It was horrible. She broke a vertebra in her neck. She fell into a coma. It was a miracle she didn't die. For several months she stayed in the hospital and after that we moved back to Florida. We stayed home the whole year. I couldn't stand to see her upset, so that's when I told my dad, 'I want to do the act. I want to help the family . . . I want to be like Mom.'"

Michelle had just turned twelve years old.

•

After stripping to her bikini, Michelle is ready for her first trick. Starting from a stationary position several feet above the ground, Michelle slips one neon-green hoop around each of her thighs and spins them toward each other. Moving deliberately, she then slips one hoop on each of her elbows, one on each of her forearms, and one on each of her hands. At this stage she looks like an octopus spinning eight mini–Hula-Hoops. Next, the three members of the prop crew who are controlling the rope that holds her hair slowly step backward and hoist her upward as if the rings around her limbs are propelling her into the air. As if to illustrate the point, the band plays "The Wind Beneath My Wings." The trick could easily seem comical, instead it is sublime.

"My father always taught me: 'It's not what you do, it's how you do it.' He's always told me you can do something very difficult, but if you

don't do it nice the people won't appreciate it. But if you do something simple and you know how to make it elegant, the act will look nicer and the people will like it."

With her sparrowlike body, her graceful figure, her caramel-candy skin, Michelle always looks nice in the ring . . . even when she's on fire. For her second trick, Angel lights three juggling torches and carefully tosses them up to his wife. Occasionally she would catch one on the wrong end, several times she actually singed the hair on her forearms, and on one frightful occasion during the fourth week of the year the torch unfortunately alit on her bangs and set her hair ablaze. "Oh, the smell!" was all she could remember. "What delight!" the crowd responded: they thought it was part of the act.

"I've noticed that people like things that look strange. If I just hung by my hair, at first they would be 'Oh, wow.' Then, after a while, they would say, 'Big deal.' I have to make it exciting. Not only can I hang by my hair but I can *juggle* while hanging by my hair. That's the way people think."

Ironically, by hanging by her hair thirty feet above the ground, even more, by juggling three fiery clubs while hanging by her hair thirty feet above the ground, Michelle does nothing but undermine any bond she might feel with the audience. The reason is simple: they all think she's odd.

"I want the audience to think my act is elegant, but I don't always get that. There are always people who say to me, 'Wow, that was beautiful.' But then I see a lot of people who are laughing. I guess I understand. If I had never seen this act and I saw it in a show I don't know how I would react. When I see these people, at first it upsets me, but then I try to be respectful."

Sometimes, she confesses, it's hard to be respectful with so many silly questions.

"For some reason everybody asks me if it's really my hair. What do they think, that it's just a wig with bobby pins in it? Some people think I have an invisible rope under my arms. One guy came up to me and said, 'So, you have a screw in your head, right?' I said, 'Yes.' I was joking, of course, but the guy said, 'I thought so.' Sometimes people are really dumb."

Michelle was not alone in this thought. Her difficulties with the au-

dience were part of a larger problem that all circus performers seem obliged to endure: most people don't think circus people are real; they think performers are fake. Just as many visitors asked Michelle if she had a screw in her head, an equal number asked her wirewalking husband if he had magnets on his feet. They asked Khris Allen if he sedated his tigers. They asked Sean if he had a double who slid into the cannon while he ran all the way around the tent and appeared magically at the bottom of his air bag 3.5 seconds later. In Ladson, South Carolina, a local woman came up to a table in Burger King where I was sitting along with several other performers. An entire section of the restaurant had been taken over by the show for a party. "I recognize you people," the woman said. "Aren't you from the circus?"

"That's right," replied Mary Chris Rodríguez.

"What are you doing here?" the woman asked.

"We're having a birthday party for our son."

"Oh," the woman said. "You mean you're normal?"

While I found this badge of oddity sad (it would seem like quite an accomplishment to be considered weird in America today), I could see how it developed. Many of the novels I read about circus life seemed to have characters that were psychopathic, satanic, or, worse, half man, half animal—a trapeze artist with the body of a swan, a sideshow prophet with the flippers of a turtle. Perhaps even more important, most of the people who came to see our show had grown up on a steady diet of television and movies and had rarely seen real people performing real feats. You can't rewind a circus act, you can't replay it either. The essence of the show is that it is real—you can smell it, you can feel it, you thrill with excitement while it happens in front of you, you tremble with fear when it happens above you, and if you decide to walk around in it, you might get muddy or sticky or covered in dung but you'll definitely know from any spot in the tent that this is the one thing you've done all day that isn't operated by remote control.

Lamentably, disbelief among audience members often translates into disrespect toward performers. I learned this matter-of-factly in Winchester, Virginia. We had pulled into town on a Thursday night for our twelfth annual stop at the Shenandoah Apple Blossom Festival, a week-

long event celebrating its sixty-sixth year that swells the sleepy Southern town of 32,000 to a population of over 100,000 and fills hotels from Harpers Ferry to Harrisonburg. The Garden Club's Annual Ladies' Lunch on Friday had been sold out for months. Saturday's Sports Breakfast for Men had no tickets available. Sunday's Blue Grass Festival was guaranteed to be packed. As a result, those looking for something to do flocked to anything available, and probably the best thing available at 6 A.M. on Friday was the tent raising of the Clyde Beatty–Cole Bros. Circus. Besides, it was free.

By 7 A.M. close to a thousand people had arrived at the little hill alongside Route 50, a number not only larger than all our tent-raising crowds put together but also larger than many of our paying audiences as well. The problem was that even though the crowd may have been our largest to date, our lot was one of the smallest and my camper was parked right up against the stake line near the front door, the best spot, it turned out, for viewing tent raising. Beginning at 7:30, there was constant bumping, scraping, and shoving against my camper. At about 8:00, in response to one particularly annoying bump that roused me from my sleep, I knocked against my back window where the crowds were gathered. The bumping didn't stop. Ten minutes later, when someone actually climbed on my fender to get a better view, I opened my blind to reveal that I was sleeping inside. The rocking didn't ebb. Finally, at 8:24, two women in their early twenties actually climbed the ladder on the back of my camper and sat on the roof of my mobile home. "I am not an animal," I wanted to shout. "I am a human being."

These sorts of incidents only got worse the farther north we went. Several weeks later, in Pennsylvania, a kind-looking gentleman holding his school-age daughter by the hand stopped me while I was in makeup and asked me if his daughter could urinate on one of the stakes in Clown Alley. In New Jersey they didn't even bother to ask. I walked back to my trailer during intermission in Freehold and found a mother supervising two young boys who were urinating directly on the back of my Winnebago. "Excuse me," I said, "I live here." A minute later, after going inside, I walked around the corner once more, to find that the boys were continuing to do their business and the mother had started to laugh.

The irony of this denigration of performers as unreal is that circus people are actually quite expert at re-creating *real life* on the road. Half the families on the show had kids; ninety-five percent had pets. Seasonal events were celebrated with all the traditional trappings: in the spring there was an Easter egg hunt for children inside the tent; in the summer a special Fourth of July picnic in the cookhouse with steaks on the open grill; and in the fall a high-stakes Halloween costume contest in the center ring, followed by a trick-or-treating bonanza in which children marched down the trailer line knocking on everyone's door. Community gambling pools were particularly popular. In the most hotly contested wager of the year, participants were invited to pay five dollars and select a fifteen-minute time period when they thought Susie, one of the ticket sellers and wife of the prop boss, would have her baby. When she had a little girl at 12:10 A.M. in Annapolis, the show's mechanic won $175. But all these activities were "abnormal" compared to the one feature of life on the show that convinced me beyond all doubt that circus people are abnormally normal. In the course of nine months on the road, in addition to dozens of birthday parties, two proposals of marriage, several baby showers, and one Pentecostal revival meeting, the Clyde Beatty–Cole Bros. Circus hosted not one but *two* communal Tupperware parties (actually they're called "demonstrations"), featuring "games, mini-prizes and special previews of products designed to ease the 'bumps' of life on the road."

Of course, life on the road does have its bumps, and therein lies the ultimate difference between circus and townie life. Most town people know where their job is, where the nearest gas station is, where the best supermarket is. All they crave is a little glamour, excitement, and travel. Circus people, meanwhile, have all the glamour, excitement, and travel they can take, but would gladly pay for information leading to the nearest pay telephone. In the end the only thing abnormal about life in the circus is the lack of telephone service. It's for that reason that normally sane people walk through the pouring rain with pockets full of change or stand in the blazing heat through the middle of the day all for a chance to worship at the altar of Ma Bell. For these troubadours of the twentieth century the telephone offered the only way to escape from their normally isolated

world. Some, like Kris Kristo, often used the phone to call girls; others, like Dawnita Bale, usually used it to call home. But a few, like Michelle and Angel, have used it in the course of their circus lives for arguably its most salient real-life function: conducting a long-distance romance.

•

As they mingle in the center ring, she hanging by her hair in bikini evening wear, he guiding her gently from the ground in bolero dinner jacket, Michelle and Angel seem like a circus fairy tale come true. The look in his eyes is adoring and passionate. The smile on her face is loving and calm. But the story behind his look, her smile, is anything but serene.

"I first saw her when I was practicing about eight years ago," Angel said. A dashing Spanish conquistador type, Angel has piercing eyes, ink-black hair, and a sprightly matador step. In addition he boasted a naughty smile. "I was twenty-three at the time. She was sixteen. I thought she was kind of young—"

"Plus he had a girlfriend."

"Well, of course," he said. "But I had many girlfriends at the time."

"Many is not the word, I'd say. Kris Kristo is nothing compared to you and your brother."

Angel breathed a guilty sigh. Sitting in their brand-new Shasta trailer on a Monday night in early summer, Angel was soaking his feet in hot water and wrapping an open sore in the palm of his hand where he had caught himself on the high wire. Michelle spooned some vanilla ice cream into three bowls, gave one to each of us, and settled into an easy chair as if she were about to watch a Hallmark romance on their portable television. In this case the romance was hers.

"So, anyway," Angel continued, "I had this friend who told Michelle's father that I wanted to go out with his daughter. He said, 'Well, he should know I've got a gun, and the one who goes near my daughter . . . Pow!' I was standing nearby when he said this and I thought: Uh-oh, better stay away. Still, I saw something in her I liked, and I never forgot what I saw. Two years later she came to the show again. She looked more like a woman that time. We started dating. Two weeks later I asked her to marry me. I thought it would be okay."

It wasn't. For the next two years Michelle and Angel were forced to conduct their engagement in secret. They were on different shows at the time—in a different town almost every night—making communication all but impossible. But still they persisted, and at the end of that period, when Michelle, her sister, and her mother, remarkably recovered from her fall, were invited by Kenneth Feld to do a mother-and-daughter hair hang on the Ringling Show, the two lovers were reunited. Unfortunately, their families were reunited as well.

"It all started with one family on the show," Michelle said. "They were Catholic and became born-again Christians. After they were born again they started talking to people on the show. About the Bible and stuff. My family was all Catholic, but we never read the Bible. We followed what the priest said and believed it. But if you read you find out the truth. So this family showed the truth to my mother and she became a Christian. It took about a year. Then Angel found out about my mom and he told me, 'You better not change.' He even told me if I ever became a Christian like her that we were going to break up."

"And I was serious," he added. "My family is Catholic. In Spain we are very proud. That's the way we are. My parents would not understand."

"Of course, I told him I was not going to do that. At that time all my family was against my mom. Then six months after that my dad became a Christian, too. And a month later, me. At the time Angel didn't know what it means to be a Christian . . ."

"What does it mean?" I asked.

"It means I read the Bible and realized that it is the word of God. To be Christian is to live like Christ, or as close to Christ as possible. Like Jesus when he walked the earth. Nobody can be perfect. God knows that. But he knows you are trying. You stop drinking, you stop smoking. Around here they say we sacrifice chickens. But if you live a crazy and wild life like Sean Thomas then *that's* considered normal."

"And were you prepared to end the relationship?"

"If it was for God." Her answer was firm. "For me, God is first. Before anybody—my mother, my father, even him. Of course, I didn't tell him right away. In fact, I said I would never talk to him about it. For a while

he knew I was going to some Bible study. I told him that was all. Then one day my father was going to church to get baptized. I didn't want to go, but my father begged me to go with him. I agreed. Angel was standing outside and he saw me leave with my family. He gave me the dirtiest look. It was then that he knew what was happening."

"And I was so mad," he seethed. "I was on fire. Boiling, I'd say. I had told her, 'If you go to that church we will break up.' Now I knew it was over."

"The next day he asked for the ring back. I gave it to him, then I tried to calm him down. 'Oh, Angel, don't get mad,' I said. 'There's nothing wrong. I just went with my father.' I tried to convince him, but he was angry. 'No, I don't care,' he shouted. I tried eight hundred ways to calm him down, but none worked. By the end of the day everyone on the show knew it was over. I thought we would never speak again."

There was a long pause in the conversation. Their gloomy faces were reflected in the oversized mirrors and glassy windows that gave their compact trailer a larger-than-life feel. Peach pillows and blown-up photographs covered a seamless path from sofa to ceiling. On the wall was an ornate scripted plaque that said: *"En este hogar somos cristianos. Aquí todos son bienvenidos."* ("In this home are Christians. Here everyone is welcome.")

"But I had a friend," Angel said. "He came to me about a week later and told me Michelle was sitting home by herself that night. 'So what?' I said. 'Well,' he told me, 'I think you should go see her.' I didn't really want to see her, but something inside of me said, 'Go, go talk to her.' So I went and knocked on the door."

"He didn't say anything at first, and I didn't say anything to him. Then I invited him in. I had been praying a lot for him, that God would make him understand the truth. But I asked God never to send me to him. Now God had sent him to me. It's hard to explain if you don't know about the Holy Spirit, but I felt like God was inside of me at that moment. I felt this voice inside of me, this is not a lie—God knows it—and the voice was telling me to go get my Bible. We were just sitting there, and I heard it again: *'Go get your Bible.'* Finally I got up to get it, and I was thinking: What am I doing? I said to Angel, 'I want to show you something.' He didn't resist. We were there for two hours."

Michelle was almost apologetic. "I had just started reading the Bible," she said. "I didn't know how to quote scriptures or anything. I didn't know where anything was. But I would somehow open the Bible to the right place every time. It was amazing. He was looking at me like it wasn't really me. I told him about my experience and I said, 'I wish you could experience the same thing.'" Her voice picked up. She moved to the edge of her chair. "As soon as I said that I thought to myself: Whatever happens now is going to happen."

Angel moved forward in his seat as well. They were in the same position they had been in that night in Dallas: she on the chair, he on the couch. They were staring toward the ceiling.

"I was listening," Angel said, his voice quivering and soft, "and when she finished I felt a kind of peace. Then I started to cry. I had never cried before that, ever. Even when my father hit me, hit me hard. I was taught never to cry. But at that moment I did, and I knew that was it." He set his hands down on his knees. "God had touched me."

Michelle followed his hands with hers. "It's hard to understand unless you have experienced it yourself," she said. "It's a beautiful thing, really."

"It's true," he added. "There's no way to describe it. At that moment I opened my heart to God. And when it was over we both kneeled on the ground and embraced. It was then that I spoke for the first time all night. I said, 'Whatever you want, God, I'm ready . . .'"

Michelle smiled at her husband and took his hands in hers. After several seconds, the tears starting to shine in the black gloss of her eyes, she turned and looked at me. Her voice was almost deathly calm. "That's when the real battle began."

•

Last comes the spin. Like an ice-skater, Michelle has moved gracefully through all of her tricks—spinning hoops, juggling fire, occasionally even balancing plates on a stick—but the act is not complete until she executes the one vivid display that everyone in the tent is secretly expecting—the spiral of death.

"I start on the floor. It's the first time I've actually touched the ground since the act began. I do a little dance, sort of like a mermaid under-

water. My husband comes behind me and lifts me off the ground, slowly walking me into space until he gives me a little push. That's when I start spinning, whipping myself around and around, kind of like turning non-stop pirouettes. I start with one hand over the other like I'm dead, then slowly lift my arms. At that point I get going faster and faster until I don't know where I am and all I can hear is the beat of the drum, and all I can feel is the pain in my neck . . ."

And in the end that's where the trick lies: not in the ring that sticks out of her head, not in the shampoo she uses on her scalp, but in the strength of her hundred-pound body that runs from her back, up through her neck, throughout her scalp, and out of her hair. True to her word, Michelle is the real Samson of the show: her life depends on her hair. Fifteen minutes before every performance she crouches before a plastic bowl in her trailer, pours a pitcher of water over her head, and combs her hair into a long ponytail. Angel stands behind her, ties a cotton rope around her ponytail, then braids the rope into her hair. When he's finished he folds the braided ponytail into a loop and ties the end to its base at her scalp. Into this loop he places the ring. Michelle Quiros is not hanging by a screw in her head, she is hanging by her hair.

"The funny thing is, I get used to it. It actually hurts more when I first go up. That's when I feel all the weight. Once I start doing the tricks I don't feel it at all. Then when I do the spin I feel it again. It's double pressure at that point. I have to concentrate real hard. I'm listening for a certain part of the music that I know is my cue to open my tuck. That gives me time to come down and do my style. Of course, when I do come down I can't see anything; everything looks blurry. I go down on one knee, because if I was standing up I would probably fall over. I would look like a drunk or something, and that sort of defeats the whole look of the act. Two seconds later, I'm fine."

Two seconds after that she's off. As soon as Michelle settles into place, Jimmy blows the whistle with alarming speed and all the performers scurry from the tent, clearing the way for the animals to return.

7

Please Don't Pet the Elephants

My dream nearly died in Fishkill, New York. Overnight the peril of the circus became real.

"Did you hear about the excitement last night?" Khris Allen found me in the dollar store. I was looking for cotton swabs.

"What excitement?" I said, stepping closer.

"In the elephant department." He was not speaking loud.

"Somebody in the circus?"

"Somebody in town. I think you better come see . . ."

The circus reached New England in early June. After four sold-out days in Princeton we headed north to the Hudson Valley before darting across Connecticut for a two-week trek around Boston. Somehow our entire Northeastern run seemed cursed. In Massachusetts one person ended up in the hospital. In Connecticut, days before that, anxiety reigned. Almost exactly fifty years earlier, in July 1944, the worst circus fire in American history engulfed the Ringling tent in Hartford, killing 168 people, injuring 487 more, and creating a rift between the state of Connecticut and the circus community that has yet to heal. Circus people still feel jinxed by the state, especially after historians concluded recently that the fire was almost certainly the result of arson. The state, mean-

while, still feels threatened by the circus, and as a result charges $7,000 in permits (most places let the circus play free) to have firefighters encircling the tent at all times with water pressure in their hoses.

Fishkill, however, was supposed to be different. For two hundred years the Hudson Valley has been considered the "Cradle of the American Circus." The area has been particularly generous toward circus animals. Isaac Van Amburgh, the famed wild-feline trainer, was actually born in Fishkill. Old Bet, the second elephant ever brought to America and the first to become a star, was purchased in 1805 by Hackaliah Bailey of nearby Somers, New York. Bailey toured the elephant around New England, but it wasn't until he threatened to shoot the animal if his partner didn't turn over half the profits that Old Bet became a national phenomenon. Even after the elephant *was* shot by a disgruntled farmer in Maine for luring money from the town, Bailey continued charging twenty-five cents a peek for fans to view Old Bet's stuffed carcass in front of his Elephant Hotel in Somers. A granite pillar topped with a gold-lacquered elephant marks the spot today, and two clowns on our show actually made a pilgrimage to this mecca during our weekend stay in Fishkill—just thirty miles away.

"The evening started funny," Khris explained as we walked out of the Dutchess Mall. The sun was high—summer was coming—but the air was fresh and spicy to breathe. "When I came back from the bar I found this couple playing with the tigers. They had climbed over my fence and were trying to pet the cats. The woman had actually stuck her hand into Tito's cage. I told them if they didn't leave I was going to call the police and have them arrested for trespassing. They said they were so in love with the cats that they just *had* to pet them. I pointed to the exit and they eventually left."

We approached the portable orange fence that surrounded his compound. The smell of rotting horsemeat swirled around the cages. The red-and-white-striped canopy reflected the noonday glare.

"Twenty minutes later I was just lying down to sleep when I felt my trailer rock. I have the fence tied to my bumper for that reason. It's like a silent burglar alarm. I hopped out of bed and ran outside—I wasn't even wearing pants—and that's when I saw them next to the cages. 'Get your

motherfucking asses away from here!' I yelled. 'And stay away! If I see you around here tomorrow, or the next day, I will have you put in jail.' They climbed over the fence. Only that time I followed them to their car. I waited for about fifteen minutes and when they didn't leave I went back to get my whip. I walked up to their car, tapped on the window, and in my best tiger-ruling voice said, 'If you don't get out of here you're going to end up in the hospital!'" Khris smiled with a certain degree of satisfaction. "They started the car, and vroom, took off. I went back to the trailer and lay down. That's when I heard the noise from the elephant compound.

"It wasn't a scream or anything," he said, "just a loud crush. But it was jarring enough to jolt me out of bed. I had a feeling. It's kind of weird. I knew something had happened with the elephants. I looked around for my pants. By the time I found my jacket and hurried outside I saw Mr. Holwadel running.

"'Douglas,' I said, 'something bad has happened.'

"'I know,' he said. 'It's by the elephants.' I couldn't believe what we found."

At a little after one o'clock in the morning Christopher Ponte walked out of the Za Bar & Grill, a pool hall—cum—beer parlor inside the Dutchess Mall, and decided to have some fun at the circus. The tent was beautiful spread out before him. The parking-lot lights made the scene appear tame. Along with a friend, the twenty-two-year-old native of Wappingers Falls wandered down the quiet line of trailers, past the tigers, the bears, and the Arabian horses, past the world's largest cannon, until he spotted the elephants in the rear parking lot.

"Let's go pet the elephants," Christopher said to his friend. His friend did not want to go and tried to stop him.

Undaunted, Christopher climbed over the four-foot-high orange plastic fence, the kind often used on ski slopes to keep reckless novices from careening out of control. Moving forward, he stepped into the pen where the elephants roam with loose chains around one foot, in a facility nicknamed the "Elephant Hotel." A few of the elephants were lying on beds of hay; the others stood swaying silently side by side. A puddle still lingered on the mottled asphalt where the herd was bathed that afternoon

with water from a nearby fire hydrant. All around the pen were hand-painted signs in bright red letters that said: DANGER: KEEP OUT, NO TRESPASSING, PLEASE DON'T PET THE ELEPHANTS.

"Hey, you!" the watchman called from his post. "You can't be in here. Get back behind the fence!" Christopher's friend tried to stop him as well.

Christopher, however, refused to stop and approached the end of the elephant line. He was wearing blue jeans, tennis shoes, and a white T-shirt that said: TEQUILA: EAT ME! with a picture of a worm. He walked up to Pete, alias Petunia, and decided he wanted to pet her trunk. He never made it. As soon as the young man approached Pete from behind, she spun around in startled defense and swung her head at the intruder, pushing him effortlessly against a nearby truck, where quickly and with stunning precision she crushed him against the steel side of the cab, Elephant Truck No. 60.

"By the time we got there the guy had stopped breathing," said Khris. "He had taken a few steps, then fallen to the ground. His friend and I pulled him away. That's when I realized: Hey, I know this guy. I had played pool with him earlier at the bar. He was there with a friend. They were nice guys, but they were wasted. The guy couldn't even hit a straight shot. Now his friend was crying. 'Oh, my God,' he said. 'I've known this guy my whole life. I tried to stop him, but . . .' The friend was trained in CPR, so I helped him to go to work. We got his pulse to forty, but every time we stopped pumping his chest, it would disappear. We lifted his shirt and you could see the indentation on his skin. There was no blood, it was all internal injuries. Every time his lungs would fill with air you could see the oxygen just disappear into his stomach."

"So that's what happened?" I asked. "A punctured lung."

"A punctured heart as well."

Within fifteen minutes the local and county police were on hand. They interviewed Fred Logan, Doug, and the man's friend, and decided the circus was not to blame. "The elephant was startled," the detective pronounced. "You'd have been startled, too, if you were half asleep standing up and someone came up beside you." The paramedics, meanwhile, examined the body and wasted little time before transporting it to the hospital. Finally, at a little after 1:30 in the morning on the first Sat-

urday in June, Christopher Ponte was officially declared dead.

The season was two months old.

•

Standing in front of the elephant pen after Khris had gone, I watched in chilled silence as the circus continued to churn its never-ending grind—a trunk picked up hay and sprayed it in the air, a push broom spread puddles to dry on the ground, a shovel scooped dung and dumped it into a barrel. Somehow in the harsh midday light the sharp edges seemed more ominous—the open blade of the forklift grip, the jutting dagger of the tent's main guy line, the deafening grumble of the tigers. Staring at this scene, I couldn't help thinking that the circus, like any dream, is meant to be viewed in the dark, where you can't see the wires, you can't watch the preparation, and you can't observe the pain. When the show is in the rings, one doesn't presume to belong. It's only when one steps outside that the dream seems accessible. With a circus, as with a Greek tragedy, hubris is the ultimate deadly sin.

"What was that man *thinking*?" a woman said to me later that day as she sold me a hot dog in the mall. "He had no business messing with the animals. He should know better than to try and touch one of those elephants."

A death in the circus is everyone's concern—it quickly pierces the illusion of the show—and walking through the mall, I overheard many similar remarks, each one gradually more inflated. "I heard he was drunk." "I heard he was high." "I heard he had a gun." Around the circus, meanwhile, the performers were noticeably more subdued than normal, but still they went about their work with grim efficiency—quiet, determined, seemingly unshaken.

"Everybody seems to be doing the show as if nothing happened," I said to Big Pablo as intermission in the first show approached. "Is everyone so jaded that they don't care?"

"The truth is, nobody wants to talk about it," he said. "It's bad. You don't hear me making jokes about it and I make jokes about everything. As far as I'm concerned, you mess with a three-ton animal you get what you deserve. It's like playing chicken with a freight train. Sooner or later

you're going to get hurt. We have chains. We have signs. We have fences. Those little orange fences are not designed to keep the elephants *in*—they couldn't if they wanted to. They're designed to keep the people *out*. Look, it's happened before, it will probably happen again."

He nodded grimly and went off to work.

•

"What do you mean 'Have I seen this kind of thing before?' Hell, I saw it happen to me!"

Dawnita stood behind the back door of the tent wearing a yellow-and-black pantsuit with an elaborate sparkling paisley design that ran from her left shoulder to her right hip. Her left breast was almost completely exposed behind a see-through window of fishnet stocking. All day I had been hearing stories. Jimmy estimated that in the thirty years he had been with the show probably twenty-five people had died in elephant-related deaths, ten people had been killed in truck accidents, and half a dozen had been electrocuted. Even given his penchant for exaggeration, these figures were alarming. For those around it long enough, death and disaster seem to hover over the circus, to give it shape and definition like the tent itself. Elephants, to my surprise, have proven to be the worst.

Elmo, who came in Saturday for his birthday party that night, told me he was sleeping just feet from the elephant compound in New London, Connecticut, in 1984 when a naked woman was found dead in the pen. She had a clean slit across her stomach, he recalled, and her boyfriend, who was staying at a nearby hotel, claimed she had wanted to be photographed with the elephants. Since elephants are not known to kill with incisions to the abdomen, police suspected she had been murdered by her boyfriend and tossed to the elephants for cover. Papa Rodríguez told me he was on a show in France when an elephant got angry at his trainer in the center ring. The trainer was able to dodge the charging animal and escape into his trailer. The elephant, however, was smart enough to pick out the trainer's trailer from the line. When she did, she promptly knocked it over and trampled the trailer—and the owner—to shreds.

But of all these stories Dawnita's was the most painful to hear. In

1965, while still teenagers, she and Elvin were performing with a show in New England. Elvin was doing the single trapeze and Dawnita was working elephants. In the act there was a herd of elephants in the center ring and two solo elephants in rings one and three. Dawnita had been working one of the solo elephants. "She was tough," Dawnita remembered, "but we got along fine." The other solo elephant had been giving her handlers trouble all year. Finally she was separated from the herd and locked in an unlit stable. At the end of the season the owner asked Dawnita if she would work that elephant for several more months on the Steel Pier at Atlantic City.

"I told the guy the elephant was dangerous. She was half nuts, and she had already been separated from the herd. He asked me to work the elephant for one day and see how it went. I told him I would try, but I would do things differently from her previous trainers. I decided not to use a hook. I just used my whip. She had been with so many handlers, really anyone who was around. She was angry. One eye was swollen shut from being hit. During the first show we went into the ring and she tried to hit me with her trunk. It was just like what Pete did last night. When they're upset they swing around and try to knock you over. I went back to the owner and said I really didn't feel comfortable working that elephant. He asked me to do one more show."

Dawnita took a drag from her pre-show cigarette. She was holding Douglas, one of the Arabian Thoroughbreds, whom she led in the opening parade. Douglas was chewing alfalfa into a slimy, pea-green mush. Dawnita was putting a silver feather into her black bouffant wig.

"That night we started doing our act. We had these elephant tubs that the bulls stood on to do their tricks. We had to hold the tubs while they stood on them. That was the most dangerous part of the act. When the time came I was ready for her. I was watching. But still I wasn't prepared for the force of that elephant. With one swing of her trunk she knocked me to the ground. Then she jumped over that tub and thrust her whole body down on top of me, actually doing a headstand on my back. That's how they kill you, you know—with their heads. I was screaming. Everyone came running to get her off me, but they couldn't do it. There was no escape. She was pushing my knees into the ground.

My legs were splaying outward. She ripped open the muscles of my arms with her tusks, and worst of all, she stripped all the flesh off my back. I was nothing but raw meat. I was delirious with pain."

"So who finally saved you?"

"It was Elvin. He was hysterical. He was waiting to do his trapeze act just after the elephants. We were only nineteen at the time. He grabbed the bull hook out of the owner's hands and hit the elephant so hard in the face that she pulled back long enough for them to drag me away. And then the elephant ran. She darted out of the tent and went running down the boardwalk in Atlantic City! She went on to kill several people in the next couple of years. So did the other one I was working that year. Eventually they both were destroyed."

"And how long did you stay out of the show?"

"About a month. My knee was dislocated and my arms torn open. I had to take these painful saltwater baths for my back." She winced in recollection and twisted her neck. "It's easy to forget that circus animals are dangerous. Elephants especially. People look at them and say, 'Look, Dumbo! How cute.' But they're not domesticated pets, they're wild animals."

"Is that what you think happened last night?"

"Listen, I look at it from the animal's perspective. The elephant didn't say, 'Hey, I'm going to kill this guy.' She was startled, that's all. She might have been sleeping. They sleep standing up, you know. Or she might have been surprised. She was probably just trying to push him out of the way."

"Do you think she knows what happened?"

"A little bit. She probably knew she had hurt someone. Elephants are very smart, you know. Smarter than many people."

Jimmy blew the whistle for the overture to begin. The cast shuffled toward the back door. The elephants lumbered into place at the end of the parade. Pete was at the head of the line.

"And have you worked with elephants since then?"

Dawnita tossed her cigarette on the pavement and ground it out with her high-heeled shoe. "Never again," she said with her painted smile, "and now you know why." The curtain opened with its artful flourish and Dawnita Bale marched into the lights with Douglas at her side.

Nights with White Stallions

The ground seems to shake when the horses start to dance. The tent seems to smile when they finally arrive.

As soon as the hair hangers disappear from sight the spotlights pivot to the back door of the tent, the elegance succumbs to a royal "Fanfare," and a line of ten Thoroughbreds parades into view, wrapped in bridles, breastplates, and surcingles, decked out in princely blue and white ostrich plumes, and led reins-in-hand by three upright grandes dames from a long line of circus royalty. The military echo is palpable. The regal allure is clear.

"*In the rich, grand tradition of the circus . . .*" Jimmy, as always, knows just what to say. "*An equestrian display of equine excellence . . . , presented by the Baaaaale Sisters . . .*"

Dawnita is the first to arrive in place, just in front of ring one. She is holding the reins of a rare black Frisian stallion, Surprisio—sixteen years old, weighing half a ton, and sporting a tantalizing black mane draped to one side of his head. Dawnita is matched in ring three by Bonnie, the youngest Bale, who is leading an equally striking white stallion, Afendi, great-grandson of Naborr, one of the richest blue bloods in history, who was once owned by Wayne Newton. Once in place the two sisters prepare to lead their black and white consorts in a precise display of footwork and dance steps that comprise a "high school" act, the deceivingly

lowbrow American-sounding name that actually refers to the ultimate origin of highbrow, the *haute école* of France.

In between the two siblings is their older sister, Gloria, who instead of a single high school horse controls eight Arabian Thoroughbreds, ranging in color from liver chestnut to bay and looking in their excited primped-up appearance like a restless collegiate marching band. As if to emphasize this theme, Gloria, like her sisters, is dressed in majorette-like wear that actually descends from the Spanish Riding School: ballroom shoes with knee-high spats; white-breasted leotard with a matching dinner jacket; and a nifty little folding hat such as nurses and female naval officers wear. Dawnita's and Bonnie's outfits are vermilion; Gloria's, like her eyes, is royal blue.

"A lot of people switch to animal acts when they grow older," said Gloria, herself clinging to her last days of middle age, her voice still carrying a hint of English propriety. "Their bodies need the break. As for me, I grew up loving them. As a girl, I loved ballet. I loved dance. I even loved to work in the air. But horses were my dream. I first did a liberty act when I was fourteen; I've been doing one ever since."

In contrast to high school, where a single horse performs a standard set of steps, a liberty act involves a group of horses performing a wide variety of tricks. The act is termed "liberty" because the horses are free to roam untethered. With no reins and no longes, the presenter must communicate with the herd through voice signals and hand gestures. The biggest liberty act in history, trained by Edouard Wulff in the nineteenth century, had one hundred and twenty horses. Gloria's, like many today, has eight.

"When I first arrive in the ring I'm a little nervous," she told me. "I have so much to worry about. In hot weather they run a little slower. In mud they might get stuck. They especially have trouble in sand because they have to work harder to get their feet out. Also I have to think about their mood. I try to keep them calm by giving them carrots, but noises bother them—popping balloons, squeaky pulleys, clanking poles. The biggest problem is the butchers who spin their empty Coke trays as they take them out of the tent. A horse's natural defense is to bite and kick. If that happens, I'm the one in the way."

Once the horses arrive in the ring Gloria sends them off to their first trick with the simple command "Partez!" She uses French because her father used it to train the act and because, as in ballet, the movements that horses do, from "croupade" and "ballotade" to "piaffe" and "pirouette," all have French names. With "Partez!" the horses sprint from their spot and begin prancing around the ring in a single-file line to the musical whimsy of "Radetsky," a Johann Strauss two-beat march. Within seconds the sleepy ring is transformed into a frolicking carousel with the horses bobbing and bouncing in a never-ending cycle of heads and tails. At one moment they seem to be burrowing into the ground like the tigers who turned to butter in the children's story; at the next they all but rise into the air like the heirs of Pegasus. This ring, so shimmering, is the sacred icon of the circus. These horses, so animated, are the source for that ring.

"Horses, you know, started the circus," she said. The Romans used to have chariot races with horses, she explained, while in Europe, much later, showmen organized enormous riding expeditions for recreation. It was Philip Astley who invented the first circus in England in 1768 when he combined bareback riding with equestrian clowning. Astley found it easier to ride in a ring and have people sitting in a circle around it to watch the show. The term "circus," from the Latin word for "circle," comes from those early rings.

As long as there have been horses in circuses, Gloria went on to say, there have been Arabians. First bred by bedouins who went to extraordinary lengths to keep the line pure—including killing foals that were not considered worthy—Arabians were eventually imported into Europe, then America. George Washington's white horse, the same one he sold to American circus founder John Bill Ricketts (himself a disciple of Astley), was believed to be an Arabian. Today, Arabians are still considered to be the purest breed of all horses, with shorter, stronger bones, wider chests, and one fewer rib and vertebra than other horses. As a result, they command prices ranging from $1,200 to $3,000 apiece—expensive for horses, but still a bargain when compared with $75,000 for an elephant or twice that for a rare white tiger.

After Clyde Beatty–Cole Bros. bought eight of these Arabians from a horse farm near Ocala, Doug and Johnny named them after their families

(Doug and his daughters; Johnny, his wife, his father, and—the ultimate honor of all—his wife's prized poodle, Schatzye). Once christened, the two-year-old Thoroughbreds were handed over to Trevor Bale to be trained. Father of the Bale sisters and Elvin, Trevor has been a renowned animal trainer for almost sixty years since he first stepped into a ring with lions and tigers at age twelve. Since that time he has trained, or "broken," as circus people say, elephants, horses, bears, lions, tigers, hippos, zebras, camels, llamas, dogs, donkeys, pigeons, giraffes, and geese. Along the way, he was the first to put lions on swings, one of the best at putting tigers on horses, and the only person ever to work black bears and polar bears in the same ring.

"My dad has some kind of attachment to animals," Gloria remembered. "For some reason they love him. He could come here today after three years of being away and they would just go nuts for him. He has that strong a connection. He's like Dr. Doolittle."

Unfortunately, he wasn't a magician, and from the beginning he encountered problems with these horses. First, there was the problem of time. In order to break eight horses properly he needed a year. The show had only six months. Second, there was the problem of gender: an ideal liberty act should have only one gender, Gloria said; this act had two. That created various difficulties. In the act, after the horses run around the ring in single file, Gloria issues a new call, "En deux!," and the horses double up along the ring curb and continue to trot in tandem. After several minutes she announces, "En quatre!," and they double up again. Here the sexual politics begin.

"They're like oil and water," Gloria complained. "I have four geldings and four mares. I've got four guys who are big, tall, and have more energy. They work in fast-forward. Meanwhile I've got four girls in first gear. They think differently." She rolled her eyes. "I feel like a therapist. Sometimes they simply drive me crazy. At other times they're almost perfect."

Gloria was not the only one who shared this sentiment. Despite their occasional fussiness, when the horses finally do reach their stride the beauty of their hallowed blood ripples through every muscle and tendon in their well-toned legs. Children are mesmerized by their beauty. Even

performers get carried away. "I'm not much for animals," Arpeggio once told me, "but those horses sure are cute." Perhaps it was inevitable that one worker would find this beauty too much to resist.

•

When I decided to join a circus, I viewed it as a life on the road, as a way to discover the backyard of America from the back lot of a traveling neighborhood. After almost four months on the show I had begun to revise my view. While each stop along our nine-month route reflected the area around it, I found that I was encountering the true variety of American life not in the various communities that lived near the tent but in the one community that lived underneath it—the circus itself. With its two hundred employees from all corners of the globe, holding all manner of religious and political beliefs, the circus represented a true melting pot. There were no educational requirements to keep you out of this company, no skyrocketing property values to keep you out of this neighborhood. In addition, there were no random drug tests to weed out misfits and no reviews of credit history to exclude miscreants.

This notion of the circus as a microcosm of America helped me answer one nagging question I had about the show: how is it that circus people, who by all accounts live on the fringes of American life, manage to perform every day to acclaim from an audience of thousands of "mainstream" Americans? The answer, I came to believe, is that the people in the circus and those in the audience ultimately want the same things—security, success, a new car, a way out. The people who come to see the show have a host of worries—they fight with their spouses, they argue with their children, they struggle with their bills—but when they step into the big top they agree to leave their problems behind. The people who put on the show have the same wealth of worries, but when they step into the big top they also agree to leave their problems behind. This is the magic of the circus: the shared illusion of escape.

But ultimately the circus is just that: an illusion, a fantasy, a myth brought to life. The horses that trot around Gloria in the center ring don't actually float, they just seem to. The bears that bounce on the trampoline aren't really docile, they just appear to be. Catastrophe most

often occurs when nonperformers try to continue the fantasy long past the time it has ended for the show people. Sometimes, as in Fishkill, these outsiders are townies. Other times they are workers from the show itself. With so many men coming and going, the show could not always control the behavior of everyone on its payroll. "What are the minimum qualifications for being hired as a worker?" I once asked Doug. "Minimum qualifications?" he mocked. "Breathe." It was one of these men whom Dawnita discovered one chilly night in June.

"I got this sudden urge to get up in the middle of the night," she remembered. "It doesn't happen to me often, so I knew something was wrong." She threw on her clothes and went running toward the horse truck. Since the night was abnormally cold, the horses were sleeping inside to keep warm. As usual, the mares were on one end and the geldings on the other. The black and white stallions were closest to the door. "As soon as I approached the truck I saw clothes on the ground. I thought something had fallen from the roof. I got closer, waving my flashlight all around, and then I saw the man on the ground. His head was directly underneath the crotch of our largest stallion. He was naked except for a bandanna around his neck. He was a hippy. He was a drunk. If nothing else he was a pervert."

But how did she know this for sure? I wondered. Maybe he was just sleeping through the night. Perhaps he was trying to stay out of the cold.

"I hate to say this," Dawnita said, "but a horse's penis is dirty. When it's clean we know something has happened. Either they've been mating with the mares or they've been played with. We know they haven't been mating with the mares."

She raised her eyebrows.

"As soon as I realized what had happened I dragged him out of there as fast as I could and beat the shit out of him with a rubber whip. I would have beat him to death if someone hadn't pulled me away. Luckily the guy was gone by the next morning. I told him I would kill him if he ever stepped foot on the lot again. And do you know why? Because if he would do that to an animal, he would do that to a child . . ."

Circus people will tolerate a lot in private—drinking, drugs, even profligate sex were all part of the daily life of the show—but if somebody

either inside or outside the community threatens to spoil the public face of the show—the basic elements of the dream—reaction is swift and lethal. The circus, at its core, is a fantasy: you can look but you cannot touch.

•

As the act nears its end, Gloria calls all the horses to the center of the ring with the simple command "Chez!" With a giant sweeping gesture of her arms she signals for all eight of her horses to stand on their hind legs. The first attempt is valiant, but short. The second lasts a little longer. It is not until the third try at the trick that her full platoon of Thoroughbreds rears back on its sixteen hind legs, punches the air with its line of hooves, and holds its pose for an impossible span that seems to defy not only gravity but time.

"The truth is, not all of the horses like to do that trick. It's hard, and they're getting old. These animals are around seven. If they're taken care of they can work for another few years. But then they'll get tired; they'll lose weight. They're like old people. Sometimes they just don't want to go out and perform anymore."

Sitting behind her trailer between shows, with the wind skipping up from the early-evening sky and the lights first appearing on the top of the tent, Gloria realized the irony of what she was saying. All good acts must come to an end. All performers have their time. In his book *Wild Tigers and Tame Fleas*, famed clown Bill Ballantine writes about living on the Ringling train in the 1950s next door to the newly arrived Trevor Bale and his family. In the book Gloria (age eleven) and Elvin and Dawnita (age eight) are seen giggling around the circus lot until they are beckoned back by the commanding call of their father: "EL-VIN! DAWN-NITA! GLOO-O-O-RIA!" "Try to imagine an ocean liner whistle at six feet," Ballantine writes, "a diesel locomotive at a crossing, and you approximate father Bale's call of the wild." Almost forty years later these names were still being bellowed around circus tents and their glory was just as strong. Still, hints of retirement were just beginning to be heard. Bonnie, who was a newborn at that time, had already retired once. Dawnita maintained that the Beatty show would be the last place she

performed. Gloria, meanwhile, who since her days as a child on Ringling had performed in over eight different acts on at least ten different shows, insisted she wasn't quite ready to quit.

"Sure, I've done what I wanted to do: I've worked with horses, I've done the trapeze, I've traveled all over the world. But it's in my blood. I'll do it until I feel like I don't look good enough and I don't feel as if I can perform well. Then I won't do it anymore. Then I'll know it's time to leave."

Tired, the horses are ready for their exit dance. Gloria sends them back into their original single-file trot around the ring, this time to the timely gallop "Homestretch." When the last horse in the line gets to the front of the ring, the horse turns a complete 360-degree revolution and obediently steps out of the ring into the outstretched grasp of a handler. The process is repeated—eight, seven, six, five, four, three, and two— until horse number one, Blair, appears to sprint unexpectedly past the gate. "You forgot to turn," Gloria calls in a public rebuke reminiscent of her father. Blair slowly backs up as if he were going to turn, then steps abruptly into the ring and, with Gloria at his side, bows his head to the audience. The simple gesture brings "aaaah"s from the house. The trick has worked to perfection. The horses have worked their charm.

"Ladies and gentlemen, Gloria Louise . . ."

The first half is coming to a close.

8

A Streak of Blood

Douglas Holwadel walked alongside the tent and rehearsed the remarks he would soon have to make on the cellular phone in his rented motor home. In the twelve years he and Johnny had owned the circus, Doug had never had to make a call like this. His anxiety was intense. His face contorted. The air was thick around him with the dense odor of pine. He decided in the space between the office and his trailer that the best course would be to be direct.

"Mrs. Mitchell, I'm calling about your son. I'm afraid I have some bad news . . ."

Natick, Massachusetts, is a small community of 30,000 people on Route 135 west of Boston, full of deserted red-brick buildings placed around a central square and with several shallow lakes ringed around its outer core. With its rich evergreens, stone sidewalks, and gentle hills, the town is perfect for sleigh rides in winter and pickup baseball games in summer. Indeed, for years the circus used to play the baseball diamond behind Natick High School every year on July 4. The town loved the circus, for it provided a focal point for its Independence Day celebration. The circus loved the town because the lot was grassy, there was a basketball court nearby and just beyond that a rare treat, Dug Pond.

This year, because business had been slow in recent seasons, the circus decided to move its date from July 4 to the last weekend in June. From

the beginning the change caused concern. The people in town were upset that they had no place to go for July 4. The people on the show were disturbed because they had no fixed date around which to imagine their summers—a simple act of surprising importance in a traveling community. In short, the narrative of Natick was off to a bad start even weeks before we arrived.

The morning of setup everything proceeded smoothly. The tent was up early, the rigging soon followed, and by lunchtime a gaggle of performers claiming to be Michael Jordan and Shaquille O'Neal moved to the basketball court for the thrice-weekly exercise in miscoordination, self-deception, and Spanish verbal assault tactics that passed for sport on the lot. The start of the semiofficial circus basketball season in June brought a new level of intensity to the show. Personalities previously constrained by the ring were allowed to run unencumbered on the court. Sean, whose shortness hampered his ability to shine, would throw himself around like a giant pinball and regularly tackle people who drove past him with ease. Danny, who certainly looked the part of a basketball star in his NBA team jerseys, would glide through the air with unparalleled grace but usually manage to miss his shot (his shoulder, though better, was a convenient excuse). Big Pablo, hobbled with a bum knee, didn't bother to run at all and relied on a nonstop barrage of abuse to keep himself in the game. In this ragamuffin ensemble I became something of a desired teammate, not because of any particular prowess on my part but because (a) I was six inches taller than everyone else and (b) I didn't understand a word of the Spanish insults continually hurled at me. "I can't believe it," I said to Julián Estrada. "I've gotten more compliments for several blocked shots than for anything I've done in the ring." His response was unhesitating. "That's because you suck in the ring."

In Natick some of the working guys wandered over to the court to scout out the competition for the much ballyhooed Big Top vs. Performers game that was slated for the following day. One man in particular, William, was laughing on the sidelines. He was new, having arrived with Bill Lane earlier in the week while the show was in Medfield, Massachusetts, on the grounds of a mental institution. He was so new, in fact, that he didn't even have a nickname. After the game, when a few of

the performers announced they were going for a swim, William and several other workers decided to join them and trekked off toward No. 63 to retrieve their swimwear.

"How is the water?" William asked Danny as he was emerging from the pond twenty minutes later.

"It's nice," Danny said.

"Is it cold?" William asked. "I don't like cold water. For me it has to be perfect."

"Nothing is perfect in this world," Danny said. "Only God."

"Well," William replied, "God made the water, so it must be perfect."

They both laughed and walked in their separate directions. William removed his shirt, stepped down the incline, and waded tentatively into the water. The water was chilly and smooth as glass. The level stayed shallow for about twenty-five yards, but then dropped off precipitously.

"I heard him cry," New York remembered. "I was just preparing to go into the water. By the time I located the sound all I could see was his arms flapping in the water and his head bobbing up and down."

New York and several of his men went running into the pond. Luke, one of the few white men on the big-top crew, ran to get a rope. Darryl, from props, hopped a nearby fence and ran to call the police.

"By the time I got out there he was struggling real bad," New York recalled. "His arms were slapping against the surface and he was screaming. Oh, Lord, I can never forget that scream. We tried to calm him down, but he didn't listen. I put my arms around him but he pushed me off. I finally grabbed him around the chest but he just slid through my arms. Before I knew it he had sunk to the bottom of the lake."

By that time a rescue team had arrived. Several divers put on their tanks and plunged back-first into the water. For several tense moments the circus held its breath. The performers, most of the crew, and several of the women from the office waited anxiously on the bank. An ambulance crew made its way to the water's edge. Finally, at eight minutes after two, forty minutes after it first disappeared underwater, the body of William Mitchell reappeared in the arms of the divers. Moving quickly, they pulled the body headfirst to the shore and lifted it onto the crisp

white sheets of the stretcher. His hands were purple; his lips white. Several paramedics began pumping his stomach. For a moment there was a surge of hope.

But that moment quickly passed. After several minutes with only the faintest pulse from the body, most of the performers turned toward home. A few people started to cry. At half past two the stretcher was placed in an ambulance and driven to Metro West Medical Center. At 3:22 P.M. on the last Saturday in June, William Mitchell was officially declared dead. An hour later Doug placed his call.

"Before I called his mother," he recalled, "I decided to call the police department in his hometown. They said they have a chaplain who helps with these duties. He went out in a squad car, checking back into the switchboard. I called several times trying to coordinate with him. I waited until he was in front of the house and then I told the family."

The shows went on as scheduled that afternoon. Kris Kristo, Danny, and a few other performers placed black tape around their wrists. Some women in the front office started up a collection. That afternoon his remaining clothes were packed in a box, along with a check for six days' work made out to the estate of William Mitchell, and forwarded to his family in central Florida, not far from DeLand.

•

The moon should have been full in Abington. Jimmy had the gout. Dawnita had a headache. And just two days after the incident in Natick a tornado came out of nowhere and hit nearby Boston in the middle of the high wire, thereby prompting Doug to run around frantically looking for Sean, provoking Jimmy to blow the whistle too early, and causing Willie to turn off the lights while Mari Quiros Rodríguez was performing a split on the wire, an action that sent Rodríguezes of every shape and size raging at the electrician, the ringmaster, and even the owner himself. No sooner had the cannon fired than Jimmy said, *"Please exit the big top as quickly as possible,"* and a torrential downpour dumped several inches of rain on the abandoned field behind Abington Junior High and on the uncovered heads of several thousand patrons who had just exited the big top as quickly as they could.

A little over an hour later I walked out of my trailer and found Kris Kristo sloshing through the mud. "Hey, where's the party?" I asked. "I gave Danny five dollars." He gestured for me to follow him and headed toward Sean's, a true honeymoon on wheels. About the size of a small dormitory room, Sean's trailer had a small bed in the back, a small table in the front, and a distinctly malodorous brown shag carpet on the floor. Once relentlessly gloomy with artificial paneling on the walls and a beleaguered screen door in front that never quite opened or closed, the room had been undergoing a domestic revolution of sorts. First, in Pennsylvania, Sean had purchased a set of frames so he could mount numerous photos of himself on every blank wall in his room. Next, in Connecticut, he had purchased an economy-sized bag of potpourri and sprinkled it around the room. Finally, in southern Massachusetts, in a sure sign that he might be falling in love, Sean went to a Kmart and purchased an assortment of pillows ("They're mauve," he corrected, "not pink"), which he carefully distributed on every surface of his room, so that it was impossible for him or anyone else to lie down, drink beer, or exchange sexual fantasies without being covered in lace.

As long as Sean was still a bachelor, though, his trailer was still the location of choice for parties on the lot. When we arrived a soiree was underway. Half-open bottles of Amaretto, Bacardi, and Rumpelminze were strewn across the floor. Muddy shoes were piled beside the door. Kris offered to fix me a rum and Coke, a process that involved picking up a mostly empty can of Coke from the floor, pouring it mostly full with rum, and urging me to drink it more quickly. All the usual suspects were present—my friends the circus hunks. Danny was lounging around on the floor asking people to go to the cookhouse with him to fix a peanut butter and jelly sandwich. Marcos, his cousin, was dancing the samba in front of one of Sean's three full-sized mirrors. Kris was soon dancing as well, but also pouring the drinks, directing the party, and pressing the button on the CD player so that we heard only the first few notes of every song, followed by the first few discordant lyrics as sung by Sean.

The last person in the room was Guillaume, a scrappy fifteen-year-old with a ponytail on his head, a scar on his cheek, and a chip on his shoulder. Since the beginning of the year I had been having minor run-ins

with Guillaume, who was Mary Jo's son, Fred Logan's grandson, and a member of the elephant department. In Ladson, South Carolina, he poured taco sauce into my root beer. In Havelock, North Carolina, he tripped me when I went to catch a fly ball during a softball game. And in what seemed like every other town he harassed me with another juvenile trivia question. While the others at the party were dancing or joking, Guillaume was lying back on the bed, complaining about the music, and periodically whacking me on the head with a plastic sword he had picked up from one of the circus novelty stands.

After about an hour of low-grade malaise, Danny announced he was going to the cookhouse to fix his sandwich. Guillaume stood up and said he would follow. But before he did, he bent over to grab his sneakers, pivoted his rear end toward my head, and with a dreary manly grunt let forth a blast of vile-smelling gas directly into my face.

Instinctively I shoved him out of the way. "Get out of here," I said. "And grow up." Guillaume did not take this suggestion to heart. Instead he threw down his hat, leapt onto my back, and began shaking my neck as hard as he could. "Take it back!" he demanded. "Take it back."

This certainly caught me by surprise. Here I was, at a little before midnight on a rainy summer night in Abington, Massachusetts, with a rum and Coke in my hand, a plate of leftover Chinese spareribs in my stomach, and a raving mad, underage, totally inebriated elephant handler on my back, gripping my neck and pounding his fist into my face. My first impulse was to turn around and smash his head against one of Sean's many pictures of himself on the wall. But at the risk of seeming like a weak-kneed writer, I thought better of this. Instead I pulled his hands from my throat as Danny yanked at his shirt, and the two of them stumbled out the door.

As soon as they left I was dumbstruck. Then confused. It was the kind of feeling I felt often in the circus when my own book-learned beliefs conflicted with the culture around me. This happened on my first day on the lot in DeLand. During practice for the firehouse gag, Marty suggested that it would be hysterically funny if Jerry, the dwarf, would disappear into the house for a moment and emerge wearing a kimono, slanting his eyes, sticking out his teeth, and pretending to be a de-

mented Japanese. They all laughed uproariously at this idea. I winced at all the stereotypes it would be perpetuating. Luckily the idea was dropped.

Later I ran into the same problem with Sean when he referred to some of the workingmen as niggers. I told him I thought that word had gone out of favor some time ago. "You've been in school too long," he said. "In the South everyone still uses that word." I'm from the South, I told him, and I don't use that word. "Well you're just a wuss," he said, thereby drawing the circle to a close. A "wuss" would naturally defend a "nigger"; anyone would know that. The circus, I realized, for better or worse, is the embodiment of the politically incorrect.

This realization cut to the heart of the chief dilemma I felt about the show. In some ways our circus was a remarkably open-minded and tolerant place. Where else could people of such varying backgrounds—Mexican, Bulgarian, Moroccan, Native American, African American, Redneck American, not to mention Catholic, Jew, and Pentecostal, as well as drunkard, dope addict, missionary, teetotaler, carnivore, and anorexic—all work and live together in such an intense environment, two shows a day, seven days a week, six inches from their closest friend and their gravest enemy? On the other hand, many of the people in the show were remarkably bigoted. People's actions were invariably attributed to their most distinguishing characteristic—race, religion, or waist size. The bookkeeper was good with money: he must be a Jew. Marcos made a misstatement: he must be a stupid Mexican. Admittedly, coming from the highly charged world of political correctness, I found this directness to be liberating. People on the circus don't run around talking about others behind their backs: they do it right in front of their faces. While they are often uncaring and unsympathetic, at least they're upfront about it.

Still this openness was not enough to balance my doubts, particularly about the macho climate that prevailed among the single men on the show.

"Don't worry about it," Sean said after Guillaume had left. "If you have to, you'll just beat his face. He doesn't attack me because he knows I'll punch him in the nose."

"But I'm not going to beat him up," I said. "What will that prove?"

"It will prove you're a man."

As he was saying this, Guillaume appeared at the door. With Danny hovering over his shoulder and poking him in the back, Guillaume uttered a brief apology and the two of us shook hands. At that moment this simple gesture came as a great relief: some things I didn't have to give up just to be a part of the show.

•

Jimmy was still in a bad mood from the gout. He was sitting behind the bandstand the following day in his hideaway ringmaster's station when I arrived, as I usually did, just as the flying act was nearing its end, *"the Flying Rodríguez Faaaamily . . ."* As soon as he finished, he handed me the microphone and I sprinted toward the center ring.

When the stomach-pump gag started in DeLand it had a simple premise: various clowns dressed as sideshow performers would wander into a doctor's office with a string of maladies, a doctor would put each patient into a giant stomach pump, and an assortment of funny objects would be exhumed from their bellies. An announcer would narrate the scene and give a name to each disease. Because of a feud between Elmo and Jimmy, I was chosen to be the announcer. *"Hurry, hurry, hurry,"* I would bark. *"Step right up and see the circus sideshow . . ."* In fact, I had to hurry myself in order to make it into the ring for the start of the gag. As I grabbed the microphone that second afternoon in Abington, I was a little behind schedule, arriving at the center ring just as the lights came up for the gag. At this point, with all eyes in the tent now focused on me since I was the only person in sight, I opened my mouth to begin my pitch when—*twannggg*—I suddenly collided face-first into a wire that was supporting the flying net. *Crunch.* The collision sent my feet into the air and my head crashing toward the ground. Dazed, all I could sense when I regained my wits was a booming outburst of laughter from the audience—the biggest I had gotten all year. Realizing I had made the fall of my life and satisfied that I still had my teeth in place, I hopped to my feet, did an Elvin-like style to make the fall seem well planned, and headed for the elephant tub in the center ring.

The next five minutes were the longest of my so-far short career. It took as much concentration as I could muster to narrate my way through the gag. When Arpeggio, who was playing the mad nurse, started to hound me, I tried to cut him off, but he jumped on me anyway, knocking off my hat for the second time in a minute and rendering me bald to the world.

At the end of the number I trotted back to the bandstand, handed Jimmy the microphone, and headed for a nearby fire truck to examine myself in the mirror. I was shocked: blood was streaming down my face from an open wound on my left cheek that ran from my eye to my upper lip. With all the red on my face perhaps the audience hadn't noticed this. I hurried back to my trailer, took a swab of baby oil, and cleaned a path across my cheek where the wire had slashed my face. When I finished I lay back on my bed and nearly passed out from the ringing pain that stretched from my ear to the roots of my teeth. Then I waited for the rush of people who would want to see what was wrong. Nobody came. The second half of the show passed. Still nobody came. Finally, ten minutes after the close of the first show, Jimmy knocked on my door. I was still in my makeup except for the wound. My costume was strewn across the floor. I still expected to do the second show. Performers are relentless in teasing people who miss performances, especially for minor injuries. There's plenty of pain on a circus lot, but little sympathy.

"Good God!" Jimmy exclaimed when he looked at my face. Glancing at my reflection in the window I saw that the previous shallow mark on my cheek had already swollen into a red puffy sore like a slice of slightly discolored peach on my otherwise pale white face. "Did you put ice on it?"

"It didn't occur to me." I was beginning to feel weak.

"Do you have any ice?"

"A few cubes, I think." I sat down in my chair.

"Wait right here."

Jimmy disappeared and returned moments later with a bag of ice and a tube of Betadine.

"First of all, get your makeup off," he said. "You're not going to perform tonight. Then put some ointment and this ice on your cut and get yourself to a doctor as soon as you can. I've got to go back and announce the second show. Do you think you'll be all right?"

I assured him that I would be fine. After he left I carefully removed my remaining clown face, unplugged my camper from the generator, and just as the whistle blew for the start of the second show wobbled slowly off the lot and away from the tent.

"So, you're a clown?" the doctor said to me as she entered the emergency room a little over an hour later. The ice pack was still on my face. Clown white was still behind my ears. I felt like a boy left behind in summer camp after the rest of my cabin had gone fishing.

"Yes," I confirmed. "I'm a clown."

"Well, then, make me laugh," she said.

Why do so many people ask this question of clowns? I thought. Everywhere I went people asked for a free performance. If you want to be made to laugh, I felt like saying, come pay to see a show. She certainly wasn't offering me free medical care.

My look managed to get the message across, and the doctor turned her attention to my face. After a brief examination she announced that I was at risk of developing an infection and if I didn't take care of my wound it might require plastic surgery. Plastic surgery? I gulped. For a cut? Maybe I should have made her laugh. Yet she assured me that surgery wouldn't be necessary if I followed her advice. "First," she said, "I want you to go home and stand in the shower for thirty minutes and use this sponge to clean out your cut . . ." Now I truly had to laugh. If only she knew that I didn't have thirty minutes' worth of water in my Winnebago. "Next," she continued, "let the shower water run over your face twice a day for the next three days. Water is the best cleansing agent." Again I had to smile. The water that came out of my showerhead was hardly a good agent for cleansing anything. "Finally," she said, "no makeup for a week."

That would be the hardest of all.

"Were you fired?" Guillaume wondered when he saw me out of costume near the end of the second show. Everyone was surprised when I told them about the accident. They hadn't seen it and, in the intervening two hours, hadn't heard about it either. I was shocked. "You mean to tell me that, with all the worthless gossip that goes around this lot, when somebody actually gets injured nobody talks about it?" The performers

know whom their neighbors are fighting with, flirting with, even forni-
cating with, but, it turns out, they know very little about what those
neighbors are doing in the ring.

This seems only fitting. The American circus, I was beginning to re-
alize, has developed its own standards of behavior unrelated to the larger
world it inhabits. With these rhythms, of course, comes a code, a kind of
artificial religion. In this religion the show itself is God. It's unjudgmen-
tal, yet unforgiving. It rewards perseverance, yet accepts no excuses. Un-
der its tent it expects allegiance, while outside its walls it doesn't care.
After four months I was just starting to appreciate the true dimensions of
this world. Inside the ring I must act like a priest and spread the gospel
of the circus, but after the show I could do as I pleased. On the surface
this formula seemed simple enough. But as the show headed for New
York City and the long sprint for home, I was unprepared for the wave of
disenchantment that gripped our fold and the challenge that this would
place on my ability to believe in the goodness of our cause. The season
was far from over.

"Welcome to the beginning of the end," Dawnita said a week later as
I was preparing my camper for the drive from northern New Jersey into
Queens.

"Any advice before leaving?" I asked.

"Yes," she said. "Don't go."

Chuckling through my trepidation, I hopped in the driver's seat of
my Winnebago and headed alone for the George Washington Bridge.

Intermission

Intermission

The Color of Popcorn

With the houselights illuminated for intermission the tent begins to stir. The clowns come pouring into the center ring to sign autographs; two elephants come plodding into ring one to give rides; and a dozen butchers come wandering down the track. The show is in recess, but the business marches on.

"Ladies and gentlemen, there will now be a precise fifteen-minute intermission . . . , with elephant rides in ring one—elephant rides for the entire family: you must purchase a ticket before boarding the pachyderm . . . concessionaires selling hot dogs, hot buttered popcorn, ice-cold Coca-Cola, peanuts, Cracker Jack, cotton candy, and delicious cherry Sno-Kones . . . plus—Mom, Dad, bring your camera, come right down to the center ring, and meet the clowns in an autograph party: don't forget to purchase the all-new Clown Alley coloring book . . ."

The business makes quite a show.

As the circus inched its way back down the East Coast from New England toward its inevitable date with New York, it also moved steadily toward another important date: the change of leadership from Doug to Johnny. By early July, Johnny's back had recuperated and he was preparing to rejoin the show. Before that could happen, Doug would have to chaperon the show's twenty-seven trucks, thirty-five trailers, and two hundred employees to the door of the Big Apple. To date it had been an uneven ride.

When John W. Pugh and E. Douglas Holwadel first became partners in 1982, the two of them could not have been more different. Johnny, a boxy boater type at home on the high seas, was short and pugnacious, an English bulldog with a lovable face and occasionally vicious bite who was raised on the wilds of a circus back lot. He always smiled and never wore a tie. Doug, a self-proclaimed "dyed-in-the-wool Bob Taft Republican from Cincinnati, Ohio," was tall and aloof, a Great Dane with an imperial mien and imposing strut who could roam golf courses and country clubs with ease but did not enjoy getting mud on his shoes. He never smiled and always wore a tie. He also understood money.

"As a kid in the 1930s I went to see the circus when it came to Ohio," Doug recalled, "but unlike my friends, I wasn't interested in the high wire or the flying trapeze, I was fascinated by the movement of the thing. Once my uncle took me to see them unload the railroad cars and I was hooked. From then on I became infatuated with the logistics—railroad cars, setups, tear-downs, things like that. Later that grew into a love of marketing."

And what a marketer he became. When the two novice owners bought the circus, their principal step after redesigning the show was to rethink the marketing plan. Together they developed a new way for the circus to approach each town, a process they later termed the "true circus parade." The first person in the parade is the booker, who, months or even years before the season, scopes out potential lots in a town and books the circus into a location. Terms are agreed on—usually the show pays about $500 to $1,000 a day—but no money is transferred. In many towns, the circus will then seek out a sponsor, a Rotary Club or high school band, which will agree to get all the necessary permits, licenses, and security personnel in return for about a third of the take. Still, no money changes hands.

Next, two months before the show arrives, a media buyer visits the town to book television, radio, and newspaper advertising. He is followed by a marketing director, who actually lives in the town for up to a month, schmoozing the local media, ordering hay and feed, and trying to generate publicity about the show. Some of the advance purchases are paid for with IOUs, far more are bartered for with complimentary tick-

THE COLOR OF POPCORN

ets. Thus, if the front end has done its job, by the time the red arrows leading to the lot are posted and the stake line is laid out, the circus has generated thousands of advance sales but still not spent any money. The actual cash doesn't arrive until the show does. When that happens lots of people smell it out.

A century ago, whenever a circus arrived in a town the sheriff would remove the central nut from one of the wheels of the show's main wagon to make sure the circus couldn't leave town until its bills were paid. Ever since, the term "making the nut" on a circus lot has implied taking in enough money to cover expenses. On our show the nut was around $25,000 a day (roughly $6 million in yearly operating expenses divided by 240 show days). That meant the show had to sell enough six- and nine-dollar tickets as well as enough one-, two-, or four-dollar concessions to earn $25,000 every day—rain or shine, ice or heat. The expenses were relentless. There was a $50,000-a-week payroll, a $3,000-a-week fuel bill, and a $500 added charge every time the circus played a mall in order to pay a local contractor to visit the parking lot after we left and fill in all 476 stake holes left behind by the tent. In addition, every week the show bought an average of three hundred pork chops, eighty pounds of ham, sixty pounds of sausage, ninety dozen eggs, thirty gallons of milk, and fifty pounds of coffee, not to mention five hundred pounds of oats, seven tons of hay, and a quarter ton of sweet feed.

Of course, there were all sorts of unexpected costs as well. A weigh station outside Burke, Virginia, for example, cost the show a small fortune. Three trucks—the horses, bears, and cookhouse—each received fines of $260 for not keeping their logbooks up to date. The cookhouse was fined an additional $1,000 for having a passenger in the cab with an open beer can in his hand.

All of this money—for food, fines, and weekly salaries—was paid out in cash. Some local vendors felt so uncomfortable receiving their fees in cash that they came to pick up their payments with armed guards in tow. I could understand their apprehension. Never in my life had I seen so much money. During a good engagement the show could take in close to $100,000. At certain times of the year there was probably close to a quarter of a million dollars locked in the safe in the office truck, stuffed

under mattresses in performers' trailers, and tucked under Q-tip boxes in the clowns' trunks. All cash. Much of it in small bills. Most of it untraceable. Since many of the people on the lot were often broke, or had very limited resources, just the knowledge that all this money was floating around prompted some pretty sordid behavior. The money was like an unspoken curse tempting people to misbehave.

Those who lacked it were desperate to get it. Workers, for example, regularly hounded performers for money. One went so far as to steal money from one of the clowns while we were doing the firehouse gag. Another, more innovative, purchased a metal detector and staked out dibs to be the first person to search under the seats after each performance. Those who had it, meanwhile, were desperate to stretch it. One senior staff member, realizing the need workers had for cash, offered to pay an advance to every worker on the Wednesday before payday. He would give them seventy-five cents for every dollar of their paycheck, then claim the full dollar for himself from their salaries five days later. In the Middle Ages, this noncompounded annual interest rate of 1,300 percent would probably have made usury the eighth deadly sin.

Still, one of the things that amazed me most about the circus was how these workers—who by the time they took their draws might make only fifty dollars a week—could live in complete harmony within inches of the show's owners—who in a good year could split nearly a million dollars in profit. In stationary America, fences, guardhouses, zoning laws, and approval boards usually make sure there's a greater distance between the haves and the have-nots. Without these barriers, the owners were almost compelled to be generous with their money, if for no other reason than to preserve the loyalty of their workers and the safety of their possessions. In the first half of the year alone Doug personally loaned out close to $25,000 to various people on the show, including $12,000 for Michelle and Angel Quiros to buy a new truck when the one they had purchased from a Pentecostal friend in Florida broke down during its second month on the road. The couple was teary-eyed with gratitude. "No other owner in the world would do that," they sobbed. "Anyone else would have fired us on the spot."

For all the equilibrium on the lot, however, and for all the profits the

show was making in the first half of the year ($153,000 in April alone, twice as much as the year before in the midst of a recession), Doug could still rarely manage a smile. First he had the problem of dispersing all that cash. Most banks will not accept large deposits of cash from out-of-towners, he noted, because they have to report every transaction involving over $10,000. The process became even trickier in the early 1980s, he said, when Florida banks were accused of laundering money from drug dealers. Even today Doug and Johnny receive an average of one or two calls a year from people seeking to launder money. Instead, they take the equally risky approach of driving long distances with hundreds of thousands of dollars in small bills. Like political correctness, gender equality, and racial tolerance, the much-heralded cashless society has yet to reach the circus.

The second and much more serious problem Doug faced was the skyrocketing cost of protecting the show. In 1983 the Clyde Beatty–Cole Bros. Circus paid a total of $80,000 for insurance. Ten years later that figure had ballooned to just under half a million—over $200,000 for trucks and general liability, and an equal amount for workers' compensation. In the weeks leading up to his leaving the show, Doug spent much of his time trying to renegotiate these rates. The show had produced only $50,000 in claims in recent years, he argued, surely his rates were exorbitant. Safety was up, he asserted, risks were down. By late May he thought he had a breakthrough when suddenly the show was battered by a series of mishaps—Danny fell from the swing, Henry chipped his teeth, Big Pablo was told he needed knee surgery—followed by a series of freak accidents—man killed by an elephant, woman slashed by a bear, worker drowned in a pond. "We are not liable for these incidents with the animals," Doug said, "especially the one in Fishkill. But when you bring ten elephants into a small town you make a pretty big target."

By early July, when Doug was ready to leave, business was up, but morale was down. The show was ready for its old captain at the helm. On the morning of July 4, Doug hopped into his maroon Cadillac with the EDH plates and headed south down I-95. The same day Johnny arrived in his matching white Cadillac with BIG TOP on the plate. The show breathed a collective sigh of relief. Little did anyone realize, however,

that within a week the show would have its first genuine financial crisis of the year.

•

KEEP OUT THE CLOWNS, blared the headline in *Newsday* on Thursday, July 15. ISLIP BARS CIRCUS, CITING COMPLAINTS.

The news from Long Island stunned the show. In the nine-month season of the Clyde Beatty–Cole Bros. Circus the seven weeks the show spent in New York were considered the highlight of the season, a core stretch of dates when business was usually good enough and the crowds generally enthusiastic enough to make up for the grit and grind of the City. The New York engagement was also the pearl of Doug and Johnny's revived marketing strategy. The circus didn't merely play New York City, it played the City's parks. The invitation came about after years of intensive lobbying of the Parks and Recreation Department. As soon as a creative profit-sharing agreement was reached, the show moved first to Forest Park, then to Shea Stadium, Staten Island, and the Bronx, and finally this year into Marine Park in Brooklyn, a grassy lot off Flatbush Avenue not far from Coney Island. Business overflowed in most of these areas, but the red tape was nearly overwhelming.

In most towns along the route the show would pay around fifty dollars for a building permit and maybe twenty-five dollars for a health inspection. Police and fire departments were usually willing to provide complimentary protection just so their members could stand in the wings and watch the show for free. In New York nothing was free. In fact, the circus was forced to pay more than $2,000 a lot in surcharges: $200 for building permits; $100 for food handlers' permits; $250 for fire guard licenses; and $1,500 for fire permits covering the tent, the welding machines, the generators, the truck repair shop, and the two carbonic drink dispensers. To make sure these rules were followed, an inspector sat in the front of every show taking notes like a court stenographer. "In the past we used to resort to bribery," Johnny recalled almost fondly. "The fire inspector would come on the lot and say, 'I sure would like to bring my family to the show.' We'd give him some tickets; he'd sign the sheet and leave. These days we can't do that anymore. If they don't like

that and want to cause trouble, I'll just follow them all over the tent and agree to the changes they suggest. They'll usually tire of the process and leave."

Sometimes, however, they don't. Early on in the show's stay in New York one fire marshal was so peeved that he decided to shadow the ringmaster throughout the performance. "It was awful," Jimmy recalled. "He was standing next to me and between every act he would slap me on the shoulder and say, 'Make another no-smoking announcement.' Finally, after about ten no-smoking announcements I got so sick of listening to the man that I turned to him and said, 'Go fuck yourself!' You can imagine what happened. He stormed off in a huff and went looking for one of the managers. The one he found was napping in his trailer. The fire marshal pounded on the manager's door, waking him from his sleep. 'Sir, your announcer just told me to go fuck myself.' 'Well, what do you need from me?' the manager shouted. 'Directions?!'"

Despite occasional breakdowns like this, the *aboveboard* bribes that the City demanded hardly hurt the circus's bottom line. As soon as we hit New York the show stopped its policy of giving out discount coupons; it added a third show on Sunday evenings (though salaries were not increased); and it raised ticket prices by a dollar. Still we couldn't keep people away. In Marine Park the community was so overjoyed that a circus would venture into its isolated neighborhood that families thronged the lot at all hours of the day and we turned back nearly a thousand people every night. All fears that New Yorkers would be hostile and cynical were, for the moment, laid to rest. In fact, several days after we left the City the following letter appeared in the *Daily News:*

CAN'T (BIG) TOP THIS

Ladies and gentlemen and children of all ages, I witnessed a miracle in Brooklyn! I saw families sitting together, laughing, having good clean fun—no violence, no nudity, no dirty language. Where was this rare occurrence? At the circus in Marine Park. A *big* thank you to the Clyde Beatty–Cole Bros. Circus and N.Y.C. Department of Parks and Recreation.

E. Francis

The show was still savoring this unexpected bouquet when the bombshell arrived from Long Island.

"Where does a two-ton elephant sit?" quipped *Newsday* in the opening line of its article about the circus being banned. "Anywhere it wants to—except Islip." The article went on to report that the Islip Town Board had voted 4–1 to deny a permit to the circus "based on pressure from animal rights activists and a recent incident where a man was killed in a freak accident at the circus." "Animal lovers have come out of the woodwork," said the town clerk, whose office received a reported one hundred letters and thirty phone calls protesting the show's alleged cruelty to animals. Complaints included inadequate food and the use of cattle prods, the report said. Also, protesters cited the incident in Fishkill as proof that animals are potentially dangerous. "God forbid [the elephants] should break loose here," one board member was quoted as saying. "About fifteen years ago at a Republican parade here, an elephant was scared by a car that backfired. It broke loose and trampled the car." The one dissenting vote came from a member who said stories of animal abuse are "greatly exaggerated," much like the story of the Islip elephant. "Every time I hear that story the elephant gets bigger," he reportedly said.

By the time the news arrived on the lot the elephant had gotten even bigger and the impact even larger. Johnny Pugh was irate. Meltdowns this serious weren't supposed to happen on two weeks' notice, especially on Long Island. Johnny had even hired a fixer for the area, a man with widely touted connections, who was supposed to escort the show effortlessly through its three-week stay on the Island—a place with well-known political and family rivalries. Now the system had broken down. In the days after the incident was first reported the details became clearer. Johnny believed that one particular animal rights activist from Islip was behind the circus being canceled. She had been bothering the show for years, he said. This year she demanded that she be allowed to speak before zoning boards in Commack and Yaphank. In Commack she was denied because the flea market where the circus plays is zoned for circuses. In Yaphank she reportedly stood up and read for twenty-five minutes from Rudyard Kipling's *Just So Stories*.

"Listen, I'm concerned about animal rights, too," Johnny griped. "Hell, my wife spends a lot of time running after stray cats and dogs. But this is going too far. When I was a child I used to have an original copy of Kipling with gold on the pages and a piece of tissue paper over every drawing. I wish I'd never given it away. Maybe that would show them I care."

At this stage it probably wouldn't do much good. The debate itself had already become part of the absurd theater of American political life, with each side posturing, sloganeering, and even threatening legal action over the other's head. In one corner were the protesters. "We welcome the clowns and acrobats," one mother in Islip had said in the meeting, "but please spare us and our precious children the spectacle of animal torment." In the other corner was the circus. Johnny and Doug told their lawyer to consider bringing suit against the organizers for slandering the circus, disrupting business, and generally being a nuisance. In the middle were the politicians. Worried it might have failed to give the show due process, the town of Islip began bending over backward to appease the circus. The media, of course, were all over the story. Radio stations in the area began blasting the town board, especially after they learned that proceeds from the show's three-day run were to benefit the Talented Handicapped Artists Workshop, known as THAW. Several lawyers in the area who regularly took their children to the circus went so far as to contact the show and offer to sponsor a class-action lawsuit against the town. The circus is supposed to bring its own entertainment to town, but with bumbling local officials, grandstanding lawyers, bleeding-heart protesters, and heroic handicapped artists, the cancellation of the circus brought out a far more interesting sideshow of modern American freaks and gold diggers. The publicity was priceless.

"We didn't want it to happen this way," Johnny said after he extended our stay in Staten Island for three days and then booked the same lot in Islip for the following year. "But in the end this case may bring us more good than harm. The truth is, I'd hate to see the animals disappear. Look at the audience. When they think of circuses, they think of animals. They can see acrobatics or gymnastics on television. They can see sports anywhere they want. But they have no chance to see trained animals. Even the ones at the zoo don't do anything. That's why they come to the

circus, and that's what they remember when they go home. A circus without animals is just not a circus."

For all his breathless enthusiasm, Johnny knew those days might soon be over. Animal acts, like the circus itself, are being pressured out of business. Human acts, even the interesting ones, can hardly fill the void. People are much less reliable than animals . . . and much harder to control.

Second Half

Second Half

9

The Star of the Show

Elvis came back to life in Queens. Big Man met him at the gates. For the two loudest crooners on the show—actually whiners is more like it—the great showdown finally occurred in New York when they battled each other grunt for grunt in the only ring that isn't round. It was the brawl of the year on the blacktop lot around Shea: "Blue Suede Shoes" meets "Jailhouse Rock."

In fairness, Sean and Big Man weren't the only ones whose blood was boiling in New York. By late July we had reached that time of the season commonly referred to as "that time of the season." Johnny was mad at Jimmy for paying Sean to usher (most performers were required to do it free). Jimmy was mad at Sean for implying his contract didn't demand it. And Sean was mad at Elvin, who ultimately concluded that Sean should stop complaining and give back the money. The Rodríguezes, meanwhile, were mad at the Estradas for not letting the Quiroses borrow their tumbling mat, while the Estradas were mad at the Quiroses for not cleaning the mat when they borrowed it the first time. Everyone, of course, was mad at the clowns—for spilling water in the ring, for splashing water on the swing, and for getting so much applause without ever having to usher. "It's called the midseason blues," said Henry, the cryptic sage of Clown Alley. "You feel like you're taking these long strokes and

you don't know if you're closer to the beginning or the end. Then suddenly you realize you're about to drown."

Drenched in self-pity, the show arrived in New York at the same time as the most devastating heat wave in a decade. For most of our first week—in Forest Park and the Bronx—the seats were mostly empty as the performers struggled through a liquid assault much more deadly than mud: humidity. The temperature in the rings was well over 100 degrees: near the top of the tent it was closer to 115. Mari Quiros nearly fainted while doing a split on the high wire. Her husband, Little Pablo, nearly slipped from the trapeze when the chalk on his hands turned to milk.

The clowns, once again, probably had it the worst. With the number of shows now at seventeen a week, we were required to be in makeup nearly twelve hours a day, an exercise that is best likened to soaking in a tub of congealed perspiration consommé. Grease may be repellent to water, but greasepaint is not repellent to sweat. In fact, by the time I put on my stocking, skullcap, T-shirt, dress shirt, gym shorts, trousers, socks, shoes, bow tie, jacket, gloves, and hat, just the mere act of opening my eyes brought torrents of chalky white perspiration gushing from my powdered pores. That, of course, is when the white stays on. You can always tell a clown in heat by the rash of pink flesh peeking out of his white upper lip or the beads of red moisture dripping off his vanishing nose. Naturally the worst thing for a clown is to reveal to the world his true colors.

Besides the heat, we still had to grapple with the trials of producing a circus in the middle of the Big Apple. Arriving in New York dramatically increased the level of tension on the lot. One clown started sitting out every gag to watch over the Alley, while Sheri from concessions bought a two-way walkie-talkie system to communicate with her children, whom she kept locked in her trailer during the show. Dawnita even placed a sign next to her door that said: DANGER: BEWARE OF LIVE COBRAS. While some of this anxiety may have been misguided, much of it was well founded. Driving into Manhattan via the George Washington Bridge, crossing the Bronx on a two-lane, two-story pockmarked thoroughfare, passing into Queens over the thoroughly clogged and completely unmarked Throgs Neck Bridge, and driving down Flatbush

Avenue through Little Havana, Little Haiti, and Little Sicily might be expected to produce a certain amount of stress even under ideal conditions. But imagine doing this in the middle of the night, on an empty stomach, with a child in your lap and a map on your dash, after walking on a high wire all day or playing the trombone for ten straight hours, all while driving a thirty-five-foot mobile home with a teeterboard in the kitchen, a tractor-trailer full of hungry elephants, or the world's largest cannon. Even my twenty-three-foot Winnebago, which took most of the bumps in stride, responded to the relentless abuse by spewing out my paper towels in a knee-high serpentine mulch and tossing my microwave onto the floor. Anyone who dreams of running away to join a circus should take a test-drive first.

When we arrived at Shea Stadium at the end of our second week in New York, the collective tension was beginning to show. On Friday, Marcos and Danny were walking home from a movie and just missed being hit by two bullets fired at random from a passing car. On Saturday, Kris Kristo had a near-crisis with a woman he picked up in a bar. "We went back to her place and screwed, went for a walk, came back, and went to screw again. Only that time I couldn't get it up. But the great thing is, around here when you get cable you automatically get the porno channel. So when I was lying on top of her and couldn't get hard, I picked up the remote control, switched to the porno channel, jerked off, blew my load, and switched the channel back—all without her knowing it."

By Sunday afternoon the silliness and sordidness brought on by the City finally came to blows. It happened in front of Clown Alley.

•

Sean stepped out of the tent just before intermission of the 4:30 show. His cannon suit was unzipped to his waist and pulled down off his shoulders. His hair was freshly combed with the new winged bangs he had recently adopted. "I never used hair spray before in my life," Sean had remarked. "Now I can't get enough of the stuff." His hair spray was indeed glistening in the sun, which itself was careening off the lights in Shea Stadium, where the last-place Mets were due back for a home stand the following day.

"It started during the first show," Sean said. "I sat down next to Big Man on one of those sets of three red chairs. There was a magazine on the seat, so I put it in the chair between us. He looked at me and said, 'What the hell did you do that for?' I said, 'Is that yours?' He said no, but looked at me real funny. He has had that attitude ever since he stole those tapes in Willingboro and I told him to watch what he did."

Sean left the tent without incident. An hour later he returned.

"During the second show I sat down beside him again. Once again he looked at me real aggressive, and when I went to help lead out the horses he put his hand to his crotch and pretended to masturbate. That pissed me off. He said if that was how I felt I should just come and fight him right there. I wasn't in the mood, so I got up and left. The next thing I know he followed me outside."

As soon as Sean stepped out of the tent Big Man stalked out after him. Sean turned around and stopped in place, and for a moment the two men just stared at each other like dogs staking out territory. Shimmering waves of heat floated up from the pavement. The sun beat down on Sean's exposed back and Big Man's broad neck. A small crowd began to gather. After several tense moments Big Man began to dance, bobbing up and down like a mock prizefighter with his fists in front of his face. Sean kept his arms at his side but began to bob and weave as well. At the time it looked like simple posturing. Big Man was considerably taller and heavier, but Sean was much quicker on his feet. Perhaps sensing this, Big Man feinted several times in Sean's direction before dropping his arms and turning away. For a moment the episode appeared to be over, until Sean—unexpectedly, inexplicably—pumped his arms, lifted his fist, and swung at Big Man's head.

"Pow! I hit him right over his eye. Dropped that sucker right to the ground. He didn't even know what hit him. Then I jumped him and started hitting him, kicking him, beating his ass."

As soon as Sean jumped on Big Man's back, several people jumped on his and tried to pull them apart. Charlie, the aging mechanic, was the first to arrive, but Sean pushed him away with ease and continued pounding away. As Big Man tried to crawl toward the tent, Sean clung to his back, eventually riding him underneath the sidewall and behind the seats.

"I lost my head," Sean said. "When I get scared, I get angry. It's almost like I lose my mind. Scared . . . angry. Scared. Angry. When that fear turns to rage there's no stopping me. So when that son of a bitch stood and started walking toward the tent I attacked him from behind. I started punching him in the back of the head and pushed him through the side flap. Everyone in the seat wagon was watching. Some boys in the top row were cheering me on. I even hit my hand on the pole and cut myself with my bracelet. I might have killed him if I had a few more minutes, but around then Marty came and pulled me away."

Big Man, for his part, was not so nonchalant. His job was not so secure.

"Everybody's trying to make out like it was my fault. All those Mexicans, those whites, they were telling the manager that I pushed him. I never laid a hand on him. He had been bothering me since the first show, actually since New Jersey. I finally had enough. I told him to stop. Then he punched me from behind and I fell flat on my ass." By the time the fight was stopped Big Man was walking with a limp; his upper lip was swollen from a blow. His red Clyde Beatty shirt was stained with blood. "Now what am I supposed to do?" he asked. "They told me if I didn't call the police I could stay, but if I did they would fire me. They wouldn't even take me to the hospital to get stitches."

"So what are you going to do?"

"I called my uncle. He's coming with all my people tonight. After that I'm going to decide."

"Why is he bringing so many people with him?"

"Why do you think? They want to see the show."

I had to smile. Here was a man who had been on the show for less than four months, who had already been fired once for shoplifting, had been to jail, had been rehired, and now had all but been fired again for getting into a fight with the Human Cannonball, and he decided not to leave the one place where he obviously wasn't wanted until his family could see the circus—not just any circus, *his* circus.

"And after that . . . ?"

"After that I'll decide." His voice was hardly optimistic. "But I don't really have much choice, now do I? He's the star of the show."

•

That star finally crashed on Staten Island.

As he had predicted, Sean hit the pavement before the end of the year. It happened during the second show on the last Monday in July. For a full twenty-four hours after his inglorious bout Sean was walking with a little more swagger and a lot more attitude. The previous night, as Sean, Danny, Kris, and I were lounging around my camper eating bagel sandwiches and drinking Yoo-Hoos, Sean was still boasting about his exploit. "I just whipped that nigger's ass," he said. Hubris never knew a purer breed. The next day his swank got even bigger and Sean felt so invincible that he didn't bother to sew a small rip that appeared in the air bag after the first show.

"I left the barrel as normal," he said. "I saw the three dots on the air bag where I usually land, but then as soon as I hit the bag everything went into a spin. From point A—getting shot—to point B—landing— everything is usually slowed in my mind because I do it every day. Anything past that is just a blur.

"This time, as soon as I hit the bag it just ripped. It didn't even slow me down. I landed on the seam in the middle and immediately ripped open a twelve-foot hole. At that point I was moving so fast I slid, bounced, and rolled around in the canvas. At first I didn't know where I was. I looked back and saw the tent through the hole and realized: Good Lord, I'm *in* the bag."

Outside the bag, when Sean didn't reappear promptly the whole cast nearly erupted in panic. As background players in the finale we had certain rhythms we were accustomed to as well: he starts at point A, he lands in point B, then he emerges and sprints to point C and takes his style in the center ring. When Sean didn't move from point B to point C our internal clocks sounded an alarm. Dawnita went dashing toward the bag. Several of the Rodríguezes covered their mouths in horror. Jimmy snapped to attention. *"Turn off the lights! Turn off the lights!"* Someone even whispered the unthinkable. "Oh my God! I think he's dead."

Inside the air bag the darkness only heightened Sean's confusion.

"I looked around to make sure I didn't break anything," he said. "I was in shock. I didn't know what was going on. I made sure everything was all right—my bones weren't popping out or anything. I moved my

toes to make sure I wasn't paralyzed. That's always the first thing that runs through my mind. I heard Jimmy say something about the lights. I heard people calling my name. They knew I was somewhere, but they didn't know where. They were looking for me in the middle of the bag, but I was at the end with all this material on top of me. Finally I managed to climb outside. Several people grabbed me, but I told them to leave me alone. 'I'm all right. I'm all right. Let go. I'm all right.'"

Sean staggered to the middle of the center ring. The performers scampered back to their places. The lights came up in a blaze of victory and Sean Thomas accepted the accolades of the audience, most of whom were undoubtedly convinced they had just witnessed a perfect display. Then chaos descended.

Standing outside the tent after the show, most people barely waited for Sean to explain what happened before hurrying off to their air-conditioned trailers. The truth was, many performers were still upset with him for losing his control the previous day. "Don't get me wrong," Big Pablo had said. "I'm a performer, so I back Sean. But in Mexico if somebody sucker-punched somebody else like that, even his friends would beat him up." The workers, meanwhile, took a parallel stand. "Look, I'm a worker, so I back Big Man," said Darryl from props. "But to tell you the truth, he had it coming." Class warfare is alive and well . . . so is stabbing your friends in the back.

By the time I removed my makeup and stopped by Sean's door he was already all alone, and already in excruciating pain. "My leg's all swollen up," he said, "and I can't even move my ankle. Plus one side of my ass is already twice as big as the other."

"I think you should go to the hospital."

"Royce said he'd take me but he couldn't stay."

"What about everyone else?"

"They say they can't be bothered."

"Would you like me to go with you?"

Sean looked genuinely relieved. "And sit with me all night . . . ? That would be great, bro'."

•

It was just after ten o'clock on Monday night when I drove the world's largest cannon into the parking lot of Staten Island University Hospital, a boxy beige institutional building tucked away behind a mental facility and a shelter for unwed pregnant women on Father Cappodano Boulevard. We had come a long way from picture-preppy Winchester, Virginia. Inside, dozens of bedraggled bodies littered the vinyl waiting-room couches, with a wide variety of bandages, ice packs, and open sores on their appendages and a generic, seemingly hospital-issued dazed look on their faces. I stepped up to a waist-high counter and was handed a clipboard with a registration sheet attached. I entered the name "Sean Thomas" in the empty space and briefly described his injury. Then we went to wait.

And wait.

"Sean Thomas. Sean Thomas. Please come to the triage room." The announcement came over an hour later. By this time Sean needed a wheelchair.

"No problem," the nurse informed me. "Wait right here."

And wait some more.

Twenty minutes later, Sean was summoned for a preliminary examination. That was followed fifteen minutes later by a supplemental evaluation. Thirty minutes after that we were beckoned again.

"Good evening, my name is Elizabeth and I'm going to ask you a few questions." Elizabeth was wearing a bright green dress. "First of all, would you like to pay with cash, check, credit card, or bill?" Our initial registration, our subsequent evaluation, even our supplemental examination were just warm-ups to our most important test: the financial investigation. After Sean asked her to send him a bill, Elizabeth proceeded down the list of queries. Who is your employer? The circus. What is your job? The Human Cannonball. Where do you live? The world's largest big top. With each response Elizabeth grew increasingly concerned.

"Where should we send the bill if you can't pay?" she asked.

Sean thought for a second, then said, "My parents."

"And their names?" she asked.

"Tim and Joyce."

"Thomas?"

"No, Clougherty."

"Clougherty?"

"That's right, Clougherty."

"But I thought your name is Thomas."

"It is."

"Then why are your parents named Clougherty."

"Because that's my name, too."

"Your middle name?"

"No, my last name."

"I don't understand."

"Look, I'm in the circus. Sean Thomas is my stage name. Clougherty is too hard to pronounce for television shows and all. Did you see me on TV last week?"

"No."

"I've been on four shows, you know: *Street Stories, I Witness Video, Regis & Kathie Lee,* Peter Jennings—"

"Excuse me." A lady stuck her head around the corner. "My grand-mother is very sick out here. Would you stop wasting time."

"Sorry, lady," Sean shot back. "First come, first served." Turning back to Elizabeth, he added, "Anyway, Clougherty has ten letters, so I don't use it."

"This is too much to handle," Elizabeth said. "I think I'll just call you Thomas."

She printed out a four-page form, had Sean Thomas (Clougherty) sign it five times, then motioned us down the hall. It was already nearing midnight.

"Hell, this wheelchair is no good," Sean complained as I began rolling him toward the X-ray department. "I can't even do a spin in it, like Elvin's." As we rolled past various open doorways asking for direc-tions, we met several women. One was doing CAT scans, another sono-grams, two were visiting patients. With each one we met Sean tried out his routine: "Hi, I'm the Human Cannonball. Did you see me on TV?" Each one was underwhelmed. "Hell, I can't pick up anybody in this wheelchair," he griped. "I can't even get any sympathy pussy."

Finally we met a woman coming out of an elevator who volunteered

to give Sean his X rays. She led us to the radiology lab and together we lifted Sean underneath the machine. "Do you think you could radiate Sean's ego while you're at it?" I said. "Won't that make it smaller?"

"Honey, that won't make it smaller," she replied. "Only brighter."

With the X rays taken, I rolled Sean to the doors of the emergency room, where he waited to get his leg evaluated and where I was kicked out and told to wait in the lobby. An hour and a half later Sean emerged again, this time on crutches with a brace on his knee, and we were allowed to leave. As we were going, I asked Elizabeth for a place to eat and she directed me to two diners on the "Boulevard," just around the corner. One had stairs, she warned, the other did not. Unfortunately, I turned left at the light (the steering was a little loose on the cannon, but the pickup was quite impressive) and ended up with the one that had stairs. COLONNADE RESTAURANT, the lighted sign said. OPEN 24 HOURS.

I parked the cannon behind the restaurant and, rather than climb the one flight of stairs with a crippled cannonball, we headed up the wheelchair ramp in back that led to a glass door marked HANDICAPPED. I pushed on the handle, but it was locked. I knocked. Four waiters looked up from their pads and quickly looked down at their feet. I knocked louder. The cashier looked up from her register and waved me away from the door. This was not encouraging. Neither of us had eaten since lunchtime, and since then Sean had been shot from the cannon, bashed by the bag, bandied around by the hospital, rebuffed by the nurses, and, even worse, totally humiliated to discover that not one person in all of Staten Island had seen him on TV. I knocked a little louder the third time and even waved one of Sean's crutches in the window to indicate that we were, indeed, handicapped.

No sooner had I lifted the crutch overhead than the owner of the diner, a tall, thin man with a turban around his head, came storming out of the kitchen, running across the floor, and started berating the two of us directly through his still locked door.

"What the hell are you boys doing!?!" he shouted. "Are you trying to break down this door?"

Fed up at this point, I started down the ramp. Sean, however, was hardly so mild-mannered. He was the Human Cannonball. The Dare-

devil of the Decade. The Great DD. He had a reputation to uphold. His response was to take one of his two wooden crutches and begin beating the door, aiming the rubber-cushioned part directly at the owner's face. Now quite animated himself, the owner reached into his pocket and began fumbling for his keys, while I grabbed Sean by the shoulder and pulled him away.

We hurried down the ramp, hopped into the cannon, and drove around the corner. As soon as I reached the light at the corner, however, I began to reconsider what had happened. Even though we had lost the battle, maybe we could get retaliation, I thought, by filing a complaint against the restaurant with the city of New York. It would be the ultimate revenge of the nerds. I pulled the cannon to a stop, left Sean in the front seat, and walked up the stairs.

"Excuse me," I said to the lady at the register. "I would like to know the name of the man who refused to open that door." No sooner had I spoken than the man himself appeared in the foyer and started berating me again. "I'm not going to tell you a damn thing!" he shouted. "In fact, I'm going to call the police."

I laughed. "You've got to be joking," I said. "We didn't do anything wrong."

The man picked up the telephone and dialed 911. "These two punks are trying to break into my restaurant," he shouted. He told the dispatcher his name, his address, and his telephone number. As he did, I discreetly wrote each of them down.

"Now stay right here," he raged at me when he was done. "The police are on their way."

As I walked back to the cannon to tell Sean, the owner walked directly behind me and came to a stop in front of the barrel. With his fists cocked at his waist and his face swelling like a child's, he looked like a taller, thinner version of Sean: the Short-Order Cannonball. Faced with such vaudevillian valor, we decided to wait. Five minutes passed. Then ten. After fifteen minutes I stepped out of the cab and said to the man, "Sorry, it looks like the cops aren't coming. If they do, just tell them they can find us at the circus."

I started up the cannon and drove to the light. Just at that moment

the cops arrived. For a moment I was overcome by the thought of a high-speed chase through New York City at the helm of a thirty-foot-long silver-and-red cannon with a stream of blue-and-white police vehicles stretched for miles behind us as we sped across the Verrazano Bridge, up Wall Street and the FDR Drive, through Central Park, down Fifth Avenue, past F. A. O. Schwarz, Tiffany, and Saks, before dashing to safety on the Staten Island Ferry and floating triumphantly alongside the Statue of Liberty as our pursuers snapped their fingers in frustration: "Damn! Foiled again." Then I changed my mind and pulled to the curb.

By the time I got out of the driver's seat the manager had already headed off the officer and was ranting about how we were in jeopardy of putting him out of business, how we wanted to break down his door, how we were a threat to Western civilization, or at least that much of it that is practiced on Staten Island. This little tantrum only riled Sean even further. By that time he had burst from the cannon and was waving his crutch in a manner that seemed to validate everything the owner was saying. I motioned him back to the cannon.

"Good evening," I said to the officer when the owner was done. I stuck out my hand in greeting. He looked at me skeptically. I started explaining what had transpired, having already decided that I was going to bore this poor officer to death with every detail of our evening. "We're with the circus," I said. "We've come to Staten Island to entertain the people . . ." What followed was the kind of sickly-sweet speech that came partly from my experiences as a onetime student in peace studies and partly from my experiences as a teacher's pet. "My friend was seriously injured during our show tonight. . . . The kind people at the hospital recommended that we get something to eat at this diner." The more obsequious I became, the more bemused the officer got and the more irate the owner. He interrupted me several times, jabbing his finger into my chest and saying things like "Do you know how much that door cost?" and "If I keep that door unlocked people will leave without paying their checks." Each time he burst into a tirade I would turn to him and say in my most angelic voice, "Excuse me, sir. I didn't interrupt you while you were speaking. Now, if you don't mind . . ."

By the time I finished the officer was almost asleep. He turned to the

owner of the restaurant and asked, "So, is there any damage?" The manager seemed stumped. He thought for a second, then said, "No," at which point the officer turned around, got into his car, and drove away. I nodded and walked back to the cannon.

The next day I telephoned the New York City Department of Health.

"I would like to file a complaint against a restaurant for violating my handicapped rights," I said to the woman who answered my twice-transferred call.

"Were you in a wheelchair?" the woman asked.

"No, I was on crutches."

"Then you weren't handicapped."

"What do you mean I wasn't handicapped? I had just come from the emergency room, where I had been in a wheelchair."

"Were you in a wheelchair at the restaurant?"

"No, but I couldn't walk up the stairs."

"Handicapped means you have to be in a wheelchair."

"Okay," I said. "Then I would like to file a complaint against a restaurant for violating my civil rights."

"You don't have any civil rights to be in a restaurant."

"Sure I do. They were keeping me out just because I couldn't walk. They have to keep their doors open to the public."

"No, they don't."

"Yes, they do."

"*No, they don't*. People might leave without paying the check."

"Okay," I repeated. "If that's the case, I would like to file a complaint against a restaurant for violating my legal rights."

"Fine," she said. "Call a lawyer!" And with that she hung up the phone.

Triple Whammy

The best trick of the show begins the second act. It's magic in the air. It's hell on the shoulders.

At the end of intermission four jugglers appear—Kris Kristo; his brother, Georgi; Marcos; and Danny Busch—who perform for several minutes while the audience returns to its seats. At the end of the routine the ring lights go out and these youthful veterans, like a barbecue quartet, juggle among them a dozen burning clubs. The darkness, the fire, and the sizzling pop music all provide cover for a surreptitious entrance by the grandest artists of them all.

"Introducing . . . those celebrated stars of the flying trapeze . . . the Pride of Meeexico . . . the Flying Rodríguez Faaaaamily . . ."

With a flourish of sequins, the team of flyers—Big Pablo, Danny, Little Pablo, and Mary Chris—toss off their capes, kick off their clogs, and begin to climb the two flimsy ladders that lead into the darkness above ring three. As they clamber toward the top of the tent, the lights gradually illuminate their rigging, their breathtaking scaffolding sky. Stretching fifty feet long and ten feet wide, the cantilevered rigging that supports their act looks like a giant bear trap suspended upside down in midair. On one end, hanging eight feet down, is a single trapeze with an aqua-blue wrap where Big Pablo, the catcher, finally sits. On the other end hangs a giant multitiered platform covered with blue carpet where

Danny, Mary Chris, and Little Pablo convene. Below them, stretching the entire width of the tent, is an enormous all-cotton net; while in front of them, dangling twelve feet from the top of the tent, is the somber means of their flight, a three-foot-long solid-steel bar, one and a half inches in diameter, and fifteen pounds in weight.

"It's my baby," Little Pablo said. "It's my life. It's more important than my pillow."

It's also subtly patriotic. The bar that hangs thirty-two feet from the ground and vaults the flyers through the sky is wrapped entirely in white gauze with two inches of red tape on the right fringe and two inches of green on the left. "Red, white, and green," Little Pablo boasts. "The colors of the Mexican flag."

"Hey!"

As soon as the entire family is in place they shout a mutual salute. Then the warm-up begins. The first on the bar is Little Pablo himself. Like his brothers, he is wearing neon-pink tights with flaming sequins on the side and a pink see-through vest that barely covers and in truth only accents his well-sculpted upper body. The look, sort of Mr. Universe meets the Sugar Plum Fairy, is an homage to the inventor of the flying trapeze and, after Robin Hood, probably history's most famous man in tights, Jules Léotard. In further homage to Léotard and his effete French aerialist tradition, Little Pablo and his brothers have shaved their underarms. In deference to their own Mexican macho background, however, they have not shaved their chests. "A bush under my arms would not look good," Little Pablo said. "But my chest, that is manly."

The manly Little Pablo, actually a boyish twenty-three years old despite his grown-up muscles, grabs the bar in his well-powdered hands, jumps from the pedestal with a slight flutter of his feet, and begins the gradual pendulum swing that is both the basic syntax and the lofty poetry of the flying trapeze. "As a boy, the first thing I learned was the swing," he told me. "It's really quite simple. As you leave the pedestal you swing your feet up, then on the way back you arch your back forward, swing your feet under, then throw them forward as fast as possible. It's just like riding a swing when you're little—that little snap of the legs is what gives you all the power. Once you get that down the rest of it just follows."

The rest of it follows, at least for the audience, in somewhat of a con-

fusing blur. The first trick is performed by Mary Chris. She does an initial swing to gain power and then on her second pass through the air, instead of hanging beneath the bar, lifts her body onto the trapeze itself and does a forward somersault that takes her over the bar, through the ropes, and into the outstretched arms of her husband, who has miraculously appeared above the ring at the precise moment she arrives. Catch. Once they complete their follow-through and are back in the middle of the tent, she releases his hands, spins halfway around, and once again grabs on to the bar, which she then rides safely back to the pedestal. Though few in the audience could describe what they just saw, they still burst into applause.

The next trick, a double layout, is Little Pablo's. After completing his swing, he releases the bar in a swan-dive position, does two complete revolutions of his body, and then at the last possible moment grabs his brother's arms. The trick after that seems even more perplexing. Danny, who is tall and shaggy compared to Little Pablo, never mastered the art of catching with his hands. Instead, after his warm-up swings, he performs two and a half revolutions through the air and is caught by his legs. The trick is impressive, a gradual escalation, but like a piece of music that takes place in different themes, the act needs a memorable climax that gives meaning to the disparate early movements. That responsibility falls to Little Pablo; the climax comes from a single trick, arguably the most famous trick in the previous century of the circus. More important, it's a trick that everyone in the audience can understand. Everyone can count to three.

•

The music stops when Juan Rodríguez, alias Little Pablo, steps to the center of the carpeted platform. Not even a drumroll fills the air. It's the first time since the show began that no sound at all is heard in the tent. All eyes turn toward the platform. Jimmy James enhances the scene.

"Introducing . . . the Master of the Legendary Triple Sommmersault . . . Fox Television Star, Juaaaan Rodríguezzz . . ."

A quick slap of the snares accompanies the applause. Juan raises his hand in a salute, plucks a piece of chalk from his waistline, and climbs three steps to the very top of the platform. There he prepares his body for

flight. After stretching his back and clapping his hands to remove the excess dust, he grabs the fly bar held up by Danny, calls to Big Pablo on the far side of the tent, and tightens his hold around the trapeze. On his wrists he wears a three-year-old strip of cotton gauze to make it easier for his brother to grab him. On his hands he wears a small leather palm guard to prevent open sores from weakening his grip. On his fingers he wears a layer of Cramer Firm Grip to make sure he doesn't slide off the bar. In a moment he launches his swing.

"As soon as my brother passes the center I go. I jump up, kick my feet up into the air, and begin my forward swing. On the way back I try to go as high as possible—I'm almost in a seated position by the time I reach the top of the tent. Coming down for the final time I have to let go just before I reach the top of the swing. If I let go too early, I'll smash into the catcher. If I wait too long, I'll fall into the net. It's all a matter of timing."

Like time, somersaults are measured in revolutions. Each spin marks not only the passage of time but also the passing of a generation. Indeed, as Little Pablo explained, the history of ascending somersaults is as closely followed in the circus as the number of home runs is worshipped in baseball. One historian has even compared the question of who would turn the first triple somersault from a springboard in the 1840s and 1850s to the early-twentieth-century anticipation over which aviator would first fly across the Atlantic.

The enthusiasm over somersaults switched to the air in the 1850s after Jules Léotard first leapt from one wooden bar to another over his father's swimming pool in France. The first *double* somersault was thrown by Eddie Silbon in Paris in 1879. The first triple was actually thrown by a teenage girl, Lena Jordan, though her technique (being thrown from one person to another) was slightly unconventional. Instead, the glory for turning the first consistent triple somersault from the trapeze falls to lithesome Alfredo Codona, who performed the trick regularly from 1920 until he dislocated his shoulder and shredded two muscles during a performance in April 1933.

After Codona few people were able to perform the triple consistently, and the trick was considered an unattainable dream. The speed of up to sixty miles an hour, the risk of crashing into the catcher, and not least of

all the mental instability that comes from spinning so quickly in the air all kept the dream out of reach. All that changed, however, in the 1960s with the advent of Tito Gaona, who not only consistently performed the triple but also performed it blindfolded. Gaona even attempted—though he ultimately failed—to catch a *quadruple* somersault in the air. Suddenly the standard had been raised. With the new benchmark came a new crop of performers eager to inherit the mantle of Codona and Gaona. One of these was a group of flyers from Mexico City, the Flying Vázquezes. Another was their cousins the Flying Rodríguezes.

"The first time I threw the triple was in 1980," Little Pablo recalled. "I was ten and I made a bet with my cousin Miguel Vázquez. It was the last day of the first year we had ever worked the flying act. He and his brother came to help us. We were in Evansville, Indiana. Before the last show I told him, 'I'll go up and throw a triple to the net if you throw a quad.' He had never done a quad, and I had never even done a double. I went and threw a triple, and he went and did the quad. It was an incredible moment."

Within a year of that moment Miguel was attempting to throw the quadruple to his brother's hands. In 1982, a year and a half after his experiment with his cousin, he tried to throw the quad on opening day for Ringling Brothers in front of Irving Feld, Kenneth Feld's father, who had purchased the show from the Ringling family in 1968. Like Tito Gaona, Miguel failed. For two months he tried and repeatedly fell short. The dream seemed out of reach. Still, the Vázquez brothers never stopped trying, and on July 10, 1982, in front of 7,000 people in Tucson Community Center, Miguel Vázquez left the bar, turned four complete revolutions in the air, and turned yet another generation in history by catching his hands with those of his brother and completing the first quadruple somersault in circus history. The following day his feat was reported on page one of *The New York Times*.

"It was amazing," Little Pablo recalled. "It was the start of a run. You have to understand, in the circus everyone has his time. Tito Gaona had his time in the sixties and seventies. In the eighties it was Miguel. But now his time is passed. Now there's almost no one left who can even catch the triple every show, not to mention the quad. That's why our time is now."

His timing perfect, Juan Rodríguez leaves the bar high above the ring and immediately tucks his body into a ball.

"The first thing I do is grip my knees, then right away I spread them open. When you throw your head back and pull your legs open that's what gives you the speed. It's called cowboying, from the cowboys, who always have their legs open. It feels like riding a roller coaster."

By the time his arms have gripped his knees Little Pablo has already completed one turn. Since the trick starts with his head facing the catcher, every time his head returns to that point it counts as one somersault. The pace of the turns is marked by the drummer—*snare! bass! crash! catch?*—but Little Pablo himself doesn't hear the count.

"I actually don't count the spins; I just feel them. Just before completing the third somersault I break: I remove my hands and kick out my legs, sort of like doing a back dive into a pool. My eyes are open but I still haven't seen my brother. Not until I'm ready to give him my hands do we actually make eye contact. At that point his hands are like a gift from God. Sometimes he catches my elbows, sometimes just my fingers, but as soon as we grab each other I just slide into place. If I'm late there might be a jerk on my shoulders. If I'm early I might bash into his face. But when it's perfect nothing hurts."

Hanging by the arms of his brother as the two of them complete their arc of triumph, Juan Rodríguez epitomizes the glory of the circus: he's defied gravity, he's defeated fear, he's done what few others have done before—and done it consistently. He's a symbol for his country, a beacon for his family, a hero to children everywhere.

And yet.

"Flying is one of the hardest acts in the business," he lamented, "and we've been doing it since we were small. It's rough. It's hard on the shoulders; it's hard on the mind. It's like gymnastics. The kids start when they're eight or nine, and by the time they're twenty or twenty-three they get burned out. It's the same thing here, except we work every day. Every day, every day. And for what? When Miguel first landed the quad Irving Feld gave him fifty dollars every time he caught it. Later he offered him a bonus of ten thousand dollars if he caught two hundred quads in a year. He caught two hundred quads. Eventually Kenneth Feld stopped the bonus because it was costing too much money. By the time I was ready to try it the incentive was gone. We slapped hands a few times, but we never caught it. As long as you do the triple and catch, the own-

ers don't really care. Let's face it, the quadruple somersault doesn't put people in the seats. Why should I risk my life?"

Back at the pedestal, Juan accepts his applause with an unassuming wave. As Mary Chris and Danny prepare for the finale, a crossover leap in which the two of them pass each other in midair, Juan has already turned his mind forward—to another act (he must return in ten minutes for the high-wire act), to another day (a long drive awaits), and ultimately to another life.

"To be honest I don't think I'm going to be doing this much longer. I like show business all right, but it's rough. If you look at our salaries, then you look at baseball players and people like that . . . they don't do shit compared to us. Not only do we have to work every day, but then we have to set up, tear down, drive, and do it all over again. Maybe I'll stay in the business another two or three years, but then I want to buy a house. Go to school. Maybe learn to weld or something. Get a town job. Relax. That's what we want to do, my wife and I. If you ask my dad, back when he was young the circus was great. Now it's starting to go downhill. It's not like one big family these days. There's no love in the circus anymore."

I certainly could understood his point, but welding? What about the glamour? The lights? The tent? The glory of being a "Fox Television Star," even if it's all just Barnum humbuggery? Ask any welder in America if he would trade his blowtorch for a shot at stardom and what would the answer be? Ask any young circus star if he wants the reverse and the answer would be surprisingly clear.

"I'm doing this because it's what I know how to do. But for me the future is elsewhere. I can still go to school. I can still get an education. I've always wanted to do welding or mechanics. As long as you make enough money to pay the food bills, the light bills, the phone bills, I'll be happy with that."

In the circus, as in America, each generation no longer expects to jump higher, or turn more somersaults, than their parents did. Like so many others, young performers in the circus today have upward desires and downward mobility. Juan Rodríguez could fly through the air, but in the end all he wanted was to land on his feet.

His younger brother was just the same. Only he did something about it.

10

Without Saying Goodbye

Before there was Danny, there was Buck.

I spent Friday afternoon at Buck's place, or what Arpeggio referred to as "Bucky's Workshop." The reason was my trunk. For four months the props department had loaded and unloaded my wardrobe trunk in each new town, a service for which I was obliged to tip them five dollars a week. Now, as a result, the wood on top was splintered, the lock on the front was broken, and the bottom was splitting its seams. Near Shea I had purchased four elbow brackets at a hardware store on Roosevelt Avenue, along with sixteen nuts and bolts. Now on Staten Island, I emptied out my mildewed assortment of dress shirts, baggy trousers, juggling balls, grease rags, makeup containers, powdered socks, dismembered roaches, and melted pieces of candy and carried the trunk over to Buck's red van. There I spent the afternoon slowly repairing the ruptured bottom and listening to stories of Buck's latest adventures on the nude beaches of the Northeast. Just that morning, while I was visiting the Statue of Liberty with Danny, his sisters, and their mother, Buck had driven from Staten Island to New Jersey for a few hours of total body tan.

"That's a long way to go for a tan," I said. "After all, you can go to the beach right behind the tent for free."

"Well, the bridges are free when you leave the City," he said. "Plus,

they want four dollars and twenty-nine cents for a twelve-pack of Coke around here. I can buy the same thing for two forty-nine in Jersey. Plus gas is only a dollar seven. I filled up on super before I came back."

I should have known better than to quibble about pennies with the World's Most Frugal Clown. I asked him instead how he got started sunbathing in the nude.

"I've always liked going to the beach," he said, still dressed in his skimpy jogging shorts and ratty thrift-store thongs. Folded into a wobbly director's chair, he looked like a giant hermit crab who had long since outgrown his shell. "Years ago a friend suggested I go with him to a secret place he knew. Well, I couldn't believe it when I first saw it: nobody had any clothes on! I decided to give it a try, and—boy!—you can really get a good tan. Then another friend told me you could buy a book of all the nude beaches in America, even the world. I still use it today."

Buck pushed back on his heels and smiled: a life on the road, a barrel of laughs, and, as always, a hint of mystery.

When my trunk was repaired I headed back to the Alley, where the boys were just beginning to settle into their chairs and apply the first halting strokes of greasepaint. Just as I sat down Jimmy appeared in the entranceway. His reddened face had the stern demeanor that usually suggested a rebuke was imminent. Maybe we were bunched too closely in spec. Maybe he was upset that so few clowns had signed for the following year.

"Okay, boys, here's the deal," he said, leaning up against the entrance pole in anguished resignation. "When you make the bangs, no more shooting the shotgun behind the seat wagons. You must shoot it behind the fourth center pole, closest to the band. Plus, no more playing with the kids during autograph party. You can shake their hands. You can sign their books. But don't touch them anyplace else . . ."

Some of the boys started to complain, but their pleas came out rather muted. I could feel impending doom. One of the things that had saddened me most about being a clown was all the things I couldn't do: I couldn't hug a child or put an infant on my lap. If a mother asked me to hold her toddler for a photograph, I had, politely, to decline. What if that child goes home at night and tells his mother he was touched by a clown? What if that child begins to cry?

"And that reminds me," Jimmy said. "Who was playing tug-of-war with a kid during autograph party?"

The boys looked around and mumbled at one another, in the process hinting at what everyone knew. He was probably talking about Buck.

Jimmy slapped his hands together in despair. "Well, make sure it doesn't happen again," he insisted. "Somebody called the office and complained, and now we have an incident. I'll have to have a talk with him."

Jimmy left the Alley and the show began. Later that evening I passed Buck walking back toward his van. His head was drooped and he was talking to himself. He was holding his clown wig in his hand.

"Goddamned parents," he said. "All they want to do is complain. I tell you, it's no fun anymore. Once you take away the contact with the kids, you take the fun out of clowning. If that's the way it's going to be, I certainly don't want to clown anymore."

I brushed off his remark as another one of Buck's low-grade grumblings. Later, when he took back his red, white, and blue barker's jacket I had been borrowing for the stomach-pump gag, I took his comment at face value that he wanted to have it cleaned. The next morning when I saw him just before we were paid and he had a frustrated grimace on his face, I took it as a sign of the upcoming "six-pack" weekend with three shows on Saturday and three more on Sunday. That afternoon when I heard Buck had taken the day off and that I would be asked to fire the gun during the firehouse gag, it didn't even occur to me that his absence was out of the ordinary. But by that evening I began hearing comments from some performers. A few of the workers started asking questions as well. And finally, during the second show as I was sitting in the Alley with the other clowns, the unspoken truth finally sank in: Buck had blown the show.

Immediately I felt the loss. Sure, we had lost workers during the year. Sure, I knew that in the circus people come and go all the time. But Buck seemed like such a fixture to me. He had been with the Clyde Beatty–Cole Bros. Circus off and on for close to forty years. He was one of the first people I met on setup day in DeLand, when he stepped into my camper, stretched his legs halfway across my floor, and told me the meaning of slukum juice—the syrupy precursor to Sno-Kones. And now he was gone. I wouldn't have anyone to recommend whether to eat in the

cookhouse (Buck's favorite was the country-fried steak). I wouldn't have anyone to suggest alternate routes to the next lot that were shorter than following the arrows. I wouldn't have anyone who could direct me to the cheapest gasoline, the largest thrift store, or the best homemade pie in any city east of the Mississippi, and a few on the other side as well. I had no source for duct tape either.

And why? What drove Buck from the circus was not health, or money, or even a desire for a normal life. It wasn't even one of the many mysteries he had been eluding all his life. Instead it was the times. Buck Nolan was the epitome of an old-fashioned clown—indeed an old-time circus man. He joined the show because it kept him on the run. He could live his life and pursue his predilections through the immunity of travel. Outside the tent he might engage in indiscretions, but inside the ring he was always professional, despite his sometimes gruff demeanor and often corny jokes. Unfortunately the distinction between public performance and private life seems less possible in America today. These days every public act is viewed as an expression of private demons.

Ultimately this is what chased Buck from the ring: a pernicious climate of mistrust, a kind of sexual McCarthyism that seems to be spreading across America. I had felt it from my earliest days on the show. In my first week as a clown a teenage boy came up to me during autograph party and asked me if I would sign his hand since he couldn't afford a coloring book. I happily obliged. A mother who was waiting nearby snatched her daughter's waiting hand and said in a voice loud enough for everyone to hear, "Never let a strange man do that to you." The girl looked up at me and burst into tears. Now, for her, clown equals pervert. In Virginia several weeks later, as Big Pablo was trying to coax his four-year-old son inside the trailer, the boy started throwing a tantrum. When Pablo reached down and started tugging his arm, several high school students who were passing by started yelling, "Child abuse! Child abuse!" at the top of their lungs. Maybe it was just bad manners, maybe bad luck, but I feared it was a sign that we are starting to believe that behind every strange face—even the face of a clown—is a serial rapist waiting to pounce.

To make matters worse, no one outside of Clown Alley seemed to miss Buck at all.

"Good riddance," one band member said.

"He was a horrible clown anyway," said one of the performers.

"I saw him play that handshake game," one of the butchers complained. "Usually the kid fell down when it was over."

"So is that all there is?" I said to Jimmy, surely Buck's closest friend on the show. "No one seems to care that he's gone."

"Are you kidding?" Jimmy asked. "This is the circus. I warned you, Bruce. The circus just eats you up. It sucks your blood and spits you out on the floor. If I dropped dead right now from a heart attack, I would probably lie here for several hours and then they would carry me out of the tent and red-light me from a truck tonight."

"Red-light?" I repeated.

"Throw me from a moving vehicle. That's what they do to people they don't want. You've got to realize that. Even if we die they don't stop for a minute. The truth is, they don't really care."

The next day few people talked about Buck. Some of the clowns speculated he might jump to another show. One person suggested he might just go home. Before the first show Arpeggio found one of Buck's old size-sixteen vermilion shoes and hung it from the center pole in Clown Alley. After the firehouse gag he found a bunch of dead daisies and stuck them in the heel. Before autograph party he sketched a sign on the back of a magazine that said: WE WANT BUCK BACK.

The next day the entire effigy was gone. The World's Tallest Clown was not mentioned again.

•

A week later it happened again.

"You see, I told you the circus was killing its stars." Little Pablo was sitting on a beach chair in front of his trailer late on Friday afternoon. His dog, Jordan (named after Michael), was scratching and digging in the sandy grass behind the flea market in Commack, Long Island.

"What are you talking about?" I said. Several members of the Rodríguez family were gathered in a circle around the door, drinking iced tea and looking somber.

"Danny," he said.

"Danny?" I repeated. "What about him?"

"He left."

"*Left?*"

"In the middle of the night."

I leaned against the open screen door. His sister looked up from the ground. "Without even saying goodbye."

I sat down. For several moments the group was silent. A series of images from the last several weeks went skidding through my mind. Just a week earlier, after riding the ferry to Manhattan for our long-planned trip to the Statue of Liberty, Danny decided that he would rather be by himself and wandered off alone toward Chinatown. On Monday, during our first stop on Long Island, Danny and I went across the street one night for a snack and he took the unusual step of buying me a pizza. "I'm feeling rich," he said. "Soon I'm going to have lots of money." And then the previous night, after our first day in Commack, Danny said he was sick and stayed behind when Kris, Marcos, and I went out to a nightclub. Sean stayed behind moping over lost love.

When we came back at around two in the morning, Kris and I went to knock on Danny's trailer. There were muffled sounds within, then clanging, and finally whispered shouts among Danny, his girlfriend, and her husband—who unfortunately had just discovered what all of us had known for the last several months. I hurried back to my camper.

"Of all the problems in the world," Little Pablo said. "If he had stolen some money. If he had hurt somebody. Then I could understand his feeling that he had the world on his shoulders. But a girl?"

A few hours after the incident in his room Danny was seen wandering down the trailer line looking for a ride off the lot. He asked Mary Jo, but she turned him down. Finally a member of the band agreed. Danny brought his suitcase, slipped into the truck, and, before the first blush of morning awakened the tent, drove off to the Farmingdale Airport. Several hours later Johnny Pugh was just dropping off his wife at the same airport when Papa Rodríguez and his wife, Karen, came rushing into the departure lounge. "Have you seen Danny?" they asked. Johnny hadn't. The three of them hurried to the information desk, where they learned that their worst fears had come true: minutes earlier Danny had taken off on a flight for Los Angeles. Standing in the middle of the airport, Danny's mother started to cry.

"You know what bothers me most," Antonio Rodríguez told me later. "Beyond what he did to his brothers, his friends. It's what he did to his mother. She's been crying all day." Antonio, Danny's cousin, was changing clothes in his room in the back of Big Pablo's truck. The flying act would be starting momentarily. "I'm not blaming the girl, or anything—she's married; she has her child to think about; she's been on this circus most of her life—but last night he told his parents he would stay. They offered to give him more money. But it was the girl who wanted him to leave so he could make more money, and it was she who was the last to see him. There was all that talk about their relationship after his accident. Everybody thought he fell because he was looking at her. But he was prepared to stay. He was just worried about his plane ticket. He had already paid for it. I told him I would buy it from him and use it to go to Mexico this winter." They had agreed that this morning at ten o'clock they would go to the travel agent and swap the ticket. "This morning he was gone."

"And he didn't say anything to you?"

"He left a note."

"A note? What did it say?"

"I didn't read it. I just put it away. If I see him at Christmas I'm going to hand it back to him. He never should have lied."

In silence the rumors quickly spread. By evening they had turned malicious.

"They say a pussy pulls stronger than an elephant," Big Pablo said. "Now I know why. But you know what? He can't blame it on her. He can't blame it on the circus. He can't blame anyone but himself. He's the one who got into this mess and now he has to get himself out of it. And he can forget coming to me for help. As far as I'm concerned, he's out of the family. Anyone who breaks a contract doesn't have any place here. And anyone who treats his own mother like that doesn't deserve respect. He told everyone in the family he was thinking about leaving but he never came and told me. He knows I wouldn't have tolerated the idea. I have no sympathy for crybabies. Now, I have no respect for him."

Reeling, none of us left the lot that night. I, like many, went to bed early. The circus seemed so unforgiving. The dream seemed out of control.

Where Are the Clowns?

Just in time the clowns arrive.

Walking now instead of running, I approach the center ring with Jimmy's microphone just as the Flying Rodríguez Family completes its final style. As they exit, Big Pablo tries to knock off my hat. Little Pablo feints a right hook to my face. The camaraderie gives way to a gulp of loneliness as I hop on top of the red elephant tub and spin around in my oversized shoes. For a second the tent is tense with silence. I'm all alone in the center ring. Jimmy blows his whistle from behind the back door and the voice that fills the tent is mine. I'm master of the moment. I'm lord of the ring. I'm a child again.

"Hurry, hurry, hurry . . ."

At the beginning of the year the sound of my own voice startled me. Blaring from the speakers and hurling through the air, it was painfully shrill—and way too fast. I couldn't hold the squirming crowd. I couldn't hold the silly accent I'd adopted for the part. I couldn't even hold the microphone, I was shaking so hard. Elmo advised me to drop my accent, lower my voice, and speak into the microphone as if I was talking to a room full of children.

"Step right up, boys and girls, and see the circus sideshow . . ."

Within a few days I had slowed myself down, and within a few weeks I had deepened my tone in an attempt to mimic the full-bodied bass that

Jimmy used so well. A former clown himself, Jimmy had a way of hang-
ing on certain vowels and soaring with certain syllables (*"The Flying Ro-
dríguez Faaaamily . . ."*) that gave his otherwise flat-footed phrases the
ability to turn somersaults in the air. It was by listening to him over sev-
eral months that I learned the central lesson of announcing, indeed the
central lesson of clowning itself. The key was not to be myself, per se,
but to be my clown. This notion, so simple, was surprisingly difficult to
comprehend, though it ultimately proved pivotal to my ability to per-
form. It freed me from any embarrassment I might otherwise suffer from
standing around in silly shoes with a pointy cap on my head. It allowed
me to transcend my otherwise critical mind and act on behalf of my in-
stincts. Above all, it empowered me to override my superego—the con-
straints learned from society—and live according to my id—my deepest,
childlike urges.

This is the genius of clowns, and for some reason only children fully un-
derstand it. An adult looks at a clown and sees a person in makeup. A child
looks at a clown and sees something else entirely—a caricature, a cartoon,
an invincible creation doing what that child always wanted to do: being
silly and not being reprimanded, being reckless and not being injured, be-
ing naughty and not being punished. Not surprisingly, the child is
right. The makeup, so central to the adults, is not an end unto itself; it's
a means of escape. It's a two-way mirror: allowing you to see what's deep
inside of me, and allowing me to reflect what's deep inside of you. I was
not myself in the ring. I was you. I was everybody. I was a clown.

*"Here he is, ladies and gentlemen, the world-famous fire-eater—Captain
Blaaaze . . ."*

At the moment, however, I am king of the roost, a sideshow barker
with a straw hat and a sassy attitude. As I start my pitch, Henry comes
stumbling into the center ring, flinging behind him a Superman-like
cape and waving in front of him a fiery torch. He staggers up to the ele-
phant tub, and just as I'm about to brag about his *"amazing feats of fire
consumption . . . ,"* he points to his stomach, groans in pain, and collapses
onto the ground.

*"Uh-oh, boys and girls! Captain Blaze can't work tonight. Heeee's got a
stomachache. What are we going to do!? Is there a doctor in the house . . . ?!?"*

The words are barely out of my mouth before a screech comes from the back of the seats, the band converts to an upbeat romp, and Marty comes speeding into the ring with flaming red hair, a long lab coat, and a four-foot stethoscope. With his manic pace and agitated action he looks like an absentminded physician—Dr. Jekyll *and* Mr. Hyde. He is followed closely by Arpeggio, wearing mud boots, a nurse's cap, and a giant white dress that sticks out two feet from his bust and butt with oversized foam vital parts. The Playboy Bunny meets Florence Nightingale.

"Boys and girls, please welcome . . . Dr. I. Killum and Nurse Anna Septic . . ."

Stopping briefly to accept their accolades (Anna just can't resist applause; at one point she actually shoves aside the doctor to blow a kiss to her fans), the two professionals from Clown Town Hospital lift the patient off the ground and carry him to a two-piece stomach pump that is waiting in ring one. After a giant suction cup is attached to the fire-eater's stomach, the procedure is ready to continue.

"Boys and girls, we need your help . . . , help us count to three . . . !"

Standing at the front of the pump, a giant wooden box about the size of a washing machine, the nurse grabs the handle and pushes toward the ground.

"One."

With each push on the bar she sticks out her butt and the patient's limbs go flailing.

"Two."

Until her final hefty push when the crowd has joined the call.

"Three."

At which point the doctor goes to the machine and reaches into its core.

"Doctor, Doctor, what was the problem . . . ?"

He pulls out a giant gasoline can and squeezes his nose in disgust.

"Too much gas . . . !"

The audience groans as the pun settles in. The next patient staggers to the door.

•

Since opening day the stomach-pump gag seemed to epitomize all

the internal rhythms of Clown Alley. At the beginning of the year the gag was a source of constant friction. Elmo had designed the routine to be what he called a "big bang" gag. "You go through a bunch of business, the object goes bang, and a big surprise pops out." As he saw it, the gag starts gradually, with each bit getting progressively funnier, until the big surprise at the end. "There's a rhythm to the gag," he explained. "You have to have three or four bits so the audience understands the routine." Jimmy, however, didn't like rhythm gags; he liked sight comedy—quick visual bits with immediate payoff. Caught in the middle, the clowns didn't much care about either theory. All we wanted was laughs, which the original gag wasn't getting. We set out making changes. First, the announcer was moved closer to the action. Next, the number of patients was reduced. Finally, the ailments that afflicted the patients were piqued to make the jokes punchier. By the time we reached New York the gag had been nearly halved in time and more than doubled in laughs. The playpen had performed successful group therapy.

Other changes in the Alley were evident as well. The early tension over my presence had given way first to begrudging admission that I was actually doing the show every day and then by the summer to a surprising brand of acceptance. One incident in particular epitomized the new atmosphere. After autograph party one night in Queens, I stopped by the side of the tent to speak with Khris Allen, who had come to discuss where we were having dinner after the show. As we were speaking, a woman in blue jeans with two small children started badgering me. "Hey, clown!" she shouted from her seat. "Come speak with my children." When I signaled that the second half was about to begin, her requests became more blunt. "What are you doing?" she blared. "Stop talking to that man and come talk with us." When I didn't respond she stood up and started yelling. "Hey, you sorry-ass clown. Come over here and talk to my kids. That's what you're paid for. Entertain us!" I left without turning her way.

Back in the Alley when I described this outburst, the other clowns decided to seek retribution. During the stomach pump that evening, Marty, who was playing the fat lady, went to the woman's side during the act and started dousing her with popcorn. At first she thought it was

funny, until the popcorn didn't stop. One handful in her face. Two hand-fuls at her mouth. And when she raised her arm to protest, another hand-ful down her blouse. "We clowns have to stick together," he said when it was over, and this time his slogan had more meaning. The change was showing in our work.

•

Almost shouting now, I call toward ring one.

"Wait, Doctor, you're not through yet . . . , here comes another patient . . ."

As soon as I speak, four-foot-seven-inch Jerry steps into the ring.

"It's the circus short man . . ."

Pointing desperately at his stomach, Jerry staggers in the direction of the nurse and collapses in her arms.

"Looks like he's got a stomachache, too, Doctor. What are we going to do . . . ?"

The doctor leads the short man to the examining table as the nurse heads toward the pump.

"Now, boys and girls, we're going to pump his stomach. . . . Are you ready to count?"

The children wriggle with anticipation. I raise my arm in the air.

"One."

This time the count begins much louder. The doctor encourages the roar.

"Two."

The entire audience enters the game. The nurse is primping her hair.

"Three."

Until all eyes inside the tent are looking directly at the machine.

"Doctor, Doctor, what was the problem . . . ?"

Marty reaches into the pump and withdraws a metal pie plate piled high with shaving cream. The audience coos in expectation.

"Look at that, boys and girls." The doctor sneaks up behind the short man—*"Too . . ."*—lifts the pie above his head—*"much . . ."*—and steadies his arm for the final blow—*"SHORTCAKE!"*

Splat.

As soon as the words come out of my mouth Marty takes the plate of cream and smashes it into Jerry's clown face. The timing couldn't be

more perfect. The audience couldn't be more thrilled. We clowns are working as well together as we have worked all year. Meanwhile the performers all around us are viciously tearing themselves apart.

•

By August I had a hard time remembering my early days on the show—the sense of excitement, the feeling of wonder, the idea that around every corner was an undiscovered dream. These impressions had been replaced with an almost oppressive feeling of familiarity with the circus, and with it a sense of isolation from the outside world. Various things marked this transition. At the start of the year the number of trucks and trailers on the show seemed too many to count; now on any highway in the middle of the night I could identify any vehicle by the shape of its taillights alone. At the beginning of the season the sheer volume of costumes was almost overwhelming; now I could pick up any spangle on the lot and identify whose costume it fell off of. On opening day I carried a watch and nervously counted the minutes between acts; now I no longer looked at the time but listened to the music instead. More than merely joining the circus, I had completely melted into the show.

To be sure, living in such an intimate community has its advantages. It's cozy, for one. There's a certain comfort that comes from living and working so closely with people, a kind of unspoken trust that comes from constant contact with your neighbors and from an encyclopedic knowledge of their most intimate noises. If nothing else, I had complete faith that after six months in this world everyone in the circus would defend me to the death from the threat of outside force. Circus people may tear themselves apart, but to the outside world they present a resolutely unified face.

Still, if this world felt so safe so much of the time, why did it seem so perilous to inhabit? Why did people flee in the middle of the night? The answer, I came to feel, exists in the nature of the melting pot itself. With such a wide variety of ingredients, the only way for this kind of community to thrive is by letting each individual component live according to his or her own rules. The circus, as a result, is fundamentally liberal. Its essence is its freedom. Its peril is its license. In this way, more than most, the circus is a startling mirror of America, presenting an image that is either a precise re-

flection or a gross exaggeration. Either way, it's definitely a world where bodies are primal, where people work with, express themselves through, and spend a remarkable amount of their leisure time worrying about their physical selves. And what about their minds? Some pray. Some read. Some sing. But many more watch Geraldo, read the *Enquirer* (that's how Kris Kristo, for one, learned English), and talk about their neighbors.

Above all, it was this lethal strain of gossip that so soured me. The sudden departure of Danny Rodríguez brought forth a seemingly endless stream of accusations and innuendo. This wasn't the tame sort of gossip about who got pregnant before they were married or who was knocking on whose trailer last night. Instead it was a more venomous breed, designed to weaken and destroy. When I first joined the show I was fascinated by all the tales of family intrigue around the lot. I was curious about the number of angles, affairs, and character assassinations that could be flown around one group of people. By August I was sick of them. Did I really want to know that a man I like, a man I admire, tried to make a pass at his own son's wife? Did I really want to know that another man I like, a man I respect, is married to two women at one time? These activities may be part of "real life," but if they are, then I know why people go to the circus, for their real lives are too much to bear.

"I knew this was going to happen," Jimmy James berated me when I told him about my frustration. "You've gotten too close. You've been at the fair too long. You can't get attached to these people. You can't think you're doing it for them. You're doing this, we're all doing this, for the ring. For the love of the circus. It's like a day-care center all around this lot. That's why I just retire to my trailer after the show and pull my curtains down. You can't let circus life ruin your love for the circus."

After thirty years of living in the same day-care center, Jimmy had tapped into one of the few consistent veins that joined people on the show: the only way to survive in the circus was to build a private world of one's own. Circus people, I realized, are like tigers: they have a tendency to devour their own. Those who survive do so by living in a tiny cage and only coming out when they have to perform. Right down the line of performers—Nellie and Kristo Ivanov; Venko and Inna Lilov; Dawnita and Gloria Bale—each of these people told me at one time that

the only way they survived in the circus was by minding only their own business and nobody else's. They survived by reaching some mysterious vigilante nirvana, where they trusted no one else and worried only about themselves. They had their forty acres and a mule. They were free.

This is America, I thought to myself. It is the circus. Could I find my way home?

•

Beaming in my artificial smile, I stand in the middle of the center ring and prepare for the blowoff of the gag.

"Okay, Doctor, you've fixed two, but look who's coming now . . ." I point my glove toward the side door of the tent, where Rob appears in a flowery dress (with an inner tube hidden underneath it) and a tub of popcorn and a drumstick in his arms. *"It's the circus fat lady . . ."*

The children giggle at the beastly sight. The fat lady stumbles into ring one, gestures toward her giant stomach, and collides, with an accompanying tympani crash, into the equally obese Nurse Anna Septic.

"Uh-oh, Doctor. She's got a big, fat stomachache . . ."

The nurse leads the fat lady to the examining table and with a certain degree of huffing and puffing finally attaches the suction cup to her stomach.

"Now, boys and girls, you better count loudly, she's got a big stomach . . ."

The nurse hurries over to the lever of the pump and most of the children rise to their feet.

"One!"

Their voices are so enthusiastic they rattle the rancor inside my head.

"Two!"

They want so much to believe in the clowns it would be a shame to let them down.

"Three!"

At the end of the count the fat lady stands up and the doctor hurries to the pump. The machine, however, is overheating—coughing and shaking, about to explode. Retrieving a rope from inside the machine, the doctor beckons the fire-eater, the fat lady, the short man, and the nurse to help him pull out the offending object.

"Doctor, Doctor, what was the problem . . . ?"

The crew prepares to do battle with the machine.

"Too much . . ." They make one collective pull of the rope. *"Too much . . ."* They make a second tug together. *"Too much . . ."* And on the third yank of the rope the line of clowns falls back on the ground and—kaboom!— a giant, eight-foot rubber chicken comes bursting through the doors. *"Friiiiied chicken!"*

Ugh.

Despite this blowoff that was never quite funny, the chicken flaps his wings in the ring as the children clap their hands in amazement. The clowns, in the end, have done their job. We have distracted the audience long enough for the flying net to come down and the elephants to move into place.

Indeed, trotting back to return the microphone, I couldn't help feeling on more days than not that being a clown is in essence being a distraction. Not only did I see it work every day on hundreds of children and their parents. I saw it work every day on me. Even in the depths of my despair about the circus I never stopped painting a smile on my face and transforming myself from a grump to a clown. The transformation wasn't voluntary. In fact, just when I was ready to cast off my vision of the circus as a childish delusion, a young boy named Justin came running up to me after the stomach pump in Yaphank, Long Island, and asked if I would autograph his program. Hundreds of other children had asked me this in the preceding five months. But on this day—two weeks after Buck had left; one week after Danny had left; on a day when I thought I might want to leave myself—I picked up Justin's book and signed my name, "Ruff Draft," and the simple act seemed like a rare gift. Justin took his book back and beamed a distinctly nonartificial smile. Then he stepped forward and embraced my knees.

11

Reborn

"I felt light, like somebody was lifting my soul. The water went rushing over my body. The white gown got wet and stuck to my skin. I could feel myself transform . . ."

Sean Thomas was lying on his newly purchased mauve sheets staring up at the ceiling in the back of his trailer. Dressed in tan shorts and white athletic socks, he looked uncommonly crisp and clean, like a child fresh from a bath. The Mighty Mouse above his left nipple was pink from the shower. It was just after eleven on Saturday night in Toms River, New Jersey, and the show was tucked in for the night behind St. Andrew's United Methodist Church just off the Garden State Parkway. Talk of God was in the air: Reverend Mark Fieger, the local pastor, was planning Sunday-morning services for the center ring. The Lord works in mysterious ways: Father Jack, the regular circus priest, was forced to hold mass in the cookhouse. Sean, meanwhile, had seen the light.

"The truth is, I owe it all to Jenny," he said. "If not for her I wouldn't have gone."

"That Jenny," I said. "She must be magic."

"I don't know about that," he said. "All I know is, she's my wife."

When Sean hit the ground he switched direction. His new course took flight surprisingly fast.

"I remember the first time I saw her," he said. "She came to see the

show in Florida at the end of last year. She was dressed real plain on account of her religion. She had no makeup on and was wearing a long dress. But she had these pretty green eyes and a killer smile. 'Kris,' I said, 'who's that?' 'That's Jenny Montoya,' he said. 'She does a flying act.' I asked him to introduce me to her. 'Okay,' he said. 'But I've gotta warn you. She won't sleep with you unless you marry her.'

"We started talking," Sean remembered. "At first it was mostly about her old boyfriend and stuff. There was this guy from town who she was engaged to, but she had to break it off. He wanted her to go to college, but she told him she had to go back on the road. He thought about joining the circus, but it wasn't really for him. Eventually they split up. I told her I had had a girlfriend, too, and basically the same thing happened. Sometimes you just can't call from the road. Sometimes you can't call for months. Jenny and I were talking about all these things, and the more we talked, the more we had in common. I swear we were like the same people."

The next day Jenny came to the show again.

"I knew she was there but I didn't say anything to her," Sean said. "Later I was walking off the lot after the show when I heard somebody say, 'Sean.' I looked around and it was Jenny. 'Hi,' she said. 'I want you to meet my pastor.' I couldn't believe it. I hadn't even met her mom and dad. I knew something was going to happen . . ."

For the moment, however, nothing did. For the next three months they didn't see each other, and when they met again in Louisville during a pre-season gig for another circus, Sean completely ignored her. "Blew her off, cold," he said. "This was my first time on a different show. There were lots of girls. Still, I always had my eye on her. I would see what she was doing, who she was with. She was always alone or with her parents. I just kept my thoughts to myself."

The season began for Beatty–Cole and another four months passed. The two of them were out of touch. Sean never mentioned Jenny around the lot, but his primping and nesting around his trailer belied his distraction. None of us knew why, until we reached New York. At the time there was a sudden flurry of activity. Nearly half a dozen shows were in the area, and every night performers went hurrying to see their friends on other circuses or hosted small reunions around our tent. It was in this stir that Jenny reappeared. She was quiet, shyly beautiful, and blended

right in. Like most circus people, she was related to many of the per-
formers on our show. Also she was best friends with Michelle Quiros.
Nobody thought anything about her visit. Nobody, that is, except Sean.

. "For a week every time I came out of the tent I would run into her.
We would talk. The truth is, I made a point of talking to her, and she did
the same with me. We just talked. Nothing more. I didn't even make a
move. One night we were sitting in front of the horses talking and her
brother came walking by and said something to her in Spanish. She
started crying.

"'What's wrong?' I asked her.

"'My brother called me a tramp.'

"'Why?' I said. 'Because you're talking to me?'

"'Because he's jealous,' she said.

"'What for?'

"'You know my brother . . . ,' she said. 'He's jealous because I'm with
you.' Then she started laughing.

"'No shit,' I said. 'You mean you people are fighting over me?'

"'I guess so, but it's still bad for me to be talking to you all the time.
People will think. You know how the circus is. . . .' For a week she
didn't come back. I thought she had given in to the pressure. That's
when I hit the ground."

In the wake of his accident on Staten Island, Sean was a different man.
Isolated because of the fight, he was mostly left alone. In pain after every
shot, he became surprisingly self-restrained. For the first time since he
joined the circus he had been rebuffed—by his body, by his friends, and,
apparently, by a girl.

Jenny, it turns out, was in a similar plight. After the incident with
her brother, she got into a fight with her parents. She was twenty-three
years old, she said. She ought to be able to talk with anybody she wished.
Sean had encouraged her to stand up to her family. Now, having done it,
she felt all alone. Finally, in a gloom, she decided to flee. With the aid of
a friend she jumped into a borrowed car and drove the length of Long Is-
land overnight to the tiny seaside town of Greenport, where the world's
largest tented circus was playing a one-day stand.

She couldn't have picked a worse day. The lot was dusty, behind an
abandoned warehouse. The circus was ornery, Danny had just left. And

to make matters worse, word had just reached the lot that Elmo—on an advance publicity tour for the show—had thrown a fit at a mall in Glen Burnie, Maryland, tossing his makeup into a fountain, smearing black greasepaint on a photographer's bald head, and quitting the show in a late-summer huff that seemed to prove that no one was immune to the back side of the circus pendulum. It was hardly the right atmosphere for a confrontation, but at this stage one could hardly be avoided. Jenny's parents, realizing what she had done, hopped in a car themselves the following morning and headed out in pursuit. The circus would have a rival show that night, just at the time that Billy Joel was said to be bringing his children to the circus.

Jenny arrived just as the first show was ending.

"I saw her step out of the car," Sean recalled, "and I could see the tension on her face. She tried to avoid me and go straight to Michelle's, but the high wire was working and nobody was home. Finally she came over to the cannon. 'Man, you just need to get away from your parents,' I told her. 'They're driving you crazy. You can't do anything. They're treating you like a child.'

"'I know,' she said. 'I'm not happy. But there's no way I can leave. I have no place to go.'

"'Sure there is,' I said. 'You can come with me.'"

"'I can't go unless I get married,' she said.

"'Well then,' I said, 'let's get married.'"

"*Ladies and gentlemen, our featured attraction, the World's Largest Cannon . . . !*"

The ringmaster's voice interrupted the scene. With Jenny left standing at the altar, Sean excused himself to go do his act. By the time he returned Jenny's mother had arrived. "'Sean,' Jenny said, 'I want you to meet my mother.'" Sean went over and shook her hand. Jenny's father was parking the car. "'Mom,' Jenny said, 'Sean wants to marry me.'

"'That's right,' I said. 'I love your daughter.'

"'That's good,' her mother said. 'That is very good. But what about my husband?'

"'I'll tell him,' I said. 'I don't care. Let's go tell him now . . .'

"'No,' Jenny said. 'No, we can't. I'm afraid.'"

The second show started. Jenny went to find her father. During intermission she reappeared.

"'Guess what?' Jenny said. 'My mom told my dad.'

"'And . . .'

"'He said he likes you. He said you're a decent man. You're clean. You shave good.'"

Shaving? For months Jenny's father had been observing Sean. In Florida he had seen the act. In Louisville they had shared a dressing room. In Greenport, finally, they met face-to-face.

"I went to see him after the show," Sean said. "He was standing by himself. 'I love your daughter very much,' I said. 'I want to marry her.'

"'Sean,' he said without hesitation. 'I want you to know. This is the happiest day of my life.'"

Two days later Sean Thomas Clougherty and Jenny Montoya were married in a private ceremony near Yaphank, Long Island. That day he twice got shot out of the cannon.

"The funny thing was, I never even held her hand until I asked her to marry me," Sean said. "I never even kissed her until we were engaged."

"So in the end, Kris was right," I said.

"But I wanted it like that. I wanted it to be all new with the girl I married."

"You're just an old-fashioned romantic after all."

"I guess you could say that."

"So why do you think her parents were so happy?"

"Because I'm a good guy."

"No, you're not," I said. "You're a jerk."

Sean laughed.

"Anyway, you're not Pentecostal."

"So what? You can always change. I told her I would be willing to do anything to marry her. She said, 'I don't want you to change just for me; I want you to change for God . . .'"

No sooner had he said that than Jenny walked through the door. Though it was still quite warm outside, she was wearing a straight beige skirt that stretched to her ankles and an off-white blouse that was buttoned around her wrists. Her skin was unpainted around her eyes. Her

brown hair hung straight to her waist. She looked like a piece of smooth, unvarnished wood. She was beautiful. Unadorned.

"Isn't she the greatest wife in the world?" Sean asked, sitting up and slapping his thighs.

"Isn't he just silly?" she countered, pushing him down with insouciant aplomb.

Earlier in the evening the two of them had invited me for dinner—stewed chicken and rice, Wonder bread and butter. It was the first time I had seen silverware in Sean's trailer. It was the first time they had received houseguests. All night the two of them alternately bickered and cuddled like the strangers and newlyweds they still were. "You are the most hyper person I know," she said to him when he jumped on her back and kissed her neck. "You are the most stubborn girl I've ever met," he retorted when she slapped his hand away from the stove. They would snap at each other, apologize quickly, then roll around on the floor in a frantic embrace. "It's just that time of the month," Sean whispered. "All girls are like that." "It's just right after his act," she countered. "All circus boys are like that." After dinner she washed the dishes and took the leftovers to Michelle and Angel while Sean lay on the bed and recounted their story. The number of pillows had blossomed again. Not only mauve, now, but fuchsia and lavender. Sean's old black blanket had disappeared. So had his gold necklace with the Florida Gator.

"Did you tell him what happened at church?" she said, finally arriving on the bed.

"I was just getting to that part," he said, putting his arms around her waist.

"Stop it," she said. "We have company."

"He's not company," Sean said. "He's Bruce."

He tickled her for several seconds until she finally gave him a kiss. Then he returned to his story. The day after Jenny moved into his trailer Sean agreed to attend Sunday-morning services at a local Pentecostal church. "It's not like it came as a total surprise," Sean said. "In recent weeks I had been reading the Bible a little with Michelle and Angel. In Commack a priest came to the lot several times and showed us the right way to read it. Once you know, it all makes sense. For Jenny's sake I agreed to go."

"But you have to admit," she said. "Even you were surprised."

"We went to church," Sean said. "It was Angel and Michelle. Jenny and myself. Mari and even Juan."

"Juan went as well?" I said.

"It was his first time. He had been reading all along, but he never wanted to go to church. You can't make anybody go. They have to want to do it, or it won't work. I think he was upset about Danny."

"So what happened?"

"We were sitting there all through the service, and at the end the priest said whoever wanted to be baptized should raise his hand. I thought about it for a second, then raised mine. At that point I tapped Juan on the leg. He didn't want to do it at first, but then, out of the blue, he raised his hand. He said he felt something inside him push his arm into the air. The priest said, '*Yes*.'" Sean pumped his fist like the athlete he once was. "Anyway, we stood up and went in front of the entire church. We changed into a thin white gown and stepped into the pool."

"The priest was in there with you?"

"The priest was right in the water, only he was wearing fishing waders so he wouldn't get wet. We stepped in the water. He said a blessing, and then he dunked our bodies in the pool. That's when I had the feeling. It was like a wave of lightness that came over my body. I wasn't myself anymore. I felt free."

"You see, a lot of other religions baptize you when you're young," Jenny added. "But at that time you haven't done anything wrong. It's important to go through this experience after you've committed a lot of sins."

Jenny's voice was earnest, her body was erect. Sean, however, was still unsure. It would be several months before he felt comfortable enough to regain some of his former spunk. At the moment he was mostly supine.

"And what about these sins?" I asked Sean.

"Well, I don't drink anymore. I'm trying not to curse. To tell you the truth, I feel a lot better. I do crave a dip every now and then. But all of those things are bad for you, even if you do them a little. It's probably better that I don't."

"We're not perfect," Jenny said. "But God doesn't expect us to be. We pray for each other. We're trying to do better. Whatever God has planned, that's what will happen—"

Far away the generator emitted its midnight cough and slowly, in-

escapably, ground to a halt. Within several seconds Sean's circuit breaker snapped and the lights went dark in the room.

"Do you believe in ghosts?" Sean asked.

"Why? Don't you have battery power?" I said.

"Only when we hit a bump in the road and the cables under the sink stick in place."

"Sean, we have to get a new trailer," Jenny whined.

"But I like it in the dark," he cooed.

I made my way to the door.

•

It was late Friday night on the eve of September, less than a week later, when I walked into Ruby Tuesday's behind Atlantic City Raceway and happened onto Darryl from the props department and a few of his friends at the bar. Like almost everyone else, they were dreaming of escape. Our race down the coast, now well under way, was moving much faster than our ascent. After a few weeks on the Jersey shore and a brief stop on Chesapeake Bay we would be making a long autumn dash toward the Gulf of Mexico, followed by the gradual slide toward winter quarters in De Land. Darryl and his buddies, like many of the workers, needed money for the journey. I decided to ask them my "question of the day."

Beginning with my earliest days on the circus I would occasionally come up with a diverting question that I tried to ask everyone on the lot. Jimmy nicknamed these odd queries my "question of the day" and egged me on to come up with more. Some of the questions were amusing, such as "How many bathrobes do you have?" (Since performers wear bathrobes over their costumes, most have a large supply. Gloria Bale, the narrow winner, counted nine, all with carrot stains in the pockets.) Others were serious, like "What's the biggest insult on a circus lot?" (The clear winner: "carny," which performers find offensive because it likens them to game dealers on carnivals.)

In Atlantic City the question of the day was "How much would you have to win at the casinos in order to leave the show for good?" I had intended this question to be lighthearted, but the answers were surprisingly revealing. Sheri, who along with her husband ran a lucrative corner of the concession wagon, said it would take fifty thousand dollars. "I con-

sider what I make here in a year," she said, "and then how much I could make on investments. Anything over that and I would leave and raise my children at home." Gloria, who makes far less, said it would take her a million. "I love my job. Besides, a hundred thousand dollars doesn't buy what it used to." Many of the clowns said they would go for twenty thousand, while Jimmy James said he would go for a mere ten grand, a shocking testimony to the feeling he and many others have of being trapped in their own privation.

At the bar the answers came just as fast. One of Darryl's friends, the one I nicknamed Michael Jackson because of his long curly hair, said he would leave for ten thousand as well. "Hell, I'd buy me a ball of crack about the size of your beer mug and sell flakes of it for twenty dollars apiece. I'd probably make several million in a month." Darryl, for his part, was more circumspect. "If I won ten thousand dollars I'd send that on to my daughters. It would take a lot for me to leave this show. I've been here almost three years. I've had many opportunities to go."

Darryl, who for some reason didn't have a nickname, was a talker. I never saw him when he wasn't talking, laughing, slapping someone's back, or just plain rapping to himself. Trim and fit with a broad toothy smile, Darryl had a slightly receding hairline and a constantly varying daily sheen of stubble that never developed into a beard yet never completely disappeared. That is, until Atlantic City.

"Look out, ladies, here comes GQ Darryl," I said to him the first time I saw his new clean-shaven look.

"Hell, I'm way past that stage," he said. "My daughter's going to have a baby next week in Baltimore and I want to look my best."

"You're going to be a grandfather?"

"Shoot, man, what're you talking about? I've already got four . . ."

No-Nickname Darryl grew up on the streets of Chicago. By age fifteen he had dropped out of school and risen to second-in-command of a gang, the Black Disciples of Death. By age sixteen he had fathered his first child. By twenty he had two more. A year later he was in prison. "This man started making moves on my old lady," he said. "Finally I confronted him and he told me if I didn't watch out he was going to fuck me up. I decided to fuck him up first. That night I slit his throat. They gave me ten to twelve."

Out of prison a decade later, Darryl started wandering. He sold vacuum cleaners and magazines door-to-door. He hustled. He even worked at a carnival. He was living the underside of the American dream: a black man with a criminal record who was running from his family and living by his wits. One night he found himself at a homeless shelter in Miami when a "fat man with a van" pulled up to the door. "You guys want to join the circus?" he said. "Seven days a week. Three meals a day. Free ride to Birmingham."

"I wanted the free ride to Birmingham," Darryl said, "so I took him up on the offer. When I got here Ahmed said to me, 'You look healthy, come with me.' I thought he was offering me something special. That's how I ended up in props."

The workers, like the performers, have a strict hierarchy. Big top is at the bottom; they do the heavy lifting. Cookhouse is slightly higher; they get free food. Props is considered near the top; they get to wear bright red jumpsuits and work in the ring alongside the performers.

"Who do you think runs the show?" Darryl asked as he bought me another beer. "We do. What do people say about the circus?"

"Everyone I know says two things," I said. "First, 'Is that really her hair?' and second, 'Boy, those guys in the red suits work hard.'"

"Damn straight. Just the other day some guy came up to me and handed me thirty dollars and said, 'Without you guys there would be no show.' And he was right. Who else could they get to pull down that rigging? Who else would lift that tiger cage? That's solid iron, my friend. If we sit down, the show don't go on. Last year it happened. We sat down at 4:29 on a Tuesday afternoon. We wanted to get a draw, even though it was only the day after payday."

"And what happened?"

"They brought that money box out as fast as they could."

"So let me ask you something," I said. "Why do so many guys do those draws when it costs them so much money?"

"It hurts, man. It really does. But you have to. We have no choice."

"What do you mean you have no choice?"

"Crack, man. Don't you know?"

"You mean you'd rather be high today and broke tomorrow?"

"You need it, man. How else could you survive around here? Look, the circus is hell. Sometimes it fucks with your mind. You haven't spent a night in No. 63. . . ." He laughed at the thought. "Sometimes you just need the escape."

"Escape from what?"

"This." He pointed to the skin on his arm. It was as black as the makeup on my clown face. His voice became suddenly sober. "You don't know what it's like to be black, man, Bruce. To come from the ghetto. To wake up every day and be oppressed. You don't know what it's like to hustle."

He indicated it was my time to buy a drink. When I agreed he said he was ready for a stiff one. My beer cost him $1.35. His rum and Coke cost me $5.00.

"So is this show that bad?" I asked.

"No worse than anyplace else. There are only two qualifications for my job: be fit and be black. We have a nickname for this place. Where I come from CBCB stands for Cold-Blooded Caucasian Bastards."

I looked at him in shock.

"Man, you don't know nothing, do you? The name of the game is survival. I'll take whatever I can. If they're going to screw me, then I'm going to hustle them."

Gradually, as I continued to nurse my beer and Darryl started guzzling his stiff one, he told me the details of a racket he was running on the show. Working with several other people, Darryl regularly let in guests through the sidewall of the tent—an old practice dating back to the beginning of tented shows that always seems to find new practitioners on the show and new takers in every town. If one of the members of the group saw a family of six he would tell them the show wanted sixty dollars from them. He would let them in for thirty-five. After tipping the guards at the door, the racket made upward of a thousand dollars a week, Darryl said. Split several ways, that raised his salary of $150 a week to around $500.

"So this life is pretty good for you," I said.

"For now. But I'm going to turn forty in about ten days. I may not look it, but I feel it. When we get to Baltimore my family's coming to pick me up and take me to the hospital where my daughter is staying.

They want me to come home. That's the way black mothers are. They want their people close."

"So why don't you go?"

"I'm not quite ready. I like this life. I like messing with women, having a drink, taking a reefer every now and then. My family's wanted me to come back for a long time. Back in Vineland my daddy came up to Ahmed, pulled out his wallet, and said, 'How much will it cost me? I want my son back.' Ahmed took a step back and looked at me. I said, 'Daddy, you have to understand. I don't want to come back.'"

We got up and left the bar. He didn't want to leave a tip. I left one for both of us.

"So why do you stay?" I said as we walked across the empty parking lot toward the tent. The day had been the hottest in a month. The night was still uncomfortably warm.

"Well, to be honest, I think I'm running from something," Darryl said. "Running from what, I don't know. Ever since my grandmomma died about five years ago, my mind's been fucked up. Then my little brother died and it got worse. He had AIDS."

"I'm sorry to hear that."

"He was a faggot," he said sadly. "I spent the last two months with him and was there when he died. Ever since then the world hasn't been the same. For a long time I had to get away. I went back to hustling. I'd go to a nice bar, like the one we were just in. I would meet some nice white man at the bar. We'd chat. I'd make him buy me a drink. I'd find out how much money he had. Then when we got outside in the parking lot I would jump him. 'This is a jack,' I would say. 'Don't make it a murder.'"

I paused on the blacktop and looked at Darryl. His eyes were yellow and clouded with smoke. His arms were shaking at his side. He was remembering his childhood. He was recalling his brother. He was re-creating his hustle. For a moment neither of us moved. My mind froze still in the face of a story I was helping bring back to life. My eyes darted nervously from his face to the nearby tent and back to his hands. I couldn't help remembering that it was only a year earlier that Darryl had witnessed a murder during setup. Two men from props were setting the high wire when one of the men pulled a knife from his blue jeans and stabbed his colleague to death in the chest. Outraged,

the rest of the crew, including Darryl, surged around the attacker and started beating him in frustration, eventually stabbing him in the eye with the weapon he had used to kill his colleague. The killer was left behind in jail. Word never leaked off the lot. The circle closed around itself.

Now face-to-face in the parking lot, Darryl and I eyed each other, each of us haunted by different fears. Across the street a young woman appeared with a dog. Darryl whistled in her direction. "Hey, babe, come on over here!" he cried. The woman ignored him. "I got a knife," he called to her. "Okay," I started to say. "Enough." But I didn't have to say it at all. He knew. Darryl put his hands over his eyes and wobbled on the pavement. For a second I thought he was going to fall over—or cry. He put his arm on my shoulder. I was no longer afraid.

"I'm getting too old for this," he said. "I've got to get a new life."

We started toward the tent. For a long time Darryl didn't say anything. Finally I broke the silence.

"You've been telling me for a long time you wanted me to remember you when I left," I said. "What do you want me to remember?"

"I want you to say that when you were in the circus you met this man named Darryl. He was a black man. And he was always jovial. No matter if you was in a bad mood, or if the world was on your shoulders, Darryl made you smile. When I sold magazines I used to love the grumps. They were the easiest people to sell because they were the easiest to cheer up. I like to make people smile. That's my thing. That's why I say to you every time I see you, 'Just let me hold something, even if it's just your hand!'"

"Yeah," I said. "What does that mean anyway?"

"It doesn't mean nothing. It just means we're in this together, brother. It means we're partners. It means that the circus is sometimes hell and the only way to survive is to enjoy it."

He stuck out his hand about chest high. I stuck out mine in the same position, re-creating the mock dance we both had mastered in the course of the year. And in that moment before our palms locked, we both laughed out loud, and smiled.

Two days later Darryl's fifth grandchild was born.

The day after that he left the show and returned at last to his family.

Love on the Wire

The penultimate act is the closest to heaven. Its actors are the nearest to God.

"Ladies and gentlemen, boys and girls, directing your attention to ring one . . . Circus producers John W. Pugh, E. Douglas Holwadel proudly present . . . three-time Golden Clown winner at the Circus Festival of Monte Carlo . . . the amazing . . . the daring . . . Angel Quiros!"

Dressed like a matador in purple knickers and saffron shirt, Angel Quiros springs out of his clogs at the edge of ring one and lands soft-footed on a diagonal wire that stretches halfway across the tent and halfway up to the summit. The crowd grows hushed. They barely applaud. Their fingers, by now, are totally coated in popcorn butter and Cracker Jack caramel. Their lips are equally adhesive with Coca-Cola syrup and cotton-candy residue. At this stage the elephants have come and gone. The Kristo family has followed in style with an exotic hand-balancing act. The smoke from that act still lingers in the sky as Angel slowly tiptoes through the fog toward his own private skyscraping tower.

"For me, walking up is simple," Angel said when I asked him why he ascended the wire instead of one of the ladders on the supporting towers. "Frankly it's the easiest way to the top. It's certainly easier than climbing the ladder. That would surely kill me."

Ta-dum! Arriving at the platform on top of the tower, Angel lifts his

arms like a triumphant bullfighter and—along with his wife, brother-in-law, and sister—waves his hands in introductory salute.

"*From Spain . . . ,*" Jimmy James exclaims, "*the Quiros Troupe!*"

With a spicy intro from the band and a cheery clapping of his hands, Angel pivots on the platform and, at last, confronts the wire. Made of tightly braided steel, it's thirty feet above the ground, thirty-five feet from end to end, and three-quarters of an inch around. In real life this type of wire is used to suspend elevators. In the circus it's used to dance.

"I remember the first time I ever stepped on a high wire," Angel said. His voice was still coated in Castilian elegance. His mannerisms were almost princely. "I was fourteen years old. We had been doing a low-wire act at my family's circus in Madrid, and my father asked us if we wanted to do the high wire. 'It's much higher,' he said, 'and more dangerous. You might be scared.' We decided to try it. It's more prestigious, and more—how do you say?—commercial. The first time I went up there, though, I was like 'Oooh, what am I doing here? Why am I doing this?' But we took our time. Sometimes we just went up, stayed an hour or so, and did nothing. Then we started to walk. Finally we began to run."

Running, dancing, even dueling on the wire quickly became the trademark of the Quiros family. While traditional wirewalkers emphasized grace and beauty—elegant tricks performed with balancing poles to the tune of flowing waltzes—the Quiros Troupe emphasized speed and bravado, or what they called *alegría*—dashing empty-handed across the wire, climbing on one another's backs, and generally behaving like raucous adolescents to the equally raucous, fast-paced rhythms of Spanish flamenco music. Angel's opening tricks reflect this bravura. First he darts back and forth on the wire with amazing velocity. Next he stops in the center of the span, catches a gold rope from his wife on the platform, and before anyone in the audience has a chance to realize what he's going to do, jumps rope with the speed of a championship boxer and the grace of a ballet star. Finally, after his sister rides a bicycle across the wire, Angel scampers to the middle of the wire with a shiny saber, thrusts it menacingly into the air, and then, holding the handle in his right hand and the tip in his left, jumps over the blade with a dramatic vertical leap. As always, he carries tension in his eyes, but the pressure is on his feet.

"My feet are my life," he said matter-of-factly. "When you walk on the wire, you can put your feet down straight on the cable, but when you run, the wire has to stretch diagonally from the inside ball of your foot to the outside of your heel. Plus, your toes always have to be pointing toward the ground. It's almost like you're a monkey: you have to grab the wire."

Beginning with his feet, which he protects in white athletic socks and black ballet slippers, Angel carefully builds his act. His legs are noticeably sturdy and strong ("just like a soccer player," he boasts), while his upper body is slender and trim ("all mush," his wife complains). "I'm not the kind of person who uses force," he said. "With me it's all timing. If you use your feet well but not your arms, you fall. If you use your arms right but not your feet, you slip." The balance is in the eyes. "When I run I look at the middle of the wire, never at my feet. If I look at my feet I'll never see what's coming. It's like when you're driving: you don't look at your hands. You always look straight ahead. Your body will follow your eyes."

Following in his family's tradition, Angel is fearless on the wire. He's bouncy, cheery, almost childlike in glee. As a child, though, Angel had little glee.

"I never had a chance to be a kid," he said. "My father was a very tough man. We had to get up at eight o'clock every morning and practice, practice, practice until two. Then we would eat, sleep, and come back again for another two hours of practice. At night we did two shows."

"And how long did that last?"

"Every day for five years. We could never go to the swimming pool or play soccer like other children. He wouldn't even let us go to the beach because we would need a nap when we got home. He didn't want us to be tired, because then we couldn't practice with the same strength."

"Why do you think he did it?" I asked.

"Because he didn't want us to be scared."

"Can you train someone not to be scared?"

"Sure. If the person is young enough you can slap him or scream at him and he'll do whatever you tell him. But if the person is older, like twenty or twenty-one, it won't matter. When you're young you do it because you have to, because you're more scared about what will happen to you if you disobey. That's why you do what he says, because you're

frightened. Then you go ahead and do it—you cross the wire—and you think: Oh, I see. It's not that bad."

"And you never rebelled?"

"I never even cried. Once we decided we wanted to do it, we never changed our minds."

Mindful and even a bit headstrong, Angel and his brothers quickly rose to the pinnacle of their profession. Their act was like no other in the circus. They were invited to perform all over the globe—in Australia, Sweden, Italy, Switzerland, and ultimately the United States. They were, in many ways, on top of the world. Then came the unexpected collapse.

•

"It happened almost overnight," Angel said. "One day we were a family. The next day we were hardly speaking."

Sitting in his trailer surrounded by mirrors, Angel was much more somber at home than he was on the wire. His face was dark with a ten o'clock shadow (a circus day ends well after dark). His eyes were weary with the weight of a season that seemed as if it would never end. It was October by now. We were in northern Alabama. To lighten an otherwise unending autumn, the Quiroses had recently invited a Pentecostal priest from Denver to travel with them for several days and lead their rapidly expanding spiritual community in prayer. In addition to Sean, Jenny, Mari, and Little Pablo, several other people had converted to the Pentecostal movement, including another one of the Rodríguezes, one of the Estradas, and even the beloved pooper scooper from the elephant department, whom everyone called Pizza Man. And one of the Bale sisters, Bonnie, was considering converting and had begun attending the regular Bible study sessions in Michelle and Angel's trailer.

Predictably, this type of mass conversion in such a small community triggered a certain amount of animosity. First there were problems with other families. When one teenage boy started attending the Quiroses' meetings, his parents lashed out at the group, accusing it of splintering the circus community and brainwashing gullible victims. Next there were problems with different sects. A rival Bible study group was so alarmed at the spread of the Pentecostal movement that its members

started an active recruitment campaign of their own, including baptizing people in New York Harbor. Finally there were problems with the neighbors. People up and down the trailer line complained that they were being harassed by proselytizers during the day, then kept awake at night by chanting, clapping, and the unmistakable sound of worshippers speaking in tongues. "I heard that one of them speaks in Chinese," one neighbor said. "I hear they sacrifice chickens," added another.

None of this controversy came as much of a surprise to Michelle and Angel. "It warns us in the Bible," Michelle observed. "It says others are going to hate you because of your love for Jesus. It's part of the territory. That's what God wants." Still, there was another reason the two of them could tolerate the strife. To them it was nothing compared with the situation two years previously when they first declared their love for each other. Then the situation was much closer to home, as their families embarked on a yearlong battle to try to separate them. Only during the final week of our season did they feel comfortable enough—with the situation and with me—to tell me what had happened.

"After that night in Dallas when Angel came to my trailer and found God, I was very happy," Michelle said. "In a way it was better that it happened after I became a Christian. That way we were able to find God together. Two days later I invited him to go to church with me. He said yes, but only if he could do it without anyone seeing him. No one did see him that day, but unfortunately his mother did see me on my way home from church and somehow figured out what had happened."

Within hours trouble erupted.

"After the wire act I heard people screaming backstage," Michelle said. "I thought: Oh, my God. What's happening here? I heard his brother say to Angel, 'You went with them! You went to church. You are a liar!' His father started screaming as well. Then his brother got real upset and punched a hole in the wall. He broke his hand. From then on it only got worse. His family didn't speak to me anymore. They wanted nothing to do with me at all—"

"They thought she had brainwashed me," Angel said. "I said to them, 'You don't understand. It's not what you think.' But they didn't listen. I was upset. They were upset. It was a very difficult time."

"At that point I didn't know what to do," Michelle said. "We had decided to get married at the end of the year. I was going to go to Europe with his family. Then after this happened I got really worried. I thought: What if I go over there with him and nobody ever talks to me? What if they totally ignore me? Finally I decided I shouldn't go at all. 'If you want to get married,' I told him, 'we can go on our own.'"

"But we already had a contract for Europe," Angel said. "My mother talked to me about the situation. I told her that I would go with the family for a year but that after that I was going to get married and go out with Michelle."

For several months the plan seemed to be working. The Quiros Troupe was performing in Europe. Michelle's family was working in the States. Michelle and Angel were speaking by phone. Then Angel invited her to come visit the following April. That's when his parents again intervened.

"They told me she couldn't come," Angel said. "They tried to persuade me to forget about her. I told them, 'If you won't let her visit me you're even less likely to let us get married. If she doesn't come, then I have to leave. The day you least expect it, I'll be gone.'" He asked his mother to give him his passport. She told him she had already hidden it.

"At that point everything was bad," Angel said. "I felt angry, like someone had betrayed me. So I told Michelle, 'Buy me a ticket. I don't want to stay here anymore.' I went to the Spanish Consulate in Frankfurt, and they told me I needed two forms of identification to get a new passport—my birth certificate and my driver's license. I had only my driver's license. My mother had hidden my birth certificate as well."

At that point Angel remembered he had a friend in the consulate in Washington, D.C. Angel called Michelle. Michelle called Washington. Washington called Frankfurt. Angel received his new passport the day before his flight. The next day he left before dawn.

"I didn't have much luggage," he said, "only a bag with a pair of tennis shoes and a T-shirt. I left everything else behind. I didn't even leave a note. I'll tell you, you think everything at a time like that. Why am I doing this? Why am I hurting my parents? But I told Michelle, 'Something inside me was saying, *It's okay what you're doing. Don't worry. Don't stop . . .*'"

"He was scheduled to arrive in Sarasota about seven o'clock," Michelle remembered. "I drove myself to the airport, hoping that he was on the plane. Then I waited. And why is it that when you're waiting for somebody they're always at the end of the plane? All of these people were coming out, and I was saying, 'Come on . . . Come on . . .' When he came and I saw him I couldn't believe it. It was a miracle, really. I was in shock. I was too happy to cry."

"It felt very strange," Angel agreed. "What I had gone through was very difficult, but when you love somebody you love somebody. Other things don't matter. If it wasn't for my family she would have come to Europe with me. But things didn't work out like that, so I had to come to her. In my culture that's a very bad thing to do, but I decided to do it anyway."

Two days later Angel Quiros and Michelle Ayala were married in the Sarasota United Pentecostal Church. That night they spent their honeymoon in a hotel by the beach. The following day they left for Reno, Nevada, where Michelle's family was scheduled to perform on a show. Angel's family was not informed.

"I didn't speak to my parents for a year and a half," Angel said. "My sister, who was already living in America with Juan, called every week, so they knew I was alive. But I never talked to them directly. I had nothing to say to them. Finally, a couple of weeks ago we were in Sterling, Virginia, and Mari was talking to them on the phone in front of a Home Depot. I told her, 'I want to talk with Mother and Father.' She said she didn't think it was a good idea. I told her I thought it would be okay. I picked up the phone and my mother spoke first. 'We want you to know we love you,' she said. 'Everything is fine. We've forgiven you. It's all in the past.'"

Michelle was holding her husband's hand. "That night he said, 'We're going to visit.'"

Angel nodded through his tears. "That's right," he said, "we're going home."

Circles are hallowed in the circus: even life is lived in rings.

•

For the final trick the troupe unites. Little Pablo, who started walking on the wire at the start of the year in an effort to expand the act,

grabs an eight-inch stainless-steel wheel and sets it on the wire. Holding the wheel by its two small handles, he tucks his feet underneath Angel's arms and lowers his head just inches from the wire. To make this human wheelbarrow even more complex, Mari climbs onto Angel's shoulders and raises her arms in the air. The trick is ready. The band stops playing. With heart-pounding accompaniment from the bass drum, Angel takes up a twenty-foot pole for balance and begins to step across the wire— pushing his brother-in-law, carrying his sister, and inching ever so carefully toward his wife, who stands at the far end of the wire gesturing anxiously at her family and trying to lure them home.

In the middle of this odd family portrait Angel Quiros remains calm.

"When I'm on the wire I'm a different person completely," he said. "I've got to show the people: I'm Angel Quiros. That means something to me. I want people to remember us. Sometimes they are a little tired. They've seen so many acts. I don't want that to happen. I want the people to wake up and say, 'What's going on? What is he doing . . . ?'"

And down below they are saying just that.

"Can you believe it?"

"His feet are so small."

"Oh my God, he's going to fall."

But Angel isn't going to fall. He's never even considered it.

"People always say to me, 'Look, you're crazy.' But I'm not crazy. I know some people who are. They don't practice. They don't know what they're doing. But they go out and work anyway. And they fall. If you know what you're doing, if you know how to pull everything together, even the most extraordinary act is just doing your job."

And what a job it is: before 3,000 people, thirty feet in the air, with your sister on your shoulders, your brother-in-law around your waist, and your wife welcoming you back home with a kiss on the cheek and a thank-you to God. All jobs—all stories—should end so happily . . . twice a day, seven days a week, every day of the year.

"Ladies and gentlemen, the Quiros Troupe!"

12

At Heaven's Door

Marty came running into the Alley just as intermission approached.

"Bruce, come quick. It's happening."

"What's happening?" I asked, standing up to go. At this point, could there be any surprises left?

"It's Barisal," he said. "Her water broke."

The answer was a resounding yes: tiger births on Halloween eve.

"Hold on," I said. "I'm on my way." I slipped on my floppy shoes.

The show arrived at the Gulf of Mexico just as the calendar tipped into fall. Now that we were starting our eighth month on the road, signs of aging were everywhere evident. Fabio Estrada, a newborn in March, was already beginning to walk. Georgi Ivanov, a teenager in August, was already sporting an earring. And Esmeralda Jamaica Queen, the baby Burmese python that Pat and Mike of the horse department purchased in Forest Park, had already increased her infant diet from one mouse a week to four. Susie, the ticket seller, meanwhile, had slashed her diet in an effort to lose her baby fat and had passed her maternity clothes on to Blair, who was one of four women on the show to get pregnant since the season began.

In Clown Alley the strain was beginning to show. In late October my beleaguered trunk finally collapsed, and in Muscle Shoals, Alabama, I spent nineteen dollars on a replacement at Wal-Mart, another reminder that we

were back in the South, along with Krispy Kreme doughnuts, NRA bumper stickers (MY WIFE YES, MY DOG MAYBE, MY GUN NEVER), and nineteen different kinds of chewing tobacco in the aisles of the Starvin' Marvin convenience stores. As the weather got steadily chillier, the boys in the Alley replaced their cans of cheap generic cola with cups of cheap generic tea, and supplanted their Saturday-morning games of pickup softball with Sunday-afternoon games of touch football. Moreover, in the most conspicuous sign of general fatigue, the number of "dick in the ass" jokes declined from a testosterone peak of five an hour to a mere one or two feeble attempts a day. I knew it must be getting late in the season when the boys in the Alley couldn't even get it up for one another anymore.

In the midst of this communal death watch—three weeks and twenty-five shows to go—a parallel watch was taking place around the tigers. This one involved a birth. Since Kathleen left in early May, Khris Allen had been confronted three different times with what he thought was a pregnant tiger. The first, Barisal, proved to be a false alarm. The second, Fatima, suffered a miscarriage. Still, acting on Josip's orders, Khris continued to mate the cats—during pre-show playtime in the ring; overnight in their cages—and by early fall he seemed to have scored. "It happened somewhere in New York," he recalled, "probably in Queens. Again it was Barisal. She's a tabby, so I mated her with Taras, another tabby. The general idea was to have a tabby-tabby litter to see what type of colors she would have. In her first litter, with a standard male, she had a snow white and a white. In her second litter, with another standard, she had a tabby and a white. By mating her with another tabby—pale custard in color with dark sienna stripes—we could learn if the tabby is an actual gene or just an aberration."

By early October the signs of pregnancy were apparent.

"Her belly got bigger, much bigger than before," Khris said. "This time when her nipples dropped they were as big as grapes. Also this time she seemed proud. When I took her into playtime she would march around and say, 'Yeah, look at me. I'm pregnant. Come scratch my belly and feel my baby.'"

By the end of the month her anxiety increased. During the last week of October, Khris took her out of the act. Twice a day he checked her nipples to see if they had started producing colostrum—a mixture of anti-

bodies and hormones that's a sign she's about to deliver. On Thursday she started defecating a lot, another sign of imminent birth. On Friday she didn't eat her dinner at all. "For the last few weeks she's been wolfing down her food," he said, "then suddenly she only picked and played. I was pretty sure today was the day."

And it was.

Marty and I arrived at the tiger compound just as intermission was beginning. The sky above the Greater Gulf State Fairgrounds in Mobile was mottled with clouds and an impending storm. The general buzz inside the tent mirrored the murmur around the tiger cages. Khris was pacing nervously, running his fingers through his hair, which was now even thinner on top and longer in back.

"I was at home when I heard it," he explained. "Actually I was in bed . . ." He winked. The previous night, in a rare moment of bravado, the normally shy Khris had succeeded in breaking the rules of the Roosters nightclub and inviting one of the young female "dancers" back to his compound for a private show. "I was rather proud of myself," he said. "Score one for the balding men of America. . . . Anyway, I was taking a nap when I heard Barisal scream. She has a moan that sounds like 'Aaaoom. Aaaoom.' But this time it sounded like 'AAAAAAhhhoooowwww.' I was like 'Oh, shit. She's gone into labor.'" Khris threw on his clothes and ran outside. By the time he arrived a small assembly had gathered—Marty, me, and Khris's friend Bushwhacker from the mechanics department.

Rocking back and forth in her cage, Barisal was agitated. Her rear end was covered in brownish fluid. The hay at her feet was clumped on one side. For a few minutes she walked around in a circle unsure what to do. She would lie down for a moment, writhe uncomfortably, then stand up again. Seconds later she would repeat the routine. Finally, at a little after 8:30, as intermission was drawing to a close, Barisal stood up for one last time, roared with a slow, almost mournful yawn, and arched her subtly striped back as the head of a cub—like a large sticky bun—first appeared between her legs.

"Holy shit!" Khris exclaimed. "The first one's coming already."

The cub's head was moist, still coated in brine; its legs were hidden from view. Barisal squatted down in her cage, strained the muscles in her

brawny legs, and with a rather indelicate pop deposited her plump little bundle of life in the six-inch pile of hay. Almost immediately Barisal turned around and began chewing off the umbilical cord that dangled limply from her baby's belly. Then she started cleaning her cub—lapping up the afterbirth to stimulate her own milk production; licking the nose to clear it for air; and finally nudging the infant's mouth to encourage it to breathe. Within minutes the baby began to squirm, and the mother pulled back to observe her cub. An unspoken creation had made the world fresh. The circus had new life.

•

Within minutes of the birth, it began to rain. And Khris was starting to panic.

"I was excited when I saw the baby," he said later, "but also nervous. I was like an expectant father whose wife was in the hospital. I didn't know what to do. It was starting to rain harder. We had another show to do, but I still had to keep an eye on her. What if she rejected the cub? What if she started to eat it? At first I thought: What the hell. I'll just take her into the tent and won't put her in the ring. Then I realized: What the hell am I thinking? She's going to be having other babies. She'll start screaming. People will think she's dying or something. I decided to load her into the truck. Then Royce came and told me the second show was being canceled because of the storm. That raised a new set of problems."

Now freed from the show but burdened by the long jump ahead, Khris moved quickly. He ordered his grooms to tear down the awning and prepare the tigers for the move. One by one he winched the steel cages up the wooden ramp and into the back of the tiger truck, No. 78. He put Barisal's cage in last so he could monitor her during the night. By 10:15, with only one cub born and the rain starting to muddy the field, he was ready to leave for Panama City, Florida. If he was lucky he could make it to the next lot in under three hours and be there for most of the other births. Unfortunately, he didn't make it five miles before his truck broke down.

"I was numb," he said. "I was really frightened. The whole thing was happening so quickly, and there I was on the side of the road with a truck full of tigers, a mother in labor, and no one else around."

Over the next three hours, as Khris waited for the show's mechanics to arrive, Barisal gave birth to the rest of her litter. By the time they reached Panama City it was 3:15 in the morning and Barisal had a total of four cubs, all of them tabby.

"I was tired," Khris said, "but very proud. This is one of the reasons I'm here. Doing a good performance is like performing well in sports. You feel confident in your abilities. You feel proud that the cats responded well. But this was an experience of a lifetime. It's a true miracle, more so than a human baby, because human babies are born every second. This is an endangered species that I'm helping nurture. She's doing all the hard work, of course. But I have a lot to consider. When she had the first baby I had to walk away for a moment because I was too emotional. I was at the point where I was ready to cry. I was very proud of her . . ."

"So who did you share this with?"

"Who do you think?" he said. "When Barisal was having her babies by the side of the road I called my dad, my mom, my brother, and my grandmother. They were all excited and wanted to know what was happening. Then I called Kathleen. She's the only one who really understands how this feels. After that whole experience between me and her it's really good now because we're talking again. She understands about the babies . . . and what might happen tomorrow. After all the bullshit that has happened—the jealousies and the intimidations—our friendship is starting to overcome it all. It's funny, isn't it? The tigers are originally what pulled us apart. Now they're bringing us together."

•

"Come on, I want to show you something."

Khris came to my door after the firehouse gag during the 7:30 show on Saturday night. His mood was subdued. His face tightly drawn. It was almost exactly twenty-four hours since the first cub was born, and since that time he had hardly slept.

"I came to check the tigers after the first show," he said. "The local media were busy filming a story. I transferred Barisal to an empty cage so I could clean up her mess and examine the babies. One by one I removed them from the hay. They were very soft, like little stuffed animals. Each

one was pliable. Their eyes were closed, and will stay so for about two weeks. Their faces were all scrunched up. Their umbilical cords were already drying up and beginning to scab.

"After taking three cubs I realized one was missing. I searched through the hay. It was wet and bloody. It had a lot of defecation in it. I began to clean it out and that's when I discovered the missing tiger. I picked it up and rolled it over. The head was in the shape of a wet sack, almost like a water balloon. It had been born with a severe deformity. It wasn't breathing. I knew Barisal had rejected it. Maybe she buried it after it died; maybe she buried it alive. Either way, I still felt bad. I looked at the photographers and said, 'Okay, you have to leave now. The mother's getting upset.'"

Arriving in front of the tiger compound, Khris turned off the overhead light. He went to the last cage on the right and opened the door. Without speaking, he pulled out the cub—caramel in color with dark vertical stripes—and placed it in a blue laundry basket lined with hay, then covered it with a pink-and-white dishtowel. Even at this moment he was thinking of the cub. The music from the hair hang drifted from the tent. A chilled moisture clogged the air.

Khris shut the cage and carried the basket behind the tiger truck, alongside the tattered bumper sticker: . . . AND ON THE 8TH DAY GOD CREATED TIGERS. Moving quickly and with glazed determination, he set the basket by the right rear tire. He kept his eyes focused on the towel, mumbled something to himself, then carefully lifted the tiny bundle from the basket and placed it into a small, coffin-like box. He was crying by now. The light drained from his eyes. All around him the sound seemed to dim. Even the music from the tent couldn't be heard on that side of the truck. The heavens, at that moment, seemed far out of reach. The circus had lost a star.

"Barisal might look for the missing cat for a minute or two," he said, "but then her mothering instincts will take over and she'll turn her attention to the surviving babies." His voice was a whisper. His hands had started shaking. Later he would have to calm himself long enough to give the cub a proper burial. "I numbed myself," he said. "I really did. I tried to be prepared. I know that the remaining babies will be better

cared for. I know it's what Barisal wanted. But still it hurts. Maybe I could have done something different. For all I know this could be something that will get me to hell. I tell you, this is not one of the better parts of animal care. But when we took cats into captivity we knew we couldn't control everything."

"Do you think most people understand?"

"My mom understands—I called her a few minutes ago—but she said she was sad. The truth is, when you go down to the very core, it's still the end of a life. That's something I hold very valuable. In a way I consider animals more valuable than humans, because I know what humans have done. That's strange, but it's true. I can care for animals better because they're straight up. They don't stab you in the back. They let you know: 'Okay, it's time to play with me. Okay, now it's not.' They don't connive and scheme to hurt you. They aren't negligent of the world around them. In fact, they go along with it. They are a part of nature. And look what happens. . . . Sometimes I hate my job."

I rested my hand on his shoulder. He started back toward the tent. The final acts were just beginning. It was Halloween night.

•

Later that night we climbed the tent.

The generator as usual went off at midnight and with it the lights on the center poles and in all the trailers down the line. Earlier, Khris and I had gone to have a drink and returned just in time to be summoned as judges for the annual Halloween costume party in the center ring. Kris Kristo had brought a girl from town. Marcos was listening to his Walkman in the seats. Blair was waiting to throw up in ring one from a bout of midnight morning sickness. With the party over, the candy put away, and the lot under cover of darkness, we decided to fulfill our last rites as graduating First of Mays and climb to the top of the World's Largest Big Top.

Outside the big top, we tightened the laces on our shoes and shimmied up the now dingy yellow ropes to the outer lip of the tent. The vinyl was moist and clammy, like a fillet of raw fish. It was slightly cold to the touch. As we were resting for a moment abreast of the outer poles, a layer of dirt came off on our bodies from the previously pristine blue-

and-white fabric that had been rubbed through the asphalt, dirt, and grass of nearly a hundred towns. Up close the brilliant background of the circus was sullied by a palette of multicolored sludge, almost the opposite of an Impressionist painting—swirling mud lilies that disappeared in the light and shone only in the dark. Now soiled ourselves in a layer of grime, we groped to our feet and started up to the top of the tent.

Wavering on the Jell-O-like surface, we slowly waded up a streak of white to the first crest of the quarter poles. My heart was pounding like the drums in the show—partly out of fear that my feet would give way, partly out of the thrill of this forbidden flight. Clowns are supposed to stay on the ground, not presume to walk on the air. Now already twenty-five feet in the air, we had two more layers of tent to go. Between each crest, like slippery dunes, the vinyl sagged in a sad sort of valley, so it felt as if we were sliding into a quicksand pit and had to grope for the next solid ridge. The last leg of the ascent was the most treacherous. The vinyl got suddenly slicker. The stripes grew gradually narrower. And the whole tent seemed to shake like a cartoon magic mountain with a sinister laugh that wanted to prevent us from reaching its peak.

We pushed ahead. The summit was near. My heart was beating behind my eyes. In the last few steps I nearly lost control as the tent soared upward to its final crest, making it nearly impossible to stand. I collapsed to all fours and crawled to the peak, grabbing desperately for the red center pole that held the promise of steady footing. For a moment the sky was spinning as I settled my body onto the bail ring and adjusted my eyes to the height. Then, in a moment, the earth was still. The tent stopped shaking and relaxed into place. The breeze was surprisingly calm. The flag above me—CIRCUS in bold letters—hung limply from its mast. The show was fast asleep for the night. Its dreams had turned toward home.

Alighting beside me, Khris surveyed the scape. "So this is the top of the world," he mused.

"The doorway to heaven."

"The entrance to hell?"

We started talking about the season, together making an informal tally of the range of events we had witnessed since the start of the year. The list was circuslike in its scope. In the course of eight months on the

road with the Clyde Beatty–Cole Bros. Circus, one person had a baby, four people got pregnant, two people got engaged, one person got married, one couple was separated, two people died, three people got arrested, one person was imprisoned, six people converted, one person gained U.S. citizenship, two people broke bones, one person chipped a couple of teeth, two people had knee surgery, one person had back surgery, one person lost a parent, one person aborted a child, dozens of people got fired, and at least one person got hired, fired, rehired, and all but refired. Plus, in the previous day alone, four tiger cubs were born and one was summarily abandoned. The pot was at full boil.

From the ground the circus often seemed to be a cauldron on the verge of bubbling out of control. There were few restraints, even fewer restrictions, and seemingly little recipe for concord. But from our vantage point atop the tent that mix seemed remarkably well balanced. From above, the circus looked like a well-ordered town. There were homes and families; private neighborhoods and public spaces; parents, children, animals, clowns. And hovering over all of them stood the silhouette of the tent like the ghost of a church the town couldn't forget and indeed carried on its back wherever it went. When I first saw the tent that initial day in DeLand I thought it looked like a whale—big and bloated with a kind of distant charm, a beast so large it couldn't help overwhelming and would be impossible to grasp. Now, instead of just the body of a whale, I also saw the character of that creature and the story of its life.

It was an enduring story of a group of people who came from various lands in pursuit of a common dream—a dream to do what they wanted in a place that was free, a desire to carve out a little corner of the world where they could be themselves. And as I imagined that story in my mind, I began to see a flood of images from recent days. I thought of Little Pablo and his wife, who had just purchased a new home to pull behind their truck but didn't have enough money to buy any furniture for it. I thought of Sean Thomas, who had given up liquor, forsworn women, and even sold his gold Florida Gators necklace for the promise of a better future. I thought of Khris Allen, now silent beside me, whose experience in the previous twenty-four hours had forced him to confront the sad underside of animal care.

As each story flickered through my mind, I thought of a parallel in

American myth. Khris Allen—a modern-day Huck—and his friend Bushwhacker, former soldier and convict, who together somehow transcended the class and racial structure of the circus and formed a curious friendship that catapulted them to freedom up and down the modern Mississippi, I-95. Douglas Holwadel—a wandering Willy Loman—who walked, talked, dressed, and drank like a salesman and who bought into the circus because it was the ultimate home for a traveler and who, by year's end, was slowing down with what he called "old man's disease." And eventually myself—a watered-down whaler?—lost at sea in a personal quest to comprehend and ultimately confront some grand, elusive dream of the circus as an allegory for American life.

And in the exaggerated rush of that moment my search finally seemed to reach its natural end. This *is* America, I thought again, this time much more at peace with the thought. It is the circus. There is sin as much as splendor. There is grit as much as glitter. But at that moment, on top of it all, there was no place on earth I would rather have been.

•

Two days later one more ring was closed.

Kris Kristo, Marcos, and I were at the Ruby Tuesday's at the Oaks Mall in Gainesville, just around the corner from the hospital at the University of Florida where Sue the elephant had been operated on at the beginning of the year. The bar was having a Monday Night Football special, whereby each person won a free seven-ounce beer every time their chosen team scored. I was single-handedly serving the entire table courtesy of the Buffalo Bills. Kris, meanwhile, ordered Buffalo wings and tried to pick up the waitress, the bartender, and even the woman vacuuming the floor. Marcos wasn't eating because of a religious fast, but he was drinking Tequila Sunrises, smoking Marlboros, and complaining about how boring the circus had become now that half the people had turned to God. End-of-the-season malaise had sunk in, not to be confused with the middle-of-the season slump, or the beginning-of-the-season blues. The performers needed a break. The circus needed a lift.

"*¡Dios mío!*" Marcos cried, pointing at the door. "Look who's coming."

"That's Pablo," said Kris.

"No, you fool," Marcos said. "Behind him."

"Is that really him?" Kris struggled to see.

"Yes, it is," Marcos said, setting down his drink.

"Oh, my God," I said, when I finally saw. "Danny's come home."

The three of us rose to our feet as Danny Rodríguez came sauntering into the bar just behind Big Pablo. He was wearing a Chicago Bulls light winter jacket. His long hair had been cut short in the back, bringing even more attention to his narrow face and bucktoothed grin. He reached toward Marcos and gave him a hug. Kris moved forward and slapped his back. Big Pablo looked at me.

"Before you say anything," he said, "I want you to know: he's blood. What else could I do?"

Finally Danny stepped toward me and we embraced.

"Welcome back," I said. "We missed you."

"It's good to be back," he said with a sincerity well beyond his eighteen years. "It's nice to be home."

We ordered another round of drinks and, when they were gone, headed back to the lot.

"So, you didn't know he was coming?" I said to Pablo during the walk home. It was the coldest day of the year so far. The central Florida newscasts had called for a freeze and ran stories urging people to read the instructions on their space heaters before using them that night.

"No, I didn't know until I saw him. He came close to me, then stopped. He was about four feet away. I saw he was crying. That's all I needed. I knew something had gone wrong out there. I knew he wanted to be let back in. I didn't wait for him to come to me. I went to him. I hugged him. Then I said, 'I don't care why you left. I don't care why you came back. You're here, that's all that matters. When you're ready, you can come tell me yourself. That's what brothers are for . . .'"

Arriving back at the trailer line, Danny hugged Little Pablo, who was out walking his dog. Kris offered Marcos a piggyback ride. Big Pablo faked shooting a basketball. For a moment the circus was made whole again. The dream had been revived.

An American Dream

The dream, in the end, begins with flight.

"Ladies and gentlemen, our featured attraction, the World's Largest Cannon . . . !"

Inside the big top the anticipation soars as the back door opens for the final time and the world's largest cannon slowly rolls into view—its siren wailing, its flashers beaming, and its barrel growing foot by foot with every gasp from the audience and every camera flash. Standing atop the silver barrel is the newest American daredevil himself. At first he looks like Elvis, only blond. Then Superman, only shorter. But when he finally arrives in the ring, with his blue eyes and blond hair aglow in the light and his white rhinestone suit shimmering like a torch with red and blue star-studded racing stripes, Sean Thomas looks taller than God.

"Introducing . . . the Human Cannonball . . . Seaaaaan Thomas . . ."

As Sean salutes and waves to the crowd, the seventy-five or so members of the cast line up just behind the back door and prepare to stream into the tent like apostles at the second coming. The atmosphere backstage is ripe with excitement, though slightly tinged with rue—another season passes safely, another year is borne by the body. As the performers inch into position most are busily saying goodbye; as soon as the show closes tonight in Palm Beach the cast will scatter in a dozen directions. A few are thinking of retiring—Venko Lilov, Dawnita Bale, even Jimmy

James himself. Many more are thinking merely about going home—Michelle and Angel are heading to Spain; Sean and Jenny are going on a honeymoon; and Danny Rodríguez, who in the end said he didn't like the pressure of earning money and missed being a performer, is returning home to Sarasota with his mother and father.

I am truly going home: this show will be my last. Earlier, feeling celebratory, I asked Fred Logan if I could ride an elephant during spec of the last performance. With a silent nod and a gruff thumbs-up, he led me to the end of the elephant line and called for the last bull in the herd to kneel down. I placed my left foot on her right front leg, and without so much as a hint of strain she hoisted me almost ten feet in the air and all but flung me onto her back. Upon landing face-first on her shoulders, I was so surprised by the scratchiness of her skin and the intense heat from her neck that it was not until I tucked my legs behind her ears and dangled my shoes beside her face that I looked down to pat my three-ton chauffeur and realized that I was sitting on Sue, whose fortitude during surgery a year earlier had drawn me into this circus and whose strength this final night would carry me out.

By the end of the evening as the moment approached for me to walk into the finale, I was feeling more nervous—more excitable and tense—than I had felt on opening day. At that time all I had noticed were the bodies and props of all the nameless people around me; now I felt the devotion and faith that ran throughout the company—more congregation than corporation, more cult than cast. Indeed, I felt a bond with this community that was greater than any I could recall feeling with any other group outside my family. The feeling is what I imagined military camaraderie to be like: the people on the show may have come from different backgrounds, we may have had different aspirations, but for nine months on the road we traveled to hell and back together and emerged in the end slightly wounded for sure but almost fanatically devoted to one another and to our near-religious cause. Onward, circus soldiers: the world needs your message of hope. And on that final night of the season the mood of fellowship was everywhere ascendant. Just before I stepped through the door with all the other clowns, Marty tapped me on the shoulder and offered his arms in embrace. "Well, Bruno," he said, "you

did it. I don't know what kind of writer you are, but I know you're a hell of a clown."

"And the stars of the Clyde Beatty–Cole Bros. Circus . . ."

At last I step into the lights. The ground seems light beneath my feet. With waving arms and beaming face I dance to the lyrics *"Join the circus like you wanted to when you were a child . . ."* In a moment I arrive in the front of ring three and stand beside the passenger door to the cannon, where the silver lettering announces GUN FOR HIRE. In ring one the giant yellow-and-blue air bag is being filled by means of portable fans. In between the bag and the barrel the cast slowly arrive at their places and stand solemnly at attention as if pointing the way for the gun to fire.

"All eyes on the giant cannon . . ."

The music changes to a fearsome dirge as the mouth of the thirty-foot silver barrel slowly rises into the air. At the top of the barrel Sean surveys his path. His face is etched with well-worn concern. His eyes squint in the manner of a ten-year-old boy trying to remember the answer to a test. His whole body seems remarkably slight.

"Lieutenant Thomas prepares to enter the gun barrel . . ."

With one last tuck to keep his hair in place, Sean slides a white helmet over his head, removes the temporary foam lid from the mouth of the cannon, and flings it almost casually in my direction. At the start of the year, when I was still unsure on my feet, this manhole-sized cover would often hit me in the head and knock me from my place. By the middle of the season, much surer-footed, I started trying to catch it in the air. By year's end, I was nearly fleet of foot, and Sean's throws became more challenging. I would often snag the lid with an artful flourish, as I do on this final night of the year. The audience flickers with applause: the Human Cannonball is jamming with a clown. The ringmaster beckons us back to our tasks.

"A final farewell . . ."

Sean positions a pair of lemon goggles over his eyes and scampers into the open barrel. Before his head disappears from sight he waves goodbye to both sides of the house and gives a final thumbs-up to the crowd. Then in a sequined flash he is gone. The music suddenly skids to a halt. Only the pulse of the tympani drum disturbs the spreading silence. The

pause is almost painful to bear. The tent is dense with fear. Jimmy James augments the alarm.

"With an ignition of black gunpowder, combined with the chemical lycopodium for safety, he will blast off at a safe speed of fifty-five miles per hour . . ."

Ta-dum! The drumroll grows even louder. Oh no! The children cover their eyes. Please! I whisper to myself even after five hundred shots.

"Countdown!" Jimmy calls, and all the performers raise their hands in salute. With each booming call from his proud bass voice the audience joins the cry.

"Five.

"Four."

Until every voice in the six-story tent begins to chant in rare harmony.

"Three.

"Two.

"One . . ."

And all our dreams confront their test.

"Fire!"

•

Inside the barrel Sean Thomas waits.

"When I first get in the barrel I check all the parts. I look at the slide to make sure it's all greased. I look at the cable to make sure it's not snagged. Then after I rest my butt on the seat and put my feet on the stand I look out through the mouth of the cannon to make sure I'm pointed in the right direction."

Outside Jenny stands at the controls—four levers and a series of flashing lights—and makes the final preparations. She wears a headset to communicate with Sean. A small video screen reveals the distance the launching capsule has been retracted. Every show the measurement is adjusted. Though the front of the cannon is always precisely one hundred feet from the front of the bag, the amount of power Sean requires depends on the density of the air, the slope of the lot, and the relative strength of the cannon propulsion system itself.

"There's no reason anything should go wrong," he said. "It's pretty close to a science."

Not particularly scientific himself, Sean approaches each date with the cannon as if he's preparing for battle.

"I call it the Beast," he said. "Elvin says be friendly to it and it will be friendly to you. But it can turn on you like that. It can kill you in an instant. It's like the enemy and we're at war. I feel like it's always trying to get me, so I've got to find another angle. Every show it's something else. Every day it's like wrestling with fate."

Lying prone in the capsule with his rear end on a saddle, Sean prepares for battle. He grips his fists alongside his face and looks once more toward the mouth of the barrel.

"Inside, just at the lip of the cannon, there's a bumper sticker that says: 'NO GUTS NO GLORY.' I used to have a surfing T-shirt that said that. There was this big wave and this tiny guy who was just a dot on the shirt. It was my favorite shirt, but it got ruined the first night I wore it. I got into a big fight and blood went everywhere. Later I saw the sticker and put it in the cannon. It's the only thing that keeps me company."

From his pad Sean announces he is ready. From her post Jenny passes on the word. From the ring Jimmy informs the world.

"Countdown."

Inside, Sean receives the command as it echoes down the solid-steel barrel. When he first slid into the cannon, two years earlier, Sean was reckless, even cavalier. Even at the start of his second season, he was ruthless with the Beast—kicking it, beating it, tempting it to challenge him. But by year's end he had been transformed.

"Five."

"I'm much calmer now," he said in the front seat of the cannon just minutes before his final shot. He was listening to Percy Faith love songs on the cassette player in the dash. A picture of Jenny was taped next to the speedometer. The handle of his white plastic brush was broken in two. "I'm a much better person than I used to be. I don't know if it has to do with reading the Bible or what. I think it has more to do with getting married and kind of growing up a little bit." His voice was lower than it was when I first met him. He was less likely to punch me in the arm for fun.

"*Four.*"

"Now I have responsibilities," he continued. "I don't just worry about myself. Before, I didn't even do that. Now I have to worry about somebody else. Plus myself. I have to feed her. I have to clothe her. She doesn't work anymore. Before, I didn't have anybody depending on me. Now I have to worry about what I do in the cannon, because if something happens to me in there, then she's left all alone."

"*Three.*"

As with his view of himself, Sean's view of the show had also evolved. The first day I met him he climbed on the cannon and left me standing on the ground. "So, you want to have a peek inside?" he had taunted. "Why not," I had said. "Because you can't," he replied. For weeks afterward I accepted his challenge and began piecing together the "world's largest secret." Much of it was simple. Inside the barrel was a coffin-sized capsule attached to a narrow cable; the capsule was pulled back into launching position by a hydraulic piston; the piston locked the capsule under the handle of a giant mechanical trigger. But what was it that gave the capsule the power to launch the cannonball? At first I thought a spring, or maybe even the explosion itself. Both of these were wrong, I soon discovered, though I couldn't figure out why.

"*Two.*"

Finally, about a week before the end and with our friendship well established, the newly humbled Human Cannonball invited me inside the barrel. There I saw Sean's bumper sticker. There I felt his source of flight. There I heard the silent echo of every child who hoped to fly.

"*One.*"

And there I realized that certain dreams are better left preserved.

"Boom!"

•

Emerging from the cannon, Sean looks like a blur. His body shoots from the barrel like a cork from a champagne bottle, bursting fifty feet into the air with a shower of bubbly oohs and aahs and an explosion of speed and light. Halfway to heaven his arms slowly open as if he's swimming toward the top of the tent. Then for an instant he seems to stop—

he's reached his peak, he's mounted the sky—before he finally ducks his head and begins his final descent.

"Flying is the greatest sensation," he said. "When I take the hit and leave the barrel I feel as if I could fly forever. That's when I know I can do anything. My mind slows down. I know I'm going to hit the bag. And then at the peak my momentum stops and finally I feel that I'm free-falling. Falling, falling, falling, falling, then, boom!, I land on my back. It's not like anything in the world. It's not like diving off a diving board. It's not like surfing on a wave."

"Is it like sex?"

"What, are you nuts? I mean it's good, but it ain't that good! It doesn't make me blow a nut."

Sean lands in the bag with a giant puff. I breathe my final smile of relief. The audience slowly rises to its feet as Sean steps out of the yellow-and-blue pond with a slightly dazed look on his face. He tosses his helmet to the prop boss and skips to the center ring.

"*Ladies and gentlemen . . . the Human Cannonball . . . Seaaaaaaaan Thomas . . . !*"

Sean plants his feet slightly apart, lifts his arms high into the air, and beams at the last row of the crowd as if to say, "Hey, look, I did it. Now let's hear some applause." For a full minute he draws that applause, and at the end of that time he looks off to the side, where Elvin Bale has returned for the final show of the year and is sitting in his wheelchair with his arms in the air like a proud parent who watches his child succeed and knows just how it feels.

"*Ladies and gentlemen, boys and girls, you have just witnessed another milestone in American show business history. . . .*" Jimmy straightens his red tailcoat and steps to the center of the world's largest tent. "*Tonight's performance concludes a ninety-nine-city tour, through sixteen states, covering over twelve thousand miles, and giving five hundred and one performances. None of it would have been possible without you, the American circus-going public. We sincerely thank you for your patronage . . .*"

With a final blow on his ringmaster's whistle and a gentle sweep of his arm toward the door, Jimmy draws the season to a close. The band marks the moment with a teary rendition of "Auld Lang Syne." The cast

quickly streams from the tent. Outside, the performers barely pause at the door before sprinting to their trailers and shedding their spangles for the final time. Quickly, desperately, they want to be free.

The last person out of the tent is the ringmaster himself. Not so fast on his feet, less desperate to flee, Jimmy slowly pads from the tent with a fog of tears eclipsing his eyes. His smile is weary. His bow tie is gone. In his hand he carries a small tote bag.

"So now you know . . . ," he says as he stops by my side.

"Yes, I do," I reply. We both shake hands.

"I hope you tell the truth," he says. "Soon all of this will be gone."

Back in the Alley the others have gone. I slip off my oversized red-and-white shoes and unhook my floppy gold tie. Piece by piece I remove my costume: my bright orange pants, my white dinner jacket, and my pointy hat with the elastic strap. I fold each of these and lay them in my trunk, already battered from three weeks on the road. At last I slip off my stained skullcap and queen-sized stocking hair net. The only thing left is my bright white face, with the smooth black clefs and the crisp red nose. Squeezing baby oil into my hands, as I have done more than two hundred times before, I smear it into my pores and rub the graphic red and black features into the layer of solid white that covers my skin from my forehead to my throat. After several quick wipes with a well-stained towel my face dissolves into its former self, like a black-and-white negative slowly changing into color. I look at the mirror that hangs in the corner and the image reflected is clearly mine. Instinctively I try to smile, but the truth is painted all over my face. I am myself.

By the time I step outside, the city is already halfway torn down. The flying rigging is being dismantled. The tympani drum is being carted away. The bears and tigers have already gone. By twenty after ten the last lights have come down, leaving behind the empty whale where elephants and horses so recently danced. A few men pull down the outer poles. Ropes dangle everywhere. In a moment a light mist begins to fall. By eleven o'clock the tent is dark. All the seats have been removed. All the magic has been excised. One by one the quarter poles are released and the heavens are slowly winched down to earth, until at twenty minutes before midnight, with a silent, swelling slap, the world's largest big top

spanks a final time against the pale, wet Florida grass. Few people are around to witness the sight—the crew, a few of the mechanics, and, fittingly, the owner.

Johnny startled me moments later as I watched the men dismantle the center poles into their male and female halves. His voice was valedictory. His eyes were heavy. "A long time ago I learned that there are many things in life that I wished I'd looked at just a little longer," he said. "I always think I might not see it again and I want to remember it. I used to do that with my home. When I left home every spring to go on the road I would walk around the house a little bit. I would wander through the flower beds and the lawn. The trees are here, I would say to myself. The house is here. They might not be here when I get back. It's the same way with the show. I'm always afraid that something will happen to me, or to the circus, and I might never see it again. One year I will be right."

Quietly and with casual sleight of hand he produced a bag from behind his back and laid it in my arms.

"I want you to have this," he said, "and I want you to know: no matter what else, you were a damn good clown. You made our show better this year."

I thanked him for his generosity, then peered into the bag. Inside were several bundles of faded cloth, four tattered talismans: CLYDE BEATTY, COLE BROS., CIRCUS, and on top of the others, the American flag.

"You can never say goodbye to the circus," he said, "no more than you can ever say goodbye to your childhood. We'll see you again. I'm sure of that. Now you're one of us."

Johnny shook my hand and walked away—vanishing himself in the cover of darkness like the show he so adored. Left alone, I followed his cue, and with one last look at the rolled-up tent, now easing around its spool, I started my camper and drove off the lot—onto a road without any arrows, toward a tomorrow without a circus.

Home

Behind the Painted Smiles

One lingering effect of my year in the circus is that various words now mean different things to me than they do to the rest of society. One of these is the word "clown," which I am distressed to observe has developed a surprising currency as an insult. Another is the word "circus," which has somehow come to mean "chaos," as in "It's a media circus out there" or "My office is a three-ring circus." After watching the world's largest big top go up and down ninety-nine times and seeing two hundred people and two dozen animals move twelve thousand miles and do five hundred and one performances in slightly over eight months, I can say with a certain degree of confidence that I have never been around anything as well organized as a three-ring circus.

With that in mind I would like to thank the two hundred men and women of the 109th Edition of the Clyde Beatty–Cole Bros. Circus, many of whom appear by name in this book. Their dedication is boundless, their skills unrivaled, and their unflinching hospitality in the worst of conditions made me a believer in the magic of the circus. In particular, I would like to thank the following people who welcomed me into their lives: Khris Allen; Gloria, Dawnita, Elvin, and Bonnie Bale; Elmo Gibb; Blair and Mark Ellis; the Estrada Family; Nellie and Kristo Ivanov; Jimmy James; Kris Kristo; Inna and Venko Lilov; Fred Logan and Family; Michelle and Angel Quiros; the Flying Rodríguez Family; Jenny Montoya and Sean Thomas; Royce Voigt; and the boys in Clown Alley: Brian, Christopher, James, Jerry, Joe, Marty, Mike, Rob, and Buck.

In addition, I would like to express my heartfelt appreciation to the men and women of the advance and marketing department (Jeff Chalmers, Bob Harper, Elizabeth Harris, Bob Kellard, Mike Kolomichuk, Tim Orris, Edna Voigt, Chuck Werner), and especially to

Bruce Pratt and Renée Storey, whose encouraging words and spirited laughter have made them seem like equal collaborators in this project. Finally, my deepest appreciation goes to E. Douglas Holwadel and John W. Pugh, who invited me to join their show without restrictions and who guided me openly through the normally candy-coated corridors of the circus. Johnny Pugh, still on the road more than fifty years after being born into show business, is one of the most respected men in the circus business today and one of the most decent men I've ever met.

Meanwhile, an equally large number of people who don't live on wheels helped bring this book to life. Jane Dystel, my agent, cradled this book from gleam to reality. Bill Goldstein, my editor, nurtured it from proposal to publication. Miriam Goderich read an early draft and made several helpful suggestions, and David Shenk, my friend and colleague, improved the manuscript with his painstaking edits and prudent advice. Numerous others offered support and escape along the way: Angella Baker, Hamilton Cain, Ruth Ann and Justin Castillo, Robin Diener and Terri Merz, Bill Fahey, Jan and Gordon Franz, Leslie Gordon, Leigh Haber, Allan Hill, LaVahn Hoh, David Hsiao, Michael Jacobs, Dominique Jando, Ben Kinningham, Ted Lee, Halcyon Liew and Arnold Horowitz, Evi Kelly-Lentz and John Lentz, Gordon Lucket, Chuck Meltzer, Irvin Mohler, Susan Moldow, Marcy Oppenheimer, Katherine and Will Philipp, Christopher Reohr, Karen Gulick and Max Stier, and last of all, David Duffy, who taught me how to juggle those many years ago.

Finally, I would not have been able to run away and join anything for a year, or sit at home in front of my computer for a year after that, were it not for the unparalleled support team that surrounds me every day: Aleen Feiler; Mildred and Henry Meyer; Jane and Ed Feiler, editors, advisers, masters of more than one ring; and Cari Feiler Bender and Rodd Bender, newlyweds for now and a lifetime to come. Above all, I would like to express my increasing and undying gratitude to my brother, Andrew. He never set foot inside the ring, but he was outside it, alongside it, and even above it, capturing the circus with his unflinching eye. One of his photographs graces the back cover of this story and this book is dedicated to him.

Read All About It

In the course of working on this book I came to the conclusion that the circus has joined the ranks of sports and war as one of the leading sources of metaphor in our language. A day would hardly go by when I didn't read about someone "turning somersaults" for some purpose or another or "keeping eight or ten balls in the air at one time."

Given this penchant for inspiring metaphor, it comes as no surprise that the circus has inspired many metaphor-laden books. Of the three dozen or so that I read, some were particularly enjoyable. In the area of history, John Culcane's *The American Circus* (Holt) is delightful and comprehensive. Others that I found helpful include David Lewis Hammarstrom, *Big Top Boss* (University of Illinois), A. H. Saxon, *P. T. Barnum* (Columbia), Earl Chapin May, *The Circus from Rome to Ringling* (Duffield and Green), and George Chindahl, *History of the Circus in America* (Caxton). While these books provided important background information, most of the material presented in this book is previously unrecorded. Since much of it comes from first-person recollections by notoriously inaccurate circus personnel, wherever possible I have tried to confirm the dates and information presented.

In addition to formal surveys, hundreds of memoirs by American circus performers have been published in the last two hundred years. I don't pretend to have read even a substantial sampling of these, but several of the ones I did read stand out as the most charming of all the circus books I examined. I particularly recommend Bill Ballantine's *Wild Tigers and Tame Fleas* (Rinehart), Fred Bradna's *The Big Top* (Simon and Schuster), and Connie Clausen's *I Love You, Honey, But the Season's Over* (Avon), which not only is the most engaging account I read but also has the best title, and, for me, the most meaning, since it was given to me by a great circus fan, Harrison Sayre of Annapolis, Maryland.

Finally, as much as I love them, books can only hope to intimate and illuminate the immediate sensation of viewing a circus in person. While the American circus is hardly in jeopardy of dying, it is changing in response to the pressures of the times. If this book has rekindled any memories of your own, go see a circus next time one comes to town and in so doing help keep the dream alive.